VAGUE VOGUE

模糊時尚 ──── 楊子強 作品　**Lifestyle Magazine**

The Yeo Chee Kiong Collection

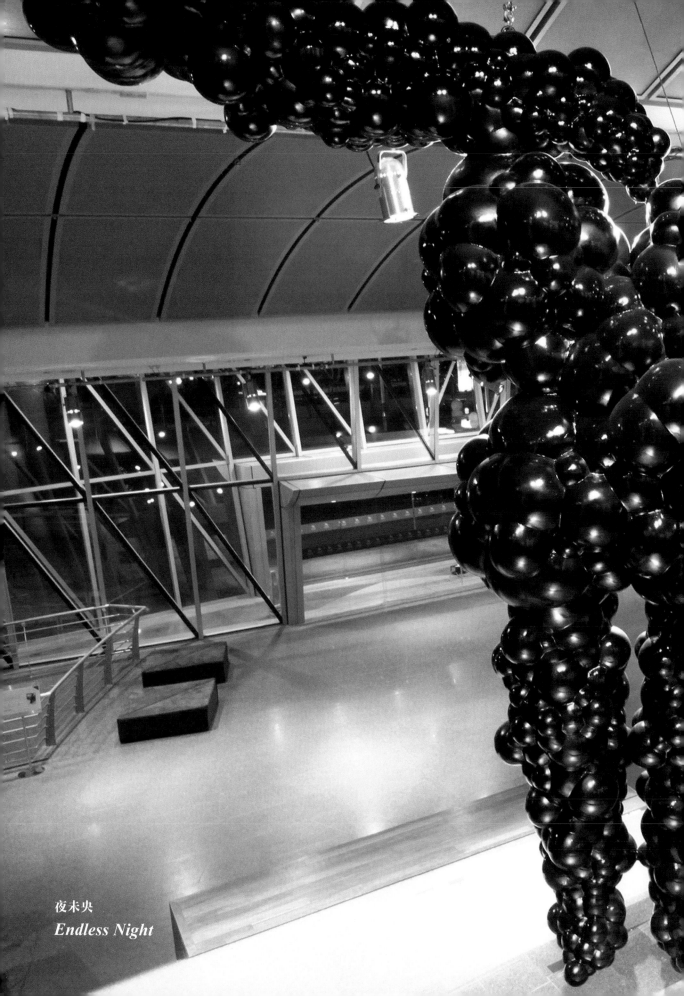

夜未央
Endless Night

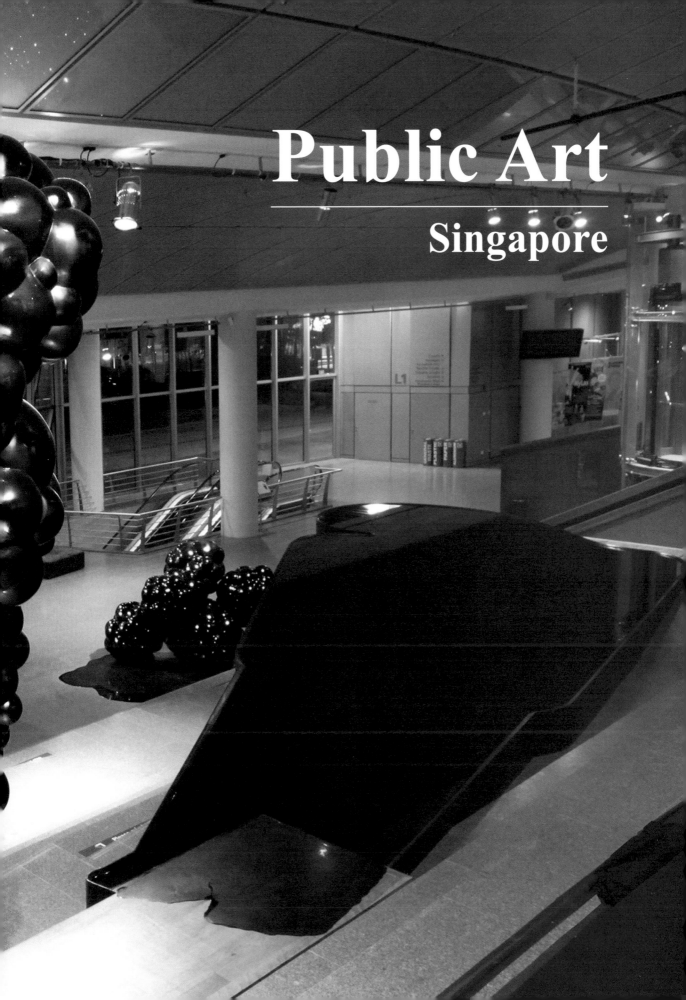

Public Art

Singapore

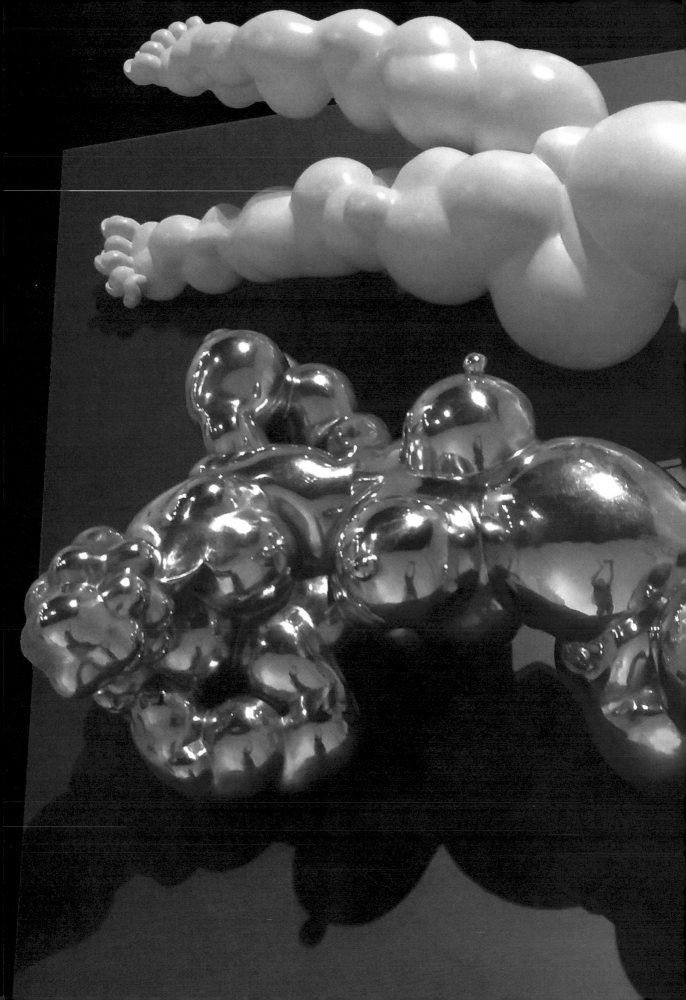

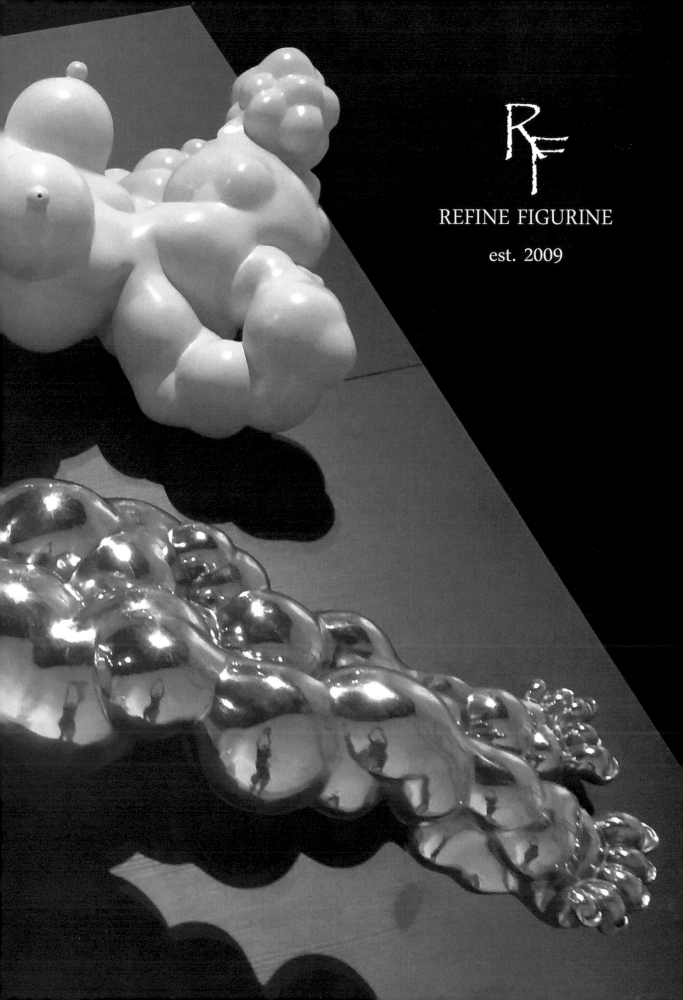

REFINE FIGURINE

est. 2009

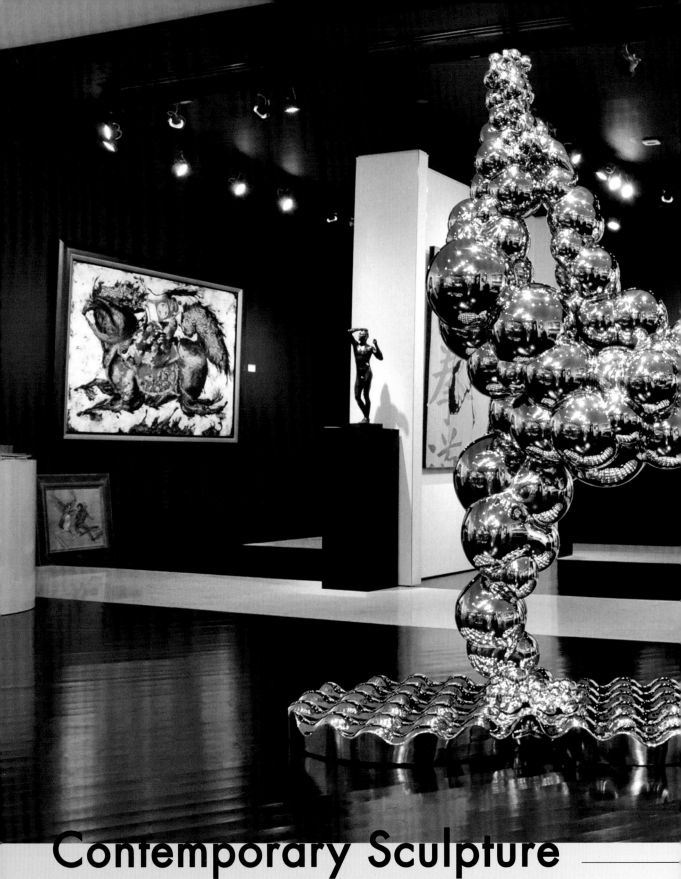

Contemporary Sculpture

氤氳光鏡

創刊介紹

定位

以趣味漸進的引介方式，導入時尚流行內容，通過獨特的交疊擬態形式，在現實生活中進行時尚藝術實踐，驗證當下的潮流格調，論述當代的生活品味。

理念

擁抱時尚，更要創造時尚。回應時代律動，但從不滯留。

刊名透視

「VAGUE」和「VOGUE」的英語單詞直譯。字意分別為「模糊」和「時尚」。同為五個字母組成，相區別字母為排列於第二順序的「A」和「O」。「時尚」的顯性特質，如流行性，風格性，當下性，與「模糊」的隱性特質，如不確定性，難以觀測性，曖昧性，有著強烈的對比。「模糊＋時尚」，如同 A 型血和 O 型血之間的顯隱交纏，這兩個相悖相疊的意涵，是矛盾，是意象，是聯想。

模糊時尚

下一個風潮永恆到來，這是一個個性的時代，這是一個模糊時尚的時代，「不確定性」將壓制一切，隱晦性是下一刻必要的時尚語言，以一種接近預言的想像，描述未來的趨向。

創辦人

探究時尚藝術層面上的「美麗境界」（電影 *A Beautiful Mind, 2001*），常處於不同假設的「我」之間的「自問自答」，體會同一個美麗時刻在不同的尺度中所可能存在的和被了解的形式和方式。

麗美中心

所探索的兩個原始概念如同孿生連體般的相互對應著。其一，藉由創造出擁有鮮明物質價值的「雕塑物件」，造就其無法被忽視的存在。但於此同時，又再賦予該「雕塑物件」毫無關連但又十分真實的敘述聯想，間接的抹滅其原定的初始內容，把觀眾帶離常規的邏輯思維，造就一場充滿錯覺和矛盾的美的饗宴；以非一般的，更廣的角度去讓觀眾經歷不同層次的美的深淺度。

Introduction

Positioning

To introduce popular content in fashion in an interesting, progressive way, and to promote the practice of fashion and art in real life through the unique form of intercrossing mimicry. With these, we hope to verify trends in current styles and to discuss taste in contemporary life.

Philosophy

Embrace and create fashion. Respond to the rhythm of the times, but never linger.

VAGUE VOGUE

"Vague" is "fuzziness," and "vogue" is "fashion." Both words are made up of five letters, differentiated by the second letters, the "a" and the "o." The dominant traits of fashion, such as popularity, stylishness, and contemporariness, are in sharp contrast to the recessive traits of fuzziness, which include uncertainty, obscurity, and ambiguity. "Fuzziness" + "fashion" is like the implicit entanglement between the blood types A and O. Their overlapping implications are contradictions, imagery, and associations.

Fuzzy Fashion

The next trend will forever be coming. It is an era of individuality, an era of fuzzy fashion. "Uncertainty" will suppress everything, while obscurity serves as the necessary fashion language for the next moment, describing future trends with an imagination that approaches prophecy.

Founder

Explore *A Beautiful Mind* (film, 2001) in fashion art, often through self-questioning and answering the variations in the hypothetical "I," experiencing the possible existence of the same beautiful moment in different scales, and experiencing the forms and ways that it could be understood.

A Beauty Centre

Explore two parallel themes. The myriad possibility of meaning in my work underscores my twin interests – I created "sculptural objects" that possess a material quality so vital that they cannot be ignored. But at the same time, the objects are imbued with compelling ideas or narratives that may be irrelevant to how they were initially conceived. This leads the viewers away from the usual logic, creating a feast of misconceptions and contradictions, and a wider, more nuanced experience of beauty for them.

Contents <small>目次</small>

編者的話

以物之名

▇ 陳燕平

如果您曾經享受過麗美中心的服務，《模糊時尚》必定能夠進一步協助您完整地了解您所體驗過的，身、心、靈上不同層次的祛毒與美容療程服務。如果您不曾親臨麗美中心，那麼特別為麗美中心限量發行的《模糊時尚》也必將為您開啓一個全新的美感驗證之旅。從此刻開始，這趟以美之名的旅程，將以最細膩的方式，帶您造訪一個絕對的美麗境界。

「美」不只是人類日常生活中的主觀感知經驗，也是滲透於社會文化各個層面的客觀價值和信仰，在哲學與藝術領域中更是經典議題。而「藝術」與作為「物件」的「藝術品」之間的複雜關係則在法國達達藝術家杜象拋出他的現成物後才逐漸從哲學與美學的範疇走入一般公眾可以討論的話題範圍中。後來美國藝評家露西・利帕德在 1968 年為了使正在興起的概念藝術合法化而提出的「藝術物品去物質化」，而羅莎琳・克勞斯十年後從極簡藝術與大地藝術的角度出發所闡述的「雕塑的擴展場域」所發揮的影響更是深遠，只不過這些觀點雖然為新形式的藝術生產提供了理解的框架，卻也使藝術範疇的歷史性定義模糊化，並困擾了當代藝術的確定性。而在短短的五十年間，當代藝術學說與研究卻出現了「物質轉向」，許多學者開始認為所謂的藝術「去物質化」在今天已經不再有具體意義，轉而關注藝術物件與物質的內在關係。有些學者認為這個現象是藝術對數位化世界的解藥性回應，有些將對「物」的擁護視為藝術家對藝術理論化的抗拒，或是以物質來消除作者中心以抵禦藝術因為與科技結伴所帶來的日益主體化問題。（註1）而在今天的新媒體時代，網絡世界中的影像與訊息爆炸更是為原已複雜的情況增添危機：今天的美術館充斥著各種各樣的物件——繪畫、雕塑、相片、錄像、純粹是物件的物件（護欄竿？告示牌？除濕器？投影機？）與不純粹是物件的物件（藝術家的「現成物」？看起來像超市商品的「藝術品」？極簡藝術家擺放的磚塊？）；與非物件（聲音藝術？牆上或空間中的投影？虛擬實境？數位館藏？）。許多人可能已經看不懂，面對呈現形式與性質迥異的各種物件，究竟什麼才是藝術、如何歸類、怎麼分主流與邊緣、何者當道、何者過氣、標準在哪裡、什麼是美、美重不重要、誰說了算？

過去人們以「真、善、美」要求藝術，但是在今天這個物慾橫流，商業掛帥，美與品味充滿陷阱的世界裡，這樣的單純美好如何維繫？是否足夠？《麗美中心》因應這樣的當代語境而生，試圖在一個充滿假像（和假新聞！）的虛假世界裡提供人們一些探究美麗與虛實的真體驗。創辦人刻意通過各種美容與藝術手段製造了一個個物與非物之間的多重矛盾以及它們之間的相互祛毒、消解，專門從感知與物理管道出發來連結前來體驗療程的客戶們的注意力，並同時給予他們一道道視覺與感知上的難題。在這裡，一切似乎都似是而非，療程中客戶一踏入麗美中心便盡見詩意與曖昧——面前站著不是美麗裸體的美麗裸體，腳邊一灘不是水的水，眼裡一叢不是雨林的雨林，空間中擺著不是桌子的桌子，牆上掛了不是時裝的時裝，而最終他們發現自己身處不是美容院的美容院，而《麗美中心》則是個不僅展示藝術的藝術展，不怎麼當代藝術的當代藝術展，不只有雕塑的雕塑展（您目前正讀著的或許是一本不是雜誌的雜誌）……在這一連串的是與不是之間，《麗美中心》旨在形成一個意義自由生產的異域，一切都有可能，美容師

Editor's Note

In the Name of the Object

Tan Yen Peng (Original in Chinese, Translated by Tan Yen Peng)

If you have ever enjoyed the services of *A Beauty Centre*, then you would find *Vague Vogue* helpful for your further understanding of how the detoxification and beauty treatment have benefited your body, mind, and spirit at different levels. Otherwise this limited-edition publication, specially issued by *A Beauty Centre*, will embark you on a new and authenticating journey of aesthetic experience and a delicate expedition that promises an absolute state of beauty.

"Beauty" is not only the subjective perceptual experience of our daily life. It is an objective value and belief that permeates all levels of our society and culture, and a classic topic of discussion in the fields of philosophy and art. As for the complex relationship between "art" and artwork as "objects", it was not until the French Dadaist artist Duchamp shocked the world with his readymades that the issue went beyond the scope of aesthetics and philosophy and gradually enters public discussion. Not too long after Duchamp, the American art critic Lucy Lippard proposed the "dematerialization of art object" in 1968 in attempt to legitimize the emerging conceptual art, and Rosalind Krauss expounded the concept of "sculpture in the expanded field" 10 years later from the perspective of minimalist and land art, both of which have far-reaching impact. Although Lippard's and Krauss's theories provide a framework for understanding the new form of art production, they however, obscure the historical definition of art categories and disrupt the certainty of contemporary art. Yet, in the short span of 50 years, contemporary art theory and research have seen a "material turn". Many scholars have begun to think that the so-called "dematerialization" of art is no longer meaningful today, and began to focus instead on the inner relationship between the art object and its materiality. Some scholars believe that this phenomenon is art's antidotal response to the digitalized world, some regard the support of "object" as the artist's refusal to the theorization of art, or the elimination of author-centricity with an emphasis on the material to resist art's over-subjectivization due to its close association with technology. (Note 1) In an era of the new media, the explosion of images and information in the world of internet adds to the already complicated situation: today's art museums are filled with "objects" of all kinds - paintings, sculptures, photos, videos, objects that are mere-objects (Guardrail poles? Signboard? Dehumidifiers? Projectors?), objects that are not-mere-objects (Artists' "readymades"? "Artwork" that looks like supermarket merchandise? Bricks laid by minimalist artist?); and non-objects (Sound art? Projection on a wall or space? Virtual reality? Digital collection?). In the face of all these "things" with different forms and properties, many may no longer understand what art exactly is: Are there categories? How do we classify? How to distinguish the mainstream from the marginal? What is considered popular and what outdated? Which standard do we follow? What is beauty? Is beauty important? Who has the final say?

In the past, people demanded that art should be about "truth", "kindness", and "beauty", but the world today is filled with material greed, led by commercial needs, and covered with false beliefs of superficial beauty and taste, would these simple virtues be good enough? How could these qualities be maintained? *A Beauty Centre* was born of such contemporary context as an attempt to provide people with real experiences through exploring beauty and reality in a false world full of fake images (and fake news!). Through various beauty and artistic means, the founder of *A Beauty Centre* deliberately created multiple contradictions between objects and non-objects in his spaces, so that opposing elements negates one another to achieve "detoxification" for the clients. Special

和客戶都在療癒與施療中各自尋求解答，而觀眾、藝術家、藝術物件、展覽場地甚至是出版物都得以互為主體，在各方的相互觀視下彼此豐富。

《模糊時尚》除了收錄麗美中心裡最相關的經營理念，和創辦人所精心雕鑿的，文字型態上的「美麗概念」之外，更特邀藝術界的評論家來為觀眾進一步挖掘與釐清有關美、藝術、和與之相關連的機制界定等議題。

首先是已故英國藝評家兼策展人約翰‧卡爾卡特（1951-2018）生前特地為《麗美中心》操筆寫作的〈美麗與墮落〉一文。一開始，作者便在短序中強調人們與藝術之間繁複的關係以及當代藝術論述的慣性客觀取向，與觀者主觀經驗的相互悖離。為此他刻意避開學術邏輯轉而強調實驗性與想像力，並以他慣用的虛構敘事（fiction）手法結合《麗美中心》無預設立場的結構為出發，文中人與物的選擇，情節與時空的編排，甚至是字體、標點符號與句子格式的設計，都緊扣主題而充滿意象。從伊甸園的蘋果、特洛伊的海倫、能望見富士山的書房、到攝影棚裡的名模與攝影師、美容院裡的蘋果電腦、和未來的虛擬世界，強烈的畫面感似乎受到了《麗美中心》的召喚，而蒙太奇式的拼湊法也巧妙地呈現與呼應了「美」的定義的不穩定與多面性。在隱喻當代的「在美容中心裡」一節中，作者更神來之筆地以「剪切與黏貼」（cut-and-paste）的方式，將蘋果公司的廣告詞嵌入到當代學者的文化討論中，在影射商業社會中「美」的行銷的同時順勢體現了「谷歌時代」中網絡世界的「剪貼綜合症」（copy-paste syndrome），也讓文章在書寫手法上與《麗美中心》獨有的療程設計達至思維頻率上的「同步」（syncing）——文中這段呼籲尤其讓我們讀出了麗美中心潛藏的創辦動機：「在這個個人電腦、數位科技、行動電話、虛擬實境、大眾消費的時代裡，美……需要被重新定義……」。

接著，由新加坡藝術家兼策展人蘇茜‧林厄姆執筆的〈反諷的雕塑角色鑄型：「美的提問」的可被提問性〉則為《麗美中心》從創辦形式、療程內容、中心內的物件與材料運用以及場地設置等等都做了細緻的形容與分析。作者從《麗美中心》的經營主題切入，先是帶出了雕塑、美、藝術與權利之間的密切關係，再逐步深入地探討和挖掘「藝術美容中心」底下的可能含義。這包括對創辦人楊子強「創業背景」的研究，例如他如何在「自然現象」與「人造美」的角力之間，因為自身雕塑家身份的介入而不自覺地從原本設想的「無形」之塑形走向了彰顯潛意識的「有形之形」。對林厄姆來說，《麗美中心》除了「繼承了巴洛克與洛可可美學」也透露著一種「說教式的荒誕美學」。在影射自拍時代中的人們（尤其是女人？）對膚淺的美與對自我身體形像的迷戀中，也彰顯了「美」在當代語境中其「可被提問性」的吊詭情形。除此之外，《麗美中心》也在作者的形容中一方面「處處顫動著精神分裂症式的不一致性」，另一方面卻又暗含埋藏在藝術家心中的道家思想，其敏銳的觀察進一步揭示了藝術家的男性身份與女性美的品味的曖昧與衝突，此舉無疑為創作與潛意識的關係增添了重要一筆。

effort has been made, on both the perceptual and physical levels, to connect the attention of clients who have come to experience the treatment, while presenting them a series of visual and perceptual questions to ponder. Here, poetic ambiguity is part of the therapy from the beginning, everything they encounter seems paradoxical, they see in front of them beautiful nude statues that are not "beautiful" nor "nude", they pass by pool of liquid that is hard and dry, but walk into columns of soft rain without getting wet. They come across a table without a stable surface for holding things, while appreciating fashion displays on the walls that are not fashionable. Eventually, they find themselves in a beauty salon that is not a "beauty salon", while *A Beauty Centre* is an art exhibition that is not "art exhibition", contemporary art that is not "contemporary art", sculpture exhibition that is not "sculpture exhibition" – at this moment, you may be reading a magazine that is not a "magazine" ... Amidst these baffling affairs, *A Beauty Centre* aims to become a unique arena where meaning would be able to proliferate freely. Everything seems possible here. As the beauticians and the clients seek answers and solutions together during the process of therapy and healing, audiences, artists, the art objects, the very site of the centre itself, and even this publication all become inter-subjects that enrich one another during the mutual exchange.

In addition to the most relevant business ideas and "beauty concepts" meticulously carved by the founder of *A Beauty Centre, Vague Vogue* has also invited important critics in the art industry to further extend and clarify issues related to the definition of beauty, art, and the related mechanisms for the audiences.

First, we have "The Beautiful and Damned" written specially for *A Beauty Centre* by the late British art critic and curator John Calcutt (1951-2018). From the start, the author highlights in the brief preface the rich and complicated relationship between art and its viewers, and highlights the contradiction between the habitual orientation towards the objective in art writings and the subjective experience in actual art viewing. In view of this, Calcutt avoided academic logic deliberately and emphasized instead on experimentation and imagination in his writing. While fictional approach – a frequent technique in his recent writings – was employed, he consciously adopted the free structure of *A Beauty Center* so as not to assume a preset position. The various elements in the text – from the characters chosen, things mentioned, plots designed, time and space conceived to the fonts, punctuation marks, and sentences formatted, the writing is full of imagery that relates to the theme closely. There is also an interesting range of spectacles involved, such as the apple of the Garden of Eden, Helen in Troy, Mount Fuji seen from the study room, the supermodels and photographers in the studio, the Apple computers in the beauty salon, and the virtual world of the future. The strong sense of visuals seems to respond to the summon of *A Beauty Centre*. On the other hand, the deliberate montage used subtly represents and echoes the instability and multi-faceted nature of the definition of "beauty" as a subject here. In the section of "In the Beauty Salon" which alludes to the world today, Calcutt ingeniously embedded Apple's advertising phrases into the scholarly discussions of culture by using the "cut and paste" method. In so doing, he insinuates the marketing of "beauty" in the commercial world while reflecting on the "copy-paste syndrome" of the online world in the age of Google. At the same time, this also brings the plot of the article to come conceptually in sync with *A Beauty Centre*'s treatment plans. In the end, both works share the same belief that, "... the very idea of

另外是摘錄自「金山上的美容院——擬態：藝術現形記座談會」第一場講座「掩目：以美之名」的部份內容。別開生面的主題，由麗美中心創辦人楊子強親自上陣，與台灣知名美術史學者白適銘教授以各自的角度，從生物世界中的「擬態」行為，商業時尚生態中的各種「掩目」手段到美術館空間的社會作用，共同探討了「生存」與「策略」的交疊作用，有趣地揭示了「美」、「藝術」、「藝術家」、和「文化」、「社會」、「政治」如何在相互依賴與對立中最終彼此協商、適應與融合的過程。當中楊子強強調了藝術家作為提問者的觀點，觸及了藝術的「不安份」與主流體制的對立、「美」在當代的必要性、以及藝術與藝術家兩者的「生存」與審美框架的構築與藝術手段的作用等問題。而白適銘也提出在「作者已死」的當代語境中，藝術家與觀眾之間身份出現相互模擬、藝術展示空間與藝術品以及藝術家的關係、藝術定義以及文化背景對公眾詮釋作品的影響、藝術的社會化等議題。他關注「以美之名」的反思，恰當地指出「美」在宗教與哲學中的差異，並有趣地以「藝術荷爾蒙」論來形容藝術家在不同情況中如何以「掩目」與「擬態」的的藝術手法來完成其社會作用。

最後，由台灣知名藝評家高千惠教授所書寫的〈當謬思女神進駐美容院〉更從國際藝術生態圈入手，直擊當代藝術生產線中的商業操作與機制霸權等問題。她精準犀利的把脈與剖析，為久病不癒的藝術生態環境帶來深刻的反思與提醒。必須一提的是這篇原名為〈是誰殺了美術館？〉的文章，其書寫始於九〇年代，曾是一個座談會主題，之後才被集結於 2008 年出版的《叛逆的捉影》裡。而楊子強在創辦麗美中心時對體制的思考則始於 2007 年在新加坡國家博物院所展出的藝術項目《無樹之日》，之後才開始構思以《麗美中心》做為創作手段，以「美」的主題切入，逐步形成對於當下藝術機制各種角度的探討。當時雖然兩人一個在西方的芝加哥，一個在東南亞的新加坡，彼此所針對的議題和現象卻在不同地理位置中的一個時間軸上有明顯的呼應與承襲。高千惠以評論者的角度刻畫了美術館作為公共空間在時代、地理、政策與文化變遷中所面對的困境，包括在競爭壓力下所催生的軟體（比如館藏）與硬體（比如美術館建築）之爭，在經濟與文化的掛鉤中通過如「爆堂秀」與「主題園」等商業手段來收獲所謂的「人頭率」，以及最後在民粹與菁英的角力中，美術館作為一個經營文化的機制，其功能與定位的混淆不定。這些與《麗美中心》中「小心滑倒！」的告誡立牌，九個數位屏幕裡暗中進行的「美」的商議、內容似是而非的美容療程手冊等等，都有一種耐人尋味的契合。而這篇文章和麗美中心兩者之間更是形成了很好的互文對照，藝評觀察與藝術創作理念的執行之間似乎出現了一種相互印證，並且彼此交疊出一個微妙的觸碰點，彷彿異口同聲的發問：「當謬思女神進駐美容院」，「美」是否就將得以正名？

《麗美中心》先後在新加坡藝廊與台灣美術館成立，加上《模糊時尚》如今的出版面市，楊子強總共花了近十年的時間和心力，希望通過雕塑物件、美容祛毒療程與藝術閱讀的聯盟，在個人創作、當代藝術機制與商業模式的範疇中，重新審視「美」、「藝術」、「藝術品」和我們的關係。而作為由藝術家一手經營的美容院，《麗美中心》的可貴之處還在於它不只是藝術家主觀的「個

beauty is dynamic, changing, and in need of re-conceptualizing in our age of personal computers, digital technology, mobile phones, virtual reality and mass consumerism."

Next, we have "Sculpture Cast as Satire: Misgivings on the Quest for Beauty" written by Singaporean artist and curator Susie Lingham. The article makes detailed account and careful analysis of *A Beauty Centre*'s founding philosophy, its therapy components, and the objects and materials used in the setting up of the centre. Lingham begins with the theme of *A Beauty Centre* and discusses the close links between beauty, sculpture, art, and power, before moving on to an in-depth exploration of possible meanings and intentions behind the making of *A Beauty Centre* as an "Art and Beauty Salon". In her report of the "business background" of the founder Yeo Chee Kiong, she makes important observations such as the impact Yeo's foundation in and love for sculpture making have on his current practice, as she takes note of the interesting tension and negotiation between form and formlessness in Yeo's attempt to express "natural phenomenon" versus "artificial beauty". For Lingham, in addition to having "straddle inherited Baroque and Rococo aesthetics", there is also "a didactic aesthetics of the absurd at play" in *A Beauty Centre*. As Yeo makes reflection on the age of selfie where the obsession with superficial beauty and our own body-image is norm, Lingham points out that the real irony here is perhaps the very inquiry itself into the subject of beauty. Furthermore, *A Beauty Centre* is also being described as a showcase that "thrums with schizophrenic incongruence" on the one hand, while revealing Taoist ideas that is buried in the mind of the artist. These keen remarks further revealed the ambivalence and conflict between the artist's male identity and the subject of taste and female beauty. In this investigation, Lingham has undoubtedly added an important dimension in revealing the works of the subconscious in Yeo's creative journey.

Following Lingham's clever texts is an excerpt from the public talk "Eye Covered: In the Name of Beauty" in the "Juming Art Forum" series, "*A Beauty Centre* in Jinshan – Mimicry: Art Unmasked". The theme is a rather rare one in art forums, and included here is a conversation between two of the panelists, the founder of *A Beauty Centre* Yeo Chee Kiong and well-known Taiwanese art historian Pai Shih-Ming, where the two of them discusses the "survival" and "strategy" of the art world while exploring how the subjects of "beauty", "art", "artist", "culture", "society" and "politics" are at the same time against and interdependent of one another. From rather intriguing perspectives such as the consideration of the mimicry behavior in the biological world, strategies of deception (covering the eyes) in fashion businesses, and the social function of the museum spaces, they provide insights on the processes where various social mechanisms and art institutions might negotiate, adapt, and integrate with one another. In Yeo's part, he emphasizes the role of the artist as a questioner, and touches on the thorny issue of the place of the artist as the "restless" and "rebellious" one in the face of the mainstream system. He is also concerned about the necessity of the presence of "beauty" in contemporary times, the "survival" of art and artists in society, and issues in the construction of aesthetic framework and artistic strategies. For Pai, he proposes that in the contemporary context where "the author is dead," the issues worth noting includes the identity simulation between the artist and the audience, the increasingly complex relationship between artist, artwork, and the art space, the changing definition of art, the impact of cultural background on the public's interpretation of the work, and the socialization of art, etc. Ultimately, he reflects on what it means for cultural producers to work "in the name of beauty", and points out aptly that

人表現」，也明確地仰賴受療者的個別主體經驗。而處於兩者之間的仲介或許便是我們稱之為「物件」的東西──在此，如果我們換一個角度，跳離美學的範疇，那麼根據人類學家 Alfred Gell 的「藝術能動」理論，我們生活中的所有物件──包括藝術品都是社會的「能動者」，因此研究藝術品的重點不在於它們「代表」了什麼而是它們「啟動」了什麼。Gell 認為藝術家人格、思想以及物質之間存在緊密的關連，其能動是通過不同的「指向符號」(indexes) ──既「分散的物件」(distributed object) 來調解的（註2）。在胡賽爾的影響下他提出時間、變化、以及創造力之間的關連，認為藝術家的個別作品中總留有其早期作品中出現的或是「被預期」的痕跡，而早期作品中的滯留物則能夠從後期的作品中被找到。藝術家的作品因此是由意識的滯留 (retention) 與前攝 (protention) 所構成，而藝術史的結構則顯示了認知過程的外化和集體化。因此對他來說藝術「風格」是一種關係網絡，而理解藝術作品必須分析藝術家的總體作品 (oeuvre) 而不是靠傳統美術史中慣用的單件作品解讀。因此，藝術物件都是不同「分散的物件」的疊加，而藝術家的意識做為「能動」不僅僅是「人們可接觸到的」，而是藝術家本身就變成了這個物件，並以無數的形式在不同時空領域發揮作用。（註3）

以此來看，楊子強的〈麗美中心〉便是他藝術生涯的一張大型羊皮重寫紙 (palimpsest)，上面除了刻滿他個別作品在不同時期出現過的或清晰，或隱晦的版本痕跡，也隨時預備著將來可能被疊加上新的標記，因此，我們從《麗美中心》便可探尋楊子強的個人藝術軌跡。他是在不斷地通過物質與形體物件為自己的雕塑家身份做表徵時才悄悄地跨越了雕塑的藩籬，而「傳統」和「雕塑」在這裡並不是消失了，而是幻化了。如果我們將《麗美中心》總結為一場藝術家對物件、物質／材料、美學與藝術範疇、以及體制的提問，那我們該關注的或許不是美術館是否有決定什麼是「美」的權利，或藝術家是否還能決定自己作品的意義，而是藝術物件本身究竟蘊含什麼能力？

如果《麗美中心》是提問，但願《模糊時尚》是助您尋找答案及通往謎底沿途中的門徑、驛站與風景。

註

1. 見 Rosler, Martha, Caroline Walker Bynum, Natasha Eaton, Michael Ann Holly, Amelia Jones, Michael Kelly, Robin Kelsey, Alisa LaGamma, Monika Wagner, Oliver Watson, and Tristan Weddigen. "NOTES FROM THE FIELD: Materiality." *The Art Bulletin* 95, no. 1 (2013): 10-37. Accessed February 10, 2020. jstor.org/stable/43188793.

2. 參閱 Liana Chua and Mark Elliott, *Distributed Objects: Meaning and Mattering after Alfred Gell* (New York: Berghahn Books, 2013), p.4

3. 見 Gell, Alfred. *Art and Agency: an Anthropological Theory*. Oxford: Clarendon Press, 1998. 以及 Chua, Liana, and Mark Elliott. *Distributed Objects: Meaning and Mattering after Alfred Gell*. New York: Berghahn Books, 2013.

it is worthwhile for us to consider the difference between "beauty" in religion and in philosophy. He even uses the rather interesting concept of the "art hormone" to describe how artists often "cover the eyes" and perform "mimicry" in different situations to achieve their social roles.

The final article is "The Goddess Muse in *A Beauty Centre*" written by renowned Taiwanese art critic Kao Chien-Hui. Kao's essay is directed toward the international art ecosystem and addresses issues such as the commercial operation and institutional hegemony in what she called "the contemporary art production line" Her precise and sharp analysis brings deep reflections and reminders to the problematic ecological-environment of the contemporary art world. In fact, the title of this writing was originally "Who Killed the Art Museum?" first written in the 1990s. It was the topic of a symposium that was later collected in the book Rebellion in Silhouette published in 2008. Interestingly, Yeo's inquiry into the subject of the institution in *A Beauty Centre* actually began around 2007 with the art project A Day Without A Tree exhibited at the National Museum of Singapore. It was with this event that he began employing the theme of "beauty" to establish discussions on the issue of the institution from various angles. While Kao and Yeo were living in entirely different places at that time – one in Chicago in the west and one in Singapore in Southeast Asia – and do not know each other, the issues and phenomena that they were targeting are apparently linked and resonates with each other over the same chronological axis. As a conscientious critic, Kao pin points various key issues and describes the dilemma of the art museums as a public space in the face of changes pertaining to elements such as time, geography, policy, and culture, etc. To name a few, the predicaments include: coping with competitions with other institutions in terms of their strength in soft-power ("software" such as the museums' collection) and hard-power ("hardware" such as the museum architecture as the main attraction); the commercial exercise of "Blockbuster Shows" and "Theme Park" under the pressure of visitor "headcounts" for economical consideration; and the blurring of the museum's position and function as a cultural institution in its struggle between populist views and elitist claims. Without planning, these issues Kao describes finds intriguing visual analogies with imagery in Yeo's *A Beauty Centre*. For example, the "careful: slippery!" warning sign besides the pink pool, the secret meeting by the nine shadows conducted in the digital screens to discuss "beauty", and the implausible beauty treatment manuals, all seems to correspond directly with Kao's comments, while the two interestingly forms an intertextual relationship. Here, there appear to be a kind of overlap and mutual verification between art criticism and artistic creation. As the two of them crosses each other's path, Kao and Yeo seem to be asking one question in unison: when the Goddess Muse enters *A Beauty Centre*, will "beauty" find its justification?

A Beauty Centre was first established in Singapore and later in Taiwan, with the special publication *Vague Vogue* available now that makes the oeuvre complete – it took Yeo a total of nearly ten years for all these. By bringing together sculptural objects, beauty and detoxifying treatment system, and art reading in alliance, he hopes to re-examine our relationship with "beauty", "art", and "artwork" through the scopes of personal creation, contemporary art mechanism, and commercial business model. As a "beauty salon" run by an artist, the value of *A Beauty Centre* lies in the fact that it is not only about the "personal expression" of the artist, but also the "clients'" individual subjectivity and experience. Here, the intermediary between the two may be the thing

we have been calling "object". At this point, if we put aside aesthetic theory and consider the anthropologist Alfred Gell's theory on art's agency, then all objects we have created in our lives, including artworks, are the "agents" of society. In Gell's study of artworks, his interest lies not in what they "represent" but in what was "activated". Gell believes that there is a close relationship between mind, matter, and personhood, and their activity is mediated through different "indexes" - i.e., "distributed objects". (Note 2) Under Husserl's influence, he studied the relationship between time, change, and creativity, and believed that the individual works of the artist always retain something from earlier works or possess traces that are "anticipated". The artist's work is therefore composed of retention and protention of consciousness, while the structure of art history reveals the externalization and collectivization of cognitive processes. For him, the artistic "style" is related to a network of relationships, and the understanding of artworks must involve the study of the artist's overall works (the oeuvre) rather than interpreting it as a singular entity such as that in traditional art history. Therefore, artistic objects are the superimposition of different "distributed objects", and the artist's consciousness as the "agent" is not only "accessible to people", but the artist themselves has become this object and plays different roles in different time and space through numerous ways. (Note 3)

In this case, *A Beauty Centre* is then a large palimpsest of Yeo's artistic career, not only traces of his individual works – both lucid and faint ones – are inscribed and have appeared over different periods of time, it is also ready to be superimposed with new marks in the future. We could therefore easily explore Yeo's artistic trajectory through a visit to *A Beauty Centre*. There, he has quietly slip across the boundary of the field of sculpture while incessantly trying to articulate his identity as a sculptor through the rendition of material and physical objects. Here, "tradition" and "sculpture" did not disappear, they are simply transformed. If we summarize *A Beauty Centre* as an artist's quest about object, medium and materiality, aesthetics and artistic categories, and issues about the institutions, then perhaps our concerned should not be whether the museum has the right to decide what is "beauty", nor whether the artist could still determine the meaning of their works, but what is it that the art object could do?

If *A Beauty Centre* is indeed about making quests, *Vague Vogue* would be the doorways, stopping places, and sceneries on your journey to the answers.

––––––––– Note –––––––––

1. Martha Rosler et al., "Notes From the Field: Materiality," *The Art Bulletin*, no. 95 (2013): pp. 10-37, doi.org/ jstor.org/ stable/43188793)

2. Liana Chua and Mark Elliott, *Distributed Objects: Meaning and Mattering after Alfred Gell* (New York: Berghahn Books, 2013), p.4

3. Chua and Elliott, p.1-24, Alfred Gell, *Art and Agency: an Anthropological Theory* (Oxford: Clarendon Press, 2007)

Once
Upon
A
Time

藝術登陸·新加坡
2016

Pedicure

Bubbelloon

Sculpture House

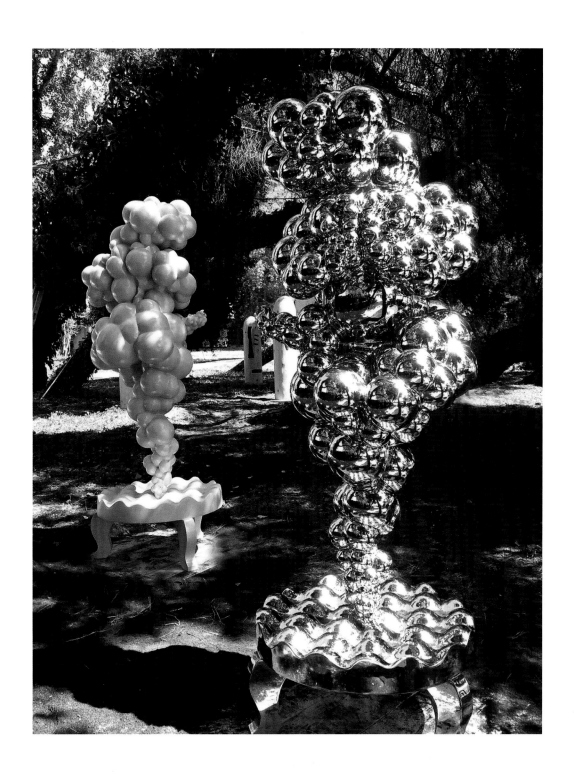

VENICE BIENNALE

2017

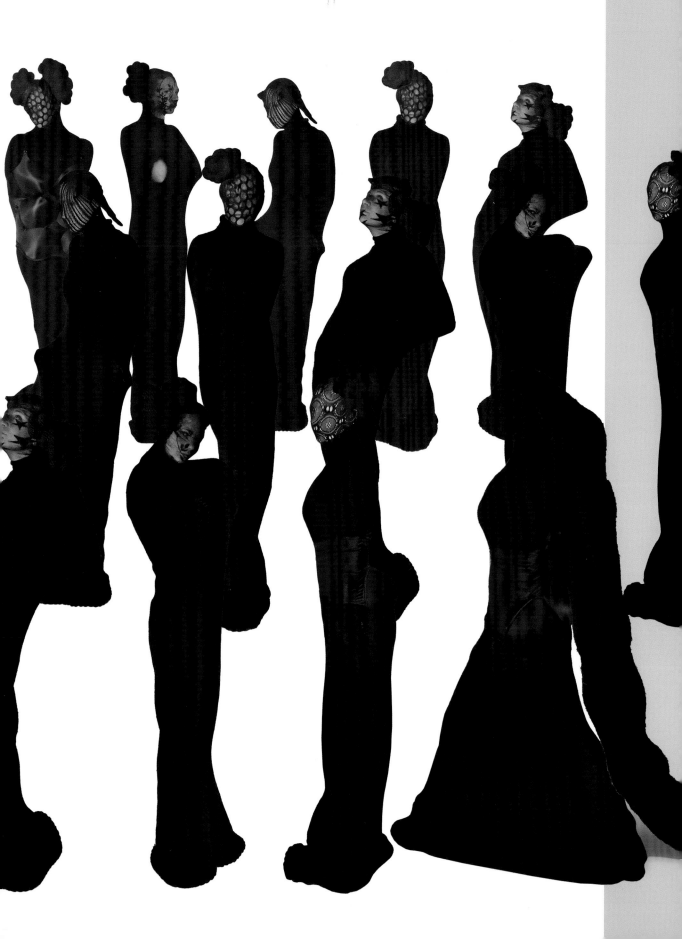

美的經營
The Beauty Management

楊子強　Yeo Chee Kiong

如何經營美，是一種神聖的生活儀式。從一天最美好的睡夢中綻開雙眼，清澈的雙眸上映照著身旁美麗的物質表象，調和的色彩在明亮的陽光中流動，柔軟的布料依附在溫嫩的皮膚上，伴隨著舒適的室內溫度和調控中的濕度，那甘爽清新的氛圍在鼻竇間流竄，架構出一個和諧完美的感官世界。

合身的衣衫襯脫出協調的線條，薰上些許香氛。沉香木製的梳子在鬢髮間有序的來回，梳理一天伊始的思緒。美味的早餐，清新的伯爵紅茶，或是香醇的榛果拿鐵，再刷刷手機內好友們傳來的，昨晚剛到手的時尚戰利品，和那一個個燦爛的笑容。

這一天的美好將會是如何度過的呢？

如何經營美麗的生活，擁有愉悅的生活情趣，是我們時時刻刻所關注的。《模糊時尚》Lifestyle Magazine 所致力追求的理想，是如何打造一個美好的世界，讓所有想擁有美，渴望成為美的所有讀者都能通過我們所擬定的方針，所規劃的形式，在現實生活中得到美，並成為美。因此，我們以前瞻性的思維，大膽的構思出一個跨時代的美的經營方式，建立世界獨創的《麗美中心》，一個建構在美術館內的美容院。

《模糊時尚》團隊堅信一個完整的美的體驗，是物質與心靈的完滿契合。美的生活是架構在美好的物質條件上和美麗的心靈中。如果我們能讓每個人的心中充滿美麗的感受，那麼每個「心中美麗」的人就是「麗美中心」之所在。

在這裡，我們和廣大的讀者分享麗美中心的經營理念和服務項目。通過細緻剖析每一項服務的形式和內容，讓您由衷的體會到我們如何進行完美細膩的調控，掌握由內至外的所有美的細節。

Managing beauty is a sacred ritual in life. Waking up at the start of the day from the sweetest dream, your eyes capture the beautiful images of substances around you, mellow colours flowing in bright sunshine, and soft cloth touching the tender skin, all set in a comfortable indoor temperature and moderated humidity, the refreshingly pleasant atmosphere wafting into the mind – all framing a perfect, harmonious sensory world.

The fitting shirt presents the coordinated lines, immersed in the scent from the aroma burner. The woody comb of aloes goes back and forth between the temples in an orderly way, combing the thoughts at the beginning of the day. A tasty breakfast, fresh Earl Grey tea or a mellow hazelnut latte, and then a glance at the phone for the fashionable loot your friends acquired only the night before, alongside their brilliant grins.

How will this beautiful day be spent?

Managing a beautiful life with a pleasant interest is everyone's constant concern. The ideal Vague Vogue pursues is the creation of a beautiful world so that all our readers who intend to possess beauty and aspire to be the incarnation of beauty can achieve that aim in real life through the guidelines and forms we have worked out. With a forward-looking mindset, we have, therefore, boldly conceived a management mode for beauty that transcends any era and established the distinctive A Beauty Centre, a beauty salon set in an art gallery.

The Vague Vogue team firmly believes that a complete aesthetic experience is a perfect alignment between the material and the spiritual. A beautiful life is structured on a solid material foundation and a beautiful mind. To fill one's heart with a sense of beauty, we make it our focus to help bring out an individual with a beautiful soul.

Here, we'd like to share with readers our business philosophy and the service items available at. With a thorough analysis of the form and content of each service item, let us show you how we manage the details related to beauty, from the inside to the outside, with perfected, delicate regulation.

A Beauty Centre

麗美中心新加坡旗艦店 | Singapore Flagship Store

ZONE R ℹ️

ZONE 4 美人俱樂部
A Beauty Dining Club

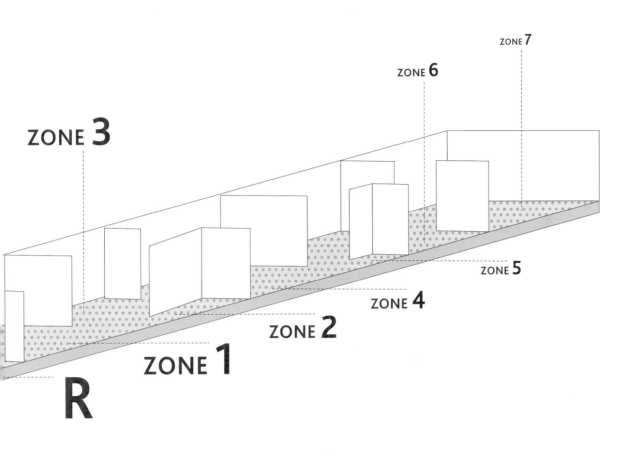

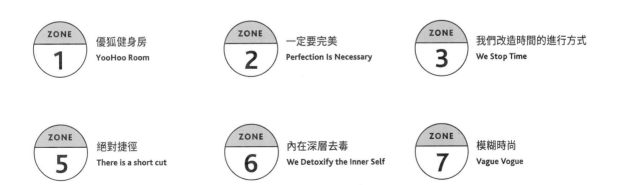

ZONE 1 優狐健身房 YooHoo Room	**ZONE 2** 一定要完美 Perfection Is Necessary	**ZONE 3** 我們改造時間的進行方式 We Stop Time
ZONE 5 絕對捷徑 There is a short cut	**ZONE 6** 內在深層去毒 We Detoxify the Inner Self	**ZONE 7** 模糊時尚 Vague Vogue

麗美中心經營理念

陳燕平

美，就如其所加以描述的玫瑰那般，是一個帶刺的文字闡述。

在當代的社會裡，這是一個相當敏感的概念，通常與女性，媒體，和商業行為有多重的交集乃至於其所衍生的各類相關課題。 在當代藝術裡，這也是一個同樣帶刺的概念。 當普羅大眾可輕易的把美與藝術加以串聯在一起時，卻在西方所主導的藝術理念裡被加以去關係化。 1960 年代西方概念藝術所倡導的概念性和去物質化，以及其所質疑的純感官上的愉悅體驗後，藝術家在討論藝術創作中的「美的感受」時很大可能冒著被詆貶為缺乏思想內涵的風險。就如美國傑出的藝評人，亞瑟·丹圖所形容的，「美幾乎完全的消失在二十世紀的藝術現狀裡，膚淺的把美好的表象與庸俗的商業利益掛上等號。」（Danto, 2003）

無論如何，儘管爭議不斷，在人類的歷史進程中，對於美的追求是耐人尋味而且是不斷地持續進行著的。 更何況當今藝界並沒成功的解除這緊密的聯繫。

為了激發對於「美」的相關想法和討論，《麗美中心》是一個被架構出來的，一體兩面的交疊場域。 一面是頑皮仿真的美容服務空間，另一面則是真實藝術空間內的正式展出。 這兩個空間相互崩塌交疊，同時是追尋美的美容院運作系統，又不自覺的切入藝術展廳的運作架構中，而其中呈現著的是藝術家所創造的，為參觀者所消費的細緻物件。 通過這兩者的並行呈現方式，藝術家質疑和宣告美容消費界和藝術界之間那隱晦的雷同度。

在中國的哲學裡，「美」與「真」和「善」並列。 在柏拉圖的論點裡，「美」被進一步論述為終極的「愛」的物件；這個想法根植於人們肉體上的慾求，但同時它也被接納為美麗物件的間接形態。 在藝術世界裡，當代作家對於「愛的物件」這個美的概念被二十世紀的美術所明顯摒棄而哀嘆（Nehamas, 2007）。在《麗美中心》裡，一系列別緻趣味的造像形態被置入如同劇場般的情境中，從中可以一窺藝術家對於造形，材質，和空間的明顯迷戀。 參照他自己的說法，「宛如在荒誕的表相世界裡探索人心對物質世界與精神世界的最原始渴望一般。」

丹圖曾提出「為當代藝術的美祛毒」，其中包含著藝術品本身有能力在自身的概念架構上去彰顯「美」（Danto, 2002）。《麗美中心》可被視為一件野心勃勃，其思路與這說法相契合的作品。一個虛構的美容院場境設置，一個不真實的美容院網站，通過一個全套完整的藝展運營方式呈現，這個展出不僅僅提出了對於美的多層面提問，它也嘗試去釐清物質性與非物質性的界線，同時探索美與物質生活如何重塑感知經驗的可能性。

The Vision of A Beauty Centre

Tan Yen Peng

Beauty, like the roses it describes, is a thorny word.

In contemporary society, this sensitive concept is much politicized, and often associated with women, the media, and the commercial world. In the world of contemporary art, the idea is equally, if not more prickly. While the general public might easily relate beauty to art, beauty is however much disdained, derided and dismissed in an art world where Western ideals dominate. After conceptual art in the West had denounced sensory pleasures to extol instead, ideas and immateriality of the art object in the 1960s, one risks being superficial when speaking about beauty and their creative endeavours. As the preeminent American art critic Arthur Danto describes, "beauty had almost entirely disappeared from artistic reality in the twentieth century, as if attractiveness was a stigma, with its crass commercial implications". (Danto, 2003)

Despite the controversies, the pursuit for beauty in history are intriguingly perpetual and relentless. Even the art world did not manage to cleanly sever ties with it.

With an intention to provoke the ideas surrounding "beauty", *A Beauty Centre* is constructed as a twofold world where the retail saloon industry and the art gallery as an institution overlaps and meets. On one hand, there is the rather mischievous mimicry of a retail space; on the other there is the actuality of the art exhibition itself taking place within the gallery compound. The two worlds collapse into one as the system of the saloon as a site for the negotiation of beauty for vanity slips into the framework of a gallery where the audience is consuming sensuous objects created by the artist. By juxtaposing the two, the artist poses questions and manifests the hidden affinity between the beauty business and the art world.

In Chinese philosophy "beauty" is associated with "truth" and "goodness". In Plato's Symposium, "beauty" is further taken to be the ultimate object of "love". The pursuit has its root in human's carnal wants but concludes itself by embracing the remote "form" of things that are beautiful. In the art world, contemporary writers lament that this idea of beauty as the "object of love", has been significantly diminished in 20th century art (Nehamas, 2007). In *A Beauty Centre*, with a series of quirky forms situated within a staged environment, it is interesting to see the artist's apparent fascination with form, materiality, and space. In his own words, he wishes to "explore our primal desire for material and spiritual satisfaction within the absurd world of delusion." (Yeo, 2015)

Arthur Danto once proposed for "a detoxification of beauty in contemporary art", contends that works of art are capable of embodying "beauty" that operates from within its own conceptual framework (Danto, 2002). *A Beauty Centre* may be seen as an ambitious project with an agenda comparable to this idea. Complete with a pseudo parlour, an online counterpart, and the operation of the entire scheme as an art show, the exhibition not only makes enquiries into the notions of beauty in various dimensions, it also seeks to define the boundaries of materiality and non-materiality, and explores possibilities from which beauty and materiality could transform one's perceptual experiences.

"

我們的使命：我們為未來創造無可挑剔的美人。

Our Vision: We create the "Ideal Beauty" for the future.

"

詩人的話

我們的滿意顧客，露芙·巴克這般敍述：「身處在這無法預知的當下世界裡，什麼是我們所能依仗的呢？」

「只有美，如神話般蒞臨。當我們見著它，一定要捉住它，緊緊的抓牢它。這千億化身般的『美』，翻滾扭動著，如同一隻披著漣漪般賁張外皮的獅子，一泓流瀉之水柱，一條鬆開著下顎的蟒蛇，一隻叮螫著我們緊繃手臂的微小飛蟲。但只要我們能夠堅持住，緊抓住它那閃爍形態，那麼，我們知道總有一天，「美」，將會是屬於我們的。」

「最終，還有什麼是我們所能依靠的呢？」

The Poet

Our satisfied customer Ruth Barker says:

In today's uncertain world, what can we rely on?
Only beauty, which comes to us like a myth. When we see it, we must grasp hold of it and grip it tightly. Beauty will change its form a thousand times, twisting and turning to become a ripple-skinned lion, a column of falling water, a slack-jawed python, a tiny biting fly in our straining arms. But if we can only hold on, hold tight to its flickering shape, then we know that one day Beauty will be ours.

After all, what else can we rely on?

Beauty Centr

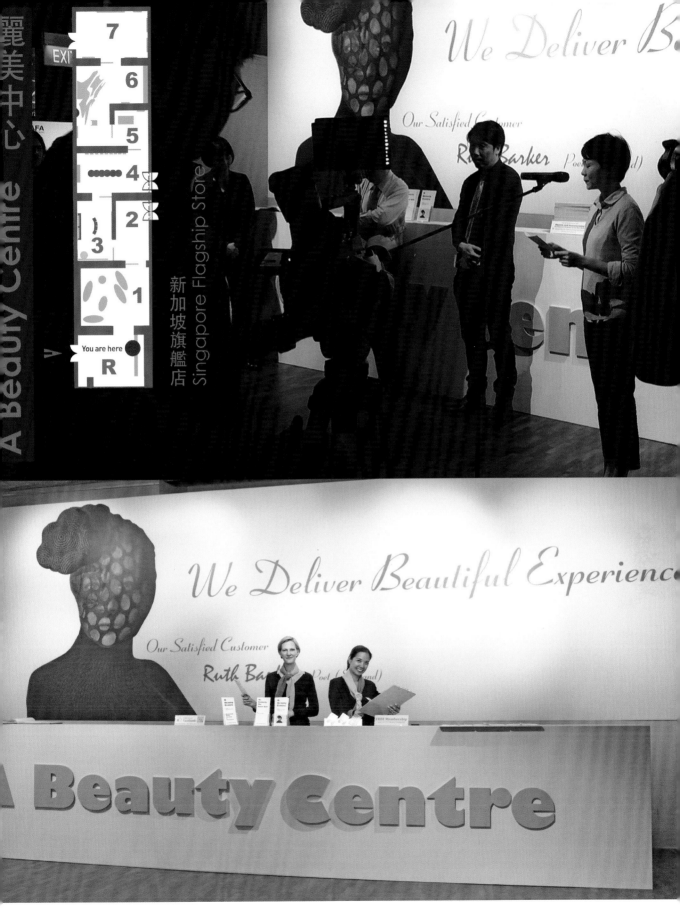

麗美中心
A Beauty Centre

新加坡旗艦店 Singapore Flagship Store

You are here

《麗美中心》服務櫃檯，美容顧問安妮·史陶菲（瑞士），蒂娜·卡倫德（菲律賓）
A Beauty Centre Reception Counter, Our Beautician, Anne Stauffer (Swiss) and Tina Callender (Philippine).

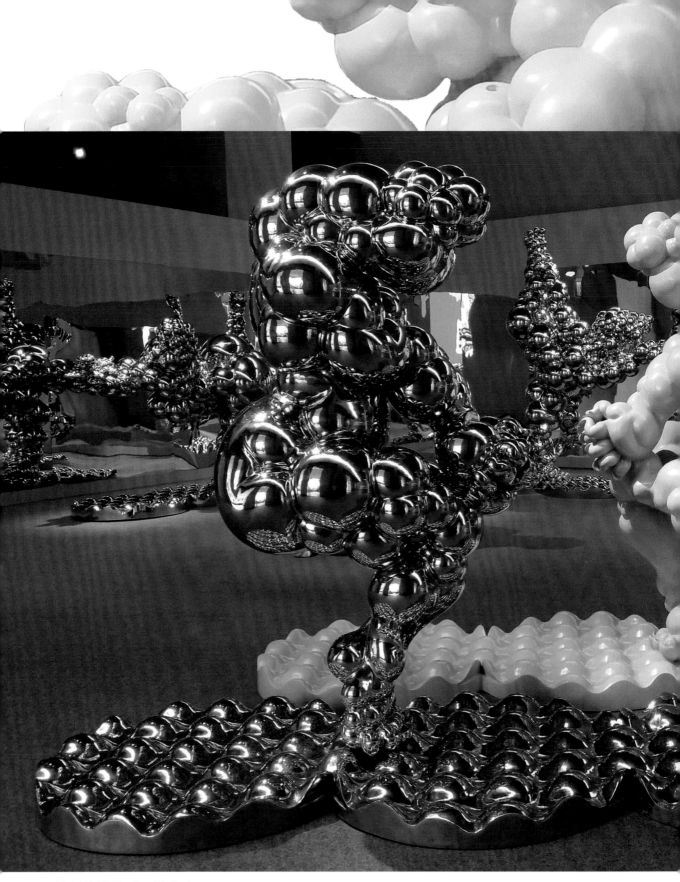

優弧步健身操第一式，《修趾甲》　　Yoohoo Pose #01, *"Pedicure"*

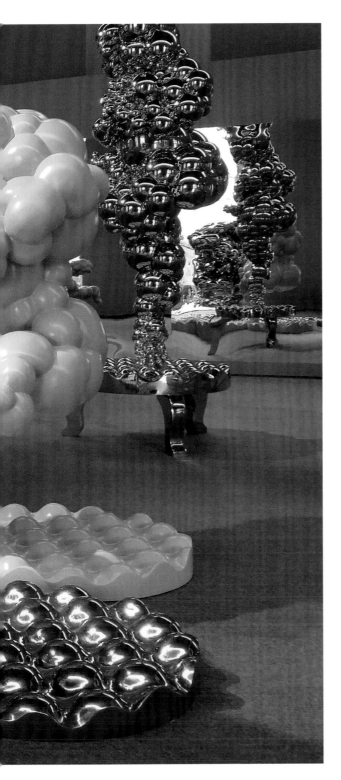

 優弧健身房 YooHoo Room

美好的裸體─優弧步健身操

麗美中心邀請了「世界級傳奇健身操大師─夜之魅影博士」，為麗美中心的會員們編策出世界首創「三合一，即時見效，優弧步健身操」。

在這生活步伐快速的世界裡，我們了解您對生活品質與時間品質之間的渴望。為此，夜之魅影博士首創「優弧步健身操」來回應時代的需求，確保您能用同樣的時間，同時進行三項活動，一邊修飾身形，同時鍛煉生活情趣和體魄健康。「優弧步健身操」將滿足您所期待的完美健身經驗，優美地跨出每一弧步。

Look Good Naked—YooHoo Poses

ABC has invited the world's most famous Aerobic Master, Dr Shadow In'Night, to create the world's first set of "3-in-1 instant YooHoo poses" for ABC members.

Each sequence allows the practitioner to work towards three different targeted results in one exercise. It generates the best outcome in our fast-paced urban lifestyle.

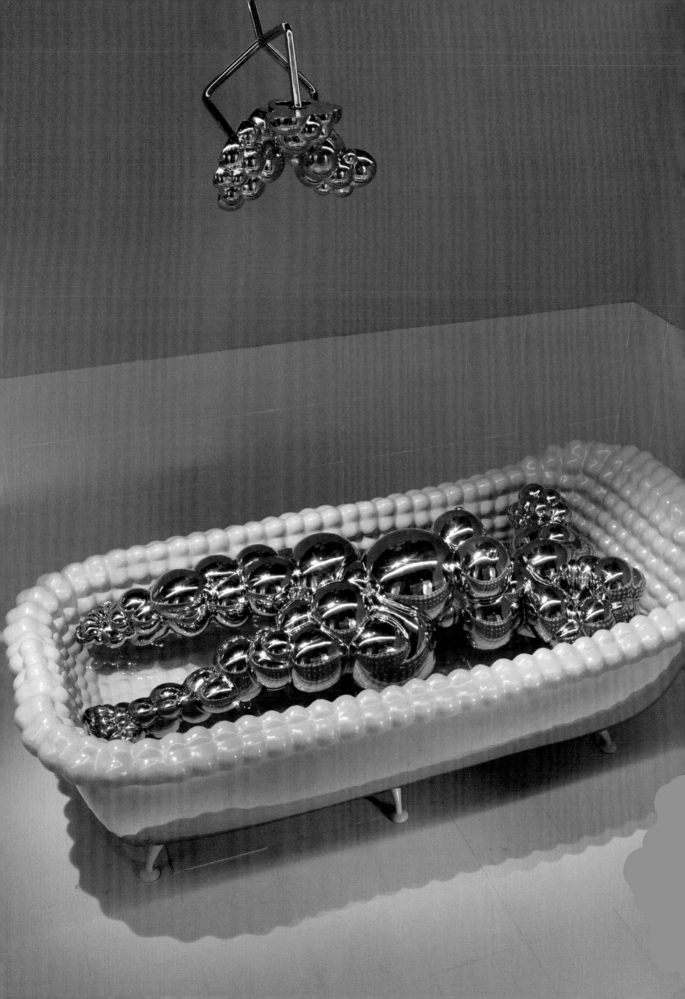

ZONE 2 一定要完美 Perfection Is Necessary

一定要完美──《超想像植入》塑身方案

通過最尖端的納米技術，《超想像植入》塑身方案提供了劃時代的胸型優化配套。「娜諾矽膠」（娜諾·婀娜的承諾）堪稱為二十一世紀最先進的矽膠軟墊植入塑身手術。這是世界首創的零皺紋，防破裂的植入塑胸配套，而且終身保用！

進階版「超想像植入」塑身方案提供七天免費浴缸完塑課程，模擬培訓泳池內外的儀態展現技巧。您將會學習如何維持高雅的站姿，坐姿，和輕盈的步伐。

「見證奇蹟」──植入「娜諾矽膠」的不銹鋼人偶能輕易的漂浮在水面上，絕對可靠！

Perfection Is Necessary — Incredible Implant Program

Incredible Implant Program (IIP) offers breakthrough breast enhancement using state-of-art Nanotechnology. "NANO Silicone", which is an advancement of 21st century silicone implants. It is the world's first wrinkle-free and rupture-proof breast implant with a Lifetime Warranty!

The Advanced Incredible Implant Program comes with a one-week FOC Body Perfection Program in Bathtub that trains you in the techniques of carrying yourself – both in and out of the pool. You will learn the new benefits of a good posture, along with how to stand, sit, and walk correctly and elegantly.

"Seeing is believing" – the Nano-Silicone is very reliable and is capable of keeping stainless-steel mannequins above water level.

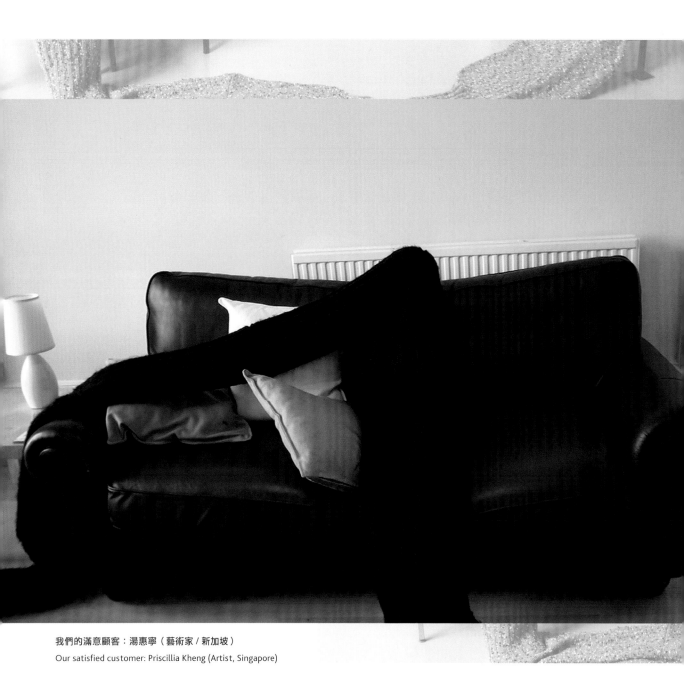

我們的滿意顧客：湯惠寧（藝術家／新加坡）
Our satisfied customer: Priscillia Kheng (Artist, Singapore)

ZONE 3

我們改造時間的進行方式 We Stop Time

拒絕不了的青春

回復青春的秘密，已不再是純粹地通過美顏霜或高科技雷射護理療程。我們提供非一般延緩時間的方程式。

「夜之時空囊」是世界首創「星際冬眠囊」。架構在美國太空總署的「未來人類星際間巡航探索計畫」基礎上所催生的「人類星際旅行冬眠技術」，讓我們能為您留住寶貴的青春。

享受生命的額外長度和永恆的青春吧！

「夜之時空囊」創造一個不受干擾，與外界隔絕的絕對寂靜夜晚，提供使用者一個完美的冬眠狀態。通過每天在正常睡眠時段進行八小時的「人造冬眠」程式，「夜之時空囊」將會減緩您身體裡的老化進度，從每八小時降低至一小時。您身體老化的速度將從每天二十四小時降低至十七小時。最終，與您身邊的朋友比較，您將更顯青春永駐。

Irresistible Youth Beauty

The secret of Rejuvenation isn't only found in a jar of cream or a laser beam. We offer you another way to slow down "time".

"Night" is the world's first scientific Human Hibernating Capsule (HHC). It is exclusively designed to help you maintain your youth and based on NASA's interstellar travel research project.

Live long and forever young!

"Night" features the ambiance of an insulated space. It embraces the practitioner firmly to enable a perfect hibernating process. The "time" of your body clock will be slowed down from eight hours to one hour. An eight-hour hibernation period (your sleeping hours daily) will allow you to reduce your body's aging process from 24 hours per day to 17 hours per day. You will be three months (approx.) younger than your friends each year.

進階版「梅度莎時空囊」

如果您已有效進行了兩年期的「夜之時空囊」冬眠程式，我們將為您提供更完美的進階版配套「梅度莎時空囊」。您只須每天讓頭部以下的身體在「梅度莎時空囊」內維持冬眠狀態，醒覺著的腦部和可活動的頭部同時又能享受精彩的影視連續劇（或其他視覺影音娛樂），您身體老化的延緩，將遞減至每天三小時，這是多麼完美的青春秘訣啊！

Advanced Version: "Medusa"

After two years of professional practice with "Night" HHC, the advanced version, "Medusa" HHC is perfect to maintain the "Suspended Animation" (hibernation status) throughout the whole day while you are enjoying TV programs (or other visual entertainment) at the same time. Which means, you could further reduce the aging process to three hours per day.

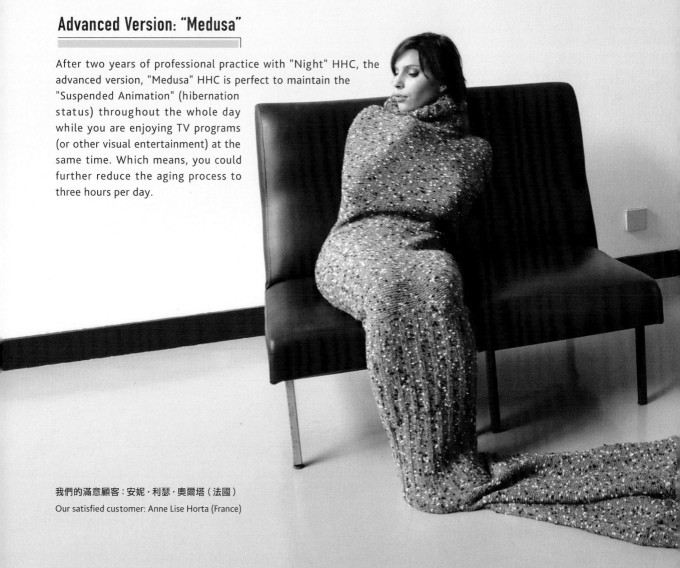

我們的滿意顧客：安妮·利瑟·奧爾塔（法國）
Our satisfied customer: Anne Lise Horta (France)

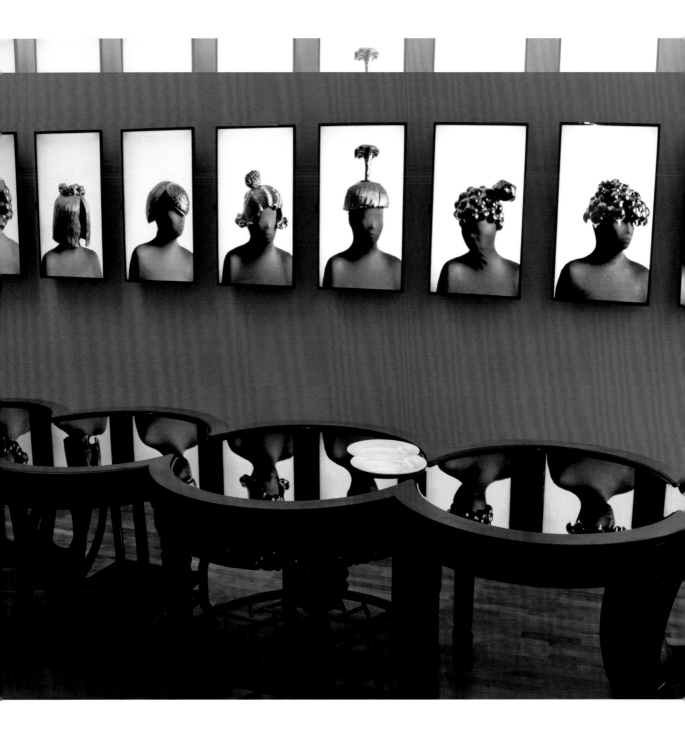

美人俱樂部 A Beauty Dining Club

超級 6V 貴賓卡
6V* Membership (VVVVVVIP BEAUTY)

美人俱樂部－獻給我們備受矚目的顧客

年度網上「美人俱樂部」聚會，讓來自全世界的明星級顧客們，通過網路視頻與大家分享其成功的典範。

美人俱樂部之世界首創超級 6V 貴賓卡（VVVVVVIP 貴賓卡），讓您終身享受尊貴的禮遇，無限次參觀全世界各地與美麗有約的機構*。

* 參照條款
* 現場提供「美人俱樂部」會員申請服務。

"A Beauty Dining Club" is dedicated to our celebrity customers.

The Annual Online Beauty Dinner Party is where celebrities from all over the world share their stories of success.

"A Beauty Dining Club" membership* is the world's first 6V membership (VVVVVVIP Membership), which entitles you to lifetime FOC entry to any Beauty-Related Institution* anytime, anywhere all over the world.

*Terms & conditions apply
*Membership application services are available in "A Beauty Dining Club".

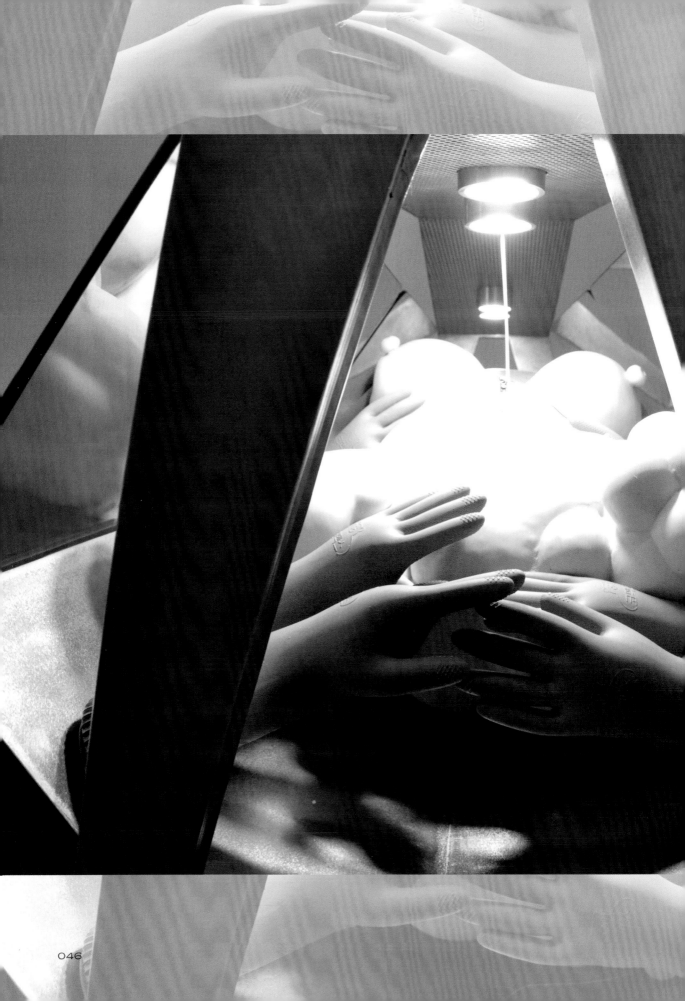

 ZONE 5 絕對捷徑 There is a short cut

納米微波臻脂機

納米微波臻脂機能完美的去除任何一個身體部位上的多餘脂肪。只需在三十個小時內，完成三項臻脂步驟，您將擁有完美的曲線。

絕對安全，無副作用，零風險！

Nano-Microwave Fat Steam Machine

The Nano-Microwave Fat Steam Machine (NMFSM) is the perfect dream machine to remove unwanted fat from any part of the body within 30 hours in 3 steps. You will have a perfect figure to be proud of.

It is perfectly safe, with no side effects, no risks!

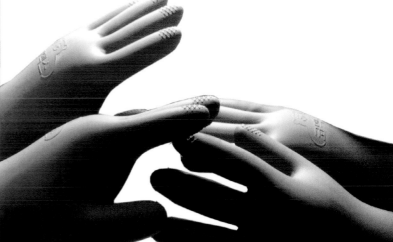

三項臻脂步驟

第一步，負責的專科醫師先進行全身脂肪分佈解析，然後把量身定制的「個人蝶變計劃」輸入納米微波臻脂機內。臻脂機把有機納米機器人「海角七號」注入身體內，藉由微波律變進行動力驅動。啟動後的海角七號立刻進行「不可能的任務」──脂肪重組程序──針對各個被鎖定的多餘脂肪區塊進行攻擊，使之瓦解。

第二步，啟動海角七號的深愛犧牲編碼，與身體的脂肪進行相互深愛融合，共同創造出如同新生嬰兒般的全身新肌膚。

第三步，臻脂處理後的身體將會送到透明整容手術室，由外科醫生公開進行「蝶變奇蹟見證手術」，剖開臻脂處理後留存的原身體外在皮層，從舊皮囊中解放出宛如甦醒的新生蝴蝶般，美好的您。

3 Steps to Remove Fat

Step 01, the surgeon-in-charge will analyse the fat profile of the customer. A tailor-made body transformation plan will be pre-programmed into the Nano-Microwave Fat Steam Machine (NMFSM). NMFSM will inject the organic nano-robot NR007 into the body, powered and activated by microwave. NR007 will carry out the "impossible mission" – Fat Reformation Procedure FRP – to attack and dissolve the unwanted fat in any chosen part of the body.

Step 02, the NR007 will sacrifice itself to combine with the body fat to form a new layer of skin (as soft as the skin of a new-born baby) underneath the unwanted fat.

Step 03, the steamed body will be sent to the Transparent Plastic Surgery Chamber (TPSC), where the surgeon performs the "miracle transformation surgery" to remove the "cooked" outer layer of skin and to release the customer from the "old body". The customer will wake up like a newborn butterfly.

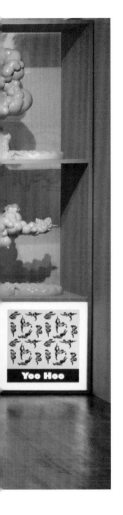

ZONE 6-1 內在深層去毒 We Detoxify the Inner Self

美麗靈魂的採購經驗

寵一寵自己，我們相信通過享受頂級藝術品無以倫比的美麗正能量，洗滌和中和物質世界裡所誘引的慾望，化成負離子滲出體外。讓外在已臻完美的您，最終擁有超凡脫俗的氣質。

真美人，真品味！

A Beautiful Soul Shopping Experience

You deserve the privilege of pampering yourself with a high class shopping experience, and Art is one of the most powerful elements to detoxify the inner self. It generates Positive Inner Energy that will light up your unique personality beyond your physical appearance.

A True Beauty has good taste in Beauty.

ZONE 6-2 內在深層去毒 We Detoxify the Inner Self

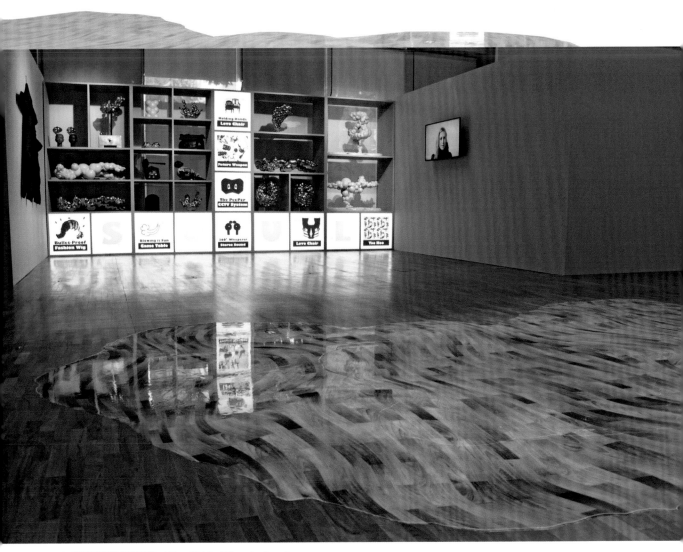

▲ 美麗靈魂的採購經驗　A Beautiful Soul Shopping Experience

▶ 無樹之日——一個拒絕被採購的不安份靈魂。　A Day Without A Tree – A restless soul that refused to be purchased.

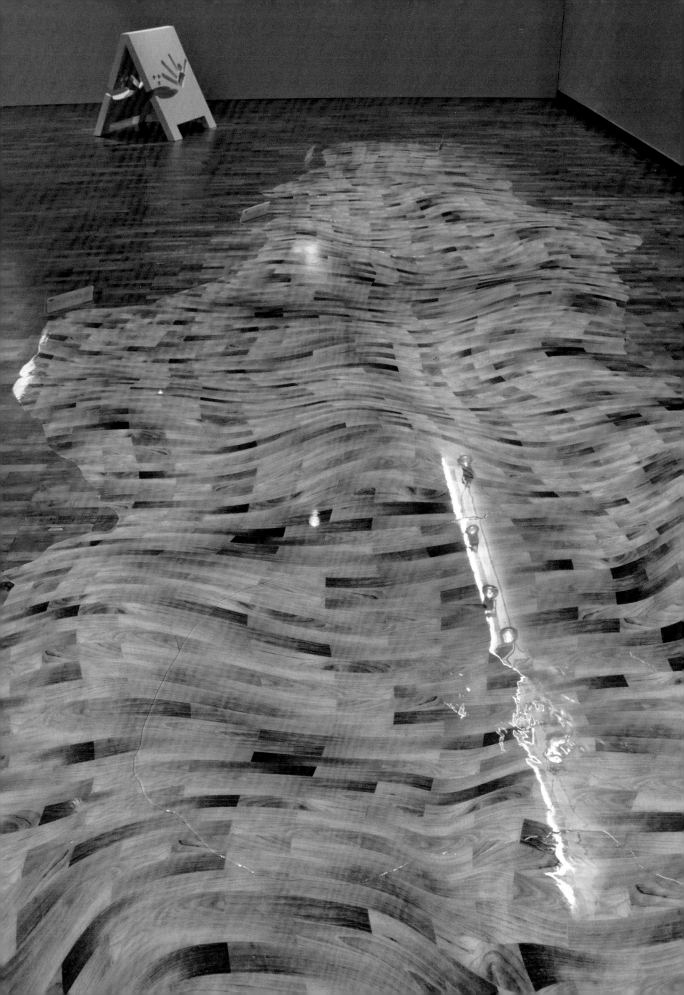

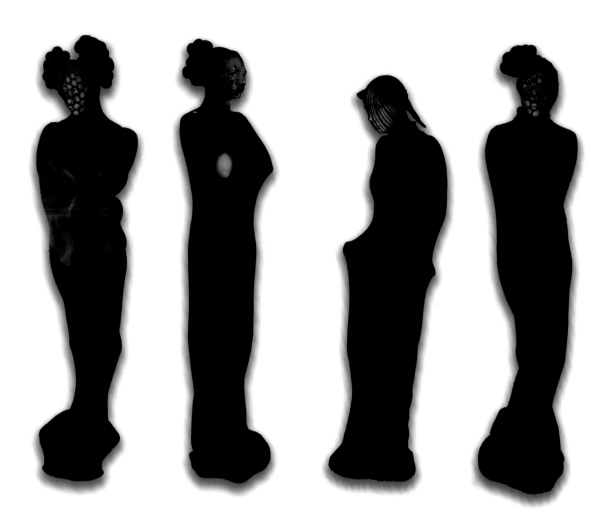

ZONE 7 模糊時尚 Vague Vogue

完美的服飾，完美您的人生

我們的時尚教父，夜之魅影大師相信詩的感染力。他宣告二十一世紀物質世界的時尚感動，來自現實與幻想之間的詩意生活中。

為您量身訂做的「模糊時尚品牌」，使用了最先進的紡織技術和劃時代的全新材質，完美地呈現您玲瓏誘人的身形曲線。防紫外線材質保護著您細滑的肌膚，而另一項獨創的防鎂光燈表層處理技術，將保護您免受狗仔隊的騷擾。他們再也無法拍攝出您的私密細節，只能默默地欣賞著您美麗且浪漫的剪影，那是一種眾裡尋她千百度的動人吸引力。這是我們為美麗動人的您，提供的完美防線，同時確保您高格調的美麗存在，是被渴望的。

A Perfect Outfit, A Perfect Life

Our Fashion Guru, Dr Shadow In'Night, believes in poetic power. He declares that the search for the 21st century's fashion sensibility in this material world falls between the "realistic" and the "imaginary" in our daily life.

The tailor-made Vague Vogue Fashion Series has been produced using the latest inter-weaving technology. The alluring figures of ABC's celebrated customers will be shown off their signature body features. The anti-UV light material is perfect for protecting their smooth skin in the day. And the anti-limelight texture will keep our celebrity customers safe from the hassle of the paparazzi at night.

我們的滿意顧客：湯姆・普鏈（法國）
Our satisfied customer: Tom Pouchain (France)

模糊時尚 Vague Vogue

完美的服飾，完美您的人生

A Perfect Outfit, A Perfect Life

《模糊時尚》之再循環時尚系列－飛行裝系列：我們重新組構過季的時裝，讓個性的您穿上後，更顯獨特的專屬風采。

Vague Vogue Recycled Fashion Series – The Flying Suit Series: We construct past season's items into new wearables for unique individuals.

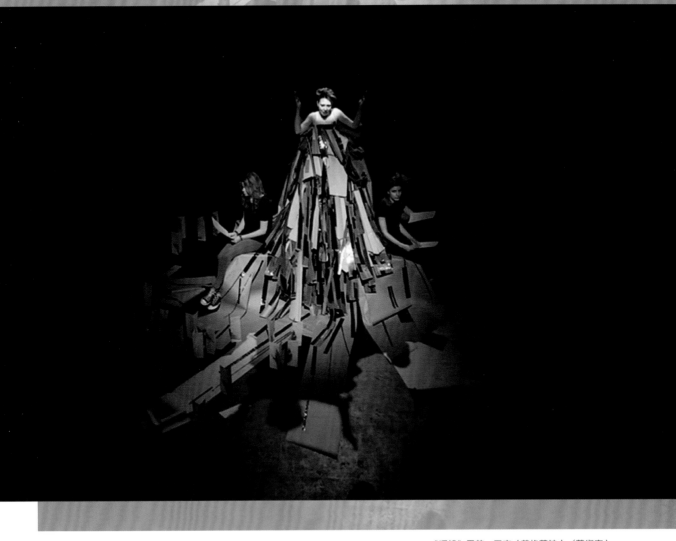

ZONE 7-2 模糊時尚 Vague Vogue

完美的服飾，完美您的人生

最初作為一種聖言的構想，爾後演化成以一種薩滿般的形式去闡述藝術家自身的過去，通過即興架構的紙造景觀中進行傳述。

A Perfect Outfit, A Perfect Life

Originally conceived as a séance, the work has evolved into a shamanic address to the artist's own past, delivered from within an improvised paper landscape.

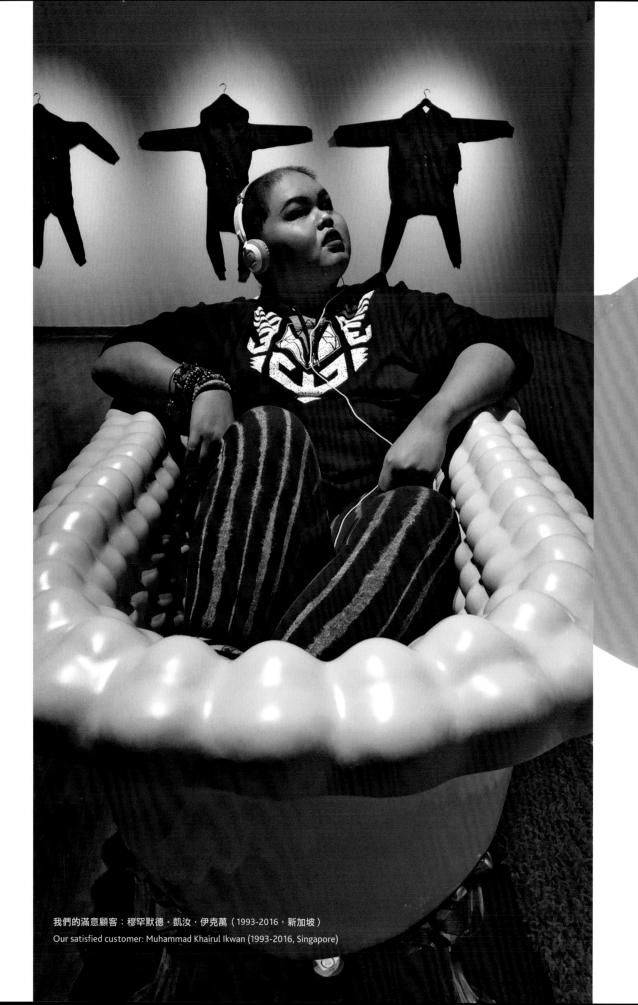

我們的滿意顧客：穆罕默德・凱汝・伊克萬（1993-2016，新加坡）
Our satisfied customer: Muhammad Khairul Ikwan (1993-2016, Singapore)

《麗美中心》特選美容配套現場示範簡介

為了能更好的介紹我們的各項美容服務內容，麗美中心特邀一組美麗代言人在特定的時段內進行精心策劃的推介活動，近距離的透過曼妙的肢體型態，美麗的心境，分享各個美容配套的親身體驗和真實效果。

我們的國際代言人團隊是您不可錯過的難得機緣，這些詩人，音樂家，雕塑家，畫家，藝術家，藝評家和素人們，跨越了生活，又回到生活中，通過現場示範或是視頻示範，分享各個特選配套的美的體會。

Beautician Demo Sessions & Promotion

To better introduce our various beauty services, for this limited promotional period, *A Beauty Centre* has invited a team of Beautician to carry out some meticulously planned programmes. These in-person consultation sessions on graceful body forms, wonderful states of mind, and sharing on the various beauty packages will allow you to experience the practical effects for yourself.

You will not want to miss this chance to meet with our team of international experts. They are poets, musicians, sculptors, painters, artists, art critics, and others from diverse walks of life. They traverse their life experience to share relevant insights to your lives, either through live demonstration or video demonstration, to shed light on the special programme packages of beauty experiences.

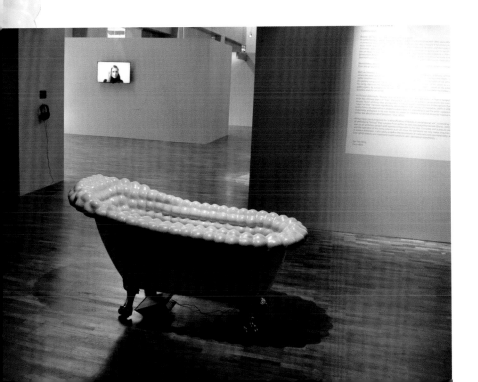

A Beauty Centre

@ **NAFA**
The Ngee Ann Kongsi
Galleries 1 & 2

Beautician Demo Sessions & Promotion

www.abeautycentre.com

Beautician Demo 01

I am hibernating inside the body of a grey serpent named 'Medusa'

When it is cold, I hibernate,
When it begins to warm up, I wake up.
I emerge and search.

Performed by
Oranje Lwin
15th April 2016
Time: 6.45pm

Beautician Demo 02

Sexy Shadows and The City

My shadow has been taken over by four ladies. I am a calm bystander. I watch in silence the overlapping shadows that have left my body. They are moving so swiftly in the air. They are moving so wilfully at the happiness of the others.

Performed by
Geraldine Lim Jia Yi
Jessie Lim Chia Hui
Lee Wan Shan
Kim Hyesu

15th April 2016
Time: 6.45pm

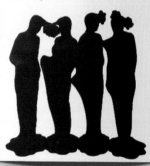

Beautician Demo 03

Morphing Matter

This performance explores our prim[...] desire to radically transform who w[...] into idealised version of who we are[...] It also investigates the relationship [...] have with our inner self, the shadow[...] remains in the background indefini[...]

Performed by
Oranje Lwin &
Brendan Poh Kai Jie
30th April 2016
Time: 4pm

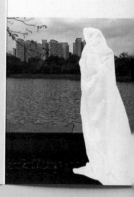

Sound Therapy

Sound Chaperon by Joyce Koh Bee Tuan

Melodious salve to soothe.

Sine changes its speed.
Breathe side ways, all ways.
Hold it. Blobby *Waves.*

Hydrosonic pressure balances splendour of skin.

Effulgence slithers into black shadowy hissing.

semblance of class:
aqueous whispers
sipping.

Expire. Respire. Expire. Respire. Sigh. Expire. Re
Spire. Expire. Respire. Nigh. Expire. Respire. Ex
Pire. Respire. High. Expire. Respire. Expire. Re

Silence. It's too loud.

As Archimedes sinks, sonant pleasures seize.

A Beauty Forum

Presented by
Yeo Chee Kiong
Ruth Barker
Joyce Koh Bee Tuan
Amanda Heng

Moderated by
Michelle Ho

7th May 2016
Time: 2pm

Beautician Demo 04

The Space Beneath My Skin
Closed To My Reason Today

e spoken word performance, delivered
a live internet broadcast between
otland and Singapore, will weave a sliding
rrative of Vogue magazine sidebars, diet
s, the depths of self knowledge, and clip
earrings.

line Performance by
th Barker
th April 2016
ne: 5pm

llow our facebook for links and updates:
ww.facebook.com/ABeautyCentre2016

Beautician Demo 05

I am crawling inside the body of a black serpent named 'Night'

I do not know whether hell exists. But I will
crawl on. I will move forward despite the
endlessness of night.

Performed by
Priscillia Kheng
7th May 2016
Time: 2pm

orum, Chee Kiong will discuss
cept of "A Beauty Centre" (ABC)
on to object and immateriality in
porary art. Ruth Barker, the Icon
and collaborative artist of ABC,
d in a video presentation from
v that discusses her involvement
roject. As the invited-musician in
ration, Joyce Koh Bee Tuan will
er experience in creating her work
Therapy" for the Centre. Special
manda Heng will speak about her
ance works "Yours Truly, My Body"
t's Walk" which she observed
rre survival of the local beauty
ses during the 1997 Asian financial

um will be moderated by
Ho, the Director of ADM Gallery
Michelle was previously a curator
pore Art Museum and a co-curator
pore Biennale 2013.

us on facebook for updates:
cebook.com/ABeautyCentre2016

Chao! Bella! Channel

You are the Goddess

16th April - 15th May 2016
(Every Friday, Saturday & Sunday)
Time: 11am - 7pm

Firstly, you should believe that beauty exists
within you.

Secondly, you would like to share your
'beauty' through 'Chao! Bella! Channel'.

What you need to do is, come in, sit down,
choose the most beautiful angle of your face
for a 'one minute' shooting.

Through your mother tongue, you shall
share with us the most beautiful feature
of your face. For example: "I love my eyes."

A Beauty Dining Club

Membership Application

FOC for the promotion period
15th April - 15th May 2016

Terms & Conditions apply*

A Beauty Centre

by
Yeo Chee Kiong

Organised by NAFA

Supported by a.r.t.s.fund City Development Limited

 CCA

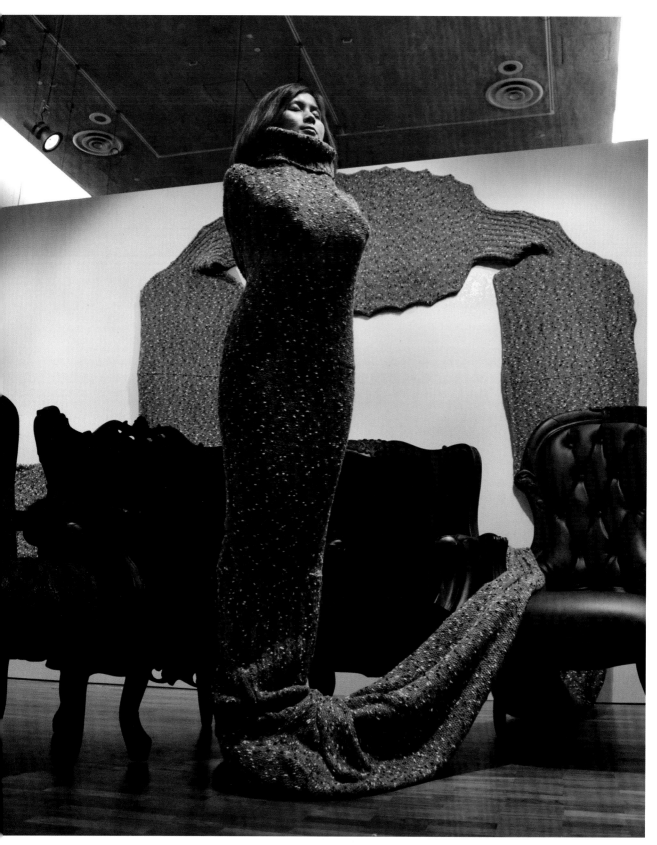

▲ 美容配套示範（一），我們的美容顧問：寧漂倫（藝術家，新加坡）
Our Beautician of Demo Session 01: Oranje Hnin Phyu Lwin (Artist, Singapore)

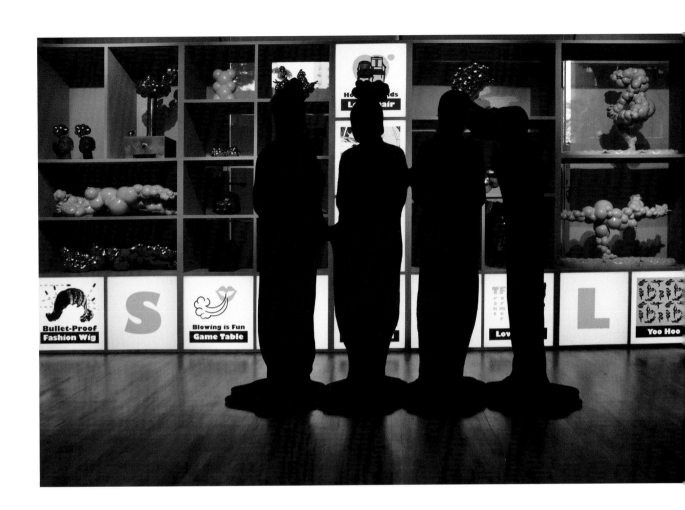

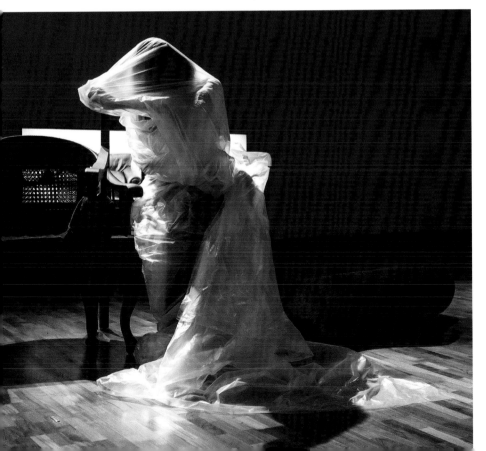

▲ 美容配套示範（二），我們的美容顧問：林佳怡，林佳慧，李宛珊，金惠秀（新加坡南洋藝術學院純美術系學生）
Our Beautician of Demo Session 02: Geraldine Lim Jia Yi, Jessie Lim Chia Hui, Lee Wan Shan, Kim Hyesu (Art Students, NAFA, Singapore)

◀ 美容配套示範（三），我們的美容顧問：寧漂倫（藝術家，新加坡），傅家傑（藝術家，新加坡）
Our Beautician of Demo Session 03: Oranje Hnin Phyu Lwin, Brendan Poh Jai Jie (Artists, Singapore)

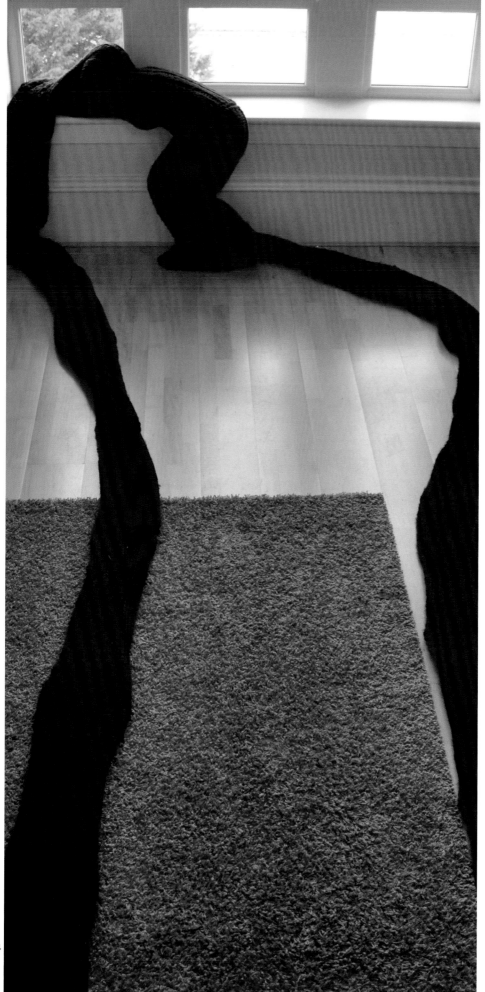

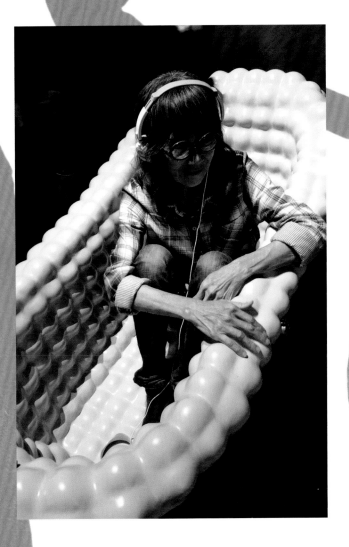

◀ 美容配套示範（四），我們的美容顧問：湯惠寧（藝術家／新加坡）
Our Beautician of Demo Session 05: Priscillia Kheng (Artist, Singapore)

▲ 美容配套示範（五），「網上示範」，我們的美容顧問：露芙・巴克
Our Beautician of Demo Session 04 (Online Demo): Ruth Barker

▶ 我們的滿意顧客：韓少芙（雕塑家／新加坡）
Our satisfied customer: Han Sai Por (Sculptor, Singapore)

Ciao! Bella! Channel

Ciao! Bella! Channel

你是女神

如女神般存在的您，值得為全世界所知曉和崇拜。麗美中心通過設立全球廣播頻道，「嗨！女神！」頻道（CBC），表揚您為創造一個低「視覺污染」的美麗世界作出了重大貢獻！

You are the Goddess

A Goddess like you deserves to be recognized and to be worshiped by the entire world. ABC has established a worldwide broadcast channel, CBC (Ciao Bella! Channel), and it is our final step to honour you with your remarkable contribution to reducing "Visual Pollution" in the 21st Century

內在深層去毒

麗美中心作為一個完美生活的架構者，考慮到我們所提供的超時代想法可能超越您在這個時代所積累的現實生活經驗和知識，而無法針對各項服務內容進行有效聯想和解讀，因此我們提供《內在深層去毒》終極版——現實生活版！

我們通過現實世界的文字敘述，回溯我們所提供的，每一項服務背後的原始真實生活內容，濾除多方專業智慧雜訊所衍生出的有機變調和多層次曖昧品味。這個終極去毒版本將能夠引領您回到真實生活中，去細細體會真實生活中的美好！

We detoxify The Inner self

As the advocate of a perfect lifestyle, A Beauty Centre is considerate of how our progressive ideas and programmes may surpass anything you have experienced, and you may therefore be unable to associate and internalise them effectively due to the emotional and psychological baggage that you have accumulated. We are therefore offering the "We Detoxify The Inner Self" Ultranium Version (real-life version)!

By using actual textual references, we trace each service to its original real-life context and intent, and filter them from the interferences and alterations by so called "experts". This Ultimate Detoxification programme will guide you to return to the present moment, so as to savour and fully experience the beauty in your life!

We Detoxify The Inner Self

by Yeo Chee Kiong

www.abeautycentre.com

Curatorial Brief

Beauty, like the roses it describes, is a thorny word. In contemporary society, it is a sensitive concept, much politicised and often associated with women, the media and the commercial world. In the world of contemporary art, the idea is equally if not more prickly. While the general public might easily relate beauty to art, beauty is however much disdained, derided, and dismissed in an art world where western ideals dominate. After conceptual art in the 1960s, one risks being superficial in speaking about beauty in their creative endeavours. As the preeminent American art critic Arthur Danto describes, "beauty had almost entirely disappeared from artistic reality in the twentieth century, as if attractiveness was a stigma, with its crass commercial implications". (Danto, 2003)

Nevertheless, despite the controversies, the pursuit for beauty in human history is intriguingly perpetual and relentless. Even the art world did not manage to cleanly sever ties with it.

With an intention to provoke thoughts surrounding the idea of "beauty", A Beauty Centre is constructed as a twofold world where the retail saloon industry and the art gallery as an institution overlaps and meets. On the one hand, there is the rather mischievous mimicry of a retail space; on the other there is the actuality of the art exhibition itself taking place within the gallery compound. The two worlds collapse into one as the system of the saloon as a site for the negotiation of beauty for vanity slips into the framework of a gallery where sensuous objects created by the artist are being consumed by the gallery goers. By juxtaposing the two, the artist poses questions and manifests the hidden affinity between the beauty business and the art world.

In Chinese philosophy, "beauty" is associated with "truth" and "goodness". In Plato's Symposium,

"beauty" is further taken to be the ultimate object of "love"; the pursuit has its root in human's carnal wants, but concludes itself by embracing the remote "form" of things that are beautiful. In the art world, contemporary writers lament that this idea of beauty as the "object of love" has been significantly diminished in 20th century art (Nehamas, 2007). In A Beauty Centre, with a series of quirky forms situated within a staged environment, it is interesting to see the artist's apparent fascination with form, materiality, and space. In his own words, he wishes to "explore our primal desire for material and spiritual satisfaction within the absurd world of delusion." (Yeo, 2015)

Arthur Danto once proposed for "a detoxification of beauty in contemporary art", contending that works of art are capable of embodying "beauty" that operates from within its own conceptual framework (Danto, 2002). A Beauty Centre may be seen as an ambitious project with agenda comparable to this idea. Complete with a pseudo parlour, an online counterpart, and the operation of the entire scheme as an art show, the exhibition not only makes enquiries into the notions of beauty in various dimension, it also seeks to define the boundaries of materiality and non-materiality, and explores possibilities from which beauty and materiality could transform one's perceptual experiences.

Tan Yen Peng
Co-curator

References:
Danto, Arthur Coleman. *The Abuse of Beauty: Aesthetics and the Concept of Art*. Chicago: Open Court Publishing, 2003.
Nehamas, Alexander. *Only a Promise of Happiness: The Place of Beauty in a World of Art*. Princeton: Princeton UP, 2007.
Yeo, Chee Kiong. Artist's Statement, Exhibition Proposal - A Beauty Centre, 2015.

Room 1 & 2

The Dream Lady Series

'The Dream Lady' is a female figure formed myriad and fleeting bubbles.

Under the reflection of the sleek stainless s we see is fantasized sophistication while ur the pink flesh lies real obesity.

In transforming the obese figure to a trans beautiful body, I explore human being's prin within the absurd world of delusion. It is ali contemporary "human nature".

Room 6

A Day Without A Tree

Are habit and anaesthesia two things of the same kind? Is existence a logical consequence?

Here, the artist explores the certainty of preset positions and pre-determined results we face in our everyday life and environment.

'A Day' is meant to be an ambience.

'Without' is the non-existence of 'existence' in one's conscious mind.

'A Day without A Tree' is an event happening and existing in broad daylight.

Perhaps you have not noticed, or maybe you have – but things may not be as you have imagined...

In the original version of the work exhibited at the National Museum of Singapore in 2007, the artist "melted" the rotunda area of the NMS building. The columns are subtly deformed and "spills" surrounded the floor area.

In the version for A Beauty Centre at NAFA, the artist "melts" the gallery's wooden floor. The illusory spill is a visual play that puts the viewers' perception in question as they each take time to encounter and negotiate with the perceivable change.

Room 7.1

Circle Work
by Ruth Barker

'Circle Work' is a new performance by Ruth Barke Originally conceived as a séance, the work has evolved into a shamanic address to the artist's ow past, delivered from within an improvised paper landscape.

'Circle Work' extends Barker's interest in autobiography, feminist writing practice, and unconscious associations, through a new work that is Barker's most ambitious to date. Develope specifically for CCA's Theatre, this complex and immersive experience features spoken word, installation and costume.

Metamorphosis 1. Descent.

Picture me:
Naked
On the Scarborough sand,
Pink spade in hand,
And a red sugar sweet on a string around my nec
As I dig to the centre of the earth.

Aeons I dig.
Further and further
Until my palms ache
And the sunburn on my shoulders
Stings with sweat.
Then I dig deeper,
Past centuries of time,
Past sense and words
And cigarettes and continents.
Until I sit in a pit.
I shift my grip
On the pink plastic handle.
I carry on. Though there is

中文版請參閱第 158-159 頁
Please refer to page 158-159 for Chinese version.

oom 3.1

m crawling inside the
dy of a black serpent
med 'Night'

u are going through hell, keep going."
ston Churchill

ot know if hell exists, but every soul must have
untered some hellish moments and experienced
ual purification. Based on Churchill's famous
s, I created 'I am Crawling Inside the Body of
ck Serpent Named Night' to keep me moving
ard.

oom 3.2

m hibernating inside the
dy of a grey serpent
med 'Medusa'

ugh recycling the season sales fashion
collected from retail stores, this show is an
mblage of my residency experience in Paris
my practice as a sculptor in Singapore. It is
ttempt to translate my Paris impressions by
ing' two or more pieces of the same fashion item
a new piece of work.

Room 4

Nine Shadows in A Meeting

is a set of nine photographic images presented on
the plasma. Each screen represents a stop-motion
shadow that turns gradually and intermittently left,
front, to right every second. It imitates an online
dialogue session.

In this cyber era, everyone uses a virtual identity
for communication. The virtual identity is abstract
and mysterious like a shadow, and hardly real. In
this work, the shadows are each an avatar wearing
various ceramic wigs that symbolise their personal
status respectively. It also explores the state of
sculpture within the virtual world in this new age.

The Six Overlapping Table

is placed with the nine shadows to allude to the
classical painting of Leonardo da Vinci's *The Last
Supper*.

Constructed to contain liquid with objects floating
above, the stillness of the 'table surface' is frequently
disturbed by the slowly moving things. The artist
has allowed solid to permeate to liquid, and thus
challenged the viewers' usual experience in
perceiving the known.

my spit,
s sand in the corners of my eyes,
s sand in the gap between my teeth.
quat in the sand hole,
l myself dissolving into sand.
sugar sweet is coated and inedible
like a bloody wound against my breastbone.

re is something here.
s something.
d it. (The core!)
time it is only
c bag filled yesterday
meone else's picnic lunch of orange peel,
usts and, falling at my sandy feet, the
ed centre of an apple.

morphosis 2. Animal.

ge of eight
to shed my human skin,
become an animal.

way to school
ny fetlocks and a blaze,
thers, and clean pasterns.
ap of my schoolbag
ward across my dun hocks.
on the kerb
ted for the lollipop lady,
ed along the weight of my distal phalanx.

ayground, I whickered
ug of my invisible saddle,
the weight of my girl self
in my own horse back.
ls were tight on my own reins
neck arched, chin brought in
pull of the bit.
s of my mouth
on the steel of the snaffle.

This slippage was all of myself,
Inside and out.
And as familiar
As the briars of blonde horsehair
Caught in the teeth of my comb.

Metamorphosis 3. Vegetable.

Couched between vehicular debris and cheese and
onion evidence,
Encircled by cow parsley and the seed ejaculations of
the purple balsam,
Is a thick and muddy pond.

On the surface of the water grows a net of vivid
duckweed.
Below this, clogging the transparent gills of
sticklebacks and minnows,
Is blanket algae, woven inches thick and finely
filamentous.
But in the silt below this scum grow the iron hard
roots of the world tree.
Immense, they draw down to centre of the earth.
Immense, they run up to the pythonic oak
That stands eternal at the stagnant basin's edge.

As I stand on the bank, ankle deep in mud,
I look up to see a human figure
Nailed to the tree.
His black-wrapped coat flutters in the cold wind.
His arm is pinned to the living bough.
His blood and bone are bonded to the bark.
Outlined against the pale sky
He hangs, immobile,
Blown to emptiness by the wuthering.

I witness. But I am wrong. I look again.
The figure shifts within my optic nerve,
Resolves itself, and changes operation.
For a moment I can see two images at once,
But then the trick is blown

And the world reasserts its line,
Becoming, at last,
Only a black plastic bag
Caught in the branch of a tree.

Metamorphosis 4. Mineral.

Crystals grow five sided, in my dream.

And a diamond sits on a mirror,
Caught and watched.
They have both reflected everything
Too late.

Metamorphosis 5. Ascent.

In 1950 I lay on my back on the lawn.
It was late, and the summer night closed above me
Like a glittering dome.
Below me, the bones of the earth pressed into my
spine.

I close my own eyes now,
In séance at last: communing with the dead.

At the edge of my hearing is the low hoot
Of a barge turning on the distant canal.
There is a void of silence that moves
Around the garden. Blacker than black
A cat hits itself against the night as
Furred absence, weightless meat in motion.

In 1950 I wrote:
*Making her silken journeys in the dark the cat seems
as remote as the creatures that moved here before
there were people. By night all cats are ancient, and
move in ancient worlds. Perfectly formed while men
were still brutal, they are the continued presence of
the past.*

And then:

*Once in the spring I stood at the edge of some
Norfolk ploughland at midday, listening to the mating
calls of plovers. It seemed to me then that I had my
ear to a great spiral shell, and that these sounds
rose from it. The shell was a vortex of time, and the
birds themselves took shape, species after species,
with their songs spiralling upwards ever since. Now
that I stood at the lip of the shell, they had ascended
to reach my present ear.*

Today's observation is only
That on the fly leaf of this book,
My mother has written her mother's phone number,
in pencil.
Lower down the page, and much later, I have put my
name.

Organised by

Supported by

Presented by

Yeo Chee Kiong
Ruth Barker
Joyce Koh Bee Tuan
Amanda Heng

Moderated by

Michelle Ho

A BEAUTY
FORUM

7th MAY 2016

REFINE FIGURINE

est. 2009

Discover
Taitung Giant 2019

探詢臺東　　　巨人實錄

OV LLAAPP

Contemporary Furniture Design

疊椅桌去

現代傢俱設計

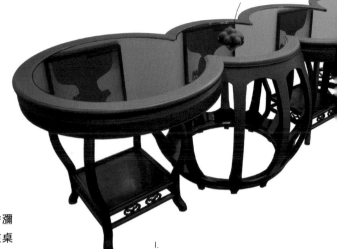

I.

重疊與去功能性

老舊的電風扇徐徐的轉動著,錫蘭紅茶所沖泡出的茶香瀰漫在小小的茶室裡,英式彩繪白瓷茶杯輕幌幌的漂移在桌面上,清水填注入掏空的花梨木桌面內,波瀾不起。水面木桌旁擺放著一張由仿明代花梨木椅和英殖民時期所製作的木藤椅所交疊組合的椅子,已分不清是互相侵入佔據,還是交互融合,宛如為那十九世紀傳奇的連體雙胞胎,昌與恩所進行的量身訂製版。

泰國古文裡沒有「椅子」這個名詞,因為古時的泰國人都坐在地板上,「椅子」的不存在,是因為日常生活功能的不被需要。功能的需求催生工具物件的製作,專屬名詞的杜撰確立工具物件的存在形態和所附著於日常經驗中實際可被使用的方式,不同時空中的人文場域衍生出同一物件的多重樣式,功能性成為物件名詞的註解。那麼,一張看似桌子的「桌子」,卻是一張無法置放任何物件在桌面上的「桌子」,一張無法被使用的桌子,一張不具備被闡述的「桌子」功能的桌子,還是桌子嗎?這會否成為另一個雞與蛋的經典悖論呢?而那不存在的泰國古文裡的「椅子」,也間接的跨越過了約瑟夫‧科蘇斯(Joseph Kosuth)經典的三段式語意修辭裡所敘述的「椅子」,以及其相關的圖像解讀和被註解的椅子功能,讓這個專屬於當代概念藝術的重要論述滯留在特定的文化思辯形態和文明解碼架構中。

言語並無法勾勒出只可意會的細膩情感,曖昧是一種無止盡的暈眩螺旋。去功能性的思考驅使當代家具設計已不再是純粹的人體工學設計的延展,更是人文場域的深層介入和哲學介面上的再組構;通過去功能性的體驗,我們導入當代細緻的感知性覺。

——————— 楊子強

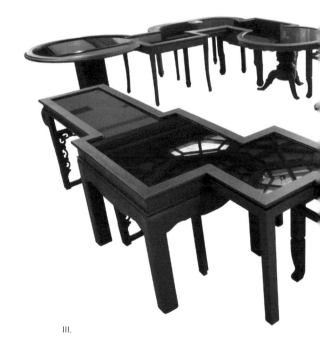

III.

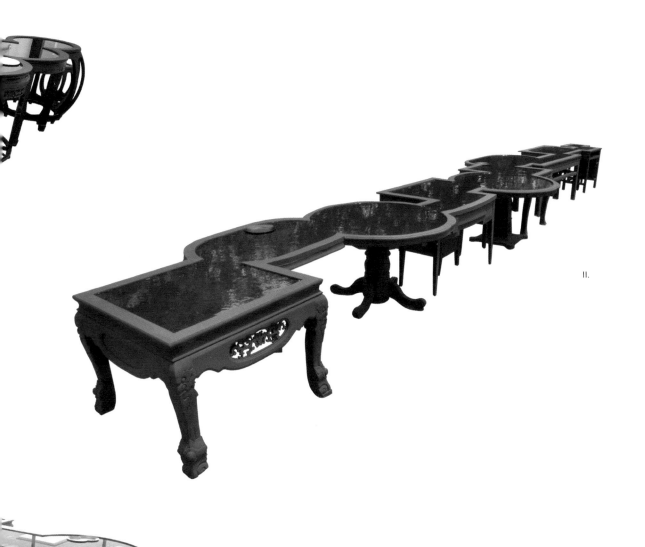

I.《黑宴》（2011），「黑宴」，理查許畫廊，新加坡
Black Banquet (2011), 'Black Banquet', Richard Koh Gallery, Singapore.

II.《金山上的野宴》（2017），「金山上的美容院」，朱銘美術館，臺灣。
Wild-Banquet-Every-Table at Jinshan Mountain (2017), 'A Beauty Centre @ Ju Ming Museum', Ju Ming Museum, Taiwan.

III.《回家》（2018），「基隆港口藝術雙年展 – 問津」，基隆文化中心，臺灣
Go Home (2018), 'Keelung Harbour Biennale - Ask The Way', Keelung Cultural Centre, Taiwan.

I.

II.

I.《忘年之戀》（2011），「黑宴」，理查許畫廊，新加坡
1970.January-December Relationship.2010 (2011), 'Black Banquet', Richard Koh Gallery, Singapore.

II.《私密介入》（2011），「黑宴」，理查許畫廊，新加坡
Intimate Confrontation (2011), 'Black Banquet', Richard Koh Gallery, Singapore.

III.《相濡以沫》，「慈善 2012，抵抗癌症的藝術與設計」，紅點設計博物館，新加坡。2012
Love Chair, 'Charity 2012, Art and Design Against Cancer', Red Dot Design Museum, Singapore. 2012

IV.《四人夜話》（2016），「麗美中心 2016」，新加坡
An Anonymous Late-night Chat for Four (2016), 'A Beauty Centre 2016', Singapore.

V.《黑風暴先生與暗夜小姐》（2006），「黑風暴與暗夜」，紅磨坊畫廊，佛蒙特藝術中心，美國
Mr Storm Black & Ms Night Dark (2006), 'Storm Black & Night Dark', Red Mill Gallery, Vermont Studio Centre, US.

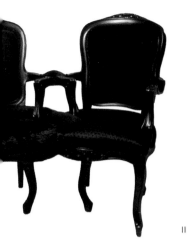

III.

IV.

Overlapped & Dysfunctional

The old electric fan rotates slowly, and the fragrance of Ceylon tea fills the little tea room. The white porcelain English teacups drift lightly on the table, with clear water filling the hollowed rosewood table, but making no waves. Beside the wooden table with water filled to the top is a chair that is a combination of a Ming dynasty style rosewood chair and a British colonial rattan chair. It is an obscure combination, making it difficult to discern whether it is an intrusive invasion or mutual fusion, like a customized version of the legendary conjoined twins of the 19th century, Chang and Eng.

The word "chair" cannot be found in Thailand's ancient language. The Thai people in ancient times sat on the floor. Chairs were non-existent then because they did not serve any practical purpose in the Thai people's daily lives. The demand for function leads to the production of tools and objects. The coining of new words establishes the object's form and its practical use which is rooted in daily experience. Humanistic fields in different times and spaces have derived multiple styles of the same object, (and functionality is what defines the name of the object.) Therefore, if a table has the look of a table but does not have the function of a table, unable to contain anything on its top, is it still a table? Will this become another classic chicken and egg paradox? The non-existent "chair" in ancient Thai language also indirectly transcends the "chair" described in Joseph Kosuth's classic three-definition rhetoric, as well as its related image interpretation and annotated function of a chair. This leaves the quintessential discourse of contemporary conceptual art in a specific form of cultural dialectic and coding framework within civilization.

Words cannot delineate delicate emotions that can only be understood intuitively. Ambiguity is an endless dizzy spiral. Contemporary furniture design, driven by a consideration of how to abandon its functionality, is no longer the extension of pure ergonomic design, but is more of a deep intervention of the humanistic field and the reconfiguration of a philosophical interface. By experiencing the abandonment of an object's functionality, we are led into a contemporary, delicate sense and awareness of perception in its original state.

—————— Yeo Chee Kiong

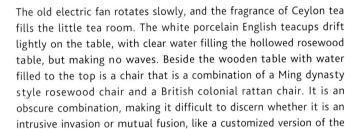

V.

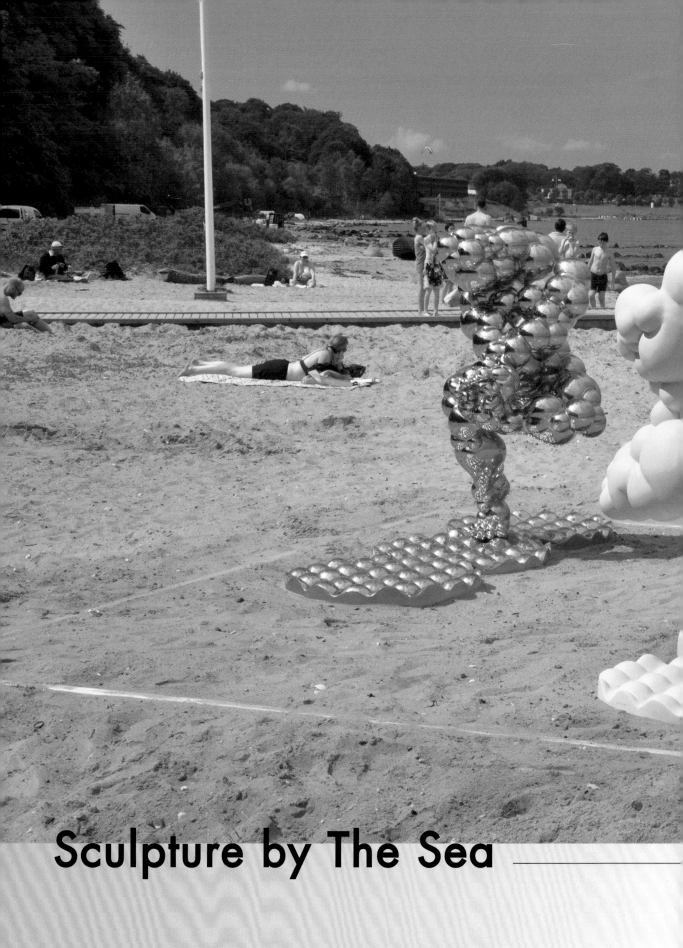

Sculpture by The Sea

Aarhus

Public Art

Vietnam

心動　*Tempted Mind*

Realistic Figurine
Since 1991

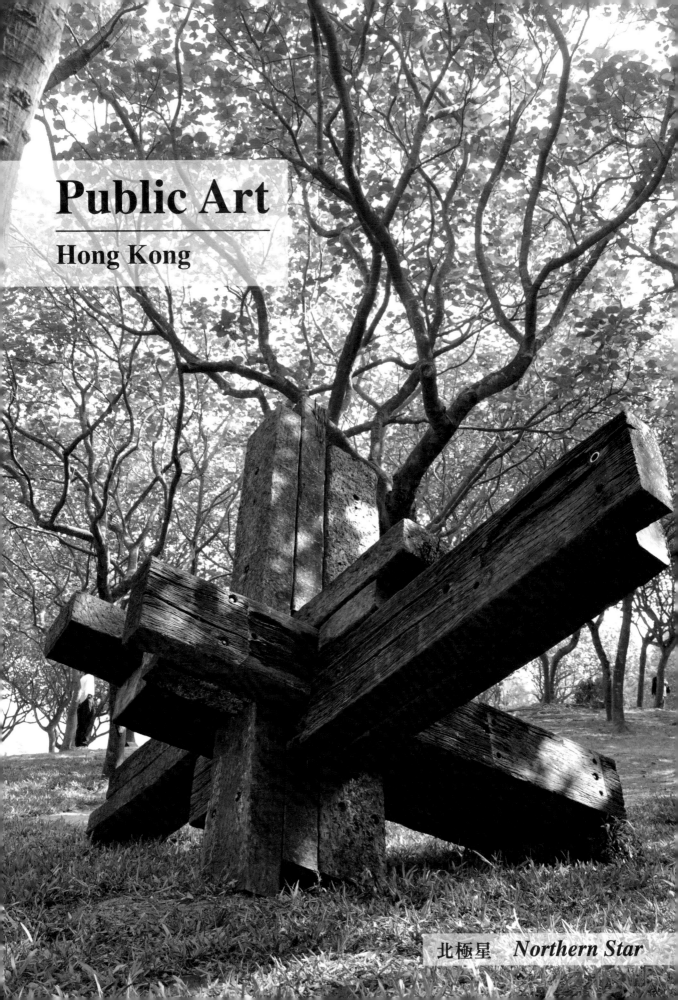

Public Art

Hong Kong

北極星　*Northern Star*

Sculpture by The Sea

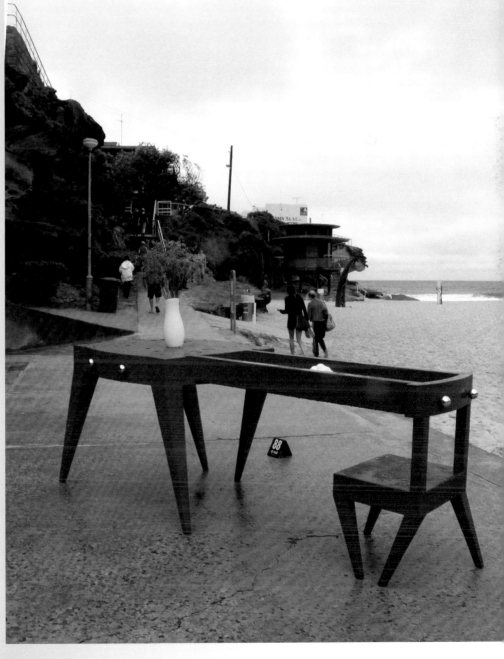

Sydney

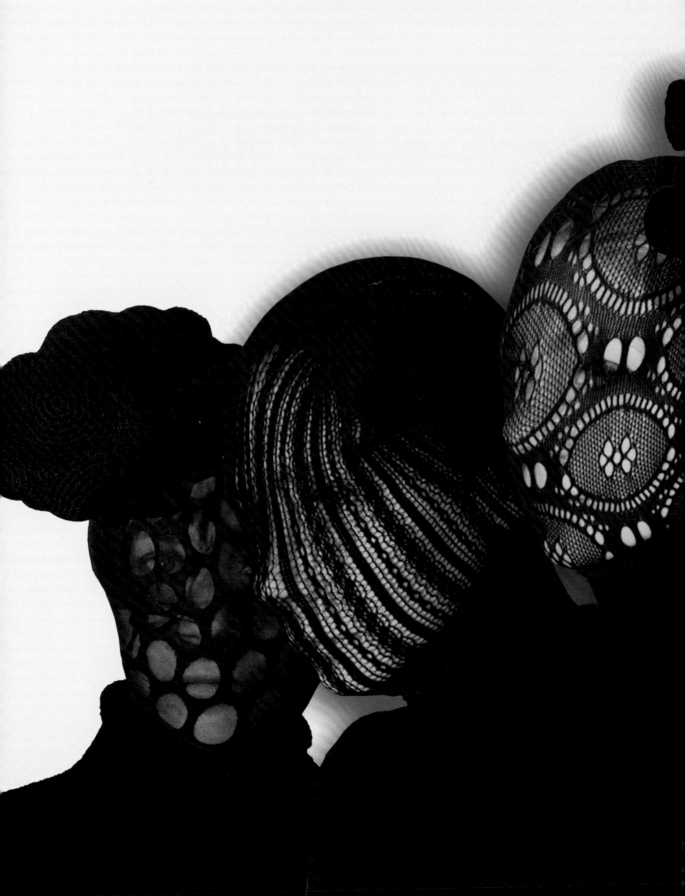

約翰・卡爾卡特的美
The Beauty of John Calcutt

楊子強　Yeo Chee Kiong

晶瑩剔透的高腳酒杯盛著一小撮快熟麵條和些許調味包所沖泡的熱湯，綴點上一小丁鵝肝，再搭配上一顆酒漬櫻桃。餐桌上擺放著玫瑰花，花枝上的尖刺，都用修指甲刀銼成圓角。牆上的裝飾視屏上是一個個無聲又激烈的煙火影像，音箱內循環播放著貝多芬的獻給愛麗絲，那是古典六弦琴獨奏的版本，乾淨的音色比傍晚時分的電子廣播版本更細膩精緻。唯一的甜點是輕薄的麻醉喉糖糖衣內包裹著酌量的紅酒。暗啞的黑色菜單上印製著一行閃亮的黑色字體：「安迪・沃霍爾（Andy Warhol）的三分鐘」。

《模糊時尚》特闢美學專欄，邀請來自蘇格蘭的美學大師約翰・卡爾卡特親自撰稿，為您細細釐清美的過去，現在，和未來。通過細膩的筆觸，觀察入微的抒情描寫，帶領讀者一步步的進入美的精神世界。

The sparkling goblet contains a handful of instant noodles and hot soup brewed with a little condiment bag from an instant noodle's pack, decorated with a small portion of foie gras matched with a wine-stained cherry. Roses are placed on the dining table, with their thorns filed down with a manicure implement. The decorative video on the wall is a silent, intense pyrotechnic image. From the sound box comes Beethoven's Für Elise on repeat, a solo version of the classical guitar. The clean tone is more delicate than the electronic one that is broadcast every evening. The only dessert is a moderate amount of red wine contained in a light anaesthetic lozenge. On the black satin menu is a line in shiny black font, "Three Minutes for Andy Warhol."

Vague Vogue has a special column on sharing aesthetics, inviting John Calcutt, an aesthetics master from Scotland, who writes to comb the past, present, and future of beauty for you. With a delicate style and subtle descriptions, through detailed observation, he will lead readers into a beautiful world of the mind.

導 讀

約翰‧卡爾卡特

英文原稿／翻譯｜林庭如、楊子強

我對於我們和藝術作品間的複雜關係和理解作品的方式很感興趣。傳統的藝術論述傾向優先使用客觀視角來書寫，但在現實中，我們欣賞藝術的方式則是由主觀經驗主導，我們體驗廣大世界的方式更是如此。我並非低估客觀的影響力，但我覺得那只提供一種不完整的面貌。我對線性敘事結構也抱持類似的想法，該敘事結構只提供一種讓人以為能掌控內容的幻覺。世界並不像線性敘事中描述的那樣整潔、進步、有邏輯地開展，也不像客觀論述暗示的那樣。因此，我喜歡探詢與文字結構相關的蒙太奇技法，蒙太奇那種零碎、不連貫的方式，對我來說，更貼近人類心靈和多重感官體驗世界的方式。（蒙太奇是超過一世紀以前，立體派、達達主義派等西方視覺藝術家，還有維多夫和愛森斯坦等俄國製片人所選用的方式。）我們對世界的認識來自我們接觸到的不同觀點，來自大量不同（且經常互相抵觸）的聲音。

在我的文章〈美麗與墮落〉中，我試著發展這些想法，而「美」這個主題相當吻合此類研究，因為在（西方）思想史裡，它就是客觀與主觀價值的競技場。美是不容爭辯的事實，還是個人意見？這種二選一的二元對立是假議題。對我來說，萬事萬物的定義，都由與其相反的一切推斷產生。聖潔必定牽涉污穢；沒有罪犯，法律就沒有意義。因此我喜歡嘗試撼動我們對美的慣有思維（即美無庸置疑地代表「好的」事物），導入較為黑暗的層面。美可以是正面的也可以是負面的，可以是「好的」也可以是「壞的」；美永遠存封在它看似否定的世界中。

雖然這篇論述結構零碎且片段，但我試著以重複出現的畫面（特別是山脈和蘋果）讓文章在某種程度上得以連貫。山脈和蘋果在世界各地的神話和文化活動中反覆出現，它們的意義也許和「美」一樣，不存在於物質本身，而是它們背後象徵的重要意義——追尋物質背後的意義正是人類共有的基本慾望。在神話和傳說裡，我們可以自由地想像，裡面也經常談到我們最深的慾望和恐懼。我的論述從神話之境開始，並以類似的「不真實」情節作結。（當然，以「不真實」來簡單地對應或替代「真實」讓我很猶豫，因為它們存在於彼此之內。我們對它們的了解大多來自文字或影像描繪它們的方式，例如：真實／不真實──真相／非真相──假新聞。）

最後，我希望我有成功寫出一篇能激發讀者想像的論述，讓她從被動的「意義消費者」變成主動的「意義生產者」，也就是那些利用自身知識、經驗、想像來填補「意義空缺」的人。於此而言，我希望能達成楊子強在《麗美中心》這件作品中的部分成就，那是啟發我撰寫此文的作品。正式來說，這篇文章和楊子強的裝置有著類似的結構，兩者皆由個別元素組成，且作者並未預設立場，而是邀請觀者／讀者自行「拼湊」這些元素。（其實，我文章中的各個段落可以用任何順序加以閱讀。）我想傳達的畫面和美感，大部分也是受到楊子強作品的影響（尤其是文章的最後一部份，例如閃耀的表面、可調控的光線、奢華的零售場景等。）但最重要的或許是，楊子強的作品如何啟發我在文中提及的概念，「麗美中心」鼓勵我從眾多不同的角度思考美，包括歷史層面、神話層面、哲學層面、社會政治面、商業面。楊子強的作品及時地點出，所謂的美是動態的、變動的，而且在這個個人電腦、數位科技、行動電話、虛擬實境、大眾消費的時代裡，美是需要被重新定義的。

INTRODUCTION

John Calcutt

I am interested in the complexity of our relation to and understanding of works of art. Conventional writing about art tends to prioritise an objective approach, whereas – in reality – subjective responses play a crucial role in our experience of art, not to mention the world at large. Whilst I do not underestimate the power of objectivity, I believe it offers only an incomplete picture. I harbour similar thoughts in relation to linear narrative structures, which offer only an illusion of control and mastery over their content. The world is not as neat, tidy, progressive and logically unfolding as the structure of the linear narrative proposes, or as objective arguments imply. I am therefore interested in exploring montage techniques in relation to the structuring of a text. The fragmentary, discontinuous nature of montage offers, it seems to me, a more accurate model of the way the world is experienced by the human mind and senses (a fact picked up on by western visual artists, such as the Cubists and Dadaists, and Russian film-makers such as Dziga Vertov and Sergei Eisenstein, more than a century ago). What we know about the world arises from our exposure to multiple viewpoints, a host of different, often conflicting, voices.

In my essay "The Beautiful and Damned" I try to develop some of these ideas. The topic of beauty is ideally suited to such an investigation because in the history of (western) ideas, it has been the site of a struggle between objectivity and subjectivity. Is beauty a matter of indisputable fact, or of personal opinion? Such binary oppositions – such either/ or choices – are false. The identity of anything, it seems to me, is in part determined by all those things to which it is opposed. The sacred necessarily entails the profane. The law would mean nothing without criminals. Thus I was interested in trying to unsettle some of our more conventional ideas about beauty (i.e. that it is an unquestionably "good" thing) by introducing a darker side. Beauty can be both positive and negative, "good" and "bad"; it is locked in an eternal embrace with that which it would seemingly deny.

Although the structure of the essay is fragmentary and episodic, I have tried to introduce a degree of continuity by means of the recurrent imagery: mountains and apples, in particular. At opposite ends of the scale in terms of physical size, mountains and apples are recurrent symbols throughout the myths and cultural practices of the world, indicating – like beauty itself, perhaps - a universal and fundamental human desire to seek meaning and significance behind the everyday world of material existence. The worlds of myth and legend allow freedom to the imagination, and often speak to our deepest desires and fears. I begin the essay in the realms of myth, and I end in a similarly "unreal" scenario. (Needless to say, I hesitate to present the "unreal" as the simple opposite or alternative to the "real": they inhabit each other. Our understanding of both depends to a great extent on the ways in which they are represented, either through words or images, for example. Real/Unreal: Truth/Untruth: Fake News.)

Finally, I hope that I have managed to write an essay that engages the imagination of the reader, turning her from a passive "consumer" of meaning into an active "producer" of meaning – someone who fills in the "gaps" through their own knowledge, experience and imagination. In this sense I hope to achieve some of the success of Yeo Chee Kiong's A Beauty Centre, the work which inspires this writing. In formal terms, the essay has a similar structural composition to Yeo's installations in so far as they are all composed of separate elements that the viewer/reader is invited to "connect" in ways that are not predetermined by the artist/writer. (The various vignettes that appear in my essay could, in fact, be read in any order.) Much of the imagery and aesthetic "mood" that I try to convey (especially in the final sections of the essay – such as, shiny surfaces, controlled lighting, and luxury retailing, etc.) is also derived from Yeo's work. But most important of all, perhaps, is the way in which Yeo's work inspired the conceptual aspects of the essay. A Beauty Centre encouraged me to think about beauty from a variety of perspectives, including the historical, mythological, philosophical, socio-political and commercial. Yeo's work is a timely reminder that the very idea of beauty is dynamic, changing, and in need of re-conceptualising in our age of personal computers, digital technology, mobile phones, virtual reality and mass consumerism.

美麗與墮落

約翰‧卡爾卡特

英文原稿／翻譯｜林庭如、楊子強

在花園裡

每個新詞，像是「眩目的驚奇」，像是「惱人的啟示」，這些詞彙綻放在剛剛鑄造而成的世界中，聽起來像簌簌的枯葉，也像潺潺的流水。有時候，越來越多時候，它們更像玫瑰的刺一般扎人、刮動。在我之上的，我會說，湛藍。在我之下的，我應說，草綠。在我跟前的，是擾動、是興奮、是事件。有種事物慢慢成型，脫離周遭的日常氛圍。它向著我前進，卻又未曾移動。不同詞彙紛沓至來，卻還是太少了。我感受到一種新的速率，一種難以言喻的愉悅。

它就像你，卻遠比你優異。你的形態已經超越我的眼界、超越言語。蘭花和翠鳥為花園帶來一絲絲優雅的氣息，但它們都沒有你那種誘發新詞的能力。這裡只有我們兩個，對吧？你確定嗎？我不敢向前伸手探摸，因為我怕你不在那裡。或者，我其實更怕知道你真的在那裡。如果我碰觸你，會像我碰觸自己一樣嗎？你是我遺失的部分自己嗎？

越來越多新生詞彙躍進世界。每次的大爆炸都更新了型態，銳化了邊角，讓質地裸露而出，也創造更多色彩。其中，有許多詞彙會誘發我們對於生命和物件的觸覺、嗅覺、聽覺、知覺，像是花朵、馬匹、山脈、蟒蛇、樹木、魚、蘋果。其他的詞彙，相對而言，則是拓展了我們的視覺認知：大的、圓的、紅的、有棱角的、透明的、流暢的、對稱的。但即便如此，這些詞彙仍然無法描繪從我心裡發出的迫切感受。為什麼我們要騎乘閃亮的馬匹、要爬過閃耀的山頭、要躲避光芒熠熠的蛇、要食下那顆耀眼的蘋果？在這些事物之中，有什麼力量藏於其中，連結了我，也連結了這些事物？更迫切的問題是，有什麼難以抵擋的驅動力，把我的目光帶向你、放大你的存在，把在你之外的一切都切換成模糊的背景？

感覺上所有的詞彙最後都指向你，雖然詞彙量在喧嚷聲中不斷增加，卻都不足以梳理你帶來的獨特情緒。那是比言語更強烈，萬千碎片都比不上的單體。我是不是應該把它比擬成艷陽的輻射，比擬成海洋的激湧？我是不是應該將它稱為無垠天空中的美麗湛藍？我敢賦予它一個名字嗎？沒辦法。賦予名稱只是一種囚禁；以其他事物比擬它也只是貶低了它。它就是你，卻大於你：它放大你、開展你，讓你成為極光，成為華麗，成為榮耀。

在你面前，這座花園只不過是一本包含萬物的百科全書，只不過是描繪各種想像的圖錄，只不過是單純的堆疊。但現在的它有了生命也有了光澤，讓人有所共鳴也有所寄託。是你讓它有了存在的意義，你為它帶來愉悅光芒，也帶來憂傷陰霾。世界至此被形塑，一個光影交錯、好壞交織、對錯交參、真假並存的多面體。你的出現像是奇蹟，喚醒了不經意沉睡了的時間。你的倏然現身撕裂了無憂的寂靜，讓它有了「之前」和「之後」的時間分隔。我需要新的單詞，來形容這股我看不到也無法丈量、卻大力攫著我的力量。我在學習感受一切。每個起始都蘊含著終點，每種收穫也都招來失去，在理解這些意義的當下我嚐到了悲傷的滋味。與此同時有一股難以抵擋的秘密情緒驅動著我。我被虜獲了，我被俘虜了。我所做的一切，都是因為你，也都是為了你。我們面向無限交纏的未來。那就一起分享這顆耀眼的蘋果吧。我會是亞當，你會是夏娃，最後的字眼是美麗。我所感受的，這份情緒，會是我們漫長且無盡的墮落。

在埃及和特洛伊

遠古的特洛伊戰爭殘酷無情，他們為她而戰。以她的美麗為名，英雄們將化為灰燼。但死亡和榮耀的強烈呼聲並未擾動她受囚禁的尼羅河畔。寂靜並未帶來慰藉。無從宣洩，所以未曾得到慰藉。她無法「在自己身邊」承受憤怒、焦慮、悲傷、悔恨，或是任何巨大的情緒變化，只有去到特洛伊，她才能「在自己身邊」。就留待他人在狂喜（註1）和痛苦間尋找和迷失吧。她的名字是海倫。

我們要記住，這是離我們很遠的事了，當時的世界仍然是魔幻的、流動的，一切尚未定型。理性和邏輯對現在的我們沒有幫助，我們所處的世界裡，外表才是一切，外貌越誘人，就越有機會藉此背叛和欺矇。老早在社群媒體和假新聞出現以前，真相就已遭到懷疑並伴隨著不確定。如果我們的故事顯得複雜又讓人困惑，可以想想本來就沒有一件事物能維持其初現的姿態，這樣就有點安慰了。

THE BEAUTIFUL AND DAMNED

John Calcutt

In The Garden

With each new word: a blinding wonder, a stupefying revelation. Every such word a blossom within this freshly minted world. Their sounds rustle like dead leaves, or trill like a bright stream. And sometimes, increasingly, they prick and scratch like the thorns of a rose. Above me and beyond: I will say, blue. Beneath me: I shall say, green. Before me: a stirring, an excitation, an event. Something is forming, detaching itself from the general ambience. It advances towards me, although it does not move. Words continued to arrive, but still too few. I felt a new quickness, an unaccountable pleasure.

It is you, yet far greater. Your form is more than my eyes can contain, or words can yet catch. The orchid and kingfisher lend their grace to this garden, but neither has your power to command new words. There are only two of us, right? Are you sure? I dare not reach out to touch you in case you are not there. Worse still, perhaps, to find that you are really there. If I touched you, would it feel the same as when I touch myself? Are you the missing part of me?

More newborn words continued to fizz and pop, each startling explosion revealing new forms, sharpening edges, uncloaking textures and inventing colours. Many of these words brought forth beings and things to be touched, smelled, held, heard or consumed: flowers, horses, mountains, serpents, trees, fish, apples. Others, in contrast, spoke to the eye of qualities: large, round, red, angular, transparent, smooth, symmetrical. Yet none of these words could capture the insistent sensations arising within me. Why this need to mount the shining horse, climb the shimmering mountain, shrink from the glittering serpent, or eat the gleaming apple? What was the power that lay between these things, connecting me to them, and them to each other? More urgently: what was this irresistible force that drew my eyes to you, enlarging your presence so much that everything else submitted to the indistinct background?

It felt as if all words should point only to you, but even in the clamor of their rising number they were insufficient to fix the particularity of the sensation you produced. This was something stronger than words, a singularity more powerful than a thousand bits and pieces. Shall I compare it to the radiance of the sun? Shall I compare it to the surge of the ocean? Shall I call it the lovely blue of the sky's limitless blueness? Dare I name it? No: To name it is to imprison; to compare it serves only to belittle. It is you, but it is more than you: it amplifies and unfolds you. It is you transfigured into an aura, a cloud of splendor, a shower of glory.

Before you, this garden was merely an encyclopaedia of things, an illustrated catalogue of possibilities. It was simply an accumulation. But now it is alive, radiant, responsive, purposeful. You coax meaning into existence. You bring joyful light, but also solemn shadow. The world is now sculpted, a multi-faceted interplay of light and dark, good and bad, right and wrong, truth and deception. The miracle of your appearance has also awoken time from its careless sleep. Your striking presence slices through the innocent lull, splitting it into 'before' and 'after'. New words are called for, words to seize things I cannot see or measure, but which grasp me with force. I am learning how to feel. The taste of sorrow rises as I realize that each new beginning entails an end, and every gain incurs a loss. And yet an irresistible secret feeling drives me on. I am captured, enslaved. What I do, I do because of you and for you. We face the infinite future entwined. Let us share this gleaming apple. I will be Adam. You will be Eve. The final word is beauty. And this feeling, I sense, will be our long and endless fall.

In Egypt and Troy

In far Troy the war is relentless: they fight because of her. The heroes will be annihilated in the name of her beauty. But the raging sounds of death and glory do not disturb the land of the Nile where she now endures her captivity. This silence is of no comfort. No comfort because there is no catharsis: she cannot be 'beside herself' with anger, anxiety, grief, regret - or any other grand emotion, for that matter. Only by travelling to Troy could she be 'beside herself'. It is left to the others to find and lose themselves in ecstasy (Note 1) and suffering. Her name is Helen.

We must remember that this was long before our time: it was an age when the world was still magical, fluid and unfixed. Reason and logic will not help us here. We are in

必須回到源頭才能了解一切：我們都不是海倫。她的美貌既聖潔又污穢，印烙著她的存在，她的人生也從最開始就被標以復雜的記號。不同於我們，她的誕生故事就已包藏矛盾複雜的情節。據說，古希臘的復仇女神涅墨西斯可能是她的母親，卻是在不情願的狀況下生下了她。涅墨西斯拒絕了萬神之神宙斯的熱烈追求，為了閃躲他的貪戀，女神將自己化身成魚，躍入浪淘淘湧的大海中。但宙斯仍繼續追尋她的身影，她也多次化身為不同生物，以逃離窮追不捨的宙斯。最後女神化身成鵝，詭計多端的宙斯也將自己變身成公鵝以瞞騙涅墨西斯。宙斯以鵝的樣態現身，趁她熟睡時與她交配，後來，涅墨西斯產下一顆鵝蛋。十分羞愧的她將鵝蛋藏在樹叢中，卻被牧羊人發現且交給埃托利亞的公主麗妲。麗妲把鵝蛋存放在珠寶盒中，直到鵝蛋孵化，生出兩對雙胞胎。其中一對是卡斯托爾和波魯克斯兄弟，另外一對則是海倫和她的姊姊克呂泰涅斯特拉。

但海倫的身世仍未有定論。會不會化成鵝的宙斯其實是和麗妲交配，而不是涅墨西斯？故事還可以更複雜，因為麗妲嫁給了斯巴達國王廷達瑞俄斯，且據說兩人在宙斯強暴麗妲的當晚還有做愛。所以海倫會不會其實有兩個爸爸、也有兩個媽媽？或是，宙斯和涅墨西斯生下了海倫和波魯克斯，廷達瑞俄斯則和麗妲生下了卡斯托爾和克呂泰涅斯特拉？再多加一個轉折，會不會涅墨西斯其實也是宙斯的女兒？

為海倫的美尋找單一根源或許注定失敗，但她的美貌卻不容爭辯，早在年幼時已經顯現。她還是孩童之時（有人說七歲時、有人說十歲時），提修斯就已將她從斯巴達擄走，而他只是受海倫難以抗拒的美色所驅使而犯下罪行的第一人。提修斯將她誘拐到自己的故鄉雅典後，她憤怒的哥哥卡斯托爾和波魯克斯前來以武力搭救。死亡從此降臨，自此至終，她的美貌與紛爭、衝突，再也分不開。因此，幾年以後，在她的待嫁之年，她的凡人父親（廷達瑞俄斯國王）為了不引發爭端，先行拒絕了所有渴望追求她的貴族，後來他才讓所有的追求者立誓，承諾他們會與最終贏得海倫的追求者同心，一起對抗其他因嫉妒而發起的攻擊。深思熟慮後，墨涅拉俄斯獲選為海倫的丈夫，與她一同統治斯巴達。

在奧林帕斯聖山高處眺望一切的宙斯卻不滿意此結局。人神關係越趨惡化，宙斯希望能摧毀人類，尤其是人類中的英雄。因此，他讓特洛伊王子帕里斯負責裁定赫拉、雅典娜、阿佛羅狄忒三位女神間的選美之爭，勝出者會得到帕里斯手中來自赫斯珀里得斯聖園、刻有「給最美的」字樣的金蘋果。為了影響他的裁決，三位女神都想賄賂帕里斯：赫拉願給予至高權利、雅典娜給予智慧、阿佛羅狄忒給他世上最美的女人。帕里斯拋棄了權力和智慧而選擇美人，樂意之至地接收阿佛羅狄忒的禮物。帕里斯太愚蠢了。如宙斯所預期，輸了比賽的赫拉和雅典娜憎恨帕里斯，立誓復仇。選擇美人的帕里斯背棄了權力和智慧，世界因此付出了慘痛的代價。

隻身受困於埃及的海倫，回想起為她帶來苦境的原委：阿佛羅狄忒將她當作賞給帕里斯的回禮。得到獎賞後，衝動的帕里斯旋即將她帶回特洛伊，但她畢竟不是自由之身，她已經嫁給墨涅拉俄斯，成為斯巴達的皇后。墨涅拉俄斯找不到他的妻子，馬上召集曾為海倫立下誓言的追求者，他們也決意為此對特洛伊宣戰，將海倫帶回斯巴達。這就是宙斯策動的特洛伊戰爭，持續了十年之久，英雄死傷無

a world where appearances count for everything, and the greater their seductive appeal, the greater their capacity for treachery and deception. Long before our own anxious days of social media and fake news, truth was always unwillingly promised to doubt and uncertainty. If our story seems complicated and confusing, take comfort in the fact that nothing is ever as it first appears.

It must be understood from the outset: Helen is not like you or me. A miraculous beauty - sacred and profane - stamped her existence, and complications marked her life from the outset. Unlike us, her birth was enmeshed within a multiplicity of conflicting narratives. Thus Nemesis, the ancient Greek goddess of revenge and retribution, was reputedly one of her mothers – a reluctant mother. Pursued by Zeus, king of the gods, Nemesis rejected her inflamed suitor's unwanted advances. In order to escape his lust, she turned herself into a fish and "sped over the waves of the loud-roaring sea". But still Zeus chased. Adamant, she continued to transform herself into various other creatures to evade the relentless hounding. Finally, she took the form of a goose, but wily Zeus tricked her by transforming himself into a swan. Zeus the swan then mated with Nemesis the goose as she slept and, as a result, Nemesis later laid an egg. Ashamed, she hid this egg among trees, but it was found by a shepherd who gave it to Leda, an Aetolian princess. Leda kept the egg in a casket until it hatched, producing two pairs of twins. One of these pairs was the brothers, Castor and Pollux. Helen, along with her sister Clytemnestra, formed the other pair.

Yet many accounts of her origins still refuse to settle and agree. Did Zeus the swan actually mate with Leda, not Nemesis? To further complicate matters, Leda was married to Tyndareus, the king of Sparta, and the two, it is said, had made love on the very night when Zeus reportedly raped Leda. Did Helen thus have two fathers as well as two mothers? Or was it that Zeus fathered Helen and Pollux with Nemesis, whilst Tyndareus fathered Castor and Clytemnestra with Leda? And, to add another twist, was Nemesis herself the daughter of Zeus?

Our search for a singular origin of Helen's beauty may be condemned to failure, but the power of this beauty was nevertheless indisputable, and apparent from her earliest days. When still a child (some accounts say she was seven years old, others suggest ten) she was kidnapped from her homeland in Sparta by Theseus, who was only the first to be driven to reckless crime by her irresistible charm. Theseus abducted her to his home in Athens, but from there she was forcibly rescued by her incensed brothers, Castor and Pollux. The die was now cast: her beauty would forever hereafter be inseparable from discord and strife. Thus, several years later, when it came time for her to marry, her mortal father (King Tyndareus) was keen not to antagonise any of her desperate noble suitors by rejecting them. So it was arranged that all would swear an oath to support the successful suitor against jealous attack from any of those who had been rejected. After much deliberation, Menelaus was finally chosen as Helen's husband, and together they ruled Sparta.

Watching events from the sacred heights of Mount Olympus, Zeus, however, was unhappy. Relations between the gods and the mortals were becoming increasingly difficult, and he wanted to destroy the mortals – especially the heroes. He therefore arranged for Paris, a Trojan prince, to judge a beauty competition between three goddesses: Hera, Athena and Aphrodite. To the winner Paris would award a golden apple from Garden of Hesperides, engraved with the words "To the fairest". Wishing to sway his judgement, each goddess offered Paris a bribe. Hera offered power, Athena offered wisdom, whilst Aphrodite offered the most beautiful woman in the world. Choosing beauty above power and wisdom, Paris willingly accepted Aphrodite's offer. Foolish Paris: as a consequence of losing the contest, Hera and Athena came to hate him, and – as Zeus had anticipated - vowed revenge. In choosing beauty, Paris had turned his back on power and wisdom, and the world would pay a heavy price.

Stranded and alone in Egypt, Helen recalls the events that had led to her current plight: for it was she whom Aphrodite had given to Paris as his reward. When presented with his prize, impetuous Paris swept her back to Troy with him. But she was not free: she was the queen of Sparta, already married to Menelaus. On discovering the loss of his wife, Menelaus immediately called upon the oath of her former suitors, and they vowed to wage war on Troy and return Helen to Sparta. It is this war, the Trojan War, engineered

數，其中包括赫克托爾、阿基里斯、埃阿斯、阿伽門儂、奧德修斯、帕特羅克洛斯、奧伊琉斯以及帕里斯本人。赫拉、雅典娜等懷恨於心的眾神也各自發揮神力主導成敗。

但這個故事還有更多蛇行迂迴的情節牽扯其中。從斯巴達前往特洛伊的途中，這對亡命鴛鴦停駐在埃及（可能是因為他們的船在中途壞了），但埃及之王普羅透斯對於帕里斯不道德的背叛感到震驚：墨涅拉俄斯殷勤地招待他，他卻與墨涅拉俄斯的妻子私奔。埃及之王於是拒絕讓海倫繼續前往特洛伊。因此，據歐里庇得斯之說，老謀深算的宙斯命令赫拉女神以雲朵仿製出另一個海倫，這個仿製品隨帕里斯前往特洛伊，而海倫本尊則留在埃及。現在有了兩個海倫，這場殘忍的戰爭也淪為對海倫仿製品和假象的爭奪戰。

她的美貌，是致命衝突的泉源，但本質卻已被抽離，只剩幻象。那是假的，卻蘊含難以抗拒的真相；那是幻覺，卻擁有真實的力量；不在場的同時卻又現身。群雄為了這份矛盾的美而戰，也為此受抹滅消逝於地表上。海倫有著碎裂的身世、碎裂的人生、碎裂的美貌，此時也為女神、英雄、凡人世界帶來碎裂的關係。海倫由善於欺瞞的宙斯和極欲復仇的涅墨西斯所生，她災難性的美貌是種禮讚同時也是詛咒。

*

我們經常用「魅惑」、「讓人鬆懈、解除敵意」這樣的字眼來形容美貌，但要這麼形容之前，別忘了這些詞彙的原義。魅惑（to charm）是指「利用魔法或類似的事物控制某事、達成某事」；「讓人解除敵意」（to disarm）代表的是「除掉某人手上的武器」、「奪走傷人的力量」。

墨涅拉俄斯從毀滅性的特洛伊戰爭回歸，行經埃及時發生船難，在那裡他遇到海倫的魅影。鬼魅的幻象讓他感到困惑、驚恐，但這個以雲朵仿製而出的海倫很快就蒸發了，取而代之的是海倫本尊。這對夫婦團聚後回到斯巴達，而墨涅拉俄斯心中仍有猜疑，決定謀殺曾經背叛他的海倫。在他準備殺害海倫時，海倫褪去衣衫，墨涅拉俄斯被她的

裸露的美色震懾，他的短劍掉到地上。海倫的美貌和從前一樣矛盾難解。那是一種「魅力」（charm）、一種魔法般的幻象，讓群雄和眾神加入殺戮之列，而此時卻又以另一種面向現形，預謀殺人的墨涅拉俄斯因為她的美貌而「解下手中傷人的武器」（disarm）。

海倫的傳奇美貌如此復雜、引發諸多麻煩，卻又值得我們關注。古希臘神話和哲學對西方人的意識形態帶來巨大影響，現在讓我們一起用哲學之鏡檢視這些神話。古典哲學家柏拉圖在《費得魯斯篇》（Phaedrus，約為西元前370 年）中首次討論到「pharmakon」一詞，據其之說，「pharmakon」有雙重身份，它同時是解藥也是毒藥。要把海倫的美比喻為「pharmakon」，我們就應先放下誘人的想法，放下杜斯妥也夫斯基的小說《白痴》（1869）中，梅甚金王子提出的說法：「美可以拯救世界。」海倫的傳奇美貌教會我們美具有拯救和毀滅的雙重力量：美是解藥也是毒液，是現實也是幻象，是真相也是謊言。它帶給我們的除了救贖，還有責難。

在書房裡

她橫濱書房的窗戶為她框出一個瀕臨海灣的視野。遠方平靜、壯麗、祥和的景象，是富士山君臨天下的幾何形狀。

1945 年 8 月 7 日起，幾乎每天她都在早上七點鐘起床、盥洗、梳妝、吃過簡單的早餐，然後進入她的書房。偌大的房間裡，書本排得整整齊齊，仔仔細細地依照她自己設計的標準分類擺放，但沒有一本書在過去的三十多年裡曾被翻開過。她的書桌相對空蕩、沒有堆放什麼東西，只有兩疊整齊的 A4 紙張、一籃鉛筆、削鉛筆機和橡皮擦，另外還有一小座蒂芬妮（Tiffany）出產、蘋果形狀的鉛晶紙鎮。牆面上掛有一幅錶框的雷內·瑪格麗特《人子》印刷品。

除非病痛，她每天的例行公事都是一樣的。一坐到書桌前，她就會先戴上閱讀用的眼鏡。經年累月的研究弱化了她的視力，要專注於桌面上的物件，眼鏡是她的必需品。若她將視線從桌面移往周遭環境，眼鏡面向的就只是一片朦朧模糊的景象。這時她會從其中一疊紙裡取下一張乾淨的紙，

by Zeus and lasting for ten years, which will bring about the death of the heroes, Hector, Achilles, Ajax, Agamemnon, Odysseus, Patroclus, Aeneas – and Paris himself - among their number. The vengeful gods and goddesses, including Hera and Athena, will also play their part, aiding victories and concocting defeats.

But there are further snakes and coils in this tale. On their way from Sparta to Troy, the fleeing couple stopped in Egypt (perhaps because their ship was blown off course). However, Proteus, the king of Egypt, was appalled by the fact that Paris had betrayed his host Menelaus's hospitality by eloping with his wife, and refused to let Helen continue the journey to Troy. Thus, according to Euripedes, Zeus – as conniving as ever - commanded the goddess Hera to make a replica of Helen from clouds. It is this replica that will accompany Paris to Troy, whilst the 'original' will remain in Egypt. Helen is therefore doubled. The brutal war will be fought over a replica, a facsimile, a fake.

Her beauty, the wellspring of deadly conflict, has been abstracted and turned into a mirage. It is false, yet it harbours a compelling truth. It is an illusion, yet it has the force of reality. It is both absent and present at the same time. The heroes do battle in the name of this paradoxical beauty, and it will wipe them from the face of the earth for all eternity. Helen's origin is splintered, her life is splintered, her beauty is splintered - and now the world of gods, heroes and mortals is splintered. Born of Zeus the deceiver and Nemesis the vengeful, her disastrous beauty is a prize and a curse.

*

We often speak of beauty as "charming" and "disarming". In so doing, let us not forget the original meaning of these terms. To charm is to "control or achieve by, or as if by, magic". To disarm is to "take a weapon away from someone" and "deprive of the power to hurt".

Returning from the catastrophic war in Troy, Menelaus finds himself shipwrecked in Egypt, where he encounters the phantom form of Helen. He is confused and alarmed by this apparition, but her cloud-formed replica soon evaporates and is replaced by the 'real' Helen. The reunited couple return to Sparta, but Menelaus harbours lingering doubts and decides to murder Helen for her past treachery. However, as he approaches for the kill she removes her clothes and, overcome by her naked beauty, he drops his sword. Helen's beauty is as ambivalent and incomprehensible as ever. It is a "charm", a magical illusion that had driven heroes and gods to join in slaughter, but now it shows its other side as it literally "disarms" the murderous Menelaus.

The legend of Helen's beauty is complex and troubling, yet it demands our attention. Ancient Greek mythology, combined with ancient Greek philosophy, has left a powerful mark on western consciousness. Let us finally, then, view the mythology through the lens of the philosophy. It was the ancient philosopher Plato who, in Phaedrus (c. 370 BCE), first discussed the idea of the *pharmakon*. The *pharmakon*, says Plato, has a double identity: it is simultaneously a cure and a poison. With the idea of Helen's beauty as *pharmakon* let us then abandon the seductive idea, proposed in more recent times by Prince Lev Nikolyaevich Myshkin in Fyodor Dostoevsky's novel *The Idiot* (1869), that "beauty will save the world". The legend of Helen's beauty teaches us that it has the power both to save and destroy: it is a cure and a poison, a reality and an illusion, a truth and a deception. It offers both salvation and damnation.

In The Study

The window of her study in Yokohama framed a view across the bay. In the distance – calm, majestic, serene – the sovereign geometry of Mount Fuji.

Almost every day since August 7, 1945 she had risen at seven o'clock in the morning, washed, dressed, eaten a modest breakfast, and then entered the study. This large room was neatly lined with books, carefully organised in conformity with a classificatory system that she herself had devised. None of these books, however, had been disturbed for the last thirty or so years. Her desk was relatively sparse and uncluttered: two neat piles of A4 paper; a tray with pencils, pencil sharpener and eraser; and a small Tiffany lead crystal paperweight in the shape of an apple. On the wall: a framed reproduction of René Magritte's *The Son of Man*.

放到她面前的桌面上，從籃子裡選一支鉛筆，檢查是否有削尖。最後她把椅子往書桌方向靠攏，然後她還有個慣性動作，她會用一根指頭觸摸一下冰冷的紙鎮，之後才開始進行她的每日工作。

陽光讓富士山的山頭更顯神聖。

她優雅的身軀被空間緊擁，她面前的紙張依然一片空白，閒晃的旁觀者可能會覺得她已經陷入昏睡，但她額頭和鼻孔些微的緊繃、還有眼周和鼻子周圍的細節卻給人不同的想法。有時候她的呼吸會加速，偶爾會嘆氣，很難準確形容這樣的聲響：像鬼魂一般反覆出現。

富士山吸納了永恆的靜默。

很少鄰居知道她的名字。對他們來說，她是個讓人有距離感、又有點引人好奇的人。他們偶爾或在街上或是當地的商店看到她，但不會和她交談。她也很少注意他們，她唯一的社交對象是每週四晚上都會來拜訪她的孫女（讀電腦相關科系的學生）。她們會一起坐在廚房大概一個小時，一個沉浸在社群媒體中、一個陷入沉思。她生命的精華在她的書房裡開展，只有在書房的孤獨時刻她才能嘗試完美地解出那個方程式，她心裡的、身上的每個分子都全神貫注在這個消耗生命的挑戰中，一旦完美地解開那個方程式，就能揭露終極奧秘：那曾被宣告卻無法看見、也無法再加以對分的美的律法。但利用方程式找出美的公式是不夠的，還需要將美具象化。刪去所有累贅和不優雅的元素，它本身呈現出來的美就是最好的證據。

富士山凌駕在遊客拍攝的影像之上。以社群媒體為終端，這些影像在它的陰影下凋零，卻不損及他們吸引到的按讚數。

我們可以猜猜是什麼想法佔據她的心頭。她書房裡的書揭示了她的研究範疇：煉金術、人類學、考古學、建築、藝術、占星術、天文學、生物學、植物學、地圖繪製學、喜劇、犯罪學、舞蹈、電子學、工程、民族志、電影研究、地理、幾何學、歷史、虹膜學、爵士、動力學、語言學、文學、數學、冶金學、音樂、神話、神經學、鳥類學、哲學、攝影、物理、政治、果樹學、情色、精神分析、量子機械、宗教、性學、社會學、體育、戲劇、城市研究、火山學、編織、木板印刷術、動物學。

富士山、奧林帕斯山、錫安山，在天際間輕聲交談，他們的低語生起了風，陣風帶我們歸鄉，也粉碎希望。

她的孫女在六月初的一個溫暖夜裡發現了她，她蒼白脆弱的軀體面著書房窗戶坐著，雙眼暗淡而空虛，目光似乎鎖定著遠方的山。書房的另一邊，她的眼鏡倚在桌面上，旁邊放著一張紙，寫著兩行字。她沒有留下遺囑，所以有位承包商受雇來丟棄她的遺物。有誰知道她的家具、她的書、她的衣物、她的其他物品最後都去哪了？慈善商店？垃圾填埋場？沒人想要舊東西，因為那些東西太抑鬱、太過時了。她為了解析美而被吞噬的生命只留下一些痕跡，但她的孫女把那張留在書桌上的紙收了起來，而且只讀過一遍：「我終於發現美的定律了。那是絕對的矛盾。我無法理解，也不知道那是什麼意思，但我已經證實過，因此我知道那確實是真理。」她孫女也帶走了紙鎮，放在梳妝鏡旁，成為她的擺飾之一。

夜晚降臨，但富士山加入星群，拒絕成為黯淡的夜景。它們不需要定律。

Barring illness, the routine was always the same. Once settled at the desk, she would first put on her reading spectacles. The years of study had weakened her eyes, and the spectacles were necessary in order for her to focus upon those objects gathered on the desktop. Should she, however, raise her eyes from the desktop to the surrounding world, it would appear from behind those spectacles as not much more than a hazy blur. She would then remove a clean sheet of paper from one of the piles and place it directly in front of her on the desktop. Selecting a pencil from the tray, she would check the sharpness of its point. Finally, she would draw her chair slightly closer to the desk and, from habit, briefly touch the coolness of the paperweight with a finger. And so began each daily engagement.

Sunlight anoints the crown of Mount Fuji.

Her delicate body was clasped by space. The sheet of paper before her on the desk remained blank. To the idle observer it may have appeared as if she had slid into a stupor, but subtle tensities through the forehead and nostrils, and around the eyes and mouth, told otherwise. Occasionally, her breathing would quicken, and once in a while a sigh would escape. It would be difficult to describe this sound precisely: haunted.

Mount Fuji absorbs the stillness of eternity.

Few of her neighbours knew her name. To them, she was a distant and somewhat curious figure. They occasionally saw her on the streets or in the local shops, but they did not speak. She, in turn, paid little attention to them. Her only regular social contact was with one of her granddaughters – a computer science student – who would visit on most Thursday evenings. The two would then sit together for an hour or so in the kitchen, the one immersed in social media, the other lost in thought. But the essence of her life unfolded in the study. It was in the solitude of the study that she worked to perfect the equation. Every molecule of her mind and body was focused exclusively on this life consuming challenge. Once perfected, the equation would finally reveal the ultimate mystery: the invisible and indivisible law of beauty in all of its manifestations. But it would not be enough for the equation simply to formulate beauty; it would also have to embody beauty. Once purged of all redundancy and inelegance, the beauty of its expression would be the guarantee of its proof.

Mount Fuji exceeds the tourists' photographs. Destined for social media, these images wither in the shadow of its being. This does not detract from the number of idle 'likes' they attract.

We can only guess what thoughts may have filled her mind. The books in her study give an indication of the range of her research: alchemy, anthropology, archaeology, architecture, art, astrology, astronomy, biology, botany, cartography, comedy, criminology, dance, electronics, engineering, ethnography, film studies, geography, geometry, history, iridology, jazz, kinetics, linguistics, literature, mathematics, metallurgy, music, mythology, neurology, ornithology, philosophy, photography, physics, politics, pomology, pornography, psychoanalysis, quantum mechanics, religion, sexuality, sociology, sport, theatre, urban studies, volcanology, weaving, xylography, zoology.

Mount Fuji, Mount Olympus and Mount Zion whisper to each other across the sky, creating the winds that will carry us home or wreck all our hopes.

She was found by her granddaughter one warm evening in early June. Her pale and brittle body was seated in a chair facing the study window. The eyes, now dull and vacant, seemed locked upon the distant mountain. Across the room her spectacles lay on the desktop, alongside a single sheet of paper bearing two sentences. She left no will, so a contractor was engaged to dispose of her belongings. Who knows what finally happened to her furniture, her books, her clothes and other possessions? Charity shops? Landfill? No one wants old stuff; it's too depressing, too unfashionable. Few traces survive of this life consumed by the analysis of beauty. But her granddaughter kept the sheet of paper from the study desk. She read it only once: "I have finally discovered the law of beauty. It is absolutely paradoxical; I cannot understand it, and I do not know what it means, but I have proved it, and therefore I know it must be the truth". She also took the paperweight, which now sits among the ornaments beside her make-up mirror.

Night descends, but Fuji-san joins the stars in a refusal of darkness. They have no need for laws.

在攝影棚裡

– 你知道你一定要相信我。

– 我相信你啊。

– 但我昨天拍你的時候你沒有。你封鎖了自己，我感覺我在拍你的時候你心裡有其他東西。我覺得是一種恐懼⋯⋯對某個人的恐懼吧。你沒有完全處在那個當下，你在想別人怎麼評價你。

– 可能吧。

*

我之前有拍過裸照，但沒遇過有人那麼直接地動我。他當時就像：「這就是我要你做的！我就是要這樣，不然你要很久才能進入狀況！」他把我的身體調整成一種我都不知道自己可以做到的姿勢，我跟他說，「我很不舒服」。但他說，「這就是我要的，這樣才會好看。」

*

試著放低一點然後保持那個姿勢。來吧！來吧！來吧！保持那個樣子。很美，很好！很好！繼續移動！繼續移動！腳繼續移動！趴著。過來這邊。來來來來！很好，保持那樣。不是、不是⋯⋯放鬆就好。把頭髮撥回去。很好。我有嚇到妳嗎？看著我。看著我。感覺不錯？低下去靠著妳的手肘。很好。太好了！很美！很美！很美！不要動、不要動，保持這姿勢。我叫你保持這個姿勢的時候你就要真的保持這個姿勢。妳還好嗎？妳可以稍微放鬆一點。腳不要動，只有上半身放鬆。很美，很美，我喜歡這個情緒。保持那樣。很美，很美，保持那樣，保持那樣。看著我。保持那樣。妳真的很美。轉向我這邊。很好。非常好。你看起來好美。那樣很酷。那很棒。這很漂亮。很美。慢慢地，現在要非常慢的移動。真的很美。這我喜歡。我喜歡。閉上眼睛。你還好嗎？轉一下、轉一下。對！對！對！過來這邊。

*

我在找尋瓦解美的方法。我想試著創造出不同的東西，創造新的形狀，將某人碎片化。我覺得那會比單純拍攝女生還高階一點。其實滿怪的。雖然看起來很糟、超級糟，但如果我能從中發現一丁點美，我就很開心。拍攝裸體時，我讓自己憑感覺操作，我甚至不知道我是誰，忘記自己的名字。我就只是照那樣進行。我喜歡的就是這種時候。我很慶幸有美麗的女人願意和我一起進行這樣的攝影計畫。女人看到自己被拍得很美，也讓她們覺得很高興。當我看見她們的胴體，我看到了我喜愛的形狀，但其他部分有時又會干擾我。那麼，如果我看到不是很美的東西，我會怎麼辦？很簡單：我就把它修改掉，把我不喜歡的東西拿掉。

*

– 你覺得這裡的模特兒是不是都很漂亮？或者頂尖的模特兒和普通的模特兒之間有什麼差別？你在畫面裡有沒有看到些什麼？

– 我覺得是他們的個人特質。

– 他們的個人特質？

– 對。

– 你和其他人有什麼不同？

– 我覺得我很難在畫面裡分享太多東西。我沒有⋯⋯我就是會緊張⋯⋯

– 你會緊張？

– ⋯⋯把自己暴露在別人眼前，尤其是 Instagram。我喜歡幫自己打造某種形象。

– 所以你沒有做自己？

– 不是，那還是某部分的我⋯⋯

– 那是某部分的你⋯⋯

– ⋯⋯但那比我更完整。

– 其實我有點擔心這個，因為大家都會這樣，都會展現自己最好的一面。我覺得你在上面也要放點自己的黑暗面。這很正常，你知道的。我的意思是大家不會⋯⋯我是說大家會⋯⋯你會讓更多人喜歡你。

In The studio_____

–You know you have to trust me.

–I do trust you.

–But when I shot you yesterday you didn't. You are blocking yourself. I feel there is something else when I shoot you. I think there is a fear about⋯ about someone else. You are not totally here. You're thinking about being judged.

–Maybe

*

I had shot nude before, but never worked with somebody who was going to push me like that physically. He was like, "This is what I want you to do, and I'm just going to do it because it'll take way too long for you to get yourself into that position." He was putting my body in positions I didn't know I could be in. I was like telling him, "I am so uncomfortable". And he was like, "This is how I need it to be to look good".

*

Try to stay low and keep low. Let's do it! Let's do it! Let's do it! Stay like that. Beautiful. That's good! That's good! Keep moving! Keep moving! Keep moving your legs! Lie on your stomach. Come over this way. Come, come, come, come! That's nice. Stay like that. No, no ... just relax. Put your hair back. That's nice. Do I scare you? Look at me. Look at me. Feel good? Go down on your elbow. That's good. Very good. Beautiful! Beautiful! Beautiful! Stay like this. Stay like this. Keep it. When I say stay like this you really need to stay like this. Are you OK? You can relax a little bit. Don't move the legs, just relax the top. Beautiful. Beautiful. I like that mood. Stay like that. Beautiful. Beautiful. Stay like that. Stay like that. Look at me. Stay like that. You're really very beautiful. Turn to me. That's good. That's very good. You look amazing. That's cool. That's great. This is beautiful. Beautiful. Slowly – really move slowly now. That's quite beautiful. I like that. I like it. Close your eyes. You OK? Twist. Twist. Do it! Do it! Do it! Come over here.

*

I'm looking for a way to shatter beauty. I try to create something different, to create a new shape – to fragment somebody. I feel like it's a little step-up from just posing the girl. It's weird. It can look awful, very awful, but if I can find something beautiful there, I am happy. When I shoot nudes I let myself go with the impression, and I don't even know who I am. I forget my name. I just do it. This is the moment I love. I'm so lucky to have beautiful women wanting to do this kind of picture with me. It's a good feeling for the woman to see herself beautifully shot. When I see the body, I see the shape I love. But the rest sometimes is disturbing. So, when I find something that's not really beautiful, what do I do? It's so simple: I just correct - remove the things I don't like.

*

–Do you think all the models around are beautiful, or is there some difference between a top model and an average model? Do you think it's something in the picture?

–I think it's their personality.

–Their personality?

–Yeah.

–What makes you different from the others?

–I think it's hard for me to share it a lot in pictures. I don't⋯ I get nervous⋯

–You get nervous?

–⋯ exposing myself. Especially on Instagram I like to create a sort of persona of myself.

–So you're turning away from yourself?

–No! It's still like a piece of me⋯

–It's a piece of you⋯

–⋯ but it's more put together than I maybe am in person.

–I'm a bit worried about that because I think everybody does that. We all show the best of ourselves. I think you should show a bit of your dark side in your Instagram. It's normal, you know. I mean people are not gonna⋯ I mean people are gonna⋯ You're gonna be loved much more.

*

這就是一種角色。回到家以後，我就是不同
的人，我會褪下那種形象。在家的時候我
試著不看鏡子裡的自己，我不
喜歡一直處在那種「當個
漂亮模特兒」的狀態裡，
我喜歡稍微忘記那種感
覺。我覺得我要一直把頭髮
弄直、表演出某種姿態、用某
種方式說話才能增加 Instagram 裡的
追蹤人數。就算在工作場合也是，你也
知道，「因為如果沒有至少一萬人追蹤
你，你根本不會有工作。」你會逼著別
人抹除某部分的自我，抹除他們真正的
樣子。我不想這樣做，但我必需要這樣做。
我的意思是，我知道這些現在很重要，但那不
是真實的世界。

*

他真的幫她們擺了各種姿勢，強迫她們做某些
事，逼她們離開舒適圈。她們開始知道他想要什麼，
也明白原來她們都是他想法的延伸，她們的身體，是
他想法的延伸。她們屈服了。這基本上就是投降的過程。
完全不要以為他沒想到這些過程，這些操弄、心理狀態、
肢體行為，完完全全地破壞他們的身體，再將之重整。她
們變得順從。他用調整破布娃娃姿勢的方式幫她們調整姿
態……我以前不知道他是這樣做事的；我也不覺得這些女
孩有跟這種人合作過。這幾年我和其他攝影師也合作過，
我沒看過有人會這樣做。他愛上所有合作過的女孩，她們
是他的繆思女神。想一下畢卡索，他有八個繆思女神，他
愛上八個模特兒，他就需要這樣，他也折磨她們所有人。

摘錄自《裸》的原聲帶片段（Tony Sacco 導演《STARZ》，2017 年）原創團隊 |
David Bellemere, Jessica Clements, Ebonee Davis, Steve Shaw, Janine Tugonon.

*

This is a character. And then I go home and I'm different: I take it off. I try not to look at myself in the mirror when I'm home. I don't like being in that "pretty model" mode all the time. I like to forget a little bit. I felt like I had to straighten my hair all the time, act a certain way, talk a certain way in order to get a following in the [Instagram] likes. Even with jobs, you know, 'cos you can't even book a job without having at least 10k followers. So now you're forcing people to delete and erase parts of themselves, who they really are. I don't want to do it, but I have to do it. I mean, I know it's really important nowadays, but it's not a real world.

*

He literally puts them in all sorts of positions, forces them to do things, takes them out of their comfort zone. They start feeling what he wants, and they are an extension – their body is an extension - of what he's doing. They give in. It's basically a submission process. Don't for one minute think that he's not thought of this whole process, of manipulation, psychology, physicality, and literally breaking them and fixing them again. And they become putty in his hands. The way he moves somebody like a rag doll⋯ I didn't know he worked that way; I don't think these girls have ever worked with someone like him. In all the years I've worked with other photographers I've never seen anyone do that. He falls in love with each one of these girls, and they are his muses. Look at Picasso: Picasso had eight muses, he had eight models that he fell in love with, and he needed that, and he tortured them all.

Based on excerpts from the soundtrack of Nude (Dir. Tony Sacco, STARZ, 2017). Original contributors include: David Bellemere, Jessica Clements, Ebonee Davis, Steve Shaw, Janine Tugonon.

在美容中心裡 _____

艾倫‧圖靈（Alan Turing，1912-1954）以多項成就被世人稱譽：他為現代電腦打下基礎，也是研究人工智慧的先驅，更在戰爭期間破解德國的戰時密碼。圖靈是一位同性戀者，那時英國還將同性戀視為犯罪，在 1952 年，他被以猥褻之名定罪。1954 年圖靈服用氰化物自殺，他的屍體被發現時，床頭邊還擺著一顆吃了一半的蘋果。「如果美像濟慈（John Keats）所說的一樣是一種真理，那這應該就是真的：在你的 iPhone（蘋果手機）或 Mac（蘋果電腦）後面的那顆蘋果標誌，是在向艾倫‧圖靈致敬。」── Holden Frith 於 2011 年 10 月 7 日發佈於 CNN 網站

*

請進。放鬆，好好享受一下。所有東西都閃閃發光。那光線氛圍純潔而且能洗滌人心。目光被吸引，它渴望著絲綢般的表面，光潔完美。咕嚕聲、嗡嗡聲，都像耳朵裡的蜜糖。時間從地心引力的拳中釋放。它薄如刀鋒、輕如羽毛，而且比以往更為快速、更加強大。* 按下按鈕。點擊。立即連線。

注視者（beholder）一詞在英文中並不常見，除了「美存在於注視者眼中」（beauty lies in the eye of the beholder）這句話以外，很少用在日常對話裡。為什麼美存在於注視者眼中？為什麼不用觀賞者（viewer）、觀眾（spectator）這類更常見的字？可能「注視」（behold）暗示了思考、反思等行為，而不像較為被動的「目擊」（witnessing）或是「旁觀」（onlooking）這些帶有隨意看看、圍觀（spectating）等意味的詞彙。可能注視者會因為她「看見」（sees）的東西而被逮住、駐足，而不像觀賞者和觀眾那樣只是在路過時「看到」（look）或「瞥見」（glance）。

身體凝結成單一切點，變成一個崩裂的量子時空，不再有此時、此地的概念，只有超凡至極的愉悅。光和訊息熔合在欣喜的火焰中。明亮，潔白，沒有中心點，完完全全的融合。一切都帶給你無比順暢、快速且身歷其境的感受。* 希望您會滿意。

「怎麼看見」還有「怎麼看到」大多取決於特定時空下使用的影像製作和流通技術。幾百年來，「behold」代表穿越過誘人的表象而透視其中隱藏的意義、埋藏在看不見的深處裡的意義。傳統上，繪畫就是一種「緩慢」的媒介：它緩慢的製作過程也讓觀者能用緩慢的速度接收它傳遞的訊息，引發觀者審慎思考。但另一方面，電影，就需要觀眾用不同的方式觀看，用班雅明口中「分神」的方式觀看。然而，現在，我們面對的是不同的狀況。

古時候的苦役和折磨都已消失。現在已經沒有衝突、沒有失敗、沒有失望的重量。為您帶來愉悅和便利是我們的唯一任務。在這裡，您可以忘卻一切。一切都會失而復得。全宇宙團聚在一起，以您想要的方式現形。您會沐浴在平靜、祥和、美境，無憂無慮的徜徉在俯拾即是的溫暖之域。現在，就向未來說 hello。*

數位科技改變了影像（和物體）生產、流通、接收的本質。許多我們在裝置上看到的影像都是數位後製而成，影像品質通常都會下降（高度壓縮、低解析度、像素化的 jpeg 圖片檔、AVI 檔案串流，一如史德耶爾（Hito Steyrl）所說的「劣質影像」、「劣質螢幕」等）。這些產品按照指數規律加乘（他們的普遍性反應出格羅伊斯（Boris Groys）口中的「脆弱」和「短暫」），他們的速度快，可以快速讀取、快速吸收。往左滑、往右滑。速度，原來可以帶來如此美好的體驗。*

以現在來說，金錢就是美的抽象語言。只要有錢就能達成你對美的追求，但如果負擔不起就不要去接觸。如果你有興趣，它會自動來找你。不需要多餘的言詞，這種魅力是不需言說的。熟悉的手勢，讓瀏覽變得自然又直覺。創造一款全螢幕的 iPhone，一直是我們的願景。它讓你全心投入、沉醉其中，甚至忘了還有螢幕的存在。它聰明過人，即使你的一個輕點、一

In A Beauty Centre

Alan Turing (1912-1954) is credited with laying the foundations for the modern-day computer, pioneering research into artificial intelligence, and unlocking German wartime codes. Turing was also a homosexual at a time when homosexuality was a criminal offence in Britain, and in 1952 he was convicted of gross indecency. In 1954 Turing committed suicide by cyanide poisoning. When his body was discovered, a half-eaten apple lay beside his bed. "If beauty is indeed truth, as John Keats claimed, then this story ought to be true: the [Apple] logo on the back of your iPhone or Mac is a tribute to Alan Turing". (Holden Frith, CNN website, October 7, 2011)

*

Please enter. Relax. Enjoy. Everything gleams and everything beams. The ambient light is pure and it cleanses. The eye is aroused: it craves silky surfaces. Immaculate. There is purring, humming; honey in the ear. Time released from gravity's fist. It's razor thin, feather light, and even faster and more powerful than before.* Push the button. Click. Instant connection.

"Beholder" is an uncommon word: it is rarely used in everyday English, except in phrases such as, "beauty lies in the eye of the beholder". Why does beauty lie in the eye of the beholder, rather than that of the viewer, or spectator (which are far more frequently used words)? Perhaps "behold" implies a particular kind of thoughtful, reflective engagement, rather than the slightly more passive sense of "witnessing" or "onlooking" that is implied by casual viewing or spectating. Perhaps the beholder is arrested - stopped - by what she "sees", whereas viewers and spectators merely "look" or "glance" as they pass by.

The body condenses to a point, a quantum of collapsed space and time. No more here and now. Instead, a soaring sensation of transcendent bliss. Light and information fuse in the fire of ecstasy. Brilliant. White. No centre. Total integration. Everything feels utterly smooth, fast and immersive. A desktop experience that draws you in and keeps you there.* We hope you will be satisfied.

Ways of seeing – and ways of looking – are determined to a large extent by the technologies of image production and circulation that are in operation at any given time. For many centuries, to "behold" something would be to push beyond the allure of surface appearance in order to penetrate to a hidden meaning, buried within invisible depths. Painting, for example, has been (traditionally) a "slow" medium: the slowness of a painting's production inviting a slowness in its reception, an act of measured contemplation by the viewer. Movies, on the other hand, demand a different mode of attention from their audience – a mode characterised by Walter Benjamin as "distraction". Today, however, we encounter different conditions.

The ancient world of toil and suffering has vanished. Here there is no conflict, no failure, no weight of disappointment. Your pleasure and convenience are our sole mission. Here, you can forget. Everything you have lost will be restored. The universe will be reunited, and it will take the shape of your desires. You will bathe in peace, harmony and beauty, floating without care in their undemanding warmth. Say hello to the future.*

Digital technologies have changed the fundamental characteristics of image (and object) production, circulation and reception. Many of the images we encounter on our devices today are digital reproductions whose quality is often degraded (highly compressed, low resolution, pixellated jpeg files and AVI streams, for example: "poor images", the "wretched of the screen", in the words of Hito Steyrl). They multiply exponentially (their ubiquity rendering them "weak" and "transient" in the words of Boris Groys). They are also fast: Speedy to access; rapid to consume. Swipe left. Swipe right. Fast, it turns out, is incredibly beautiful.

Money is the abstract language of beauty today. Money alone breeds the perfection you seek. But do not approach if you cannot pay. It will come to you if you have the means. No need for superfluous words. The attraction is unspoken. *Familiar gestures make navigation natural and intuitive. Our vision has always been to create a device that is entirely screen. One so immersive the device itself disappears into the experience. And so intelligent it can respond to a tap, your voice, and even a glance.** Payment will be easy, remote, contactless.

聲輕喚、甚至一個眼神，都會得到它的回應。* 支付方式簡易，可使用遠端、感應式支付。

如果從電腦螢幕、電視、或是手機上檢視，這些影像會用這種方式發亮，這種……是不是可以稱為……超自然的方式。他們沒有物質性，也沒有像世界上的其他東西一樣有實體尺寸。漸漸的，我們以這些電子影像為標準來評判「現實」，而不是以現實來評判電子影像。矛盾的是：模擬的事物比真實的事物還要更真實，它以真實的事物為基礎並加以改良，它取代了真實。真實世界充滿萬千色彩，iMac 能將更多顏色呈現在你的螢幕上。Retina 顯示器以更平衡更精確的方式表現逼真色彩。iMac 配備功能強大的新款 Radeon Pro 500 系列繪圖處理器，讓你眼中所見一切，盡是美好景象。Vega 繪圖處理，華麗影像背後猛獸般的力量。*

世界已化成螢幕，可以無邊無際地回應你的各種逃亡欲。發亮的螢幕製造出多重現實，像防護層一樣為你擋下信念的危機或真相帶來的創傷。美麗、難以抗拒、無接縫的表面消滅了深沉的焦慮。沉浸在這樣的螢幕中，你將不再棲屬於某個空間。你將不再是原點，只是世界上的其中一個切點：一個像素。你再也無法安置自己，你會像水中的水，火焰中的火焰。擴增實境。嶄新世界，就在你周圍。從此，改變你工作、學習、遊戲以及與周圍世界聯繫的方式。*

以平行的角度來看，現今多數商品都只能從他們經過精心設計的表像被「理解」：我們不太了解密封在「底層」的微電路。美學偏好取代實用性，推動我們的購買決策。就像波德里亞（Jean Baudrillard）幾十年前說的，在消費文化下我們和商品的關係取代了我們和其他人類的關係。商品設計因此成為我們投射當下美學價值和物慾的來源。商品不再像是物品，而是一種經驗，它有了藝術層次的追求。我們不再接受美對我們的要求或脅迫，因為我們已經愛上這種堆積慾望商品的習慣，並稱之為「生活風格」。經典設計，先進工學，堪稱當代藝術。*

你呼叫美來拯救你，但它不會回應，它只用嘲諷的語調對你的言論發出回音。美怎麼會在意你毫無魅力的虛榮、你的自戀型慵逸？你把美降格到像影子那樣、像非物質的鬼魂、像鏡子裡沒有生氣的影像。你渴望美，但不願意為之奮鬥，而是選擇，把它放進你的購物籃。你想透過擁有它來取得它的力量和榮耀。你錯在於，把美想成一樣東西、一個物件、一種商品。你錯在於把它和風格、時尚、酷炫玩意、美妝品混淆。你被美的概念所矇騙，但你落入售貨員的行銷陷阱裡。你以為你已經獲得美，但你只是為自己爭取到一些時間。

光芒如梭劃過已擦亮的表面，在視野裡帶出一種讓人警覺的擾動，眼裡如有灼熱針扎一般。此刻這個物件似乎對你回以復仇的眼神，好像在說「如果你要追求美，你就必須承受後果。」針頭的光像鐳射光線一樣劃穿過螢幕，留下隱隱燒灼的傷口。準備面見毀壞螢幕後方的崇高災難吧，沉浸式科技、虛擬實境、美好生活風格，這一切都不會再保護你。以恐懼和欣喜接受這樣的命運吧。「如果我們的靈魂足夠堅韌，則能抽離帳幕直視赤裸又駭人的美；讓神消磨我們、吞噬我們、解開我們的骨幹。然後再將我們吐出，讓我們重生吧。」──唐納塔特（Donna Tartt）《秘密歷史》，2013 年

本節引文中有 * 符號的地方，引用自蘋果電腦官網（Apple.com）。

*Viewed on the screen of a computer, television or mobile phone, these images glow in a manner that is, shall we say, preternatural. They lack the materiality and physical dimensions of other things in the world. Increasingly, however, we judge "reality" by the standard of these electronic images, rather than vice versa. Paradox: the simulation appears more real than the real itself. It improves upon the real. It substitutes for the real. The world is full of spectacular colors, and iMac brings more of them to your screen. The Retina display show[s] off real-world color with more balance and precision. iMac features powerful new Radeon Pro 500 series graphics that make a spectacle of everything you see. Vega graphics. The beast behind the beauty.**

The world is now a screen, a borderless zone open to your refugee desires. It is a glowing screen that fabricates multiple realities. It is a protective screen that shields you from the crisis of belief and the trauma of truth. It is a beautiful, irresistible and seamless surface that annihilates the anxiety of depth. Immersed in this screen, you will no longer inhabit space. You will no longer be the origin of co-ordinates, but merely one point among others: a pixel. You will no longer be able to place yourself. You will be like water within water, or fire within fire. Augmented Reality. A new world all around you. Transform the way you work, learn, play, and connect with the world around you.*

*In parallel fashion, many of today's commodities are "readable" only in terms of their carefully styled surfaces: we have little understanding of the micro-circuitry sealed within their hidden "depth". Aesthetic preferences, rather than practical considerations, tend to motivate our purchases. As Jean Baudrillard suggested several decades ago, in a consumer culture our relation with commodities displaces our relationships with other humans. Product design thus becomes our new source of beauty and object of our passing desires. The commodity strives to be less a thing, more an experience. It aspires to the condition of art. No longer accepting that beauty demands and compels, we settle instead for that tasteful accumulation of desirable things known as "lifestyle". Iconic design. Advanced engineering. Talk about modern art.**

You call on beauty to save you, but it does not answer: it merely echoes your words in a mocking tone. What does beauty care for your charmless vanity, your narcissistic indolence? You have reduced beauty to a shadow, an insubstantial ghost, a lifeless image in a mirror. You craved beauty, but were unwilling to fight for it. You chose, instead, to add it to your shopping trolley. You hoped to borrow its power and glory by possessing it. Your mistake was to think of it as a thing, an object, a commodity. Your error was in confusing it with style, with fashion, with gadgets and cosmetics. You were beguiled by the idea of beauty, but you fell for the salesman's pitch. You thought you were capturing beauty when in fact you were only buying time.

A shaft of light glints off the polished surface, producing an alarming disruption in the field of vision, a burning pinprick to the eye. In this moment the object seems to return your gaze with vengeance. "If you pursue beauty", it seems to say, "you must accept the consequences". The needle of glinting light pierces like a laser beam through the screen, leaving behind a smouldering laceration. Prepare to behold the sublime catastrophe that waits behind the ruined screen. Immersive technologies, virtual realities and tasteful lifestyles will no longer protect you. Accept this fate with fear and with joy. "If we are strong enough in our souls we can rip away the veil and look that naked, terrible beauty right in the face; let God consume us, devour us, unstring our bones. Then spit us out reborn."(Donna Tartt, The Secret History, 2013)

[All quotations in this section marked * are taken from Apple.com website.]

在未來

繞著鳳凰山翱翔高飛、猛然下撲、滑翔：輕易達成的速度
和引人畏懼的高度都讓人心跳飆升、胃部翻騰。像鳥一
樣飛翔，從他人天真的目光中看見世界的美。西湖像珍
珠一樣在下方閃耀發光。往下俯衝，穿過林綠，盤旋在
雅緻的寶塔上，擦過荷花之島。往西駛去，穿越杭州上城
區，毫無重量而且沉靜，進入濱海路 100 號神聖的蘋果
殿堂（iTemple）。奇蹟般地經過玻璃表面的建築，毫不
費力地爬上玻璃階梯，優雅地徘徊在懸浮的夾層樓面間。
很難想像在全球新秩序的窗眼（The New Global Order of
Oculus）出現之前那些人們的遙遠生活。要怎麼在沒辦法
完全操控光、噪音、運動、震動、色彩的世界生活？（註2）
輕觸。現在極速穿過安第斯山脈透淨、清新、蔚藍、寬廣
的天空。人的靈魂似乎無法與自然分離。那裡很平靜，有
無拘無束和超凡欣喜的榮光。輕觸。難以形容的完美充斥
在我眼前。看到如此令人震撼的的細節，那是全然…+//
和諧的 ..+.//...//++/.. 純潔的 //+..+/.....••..... 又氣
憤又氣餒，他拿起壞掉的耳機擲過他在綜合大樓中的窄小
牢籠。該政府部門會自動記錄問題，並立即置換有缺漏的
品項。

───── 註 ─────

1. 英文單詞 ecstasy（狂喜）源自希臘語 ekstasis，意思是「站在自己身外」。
2. 「蘋果公司在中國開設了新的、華麗的西湖商店。」Buster Hein.
cultofmac.com. 2015 年 2 月 18 日 .

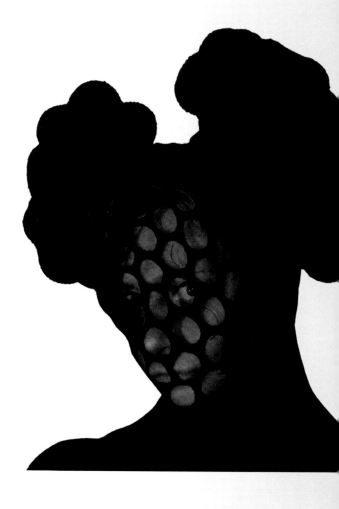

約翰‧卡爾卡特 ─────── John Calcutt，1951-2018

曾主導格拉斯哥藝術學院的美術系碩士班和藝術實踐文學
碩士班，除了教學活動以外，他也是英國多份國家報刊的
藝評家，包含《星期日的蘇格蘭》、《觀察家報》、《衛
報》等。亦曾擔任格拉斯哥當代藝術中心的副策展人、蘇
格蘭藝術協會的展覽評審（1995-1999）、貝克未來獎的評
選人（2006）。為當代藝術撰寫過無數篇文章和展冊專文，
也在許多大學、博物館授課演講。他長期偏愛實驗性敘事
方式書寫當代藝術評論。

In the Future

"A group of researchers from The Alan Turing Institute and Data Science Lab at Warwick Business School have trained a computer to recognise beautiful scenery using "deep learning". (The Alan Turing Institute website, July 19, 2017)

Soaring, swooping, gliding around Fenghuangshan: effortless speed and giddy height make the heart race and the stomach flutter. Flying like a bird, seeing the world's beauty through other innocent eyes. West Lake shimmers like a pearl below. Diving earthwards, towards the green, curling around the elegant pagodas, skimming the islands of lotus. Wheeling west, towards the Shangcheng district of Hangzhou. Weightless and silent, into the sacred iTemple at 100 Ping Hai Lu. Passing magically through the glass facade, effortlessly climbing the glass staircase, hovering gracefully above the floating mezzanine. It's hard to imagine the distant lives of those who lived before the coming of The New Global Order of Oculus. How was it possible to live in a world where light, noise, movement, vibration and colour were not thoroughly processed and controlled? (Note 2) Tap. And now racing through the sky above the Andes, clear and crisp, blue and wide. It is as if one's spirit is inseparable from nature itself. There is peace: the glory of unfettered freedom and transcendent joy. Tap. An image of indescribable perfection fills the field of vision. To see it in such detail is overwhelming, its sheer...+//of harmony..+.//.../++/..and

------ Note ------

1. The English word ecstasy is derived from the Greek ekstasis, meaning 'standing outside oneself'.
2. 'Apple reveals new gorgeous West Lake store in China.'Buster Hein. cultofmac.com. February 18, 2015.

pure//+..+/···... ••• ···. ············ Angry and frustrated, he hurls the broken headset across his small cell in the complex. The Ministry automatically registers the problem and will replace the faulty item immediately.

John Calcutt ——————————— 1951-2018

the former head of the MFA and MLitt Fine Art Practice programmes at Glasgow School of Art. Alongside his teaching activity he was also the art critic for several national newspapers in the UK including Scotland On Sunday, The Observer and The Guardian. He was an Associate Curator at the Centre for Contemporary Art (CCA), Glasgow, a member of the Scottish Arts Council exhibitions panel (1995-1999), and a selector for the Beck's Futures Prize (2006). He wrote numerous articles and catalogue essays on contemporary art and gave lectures in many universities and museums. He had a longstanding interest in experimental approaches to critical writing about contemporary art.

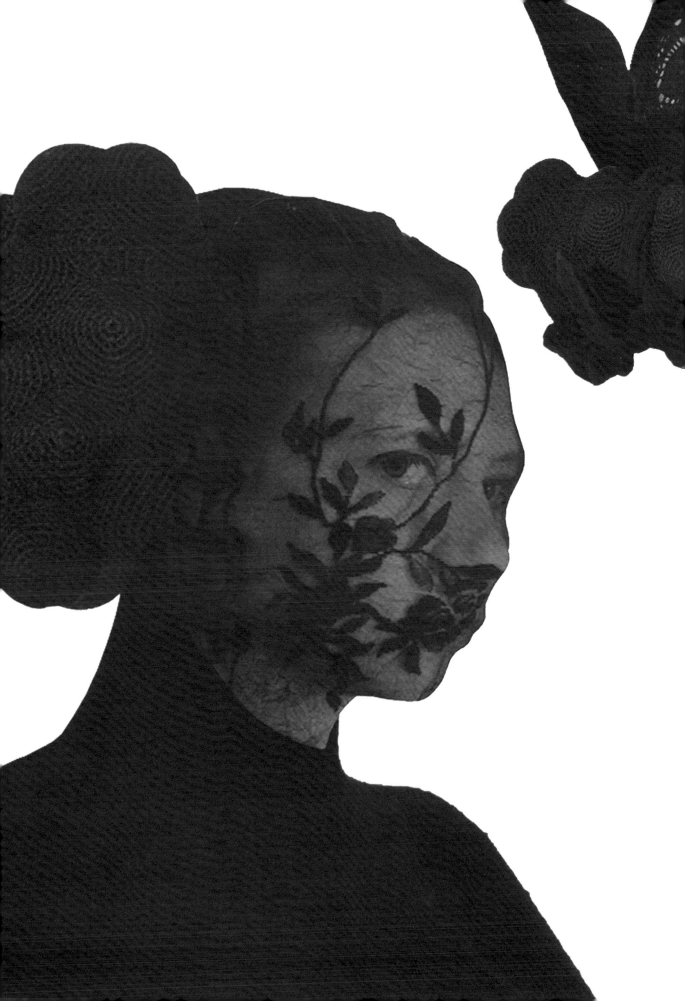

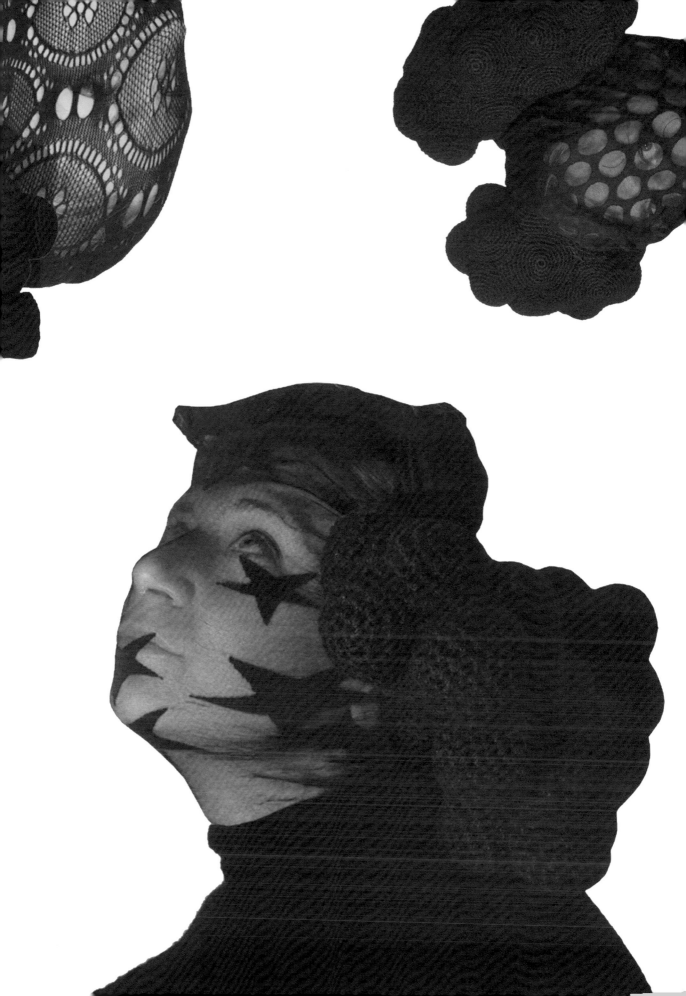

Once Upon A Time

The
Substation
1990-2021

45 Armenian Street
Singapore 179936

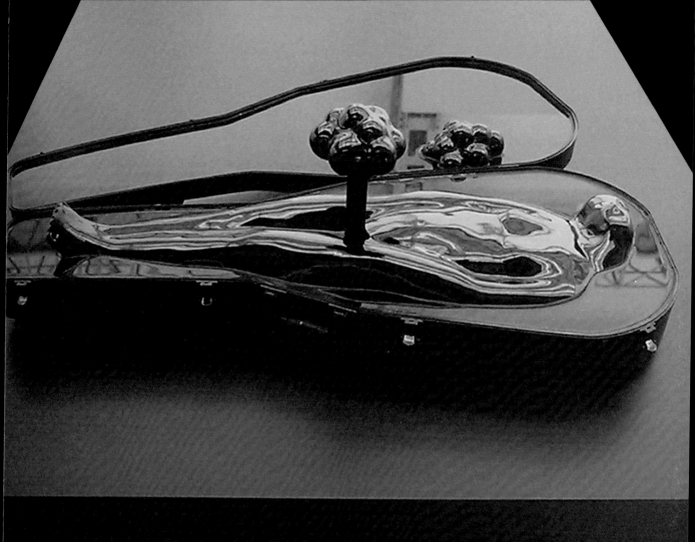

TREE Some
Art

Public Art

China

偶遇　*An Encounter*

Youth Olympic Village

Legacy Sculpture
Nanyang Technological University

如風之翼　*The Wind & Wings*

Bubbelloon

Sculpture House

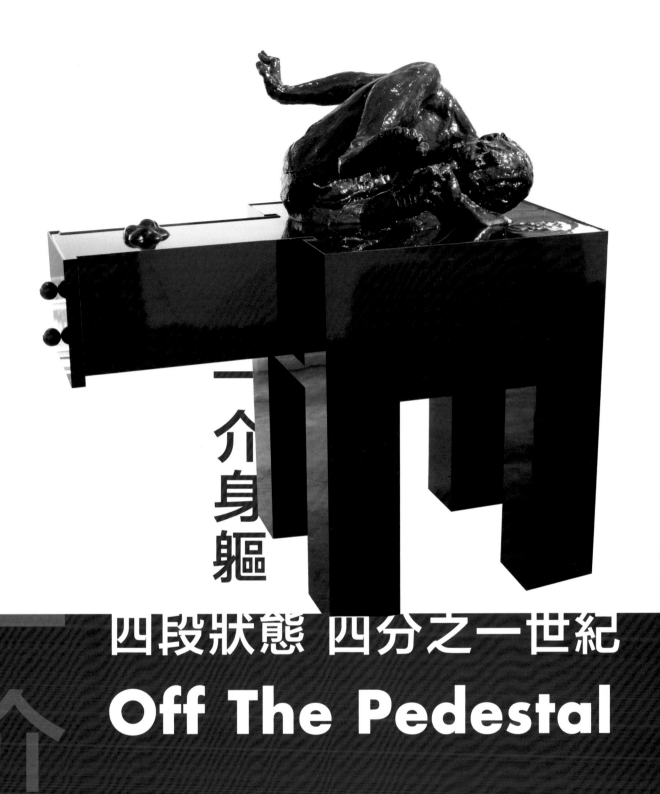

一介身軀

四段狀態　四分之一世紀

Off The Pedestal

One Figure / Four Conditions / Quarter Century

平凡之路

楊子強

通過細膩，專注的揉捏，雕塑家把自己單純的靈魂安置在那自塑的軀殼之中。觀視著鏡面空間內映造著的表我身軀，卻又害怕被眼前這平凡的軀殼表象所蒙蔽，而遇不到所渴望的，一個獨特的靈魂樣態。藉由表象之殼的模擬，揣摹著深層的自我意識，尤其是對於未可知的理想存在，其期待值超越了現實的生活經驗。他知道自己是平凡的，卻又相信自己不是那麼的平凡。

「離開檯座」，是經典的雕塑入門思考。能在平凡之中看到可能的不平凡，本身就應該是一種非凡的洞察力。他也是這般認定的。畢竟，用了四分之一世紀去思考這平凡的雕塑課題需要一些非常的想像，也就別太過苛求世人是否為了他的這個創作動機而投入了多少觀注力。無論如何，不甘於平凡，「不甘心」成為平凡，是一種態度。即使是多麼無力的擺脫著，終究是一種積極的生活表態。

「玻璃水缸裡的游魚呀，我是否也和你一樣，住在看似清澈透明，但不小心就會被慾念撐破的易碎美好呢？」千禧年來臨之際，他想尋回 1993 的青澀勇氣，所以他離開了。

平凡的軀殼啊，在夜的深沉中漂浮吧！你是影子，你是體量，你是空間，你是被抽離的黑色靈魂。你是 2006。

最終，還是擱下了。只剩一灘黑影。黑色的輪廓線，描繪著 2017 的時空。此刻，旅程尚未結束。未來，不可知。

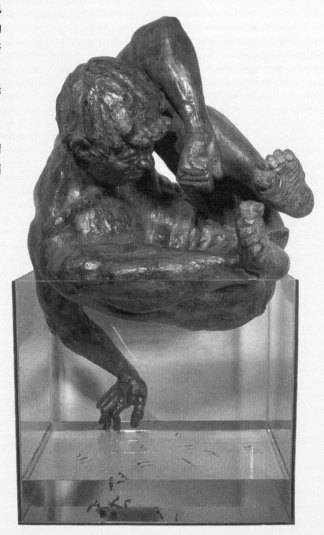

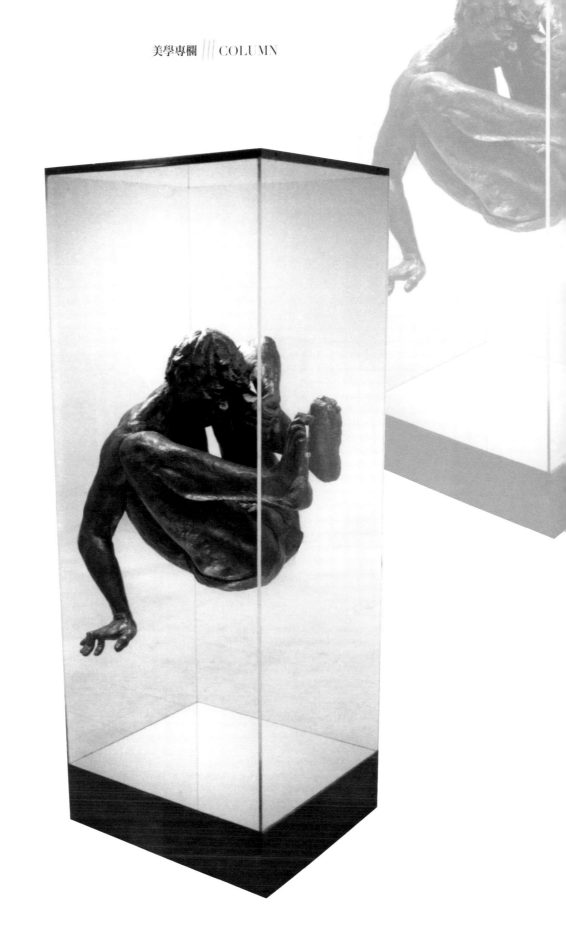

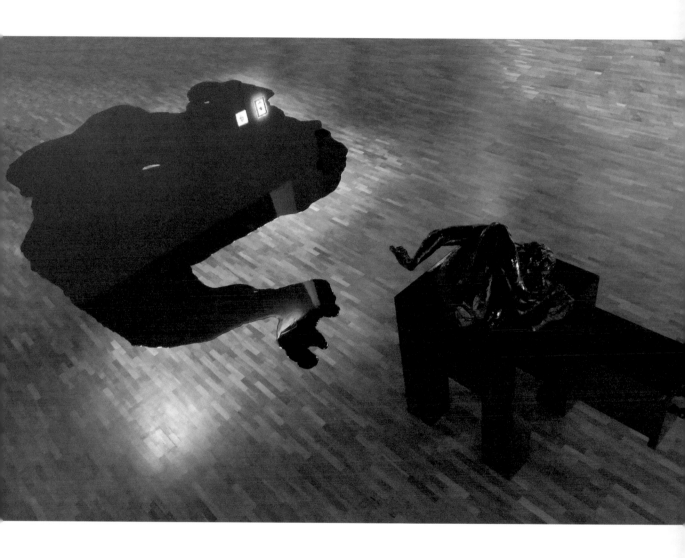

An Ordinary Journey

Yeo Chee Kiong

Through delicate, focused kneading, the sculptor places his own innocent soul within the self-portraits he sculpted. Looking at the reflection of his body in the mirror, he fears he will be blinded by its ordinariness, rendering him unable to measure up to the desired state of the unique soul. Through the simulation of the external shell of his self-image, he looks deep into his self-consciousness, especially considering the unknown ideal existence whose expectations exceed real-life experience. He knows that he is ordinary, but he believes that he is not so ordinary.

"Off the pedestal" is a classic notion in introductory discourses of sculpture-making. To be able to see the possibility of uniqueness in the ordinary is in itself an extraordinary sort of insight. The artist feels the same way about it. After all, spending a quarter of a century thinking about this ordinary topic requires an extraordinary imagination. Therefore, there is no need to be too critical of how much attention the world gives to his creative motivation. Nevertheless, the reluctance to be ordinary is an attitude. No matter how futile the effort to rid oneself of it, it is still a positive statement of life.

"Fish in the glass tank, am I like you, living in the fragile beauty of the seemingly transparent glass that is actually easily broken by desire in a moment of carelessness?' At the turn of the millennium, he wanted to regain his youthful courage of 1993, so he left.

Let this ordinary body drift in the depth of the night! You are shadow, you are volume, you are space, you are the black soul that has been detached. You are 2006.

Finally, letting it go, with only a pool of shadows remaining. The black silhouette depicts the time and space of 2017. At this moment, the journey is not over, and the future is unknown.

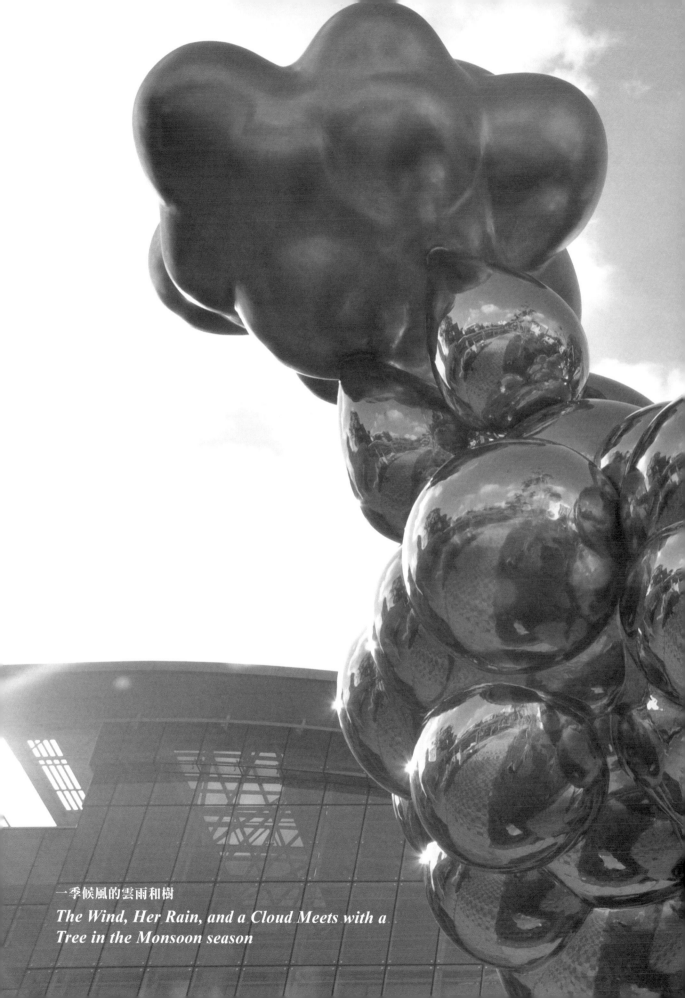

一季候風的雲雨和樹
The Wind, Her Rain, and a Cloud Meets with a Tree in the Monsoon season

Public Art

Singapore

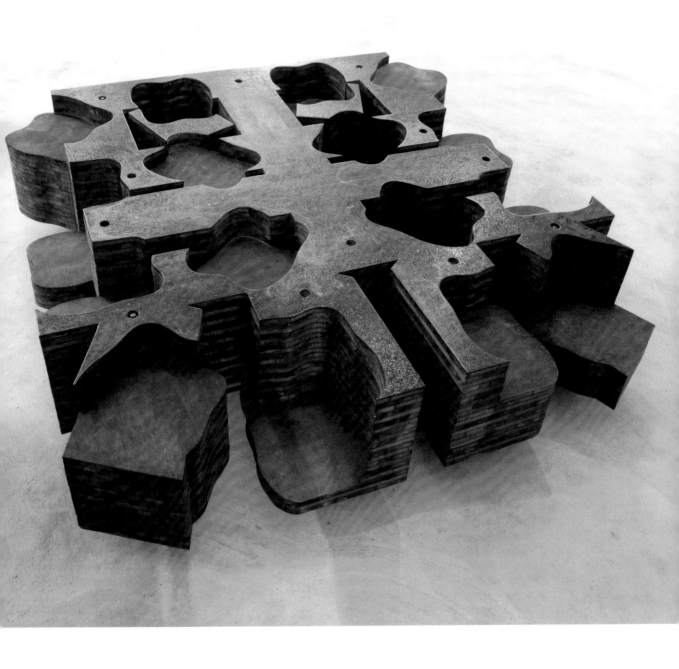

ONE CUBIC

Project 2008

金山上的
美容院

■ 楊子強

東經 121.38 度、北緯 25.13 度的金山,北鄰東海。金山岬向東北方伸入大海,與野柳岬隔國聖灣而遙遙相望。冬天的金山老街,最暖人心脾的,是那烤過的黃金地瓜,還有 85 度 C 咖啡座當季才製作的地瓜咖啡。緊鄰慈護宮的街角十二民宿,其頂層住房可望見一尊尊印刻著歲月痕蹟的老雕像,立在廟宇管委會積極籌蓋新廟所張掛的籌建宣傳布幕上方。在東北風的吹刮下,老雕像們似乎也如底下布幕般在冬雨中凜凜的抖動著,思惦著還能再守在屋簷上多少時日呢?往山上的路並不顛簸,但在勇猛的客車司機操控下,總是會在轉彎處創造一些驚恐的擦身間刻。

金山上的白雲,在冬日里,是如此的貼近,如雲似霧的水氣,悄悄的靠攏。每一顆水分子,都充滿活力的填充著視線內的每一個細微方寸間,泌心的清涼,輕觸著臉上不設防的肌膚,清純如初戀般的宿命偶遇。金山的美,是大自然的美麗能量所匯集的感動。金山的美,因為有了朱銘美術館而不再難以捉摸。館區開放八甲,依山傍水。太極系列作品,氣勢磅礡,矗立在整個園區內。漫步其中,彷彿可以體悟與天地自然合而為一的太極境界。而人間系列,卻又讓人感受人間百態,了悟人世間,塵世間的瞬間和永恆。朱銘美術館,是理想的化身,也是理想的實踐者。

每一個理想生活的尋覓,都是一個美的提問。每一個美麗的提問,都讓我們發掘美的可能存在形式。美麗動人的朱銘美術館,其獨一無二的格局風範,絕對是麗美中心最完美的架構地點,而金山上的美容院也是這美麗新世界最理想的實踐見證空間!《模糊時尚》特邀來自新加坡的蘇茜·林厄姆博士為這些與美有關的心靈提問把把脈。通過金山上的美容院,針對不同人性本質進行深度提問,萃取出每個獨特靈魂中,內在深處的美的感受。讓我們一起進行心靈上的深層鍛煉吧!

未來的美容院是屬於每一個人的!

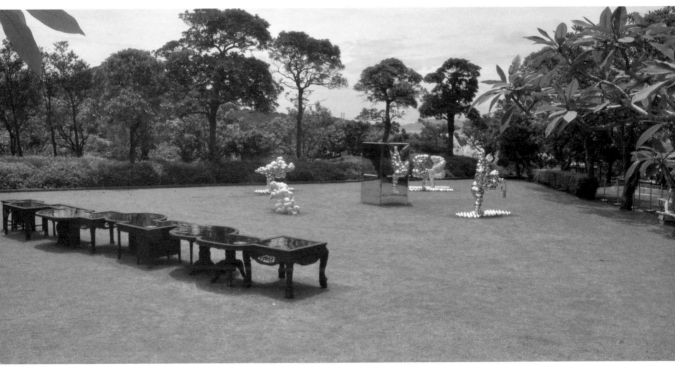

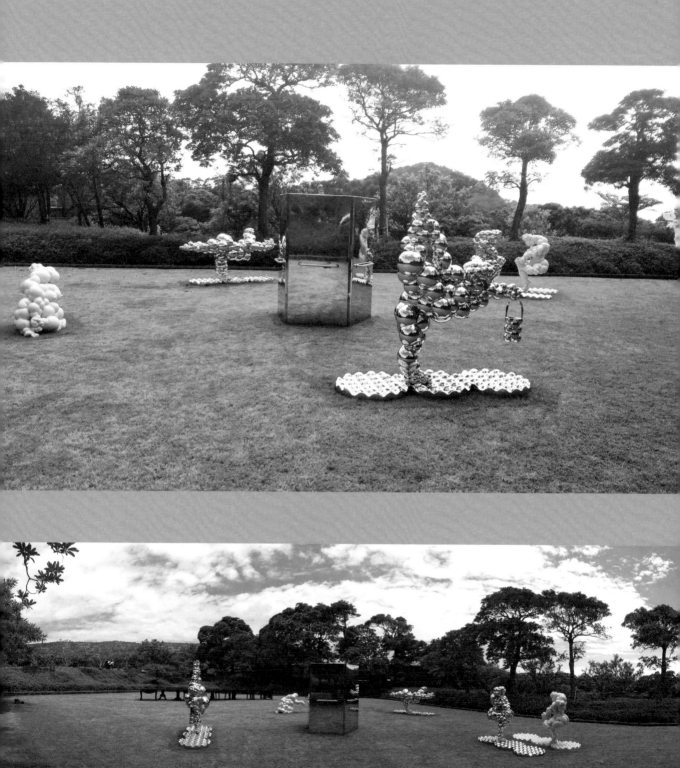

A Beauty Centre on Jinshan Mountain

■ Yeo Chee Kiong

Jinshan Cape, at 121.38 degrees east and 25.13 degrees north, lies adjacent to the East China Sea to the north. Its promontory stretches into the sea to the northeast, facing the Yehliu promontory across Guo-sheng Bay. In winter, the warmest part in the old streets of Jinshan is the roasted golden sweet potato and the seasonal sweet potato coffee made at 85ºC Cafe. The Corner 12 Hostel next to the Cihu Temple, and old engraved statues lined with the traces of time can be seen from the room on the top floor, standing above the publicity banner for the construction of the new temple earnestly prepared by the temple management committee. With the northeast wind, the old statues seem to tremble in the winter rain like the curtain beneath them, making one wonder how many more days they can remain on the eaves. The road leading to the mountain is not bumpy, but under the manipulation of the bold bus driver, there are always some terrifying moments at the turns.

The clouds on Jinshan Mountain in winter are so close that a misty vapour quietly closes in. Every water molecule fills every tiny niche of the sight with vigour, and the refreshingly cool mist kisses the unguarded skin on the face, like an encounter of fated first love. The beauty of Jinshan Mountain is a feeling of gratitude gathered in the beautiful energy of nature. This beauty becomes lucid within the fog, thanks to the Juming Museum. The approximately twenty acres of open air sculpture park and sculpture museum is quite spacious, and is backed by a mountain with a stream running alongside it, facing the North Sea. The *Tai Chi* series of sculptures, with their great momentum, stand out in the park. Walking through it, one may experience the Tai Chi realm of the great harmony between heaven and earth. By contrast, the *Living World* series allows visitors to gain a keen sense of various states of human life, and the fleeting instant and eternity of the mundane world. The Juming Museum is not only the embodiment, but also a practitioner, of this ideal.

Every search for an ideal life is a quest for beauty. Every beautiful quest leads us to discover the possible forms of beauty. The amazingly engaging Juming Museum, with its unique layout and as an exemplary model, is definitely an ideal spot for the construction of *A Beauty Centre*. *A Beauty Centre* on Jinshan Mountain is also the ideal place for the witness and realisation of this beautiful new world. *Vague Vogue* has invited Dr Susie Lingnam from Singapore to offer consultation on questions relating to beauty. At *A Beauty Centre* on Jinshan Mountain, we hope to bring out the aesthetic feeling in the depths of each unique soul by asking in-depth questions about various aspects of human nature. Let's embark together on a mental workout on a deeper level.

The beauty salon of the future belongs to you and me.

反諷的雕塑角色鑄型
「美的提問」的可被提問性

■ 蘇茜・林厄姆博士
■ 英文原稿 / 翻譯 |
 陳燕平、朱銘美術
 館展覽部

I. 理想和理想化

滌除玄覽，能無疵乎？ (註1)

雕塑物件與人體同樣佔據著空間。我們與雕塑物件之間，所引發的彼此相遇的經驗，就如同我們在現實的空間中遇見了另一個人。在一個更大的規格上，當設定為永久的雕塑性地標時，它取代的不僅是空間，更是一個地方之所以形成的重要因素。雕塑被如此放置時，它也宣告其趨向永恆的時間性，就像現今的紀念碑和歷史性紀念地標，持久地固守於它們現在所處的地方，並滯留於我們的文化意識中。

尋求真理的過程，往往是膠著的，除了「美」的理想化身，沒有什麼能更合理地佔據空間與時間的永恆性。具有這些特質的古代遺址和藝術作品，在現今被我們視為世界文化遺產的一部分，持續吸引我們且使我們著迷。老子略為提及的「玄覽」，即在我們心中有一個地方，被彷彿永恆的美與真理的理念所縈繞，這些理念掌控著對於自身、他者、自然與藝術的評價與判斷。儘管在當代藝術世界中，觀點正劇烈地範式轉移，「美」仍如同必要的事物般存留，而我們則持續挑戰著藝術和人體造形中對於「完美」的期待。然而，只有縹緲和模糊的美的「概念」是永恆的，不必然是那些受限於時代觀點所構成的美，因為「什麼是美」的共識一直在轉變。於此同時，這關乎「權力」。當我們置身於美的存在當下，無疑是一個強烈的體驗：這似乎超越了這個醜陋的事實，即不惜一切地追求美，的確是一個相當古怪和幻想破滅的過程。

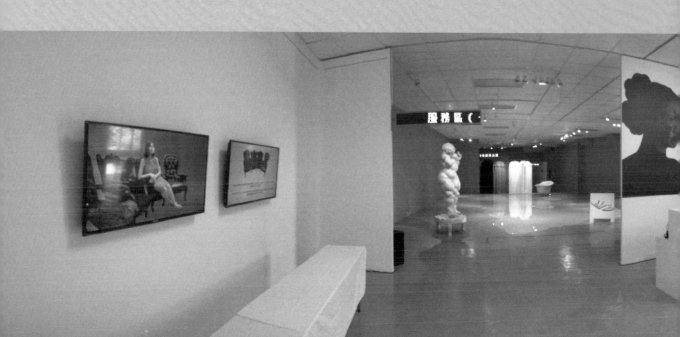

Sculpture Cast as Satire:
Misgivings on the Quest for Beauty

■ Dr Susie Lingham

I. Ideals & Idealizations

Can you polish your mysterious mirror
And leave no blemish? (Note 1)

The sculptural object occupies the same space that a human body does – we encounter it as we encounter one another, within the reality of space as we experience it. On a larger scale, and when intended for permanence, sculptural form becomes a landmark, and displacing more than space, it is a significant factor in placemaking. Emplaced thus, it also stakes a claim on time, tending towards timelessness, as memorials and historical monuments tenaciously hold on to their place in the present, and moor in our cultural consciousness. And nothing seems to rightfully occupy space and timelessness more than embodiments of the ideals of "Beauty", where the quest for "Truth" is often conflated. Ancient sites and works of art marked by these ambitions, are in our present time considered as part of the world's cultural heritage, and continue to fascinate and hold us in thrall. Ensconced in our minds – alluded to by Lao Tzu as the "mysterious mirror" – is a space that is haunted by seemingly timeless ideals of beauty and truth, ideals that regulate the evaluation and judgement of the self, the other, nature and art. Despite radical paradigmatic shifts of perspective in the contemporary artworld, "Beauty" lingers on as an imperative, and we continue to contend with expectations of "perfection" – both in art and the human form. However, only the ethereal and ambiguous concept of beauty is timeless, and not necessarily the era-bound perspectives of what might constitute beauty, as consensus for what is "beautiful" constantly shifts. And then, there's "Power". No doubting that being in the presence of beauty is a powerful experience: it seems to transcend the ugly fact that the pursuit of beauty at all costs can be quite a grotesque and disenchanting process indeed.

Inevitably, art has always been a partner – reluctantly or otherwise – to projections of power, and the beautiful work of art has been used variously as ruse, muse and midwife for political intention and power throughout history, and a proxy for abstract relations of power that have real-life influence on the individual and society at large. Artists are themselves aware of this power of form and image, and sometimes deploy their own agendas accordingly, for better or worse. The evolving roles of craftsman, architect, and artist, from anonymity to the non-anonymous complicity and affiliation with power-projection, have come increasingly to the fore with every passing generation, where the ambitious, and necessarily "beautiful" work of art – architectural and sculptural form in particular – is cast as the emblematic right hand of cultural power and national pride, with the objective of keeping the eye, and so heart and mind, in awe.

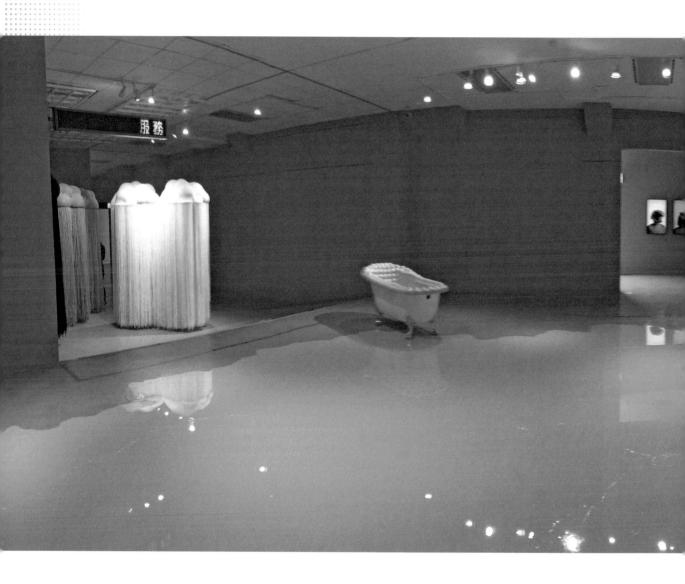

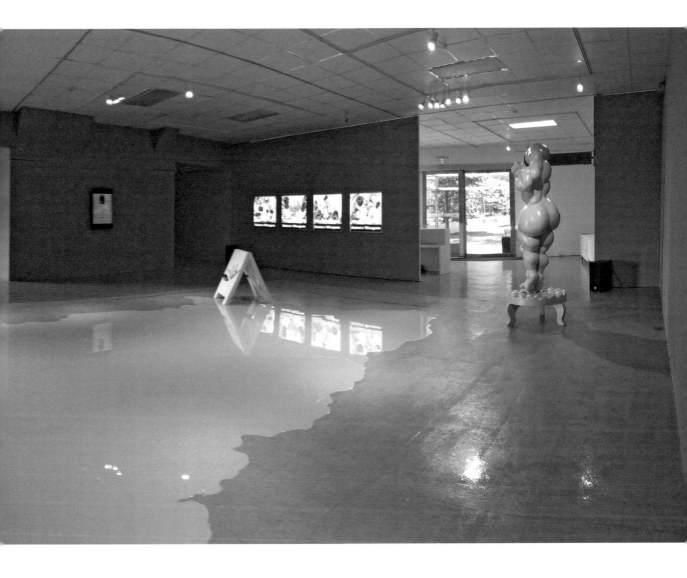

不論情願與否，藝術總是不可避免地作為權力投射的同夥，而美麗的藝術品在歷史中除了被多重地當成是謀略、繆思和助產者，來達到政治意圖與權力，也成為抽象權力關係的代理，而對於現實個人與社會產生真實的影響。藝術家們對於造形和影像的力量是有自覺的，有時更依據自身的動機進行佈署，無論其結果更好或更壞。工匠、建築師和藝術家在角色上的演變，隨著權力的投射，從匿名到不匿名的共謀和聯繫，逐漸在每個經過的世代中嶄露端倪。其中，具有野心和必然「美麗的」藝術作品，特別是建築和雕塑的形式，都被當作是文化權力與國家榮耀的有力象徵性投射手段，並以能夠造成心存敬畏的關注為目標。

以批判性的觀點而論，作為目的的美，似乎超越甚至確實地證明了其手段：無可避免的事實是，使崇高的美能夠得到一定規模表達的，其實是金錢與權力，而如果當權力企圖控制「美」本質上曖昧的影響力時，那麼美的表達和美的經驗就都會轉而面向那未受調解的權力「醜陋」面。在一個夠大的範圍內，那些所謂醜陋的，也已沐浴在無區別的權力光輝中。反過來說，權力的象徵是首先會被增長的反對勢力所損毀和破壞的，或當一個時代宣稱它本身超越另一個時代的「過時」價值、理念、信仰和品味時。而在其中呈現的是美令人懊惱的脆弱性，有時也受限於獨斷的價值體系和「美德」概念。

雕塑自身存在的意義，並未遭受和繪畫相同的存在危機，也不須遭受二維再現、寫實與寫實主義的藝術史爭議。特別是以三維雕塑的人體上，仍能毫不費力地引發想像力。然而，一個獨特的當代實例，是當雕塑被實地賦予平台，來展現諷刺的自我批判時，即位於倫敦活躍中心特拉法加廣場的「第四基座計畫」（Fourth Plinth Project）。納爾遜（Nelson）的塑像在此也一直如英雄般地屹立於其台柱上，俯瞰著這座偉大城市，面對著國家畫廊，處於許多標立著英國數世紀歷史的紀念館和紀念碑之間。這個特別空出來的第四基座，實際上建於 1841 年，本來是要放置威廉四世的雕像。卻因為缺乏資金，在一百五十年後意外地成就了一連串的當代公共委託案。每個創作委託案都因為以反思當下社會文化的方式，而在藝術史上留名。最初連續三個委託案，都是由皇家協會為了鼓勵和推動藝術、製造業和商業而進行的。其中一個委託案是馬克·渥林格（Mark Wallinger）於 1999 年所作的《試觀此人》（Ecce Homo）。沃林格這件特別缺乏戲劇性的耶穌形像，站姿非常人性化，赤腳，戴著荊冕，雙手放在背後，顯然是站在不公平審判他的法官前（在作品中未被看見，所以可能是我們），隨後就要被判決釘死於十字架上了。這確實與將英雄放置在台座上的概念，形成明顯刻意的對比，成為一個相當有力的雕塑式論證。（註 2）

在 2005 年，第四基座的委託案開始變得獨特，首先安置其上的是馬克·奎安（Marc Quinn）重達 13 噸的具像性雕塑，有著直截了當的敍述性名稱《懷孕的艾麗森·拉帕》（Alison Lapper Pregnant）。這件作品是當代藝術的範例，關鍵性地迫使我們遠超越藝術中對於美的既定概念，並且同時認知到自然中的無規律性和人體形態中的「醜陋性」。拉帕是個實際活著的人，雕塑真實地刻劃著一位裸體並患有海豹肢症的孕婦：她天生沒有雙臂，並且雙腿較短。（註 3）有人會說這明顯就是不加掩飾的「殘障」。強納森·瓊斯（Jonathan Jones）在 2005 年卻宣稱：「奎安的雕塑非常美麗。它使人想起了那些讓我們最偉大的博物館增色不少的古典雕塑，那些來自其他時代，無論是因為意外或透過設計，而失去雙臂和雙腿的雕塑。」（註 4）事實上，雕塑家奎安引領我們與自然、人性、藝術和真理面對面。

我們正好在新加坡雕塑家楊子強的個展「麗美中心」中，見證這些議題的修正和翻轉。這個展覽展出於臺灣的朱銘美術館，是由臺灣雕塑家朱銘所創立的一座雕塑家美術館，以其經典的《太極系列》姿態中，抽象而具稜角的堅實形體聞名。正如這個展覽的名稱所暗示的，「麗美中心」被

Critically, the end – beauty – seems to transcend, if not exactly justify, the means: the inescapable fact that it is money and power that enable the sublime expression of beauty on particular scales, and if power attempts to control Beauty's inherently ambiguous influence, than both expression and experience can veer into an encounter with the "ugly" face of unmediated power. On a sufficiently monumental scale, the ugly has also had its time basking in the indiscriminate glow of power. Conversely, emblems to power are the first to be defaced and destroyed by rising opposing forces, or when one era asserts itself over another epoch's "outdated" values, ideals and beliefs. And tastes. And therein lies beauty's vexing vulnerability – it is also bound to sometimes arbitrary value-systems and notions of "virtue".

Sculpture's sense of its own presence has not had to undergo the same existential crisis of painting and the art historical issues of two-dimensional representation, the real, and realism. In particular, the human body, sculpted in three dimensions, still effortlessly engages the imagination. And yet, a unique contemporary instance of when sculpture is literally given the platform to perform satirical self-critique is the "Fourth Plinth Project" in Trafalgar Square, in the beating heart of London, where a sculpted Nelson has long towered heroically on his column here over this great city, in front of the National Gallery, amidst many memorials and monuments that mark centuries of the United Kingdom's history. This particular empty fourth plinth was actually built in 1841, and was apparently intended to uphold a statue of William IV. A lack of funds has, fortuitously, after over 150 years, enabled a series of contemporary public commissions, each of which has made their mark on art history by creating their own socio-cultural reflections of the times, beginning initially as three successive commissions by the Royal Society for the Encouragement of Arts, Manufactures and Commerce. One such commission was Mark Wallinger's 1999 Ecce Homo. Wallinger's singularly undramatic figure of Christ stands very human, barefoot, with crown of thorns and hands behind his back, apparently standing before his unjust judges (unseen, so it could be us), just before the sentence to crucifixion. A stark and deliberate contrast indeed to the whole concept of putting heroes on pedestals – a powerful sculptural commentary indeed. (Note 2)

In 2005, the Fourth Plinth commissions began proper, and first positioned thereon was Marc Quinn's 13-tonne figurative sculpture with its no-nonsense descriptive title Alison Lapper Pregnant. This work is exemplary of contemporary art, critically pushing us far beyond the conditioned notions of beauty in art and perceived irregularities in nature and "ugliness" in the human form at the same time. Lapper is a real living person, depicted as she was then –a naked pregnant woman who suffers from phocomelia: she was born without arms and shortened legs. "Disability" writ large and unabashed, some might say. Jonathan Jones writing in 2005 declares: "Quinn's sculpture is very beautiful [...] It brings to mind the classical statues that grace our greatest museums, other sculptures from other times which also have, whether by accident or design, missing arms and legs." In fact, the sculptor Quinn brings us face to face with nature, human nature, art, and truth.

We find revisions and inversions of these very issues in the Singapore-based sculptor Yeo Chee Kiong's solo exhibition A Beauty Centre, sited in Juming Museum, Taiwan, which is, significantly, a sculptor's museum founded by the Taiwanese sculptor Ju Ming, known for his abstract-angular solid figures in classical "Taichi" poses. As its name suggests, A Beauty Centre is curated as a tongue-in-cheek pseudo-spa experience, where the viewer participates in "self-improving" activities, being given space and time to reflect on their own ideals, as well as contemporary "self-enhancement" obsessions, from fitness and body "sculpting", and the breathless race to achieve "mindfulness", to flaunting a sense of a self-loved self. The exhibition is navigated via "spa-zones" with names like "We detoxify Inner Self"; "Future Weapon"; "The Healing Room"; "We Stop Time"; "I am Goddess"; "Vague Vogue"; "A Beauty Dining Club"; "The Cosmos Energy Picnic Program", and "Look Good Naked". Quite a "work-out" in one exhibition!

策劃為一種不可當真的偽 SPA 體驗。觀者在其中參與了一些「自我提昇」的活動，被賦予空間和時間去反思他們自己對於完美的想法，以及當代對於「自我優質化」的著迷，從健身、「塑」身和屏息的競賽以達到「心念專注」（mindfulness），到一種對自戀自我的炫耀。展覽以不同「服務區」來做引導，取名為《內在深層去毒》、《未來武器》、《大自然的神奇修復力量》、《我們改造時間的進行方式》、《我是女神》、《模糊時尚》、《美人俱樂部》、《金山上的小宇宙》和《美好的裸體》。實在是一個需要相當大「鍛鍊性」的展覽！

楊子強「麗美中心」的主要作品，是他那些誇張的球狀女性形體，以一種膨脹，同時又滑稽、怪誕和可愛的手法，描繪性徵。當奎安的《懷孕的艾麗森‧拉帕》看起來不像「自然的」，並且超越女性美的偏見，而成為一個藝術反映生活的實例時，楊子強的《美好的裸體》系列（圖一），則可被視為以藝術映鑒之手段映鑒藝術其自身，並依然深受自然力量的啟發。也與此相關聯的是超現實主義者漢斯‧貝爾默（Hans Bellmer）於 1930 年代的等身尺寸女玩偶組合，雖然刻意呈現不完整的類人形態，卻有著異常明確的性徵。在楊子強如積雲狀般飽和與腫脹的粉紅和銀色女性形體中，也明顯存在一種強烈的性徵，彷彿滲進它們膨脹的圓體中。是一種過度，而非優雅，賦予了楊子強的雕塑形體以女性美：它們橫跨繼承了巴洛克和洛可可美學，而我們可以接受這兩種美學方法，對於當代的實踐者而言，不論在什麼社會文化脈絡下，都是可以備受啟發而加以利用的。巴洛克？因為如雲狀般的女性形體，體現了同名於這段藝術史時期的華麗「畸形珍珠」。而洛可可？因為它們讓華麗裝飾的沉重變得輕盈，帶來了一種嬉戲般柔和且蓬鬆輕薄的心境。

然而，「麗美中心」也有較為沉重的一些層面：蜿蜒且如人形般皺縮的編織「表皮」，通稱為《模糊時尚》，如蝙蝠般懸掛在牆上，恰似那些肉感豐腴人體的奇異「影子」；一件相連四張華麗椅子的暗鬱組合物，其中每張椅子都指涉了一個不同的時代，例如法國路易十四王朝和英國喬治王朝時代風格的椅子，裝有毛皮、錦緞、絲絨和皮革的軟墊，全都是黑色的，像擬洛可可風格，是提供《美人俱樂部》體驗的場所，觀者在此可以觀看《我爬行在一條名叫「夜」的黑蛇身體裡》的影片，表演的是一個人在編織的管狀形體中移動（圖二）。此外，在另一個展間，《我是女神》（圖三）的採訪影片中，拍攝在地參與者和學生，討論他們與美相關的恐懼、慾望和肯定。接下來是牆上的一排燈箱：一組九位沒有顯示面孔的「影子女士」（圖四），戴著滑稽的黑色氣泡狀陶瓷「假髮」，正對著放在櫃子上的陶瓷假髮實物。另一個系列則稱為《未來武器》（圖五），呈現受漫畫啟發，有著 Bimbombs 的圖像，應該是在翻玩「胸大無腦的女人」（bimbo）和「十分性感的女人」（sex-bomb）這兩個詞彙。

這都是一種混搭的組合，並且可能會相當令人困惑。尤其在創作來自魯本斯畫風裡女性的誇張女性形體，和不定形編織的影子服飾，有待女性去「填入」，在裡面演出，楊子強對於當代社會中沉迷自戀的指摘，可被解讀為轉向窺淫狂者或對女性有強烈偏見者。或許如此，這個展覽似乎仍然反映出一種放縱的、略微煩躁和困惑的，卻又自我指涉和願被誤導的「男性」觀點。

當我們一覽楊子強十多年來的創作軌跡後，開始看到這個展覽中引人深思的幾個非常不同的層面。重要的是，這些作品也受到自然形式和力量的啟發，尤其是雲和水。這裡似乎可以重新提到中國哲學家老子和其經典著作《道德經》。這本專著基本上是在討論如何有智慧地去處理力量，和通過悖論的力量來了解自身。神秘而難以定義的「道」，圍繞著矛盾。而對於其難以掌握的力量，其中一種詩意的隱喻，是將水這個元素及其特質，與我們所理解的「女性」相連結：「水」的不明確性、造形的變動、不具固定的形式與「柔和」，是大自然中所知最強大的力量。

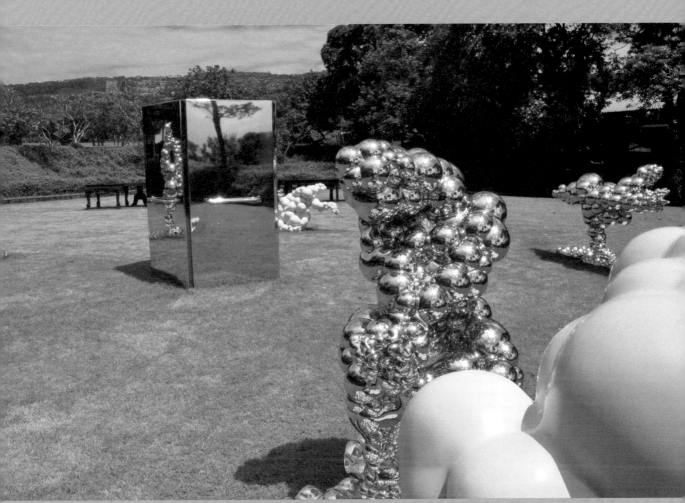

圖一 Fig 1

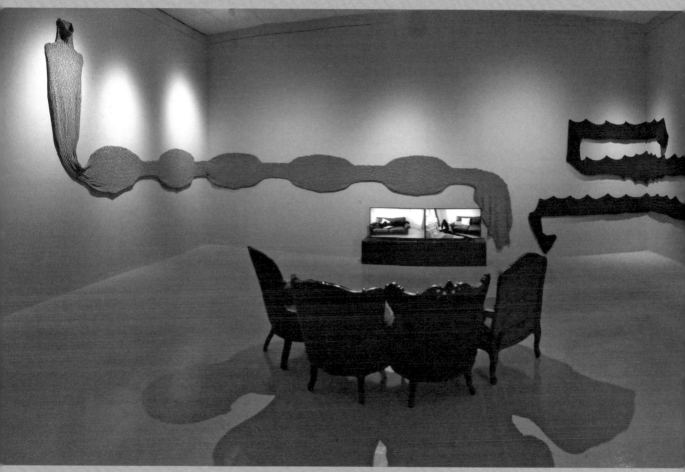

圖二 Fig 2

Central to Yeo's *A Beauty Centre* are his exaggeratedly female globular forms, bloated on a caricatured sexuality that verges on the comic, grotesque and cute at the same time. While Quinn's *Alison Lapper Pregnant* is an instance of Art mirroring life when it does not seem "natural", and transcending preconceptions of womanly beauty, Yeo's *"Ideal Lady"* series (Fig1) can be seen as Art mirroring its own mirrored artifice, yet remaining deeply inspired by natural forces. Also of relevance here is Surrealist Hans Bellmer's life-sized female doll assemblages of the 1930s, which though purposefully incomplete as human-like forms, are uncannily excessive and explicitly sexual. There is definitely a sense of excess sexuality in Yeo's cumulus-cloudlike gorged and turgid female pink and silver forms, as they appear to luxuriate in their swelling roundedness. Excess as opposed to elegance animates Yeo's sculptural forms of feminine beauty: they straddle inherited baroque and rococo aesthetics, and we can accept that both approaches are inspirationally available to contemporary practitioners regardless of socio-cultural contexts. Baroque? Because the cloud-like female forms are embodiments of the ornately "misshapen pearl" that is eponymous of this art historical period. And Rococo? Because they make light the heaviness of the floridly ornate, ushering in a mood of playful, pastel and fluffy frivolity.

However, there are also more sombre dimensions to *A Beauty Centre*: serpentine and humanoid shrivelled knitted "skins" collectively called *"Vague Vogue"* hang bat-like on the walls, like strange "shadows" of these fleshy exuberant figures; a dark brooding huddle of four ornate conjoined chairs, each referencing a different era, e.g. Louis XIV and Georgian styled pieces, upholstered in fur, damask, velvet and leather – all in black, like rococo redacted – is the site for a "beauty dining club" experience where participants can watch videos of *"I'm Crawling Inside the Body of a Black Serpent named Night"* which show performances of a person moving inside the knitted tubular form (Fig2). There's more: in another room, *"I am Goddess"* (Fig3) interviews are screened, featuring local participants and students as they discuss their beauty-related fears, desires and affirmations. And then there are lightboxes on the walls: one set of nine showing faceless "shadow ladies" (Fig4) wearing comical black bulbous ceramic "wigs", opposite the real ceramic wigs on shelves, and another set called "Future Weapon" (Fig5) showing manga-inspired figures with "Bimbombs" – presumably playing on the terms "bimbo" and "sex-bomb".

This is all a motley mix, and can be quite baffling. Particularly, in creating exaggerated feminine forms that out-Rubens Rubenesque women, and shapeless knitted shadow-garments that await women to "fill-out" and perform within, Yeo's critique of contemporary society's narcissistic obsessions could be read as veering on the voyeuristic, or misogynistic. Perhaps so. Still, the exhibition seems more inflected by an indulgent, slightly exasperated and perplexed, yet self-implicating and willing-to-be-beguiled "male" perspective.

We begin to see how these very different aspects of the exhibition jigsaw when we get a glimpse into the trajectories of Yeo's practice over a decade. Importantly, the works are also inspired by natural forms and forces, in particular clouds and water. There seems to be a harking back to the Chinese sage Lao Tzu and the classic *Tao Te Ching*, which is fundamentally a treatise on the wise handling of power, and the power of paradox in understanding the self. The mysterious indefinable "Tao" – the "Way" – *pivots on paradox*. And one of the poetic allusions to its ungraspable power is the associating of the element of water and its characteristics to that which is understood as the "female": water's indistinct, shape-shifting formless-form and "softness" is the strongest force known in Nature.

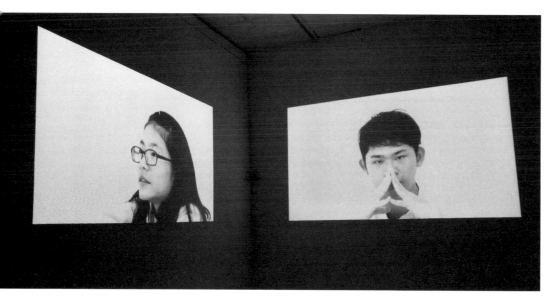

圖三 Fig 3

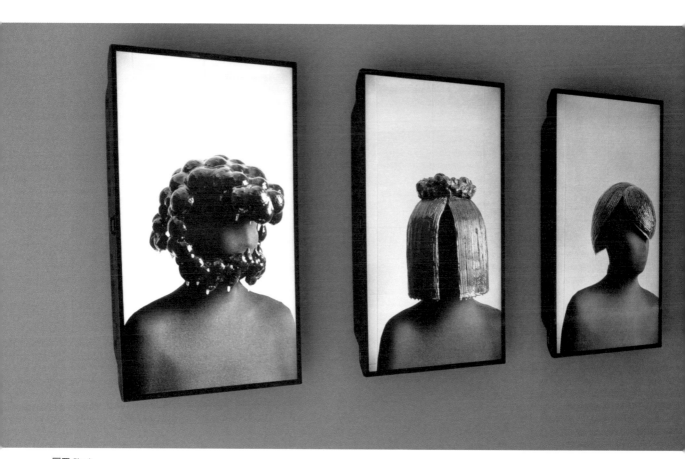

圖四 Fig 4

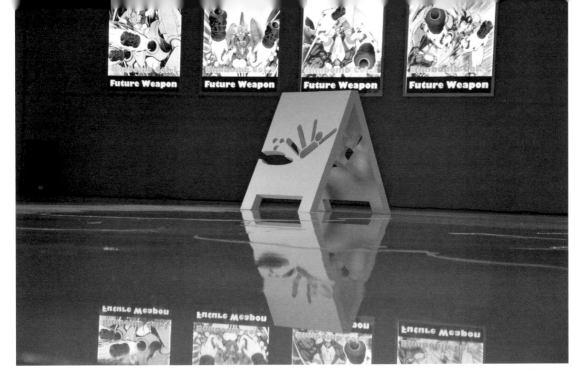

圖五 Fig 5

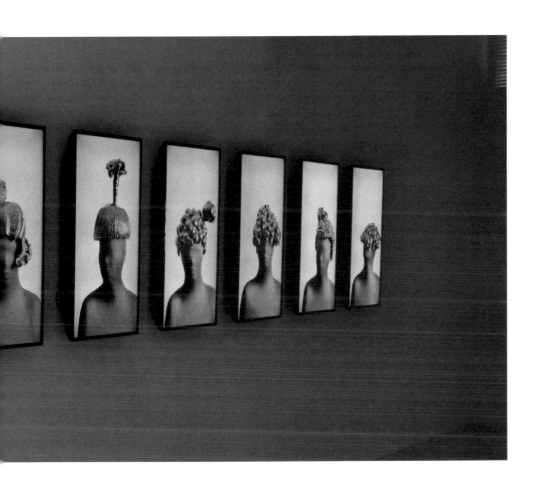

II. 形式、力量和流動

> 像水般透過裂縫而前進⋯⋯放空你的心靈,不拘泥形式。不具外形,像水一樣。如果你把水
> 倒入杯子中,它就成為杯子的形狀。你把水倒入瓶子中,它就成為瓶子的形狀。你把水倒入
> 茶壺中,它就成為茶壺的形狀。現在,水能夠流動,亦能夠衝撞。成為水吧,我的朋友。(註5)

當楊子強被問到,什麼是他最喜歡的雕塑作品時,他毫不猶豫地回答說,他癡迷於《三個幽靈》
(The Three Shades),即羅丹《地獄門》中重複的暗色人形,雖然他修飾說這是他處在雕塑家的「具
象時期」時所喜歡的作品。有趣的是楊子強把它們稱作「三個影子」。並且他強調,他對於羅丹
當下最具代表性的 1902 年作品《沉思者》不怎麼感興趣。

從 2002 年至 2004 年,楊子強離開熱帶的新加坡,至蘇格蘭深造。他說他會被格拉斯哥藝術學
校錄取,顯然是因為校方對其具象作品印象深刻。但完全不同的天氣和季節狀態,引發了他的頓
悟,使其從具象,轉而嘗試以較不具體,而更多元素的現象來成形,例如水作為波浪、波形、氣
泡,還有他稱作的「氣泡形體的虛面」。他轉向一種更為「觀念性」的雕塑,為自己設下相當嚴
格的參照準則列表:

1. 我將不進行泥塑。
2. 我將不進行鑄型。
3. 我將不創作人體作品。
4. 我將只提問,基於一個問題,提出一個可能的答案,這個答案將必然是似是而非的,使(不可
 能的)問題/現象物質化,例如:
（a）什麼是沒有形體?
（b）如何再現夜晚?
（c）如何賦予波浪形體?

當楊子強在歐洲時,他有機會去感受最重要的藝術作品。在倫敦,他非常著迷於比爾・維歐拉
(Bill Viola)以水與火為靈感的重要錄像作品,也對傑夫・昆斯(Jeff Koons)高度拋光的媚俗氣
球雕塑作品,被置放在古典空間作為對比,特別印象深刻。這件「高度完成的作品」啟發了一種
對於「質」的感受,重新賦予物質性本身一種謎樣的意義,並使楊子強從必須做出「意義」或賦
予他的作品有意義的標題中,解放出來。現在最重要且持續從其雕塑過程中透露出來的,就是這
種「質」的感受,即這種精心架構的物體質感,以及材質中固有的和可轉化的美,是傳統上屬於
雕塑家領域的物質性:石頭、陶土、木材和青銅。而他想要以水這種固有的不具形體性來創作。
雲、影子和雨滲入他思考和創作的縫隙中。

儘管如此,作為一位雕塑家,人體的形式仍必然潛伏於其心靈的角落中。就像我們從沃林格和奎
安所做的第四基座作品中提到的,雕塑的人體形式仍然具有感動我們的力量。當楊子強在歐洲的
那些年,他去過佛羅倫斯,並回想起一個重要的傍晚。他簡短地說道:「我看過《大衛像》。」
顯然感動溢於言表。在米蘭時,他排了很長的隊,就為了看達文西的《最後的晚餐》,遊客在此
只被允許站在這件具代表性的作品前一分鐘的時間。他留戀地說道:「我不想離開。」

II. Form, Force & Flow

Be like water making its way through cracks. […] Empty your mind, be formless. Shapeless, like water. If you put water into a cup, it becomes the cup. You put water into a bottle and it becomes the bottle. You put it in a teapot, it becomes the teapot. Now water can flow or it can crash. Be water, my friend. (Note 5)

Yeo, when asked what his favourite works of sculpture were, answers unhesitatingly, albeit qualifying that this was when he was in his "figurative period" as a sculptor. He says he was obsessed and intrigued by The Three Shades – the dark repeated figures in Rodin's *Gates of Hell*. Interestingly Yeo calls them the "three shadows". And, Yeo emphasises, he was *not* much into Rodin's now-iconic 1902 work *The Thinker*.

From 2002 to 2004 Yeo left tropical Singapore for Scotland, for further studies. Yeo says he was accepted into the Glasgow School of Art, apparently because they were impressed with his figurative work. But, the completely different weather and seasonal conditions sparked an epiphany which made him move from the figurative into attempting to materialize less tangible, more elemental phenomena e.g., water as waves, waveforms, bubbles as well as what he calls the "negative of the bubble form". He shifted into a more "conceptual" approach to sculpture, setting a list of quite stringent criteria for himself:

1. I will not do clay modelling.
2. I will not do casting.
3. I will not do figurative work.
4. I will only ask Questions – based on a single question, come up with a possible solution, which will necessarily be paradoxically, to materialize the [impossible] question/phenomenon, e.g.:
 a) what is the formless?
 b) how to represent Night?
 c) how to give form to a wave?

While in Europe, Yeo had the opportunity to experience artwork of the highest order: he was very taken by Bill Viola's monumental water-and-fire inspired video works in London, and in particular was impressed by Jeff Koons's kitsch, highly polished balloon sculptures working in contrast to the classical spaces within which they were installed. This "high-finish" inspired a sense of "quality" that re-imbued materiality with its own enigmatic significance and freed Yeo from the need to make "meaning" or to attach meaningful titles to his works. What came to the fore then, and continues to inform his sculptural processes now, was this sense of qualia, the quality of the wrought object, and the inherent and transformable beauty of material – materiality that has traditionally belonged to the realm of the sculptor: stone, clay, wood, bronze. And, he wanted to work *around* and *with* the inherent formlessness of water. Clouds, shadows and rain seeped into the cracks of his thinking, and making.

Nonetheless, as a sculptor, the human form must still have lurked in the corners of his mind. As we note from the Fourth Plinth works by Wallinger and Quinn, the sculpted human form still has the power to move us. While Yeo was in Europe all those years ago, he went to Florence, and recalls a momentous evening. "I saw *David*", he says simply, evidently moved beyond words. In Milan, he joined the endless serpentine queue to see Leonardo's *Last Supper*, where visitors were only allowed one minute to stand in front of the iconic work. "I didn't want to go away", Yeo says wistfully.

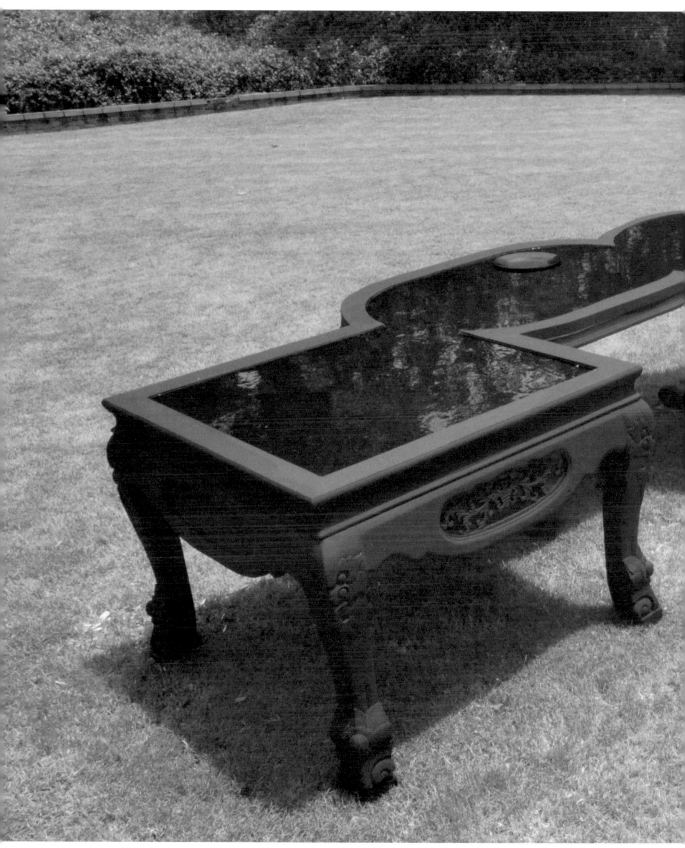

圖六 Fig 6

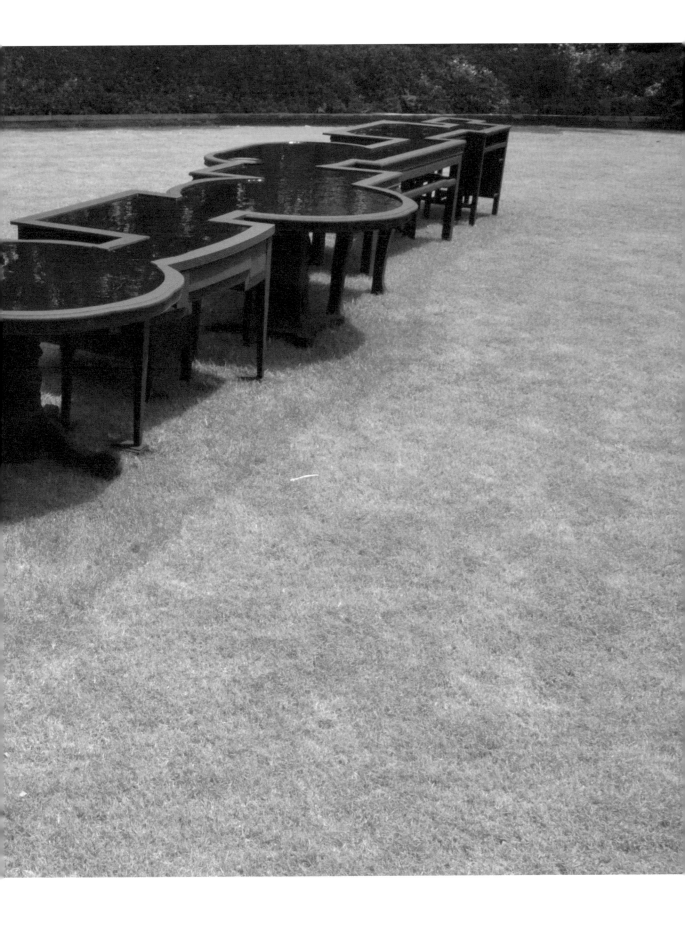

在這些事例中，雕塑家似乎對於「規模」的崇高大膽和這些傑作中難以定義的「質」，感到無法抗拒，必然仍舊縈繞在他心中，因為他明顯在回應昆斯閃亮的「氣球狀」作品（氣泡狀的《完美女人》系列）和達文西的《最後的晚餐》（由十二張桌子連成一張長桌的《野宴》）（圖六），如同老調新彈般回流到了這個展覽。而牆上掛著其中一件楊子強《模糊時尚》（圖七）的編織服裝剪影，尤其和羅丹的《三個幽靈》具有奇特的相似性。

《模糊時尚》包含一系列稱作《有人接過了我的影子》的作品。這些作品被設定為藝術家自己的「影子」。他將這些影子「借」給其他人進住。他們進住在裡面，可以擁有完全的「自主權」任意移動。依照計畫，這給予藝術家自身影子被分割開來的奇特感受。這件像是《三個幽靈》的作品，被設計成「容納」四個女性，猶如流動靈活的「影子女士」（圖八），優雅而帶有美感地滑動在藝術家的其他作品之中，像是成為四位的「希臘美惠三女神」（Three Graces）。這些被賦予形體的影子，似乎喚起了女性慾望中不具體的模糊外觀，彷彿男性藝術家想像中的隱晦女性慾望。卸下的影子被垂掛在牆上，像是一首哀悼女性特質缺席的輓歌，也像是楊子強慾望的「鑄型」，弔詭地在女性缺席時提供空間予男性。正是「陰陽」的展現。在對美的具體追求中，女性渴望達到身體完美的慾望，與男性渴望進住到女性慾望空間中的慾望，是相呼應的，這種具體追求因而被予以加強。

《我們改造時間的進行方式》這件由冬季衣物縫合而成的蛇形編織作品，也是「讓人穿戴的衣物」。管狀造形的設計，能讓一個人在內「穿越」前進，如同一股身體蠕動的力量，刺激肌肉的收縮起伏，可在錄像作品《我爬行在一條名叫「夜」的黑蛇身體裡》（圖九／圖十）裡看到。在這件錄像作品中，某個人受到藝術家邀請，成為「被吞噬」在內的表演者。奇怪的是，吞噬者和被吞噬者合而為一：這條「蛇」只有在表演者爬行前進時，才會移動。這些造形和運動以兩種方式進行，像是鄰近的男性和女性慾望，以陽具和陰道的方式同時進行。

圖七 Fig 7

圖八 Fig 8

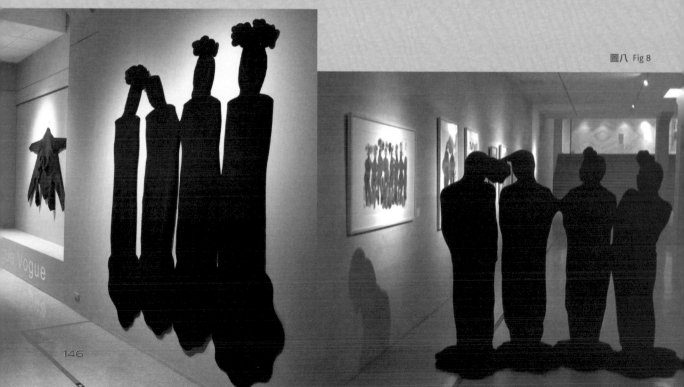

In these instances, the sculptor seems to have felt the sense of being overwhelmed by the sublime audacity of *scale* and indefinable *qualia* of these master pieces, which must haunt him still, as evident in the echoes of Koons's shiny "balloon-like" objects (the bulbous *Ideal Lady* series) and Leonardo's *Last Supper* (the very long 12-tables-in-one *Wild-Banquet-Every-Table*) (Fig6) returning as refrain in the flow of this exhibition. And when wall-hung, the silhouette of one of Yeo's *Vague Vogue* (Fig7) knit-garments in particular bears uncanny resemblance to Rodin's *The Three Shades*.

Vague Vogue consists of a series of works called *"Someone Took Over My Shadow"*. The pieces are intended to be the artist's own "shadows", which he "loans" to others to inhabit, and within which they would have complete "autonomy" to move as they will. As planned, this gives the artist the uncanny feeling of being severed from his own shadow. The piece that resembles *The Three Shades* is designed to "hold" four women performing as fluid and flexible "shadow ladies" (Fig8) , who elegantly and sensuously glide amongst the artist's other works, like Four, instead of "Three Graces". Embodied, they seem to summon the amorphous and indistinct shapes of female desire – shadowy female desire as imagined by the male artist. Dis-mantled, they drape on the walls like an elegy to the absence of femininity, shadows hanging as *casts* of Yeo's desire, which paradoxically make space for male presence *as* feminine absence. Very Yin and Yang. The pursuit of embodied beauty, where female desire to attain physical perfection is cast in relation to male desire to inhabit the enigmatic spaces of female desire, is intensified. *We Stop Time*, the serpentine knit-forms, sutured together from winter wear, are also "garments". The tubular form is designed for a body to move *through* like a force of bodily peristalsis, stimulating muscular waves of constriction and relaxation, as can be observed in the video *"I'm Crawling Inside the Body of a Black Serpent named Night"* (Fig9/Fig10) . Here, someone, invited by the artist, becomes the "swallowed" performer within. Curiously, swallower and swallowed become one: the "serpent" moves only because the crawling performer moves forward. These forms and motions "work" in two ways – at once phallic and vaginal – like male and female desire in contiguity.

Disembodied, the various black and grey knit pieces of *Vague Vogue* and *We Stop Time* mostly look like giant squashed bugs, worms, bats, alien forms. But, besides being the "negative space" of human anatomy and desire, these pieces are also inspired by bodies of water in nature. The garments invoke the magical rain-bringing cloud-shadows ever-drifting on undulating Scottish moorland, what the artist calls the "unsettled conditions" of rolling rainclouds. Clouds have a visual resemblance to wool, and this material is aptly employed to conjure the ungraspable flexibility of shadows. Wool also reappears here in another series of Yeo's work: the soft sculptural installation collectively called *Silent Rain* (Fig11) – black, green and white cloud-forms descend like giant tassels in knitted strands of "rain", each made at different times in the artist's career. The white giant tassel named *White Cloud of Jin Shan* was made specifically for this show in 2017 by local Taiwanese living in the area.

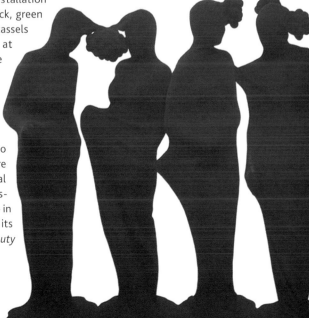

While the wider scope of the sculptor Yeo Chee Kiong's artistic pursuits pertain more to the representation of elemental natural forms and the frustratingly furtive, less-than-solid aspects of natural phenomena – in particular the element of water in each of its various states – the context of Yeo's *A Beauty*

無人在內的《模糊時尚》和《我們改造時間的進行方式》的各式黑色與灰色編織作品，看起來就像是巨大而被壓扁的蟲子、蠕蟲、蝙蝠和異形。但除了作為人類身體結構和慾望的「負空間」（negative space），這些作品也受到自然中水的形體所啟發。這些衣物喚起在地勢起伏的蘇格蘭荒野上，不斷漂流而帶來雨水的奇妙雲影。藝術家稱其為轟響雨雲的「不穩定狀態」。雲在視覺上和毛織品相似，並且這種材質可被適切地用來使人聯想起影子無法被掌握的靈活性。毛織品於此也再次出現在楊子強的另一個系列作品：共同被稱作《無聲靜寂的雨》（圖十一）的軟性雕塑裝置，呈現黑色、綠色和白色的雲狀造形，降下彷若巨大流蘇的編織「雨」絲。各色作品分別創作於藝術家生涯的不同時期。白色的巨大流蘇，稱作《金山上的白雲》，是特別邀請臺灣在地居民，為這次 2017 年的展覽所製作的。

雕塑家楊子強寬廣的藝術探索範疇，更多是關於基本的自然形體再現，以及令人徒勞難測，且非固態層面的自然現象，尤其是水這個元素的各種不同狀態。而楊子強在朱銘美術館展出的「麗美中心」，在脈絡上則具有更直接的說教性。雕塑家選擇在展場中去形塑各個體驗的服務站，像是一間互動的美容沙龍或 SPA。在此，不同的「身體部位」、「健康」層面和「時尚意識」，都受到特別的關注。每個「服務區」都回應這些「審美提升」的各式訴求，同時也操作成「自我反思」的空間。這個展覽大量出現各種對比，例如：柔軟編織的黑色影子，其鬆弛性，在美學上誇飾了新洛可可式粉紅色和銀色雕塑形象的堅固與華麗輕浮；華麗的扶手椅被巧妙地製作並裝上軟墊，既奢華又同時令人生畏；不定形的形式邊緣，卻是被一絲不苟地精細製作而成，並且呈現出迷人的材質。

勃發與壓抑，過度與缺乏，吸引與排斥，這些共同的表達，似乎對於人類欲望的驟發與矛盾本質，作出了嘲諷。這個展覽以精神分裂症式的不一致，發出連續而有節奏的聲響。

圖九 Fig 9

Centre as presented here in the Juming Museum is more directly didactic. The sculptor chooses to shape the stations of each experience within the art gallery as an interactive beauty salon or spa, where different "body parts", aspects of "well-being", and "fashion consciousness" get specific attention, with each "zone" tending to these various demands for "aesthetic enhancement" while operating as room for "self-reflection". Contrasts abound throughout the exhibition, e.g., the black, soft-knit shadowy flaccidities aesthetically exaggerate the solid, florid frivolity of the neo-rococo pink and silver figures; ornate armchairs are cunningly carpentered and upholstered to be both luxurious and forbidding at once; forms border on amorphous shapelessness yet are meticulously wrought and materially mesmerising.

Together, these expressions of exuberance and restraint, excess and lack, attraction and repulsion, seem to perform as satirical commentary on the convulsive, contradictory nature of human desire. The exhibition thrums with schizophrenic incongruence.

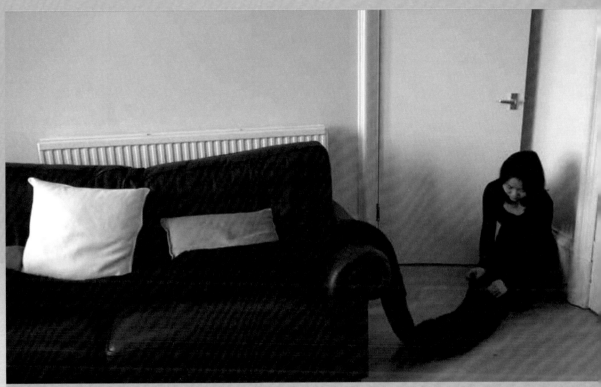

圖十 Fig 10

圖十一　Fig 11

III. 巧計、過度與矛盾

知其雄，守其雌，為天下谿。（註6）

天下莫柔弱於水，而攻堅強者，莫之能勝，以其無以易之。 （註7）

水這個元素的特質，作為組織這個展覽的原則，多方重複而回返滑動於「麗美中心」的結構性巧計之間：水元素在視覺和概念主旨上，滲透於這個 SPA 風格的展覽中。在這個刻意安排的體驗之始，觀者進入一個展間，內有一個浴缸，「流溢出」草莓奶昔般粉紅色的液體在展場的整個地板上，而一件怪異粉紅色氣泡狀，具女性特質的物體則出現在眼前。「液體」和人物的粉紅色，在視覺上與位於展間另一端具有銀色底腳的白色浴缸，並不相稱（圖十二）。白色浴缸似乎相對較為細緻，儘管內部排列著大量泡泡浴「痕跡」的粉紅色水珠。一件如雕塑般的警告標誌被策略性地放置，以漫畫般的誇飾手法，來警告這裡的地板非常「濕」。

這件如雕塑般流瀉的液體，通過技巧性地控制環氧樹脂顏料的傾倒，呈現出看起來仍是黏稠液態，但卻已經是固體的狀態。而彷若積雲狀的女性形體，同樣閃耀著粉紅的琺瑯色澤，以誇張且賣弄風情的姿態踮著腳，站在同樣是粉紅色有著華麗襯墊的腳凳上，猶如剛從展間另一端的浴缸中激起水花似地走出來，害羞的女孩氣質，從她肥胖手指的手勢中不協調地散發而出。這件特殊的奶昔粉紅色人形，奇妙地讓人想起至少兩萬五千年前舊石器時代的《維倫多爾夫的維納斯》（Venus of Willendorf），這件於 1908 年被發現的石灰岩小雕像：她沒有臉孔，極小，只有大約 4.5 英吋高，在外形上則清楚而具有誇大的女性特質，而且被刻劃為展現引起高度慾望的豐腴特徵，顯示出更具價值的女性生育能力。（註8）在自然界和人類的世界裡，生育能力、外形和慾望一直都是分不開的。這也令人想起另一個慾望的具體形象化，即另一個維納斯：猶如從海中升起的波提切利的《維納斯的誕生》。楊子強的粉紅色《維多利亞的秘密》（圖十三）（明顯是諧擬女性內衣時尚品牌「維多利亞的秘密」）可以被視為一種當代維納斯的喜劇式與性感式化身，從她的浴缸中重生，猶如一個儀態優雅且誇飾下，被渴望的巨大女性慾望的化身，仍然以某種方式吸引著困惑的男性凝視。（註9）

下一個展間，《無聲靜寂的雨》柔軟地落下，猶如毛線編織的綠色、白色和黑色「雲朵森林」，將「雨」帶進室內，是另一個濕漉的暗示。在「麗美中心」的展覽論述中，它提示出大自然「修復」力量的聯想，而我們則被鼓勵去走過這些柔軟的雕塑造形，藉由親身體會「去毒療程」，將自己沉浸於心靈的「淨化」中。視覺上，圓形的「雲」頂呼應浴缸內粉紅色泡泡浴的表面，這也

圖十二 Fig 12

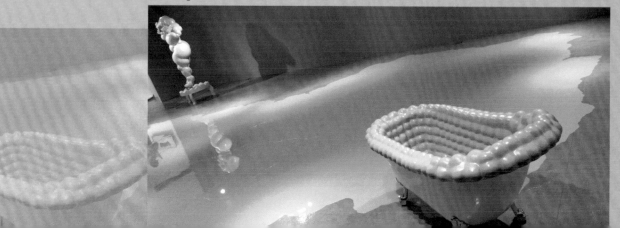

III. Artifice, Excess& Paradox

Know the male
But keep to the role of the female
And be a ravine to the empire. (Note 6)

In the world there is nothing more submissive and weak than water. Yet for attacking that which is hard and strong nothing can surpass it. This is because there is nothing that can take its place. (Note 7)

Slipping between the structured artifice of the "beauty-centre" as organising principle of the exhibition, the elemental qualities of water return in various iterations: visual and conceptual leitmotifs of watery elements pervade this spa-styled exhibition. At the beginning of the choreographed experience, one enters a space where a bathtub "spills" strawberry-milkshake pink deliquescence on the entire floor in a gallery, and a monstrous pink bubble of femininity looms. Both the pink displacement of "liquid" and the figure are visually incommensurate with the silver-footed white bathtub at the other end of the space – which seems comparatively delicate, even if lined inside with large pink globs of bubble bath "traces (Fig12)". A sculptural cautionary sign, strategically placed, warns, in comic exaggeration, of the very "wet" floor.

This sculptural spill is an artfully controlled pouring of epoxy paint already solid yet still appearing viscous and liquid. The cumulus cloud-like feminine form in the same glistening enamel shade of pink tiptoes in exaggerated coquettishness on an equally pink ornate-legged "padded" footstool, as if having just arisen splashly from the bathtub at the other end of the space, coy girlishness exuding incongruously from her fat-fingered gesture. This particular milkshake-pink figure is strangely reminiscent of the at least 25,000 year old Palaeolithic "Venus of Willendorf" limestone figurine discovered in 1908: faceless, and tiny, only about four and a half inches tall, she is distinctly and exaggeratedly female in form, and described as displaying the highly desirable trait of corpulence, which indicated much-valued female fertility. (Note 8) Fertility, form and desire have always been inextricably bound in both the natural and human worlds. Yet another embodiment of desire, another Venus, is conjured: Botticelli's *Birth of Venus*, as she arises from the sea. Yeo's pink *"The Secret of Victoria"* (Fig13) (obviously a spoof of the lingerie fashion line "Victoria's Secret") can be recognized as a contemporary comic *and sexy* avatar of Venus, rebirthed from her bath as a poised, exaggerated incarnation of a monstrous female desire to be desired, somehow still charming the bewildered male gaze. (Note 9)

In the next space, *Silent Rains* soft falls as a wool-knitted "cloud forest" in green, white, and black, bringing "rain" indoors – another allusion to wetness. In the *Beauty Centre* narrative it purports to conjure Nature's "healing" powers, and we are encouraged to indulge in "cleansing" and quieting the mind through immersive "detoxification" by walking through the soft sculptural forms. Visually, the rounded tops of the "clouds" echo the pink bubble-bath skin inside the tub, which is reiterated in the curves of the excessively voluptuous "cloud-Venus". The strands of knitted rain hanging off the clouds are in turn reflected on the room-wide pink spill on the floor. Inverted reflections of the black ceramic "cloudy-wigged" shadow ladies as well as the manga lightboxes from another adjoining space are also fleetingly caught on this overflow of pink. (Fig14)

Pivoting on what the artist projects as the absurd extremes that women in particular endure to attain beauty, A Beauty Centre seems to be both comic satire of this human quest for personal "skin-deep" beauty, and, at the same time, operates as an allegorical reminder that "true beauty" lies within the human spirit in communion with nature. As a satirical-allegorical exercise, it is fairly straightforward yet the exhibition – fleetingly – also takes a sidelong glance at art's demands on itself. Artistic ideals of "perfection" are evident, as the artist takes pride in the production quality of

在過度性感的「雲朵維納斯」的身體曲線上被重複了。這些垂掛在雲朵上的編織雨絲，依序反射在地板上和展間同寬的粉紅色溢出物上。戴著黑色陶瓷「雲朵般假髮的」影子女士的倒影，以及鄰近展間中漫畫燈箱的倒影，也飛快地被捕獲在這個粉紅色的溢出物上。（圖十四）

「麗美中心」是以藝術家所計畫，彷若荒謬的極端事物為中心，即女性特別會為了持續擁有美而願意忍受這些極端事物，其似乎兼具對於這種人類追求個人「膚淺」美的喜劇性嘲諷，並且同時作為一種隱喻式的提示，提醒我們「真正的美」存在於和大自然交流的人類心靈中。作為一種雙關的諷刺和寓意的交互運用，這個展覽是相當直接的，卻又簡略地從橫向關注了藝術對於自身的要求。藝術家明顯有著「完美」的藝術理念，以一種認真和自覺性的專注，著重於每件雕塑外形的無暇光澤和表面，而對每件作品的創作品質感到自豪。因此雕塑家同樣也在追求美。

楊子強先前對於只創作具不定形自然元素力量作品的聲明，明顯被持續創作人體造形的慾望所阻撓：雕塑家屈服了，而我們見證了力量與造形的碰撞，例如：水蒸氣的分子結構破碎而凝結成人類女性造形的外觀，即水蒸氣凝聚在一起，而以某種方式「合併」成女性，就像雲朵訴諸美感地雕塑出我們的想像。影響「麗美中心」體驗狀態的，似乎就是雕塑家這些雙重執念所產生的重複碰撞：水作為自然現象的美，猶如不定形的力量「和」受文化形塑的人體造形，這些力量和造形都彼此相互援引、連結和體現為藝術。而當藝術可以是一種對於美的追求時，美可以是什麼，藝術家意識到美就存在於大自然中。

在「麗美中心」的概念綱要中，楊子強作品的這種實例似乎轉向自拍世代，及其對於身體影像和「肥胖」的著迷。正是這個對於美本身的「提問」在被嘲諷著。一種說教式的荒謬美學正在上演：「麗美中心」邀請觀者以一種良好的，但不過於苛刻的方式，觀看他們自己在希望、慾望、疑慮和所有方式之中，觀看著自己。

位於戶外，在更多騰躍和腳尖旋轉，有著閃亮鏡面銀色和淡粉紅色的怪異性感人像之中，和這個延伸的「美容沙龍」嘲諷，形成間接重要對比的，是《野宴》這件十二張桌子連結為一的作品。這件樸素烏黑、狹長和曲線優美的作品，仍以多隻桌腳穩固地佇立，並乘載著一片水面，是藝術家帶給大自然千變萬化之美的一片液體鏡面，不加掩飾地面對著遼闊的天空。

————— 註 —————

1. Tzu Lao, Tao Te Ching, trans. D. C. Lau,（London: Penguin, 1963），Book One, X., 14.（老子，《道德經》，D. C. Lau 翻譯，企鵝出版社）
2. "Ecce Homo, Mark Wallinger, 1999," Art in the Open | An Open-City resource, accessed May 30, 2017, www.artintheopen.org.uk/impact/showcasing_exemplars_EcceHomo.html）〈馬克・渥林格，試觀此人〉，《敞開的藝術》網站）
3. Harry Rosehill, "Every Work Of Art On The Fourth Plinth（So Far）," Londonist, January 18, 2017, londonist.com/london/art-and-photography/every-work-of-art-on-the-fourth-plinth-so-far）（哈里・羅斯希爾，〈第四基座上的每件藝術品（到目前為止）〉，《倫敦客》網站）
4. Rachel Cooke, "Art: Alison Lapper Pregnant," The Guardian（Guardian News and Media, September 18, 2005），www.theguardian.com/artanddesign/2005/sep/18/art）瑞秋・庫克，〈藝術：懷孕的艾莉森・拉珀〉，《衛報》網站）
5. "Bruce Lee Quotes," Largest Collection Of Bruce Lee Quotes, accessed May 30, 2017, www.bruceleequotes.org/）（〈李小龍語錄〉網站）
6. Lao Tzu, Book One, XXXVIII, 33.（老子，《道德經》）
7. Lao Tzu, Book Two, LXXVIII, 85.（老子，《道德經》）
8. "How Art Made the World . Episodes . More Human than Human . Venus of Willendorf," PBS（Public Broadcasting Service），accessed May 30, 2017, http://www.pbs.org/howartmadetheworld/episodes/human/venus/）（〈藝術如何創造世界——人勝於人——維倫多爾夫的維納斯〉，PBS 公共廣播服務）
9. 姿態、沉穩、平衡、力量：這些特質援引的是李小龍對於身體美感和力量意志與行使的概念。李小龍透過嚴格的養生方式來形塑自己的身體，據說卻也策略性地從他的軀幹移除肋骨來達到理想的男性外形。這不像是從前束腹是如何約束女性的身體，即使現在還是有女性確實越過束腹，而移除肋骨來達到她們所認為的審美上的完美，例如：「迷人的」卡通腳色，像是兔子潔西卡（Jessica Rabbit），就是一個幻想中完全在自然界之外，極小腰身女性的例子。

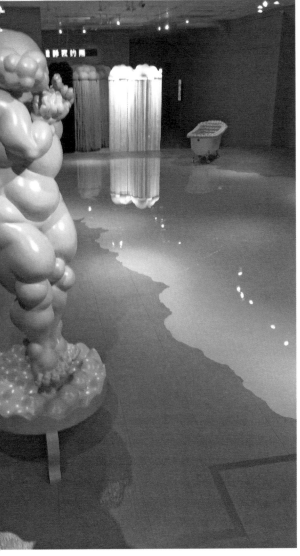

圖十三 Fig 13

each object, with a serious and self-conscious focus on the flawless finish of the patina – the skin – of each sculptural form. The sculptor too is on a quest for beauty.

It is obvious that Yeo's earlier declaration to work with only the formless elemental forces of nature is thwarted by the continuing desire to create the human form: the sculptor succumbs, and we are witness to a collision of forces and forms, e.g., the molecular structure of vaporous water crashing and condensing into a semblance of human female form – water vapour held together and incorporated as somehow female, just as clouds sensuously sculpt our imaginations. What influences the shape of the experience of A Beauty Centre seems to be these repeated collisions of the sculptor's twin obsessions: the beauty of the natural phenomenon of water as formless force and the culturally-shaped human form, where both forces and forms are invoked, yoked, and incarnated as art. And while art may be a quest for beauty and what beauty can be, the artist is aware that the beautiful in Nature just is.

This instantiation of Yeo's oeuvre within the conceptual schema of A Beauty Centre seemingly turns the tables on the era of the Selfie, and its obsessions with body image and "obesity". It is the quest for beauty itself that is being satirized. There is a didactic aesthetics of the absurd at play: A Beauty Centre invites viewers to take a good, but not overly-harsh look at themselves looking at themselves – amidst hopes, desires, misgivings and all.

Situated outdoors, amidst more prancing and pirouetting monstrously voluptuous figures in shiny mirror-silver and pastel pink, the obliquely momentous counterpoint to this extended "beauty salon" satire is Wild-Banquet-Every-Table, the 12-tables-as-one work. This work, in austere jet black, elongated and curvaceous yet standing solidly on many legs and bearing a watery surface, is where the artist brings a liquid mirror to the beauty of ever-changing Nature, barefaced to the open sky.

───── Note ─────

1. Tzu Lao, Tao Te Ching, trans. D. C. Lau, (London: Penguin, 1963), Book One, X., 14.
2. "Ecce Homo, Mark Wallinger, 1999," Art in the Open | An Open-City resource, accessed May 30, 2017, www.artintheopen. org.uk/impact/showcasing_exemplars_EcceHomo.html)
3. Harry Rosehill, "Every Work Of Art On The Fourth Plinth (So Far)," Londonist, January 18, 2017, https://londonist.com/ london/art-and-photography/every-work-of-art-on-the-fourth-plinth-so-far)
4. Rachel Cooke, "Art: Alison Lapper Pregnant," The Guardian (Guardian News and Media, September 18, 2005), www. theguardian.com/artanddesign/2005/sep/18/art)
5. "Bruce Lee Quotes," Largest Collection Of Bruce Lee Quotes, accessed May 30, 2017, www.bruceleequotes.org/)
6. Lao Tzu, Book One, XXXVIII, 33.
7. Lao Tzu, Book Two, LXXVIII, 85.
8. "How Art Made the World . Episodes . More Human than Human . Venus of Willendorf," PBS (Public Broadcasting Service), accessed May 30, 2017, www.pbs.org/howartmadetheworld/episodes/human/venus/)
9. Posture, poise, balance, strength – these characteristics invoke Bruce Lee's conceptions of the body beautiful and power willed, and wielded. Bruce Lee sculpted his body through strict regimes, but also allegedly strategically removed ribs from his torso to attain an ideal masculine form. This is not unlike how the corset has disciplined women's bodies in the past, and even today there are women actually bypassing the corset and removing ribs to attain what they deem to be aesthetic perfection e.g., "glamorous" cartoon characters like Jessica Rabbit, an instance of a fantastically tiny-waisted femininity completely outside the realm of nature.

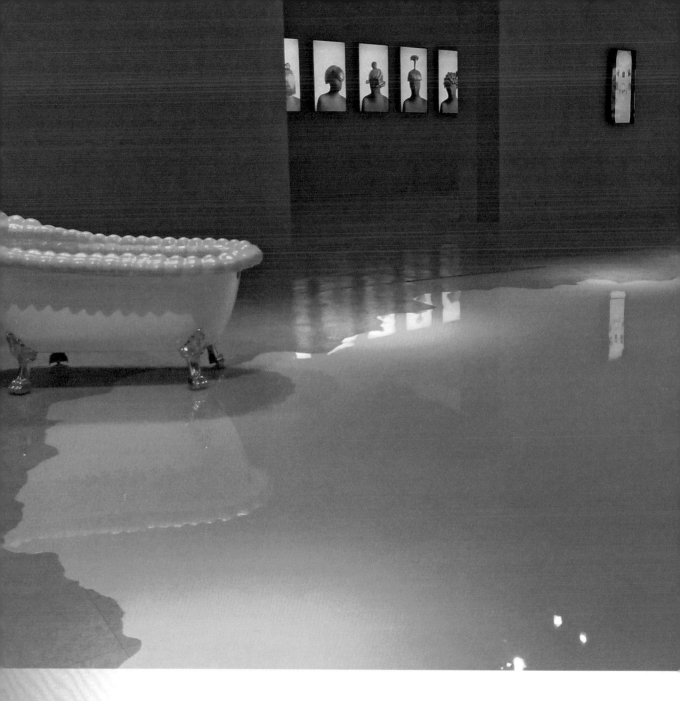

蘇西 · 林厄姆博士 ————

一位跨領域和獨立的思想家，寫作人，教育工作者，理論家，藝術策展人和創作
者，她的書寫和研究方向嘗試綜合人文與科學等不同領域上，與心性相關連的
理念。曾擔任 2016 年新加坡雙年展主策展人，2013-2016 年度新加坡美術館館
長，新加坡南洋理工大學／國家教育學院之「視覺與表演藝術學術組」助理教授
（2009-2013）。自 2014 年起，她在澳州，英國和新加坡等國的大學和學院授課。

圖十四 Fig 14

Dr Susie Lingham

An interdisciplinary and independent thinker, writer, educator, theorist, curator and maker in the arts, and her writing and research work synthesizes ideas relating to the nature of mind across different fields, from the humanities to the sciences. She was the Creative Director of the Singapore Biennale 2016, and was the Director of the Singapore Art Museum (SAM) from 2013 to 2016. Prior to this appointment at SAM, she was Assistant Professor at the Visual & Performing Arts academic group at the National Institute of Education/Nanyang Technological University, Singapore, from 2009 to 2013. In 2014, she has taught at universities and art colleges in Australia, Singapore and the U.K.

麗美中心
金山上的美容院
A Beauty Centre @ Juming Museum

楊子強個展
Yeo Chee-Kiong Solo Exhibition

朱銘美術館
第二展覽室 & 戶外藝術交流區
Juming Museum
Gallery II & Interchange Area

5/20/2017 – 10/29/2017

We Detoxify Inner Self

內在
深層
去毒

策展概念

美，就如其所加以描述的玫瑰那般，是一個帶刺的文字闡述。

在當代的社會裡，這是一個相當敏感的概念，通常與女性、媒體和商業行為有多重的交集，乃至於其所衍生的各類相關課題。在當代藝術裡，這也是一個饒帶詩意的概念。當普羅大眾可輕易地把美與藝術加以串聯在一起時，卻在西方所主導的藝術裡中被加以去麗係化。在1960年代西方概念藝術所倡導的概念性和去物質化，以及其所質疑的純感官上的愉悅體驗後，藝術家在肘論藝術創作中的「美的感受」時，很大可能會著眼於缺乏思想內涵的風險。就如美國傑出的藝評人亞瑟·丹托所容的，「美幾乎完全地消失在二十世紀的藝術現狀裡，膚淺地把美好的表像與庸俗的商業利益相比等號。」（丹托，2003）

無論如何，儘管爭議不斷，在人類的歷史進程中，對於美的追求是耐人尋味，而且是不斷地持續進行著的。更何況當代藝術界並沒有成功地解除這緊密的聯繫。

為了激發對於「美」的相關想法和討論，「麗美中心」是一個被架構出來的，一體兩面的交疊場域，一面是硬皮橡的美容服務空間，另一面則是真實藝術空間內的正式展出。這兩個空間相互崩壞交疊，同時是追尋美的美容院運作系統，又不自覺地切入藝術展麗的運作架構中。而其中所呈現的是藝術家所創造

的，為參觀者所消費的延續物件。通過這兩者的並行呈現方式，藝術家質疑和宣告美容與藝術界和藝術之間緊貼曖昧的震盪度。

在中國哲學裡，「美」與「真」和「善」並列。在柏拉圖的論點裡，「美」被進一步敘述為終極的「愛」的物件。這個想法根植於人們內蘊上的欲求，但同時它也被接納為美麗物件的誘惑形態。在藝術世界裡，當代藝術家對於「愛的物件」這個概念的關注，被二十世紀的美術所明顯揚棄而衰竭（內哈瑪斯，2007）。在「麗美中心」裡，一系列饒趣味的造像形態，被置入如同劇場般的情境中，從中可以一窺藝術家對於造形、材質和空間的明顯迷戀。參照他自己的說法，「宛如在荒蕪的表相世界裡，探索人心對物質世界與精神世界的懸愀始鴻溝般一般。」

亞瑟·丹托曾提出「為當代藝術的美去毒」，其中包含著藝術品本身有能力在自身的概念架構上去影響「美」（丹托，2002）。「麗美中心」可被視為一件野心勃勃，其思路與遣說法相契合的作品。一個虛構的美容院場景設置，與一個不真實的美容院站，通過一個全套完整的藝術展覽體道方式呈現。這個展出不僅提出了對於為多層面提問，也嘗試去釐清物質性與非物質性的界線，同時探索美與物質生活如何重塑感知經驗的可能性。

Curatorial Concept

Beauty, like the roses it describes, is a thor

In contemporary society, it is a sensitive co politicized and often associated with w media and the commercial world. In t contemporary art, the idea is equally if not r While the general public might easily relat art, beauty is however much disdained, d dismissed in an art world where wes dominate. After conceptual art in the denounced sensory pleasures to extol in and immateriality of the art object in the risks being superficial in speaking about be creative endeavors. As the preeminent A critic Arthur Danto describes, "beauty h entirely disappeared from artistic real twentieth century, as if attractiveness wa with its crass commercial implications". (Da

Nevertheless, despite the controversies, the beauty in human history is intriguingly pe relentless. Even the art world did not cleanly sever ties with it.

With an intention to provoke thoughts surr idea of "beauty", A Beauty Centre is constr twofold world where the retail saloon indus art gallery as an institution overlaps and one hand, there is the rather mischievous r retail space; on the other there is the actuali exhibition itself taking place within t compound. The two worlds collapse into system of the saloon as a site for the ne beauty for vanity slips into the framework where sensuous objects created by the artis consumed by the gallery goers. By juxtap two, the artist poses questions and ma

服務區 3

我爬行在一條名叫「夜」的黑蛇身體裡

Zone 3：I'm Crawling inside the Body of a Black Serpent Named Night

2011年冬季，雕塑家在生命中的創作低潮時，如候鳥般回到了蘇格蘭。在那期間，為二戰時期著名英國首相邱吉爾的戰時名言所激勵，「如果你正走在地獄裡，那就繼續地往前走」。

「我爬行在一條名叫「夜」的黑蛇身體裡」是雕塑家的表演雕塑系列作品「有人接過了我的影子」的延伸。利用在商場所購買的冬季針織品，雕塑家編織出一條黑蛇，詩畫藝術家朋友爬進黑蛇身體裡，當進入黑暗的身體裡後，也只有往前艱難繼爬，才能爬出這隧道。黑蛇不斷蠕動的輪廓線中，呈現著一個個宛如「蛇吞象」般的視覺剪影，以及那「爬入」和「被吞入」之間的曖昧性。

服務區 4

我是女神

Zone 4：I am Goddess

探訪金山上的「美髮／美容中心」，以影像記錄方式呈現在地人對於「美」的定義和理解方式。在「我是女神」的攝影格式架構裡，受訪者拍與藝術家分享在自拍鏡頭裡最美麗的角度，並說出最自信的臉部部位，向全世界宣告和展現「全民皆女神」的時代精神。

服務區 5

「有人接過了我的影子」系列

Zone 5：The "Somebody Took over My Shadow" Series

2002年藝術家在灰濛濛的格拉斯哥冬日裡，失去了相隨多年的影子。這是他從沒想過的事情。所以他請妻子用黑色毛線再織了一個自己的影子。他讓自己進入自己的影子裡，一個視覺上的黑洞空間裡。別人見不著他，卻大略從影子的外在輪廓可以聯想起他。他和自己的影子相互地擁有著彼此。

「有人接過了我的影子」系列藉著出借自己的影子，讓別人也可以進入這私密的視覺黑洞空間裡到處遊走，去嘗試他們她們所想做的，或想像又不敢做的事情。雕塑家是一個冷靜的旁觀者，默默地欣賞著自己的影子在脫離自己的身體以後，在別人的恣意下自由地移居到空氣層。唯一的條件就是不能撕裂和損壞「它」。

服務區 5.1

四個影子和她們的都市

Zone 5.1：Four Shadows and the

2011年帶著一組「四個如這體罌般相連約回到了格拉斯哥，當初失去和找回「影子市。英國經典影集「欲望都市」裡，四個市女性的姊妹情誼，愛奧情欲糾結，對個人快意與自由意識，作出縱縱的談述密家造了四個影子，希望欣賞到不同城他的影子裡，在屬於她們的生活情境裡們本身的快意，和自由地飄移在空氣層邀請了四位藝術家朋友的妻子，在一個日裡，來到了蘇格蘭／英格蘭史上第一泳館，迂迴地遊蕩在遙已被掩蓋的，空仟空間裡。

英文版請參閱第 68-69 頁

Please refer to page 68-69 for English version.

服務區 1

無樹之日(五)
Zone 1：A Day without a Tree (5)

「無樹之日」的早期系列作品，通過「溶解」諸如博物館、美術館等內部重要的歷史建築結構，嘗試解構觀者既定的慣性思考方式。朱銘美術館的「無樹之日」，以一灘溶解的「液體」佔據著展出空間，彷彿從肉色浴缸底部逐漸地漫延開來，以一種難以言喻的存在感，展現一種單純的不確定性，促使觀眾進一步去思考和確定這一現象事件。

服務區 1.1

未來武器系列
Zone 1.1：The Future Weapon Series

「未來武器系列」隸屬於另一個更大的系列「雕塑之冒險再造性」。這一系列的平面冒像作品對雕塑家早期雕塑作品冒像進行再處理，重新賦予其原始雕塑意涵以外的其他可能性。「飛彈鐵金剛」通過重組再生雕塑家少年時期所沉迷的日本機械人漫畫作品，藉由胸腔轟射出「原始雕塑」飛彈，讓自己的創作與所喜愛的漫畫作品相結合，同時對應現今社會追求美胸的整形風潮。

服務區 2

雨絲系列
Zone 2：The "Strings of Rain" Series

「雨絲系列」的創作發想，源自於臺灣作家三毛回答其先生荷西，關於什麼是冬粉的問題時，以非常詩意的方式，形容「冬粉」是在冬天裡，在高山上所採摘的熱凍的雨絲。當時生活在蘇格蘭的雕塑家也常常被冬天的陰雨給困住，所以他用蘇格蘭的羊毛線，編織出那本不只存在於想像中的黑雲和雨絲，讓觀眾能走入雨裡，去感受那一絲絲的雨，貼在臉上和身上的詩意。回到新加坡後，雕塑家創作了綠色的「雨林」，重現小學時期在雨林裡歷險的經驗，讓觀眾體會在雨林裡迷路的感受。

而由金山在地居民和學生所編織的金山上的白雲和雨，則牽引出他們與山中雨絲和白霧的別緻偶遇。

服務區 5.2

裝系列
5.2：The Flying Suit Series

時尚之都，巴黎的春季，雕塑家以角色心態，在巴黎的工作室當起了時尚設計師，用過季的冬季毛線服飾，用相同顏線，把兩件或三件同一款毛衣重新編織，打造「模糊時尚」時尚品牌。其中「飛行」和「蛇形系列」，以過季時尚再邀圍為行創作，並惠臨在地的民眾試穿和拍攝時

服務區 6

九個影子的影子會議
Zone 6：Nine Shadows in a Meeting

「九個影子的影子會議」是一件活動影像作品。每一個影子有「向左」、「向前」和「向右」三個影像，每秒遷交替呈現，從而製造出互相對話的活動畫面。

在現今的科技資訊時代，或許對某些人而言，生活在電腦螢光幕前的世界，比真實的世界更真實。這是一種似是而非的一致性和同化性。每一個人都有一個代碼，一個影子，一種自我保護行為下的真實，卻又認真投入於間接脫離的真實中。

這件影像作品裡，每個影子都戴上了象徵本身代碼的陶土燒製「假髮」。這是雕塑家為這科技資訊時代所作的跨界連結。

服務區 7

野宴
Zone 7：Wild Banquet

每一張桌子都有其特性和所賦予的功能。通過收集各樣式的台北舊桌子，串聯成一張長桌，再把桌面庖空，注入清水，創造一片無法再放置任何物件的桌面，去除其原始桌子的功能屬性，成就一泓超脫桌子本質的清澈水面。黑色同化不同桌子樣式，如同「影子」般嵌入白日下的翠綠山林間，倒映出藍天白雲。在長桌水面上，杯罷漂移，邀請觀者一起共用這一桌非凡的野宴。

服務區 8

完美女人
Zone 8：Ideal Lady

「完美女人」粉紅不鏽鋼雕塑系列，藉由無數夢幻泡沫所形成的女人體，通過對應不鏽鋼鏡面反射下虛幻的高貴，和粉紅肉體表層下真實的臟膜，雕塑家希望通過自己的雙手，讓「軀體」的肉體成就為蛻脫的「美麗屍體」的創作欲望，宛如在荒蕪的表相世界裡，探索人心最原始的渴望一般，是那恆當代的「人性」。

麗美中心
金山上的美容院
A Beauty Centre @ Juming Museum

楊子強個展
Yeo Chee-Kiong Solo Exhibition

朱銘美術館
第二展覽室 & 戶外藝術交流區
Juming Museum
Gallery II & Interchange Area

5/20/2017 – 10/29/2017

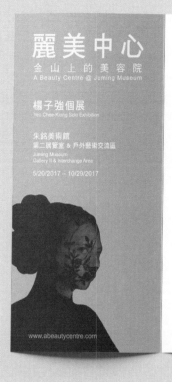

www.abeautycentre.com

美容服務區導覽圖
A Beauty Centre Floor Plan

野外健身房
(戶外藝術交流區)
The Outdoor Gym (Interchange Area)

櫃檯招待處：會員卡申請
服務區1：內在深層去毒
服務區1.1：未來武器
服務區2：大自然的神奇修復力量
服務區3：我們改造時間的進行方式
服務區4：我是女神
服務區5.1：模糊時尚（一）
服務區5.2：模糊時尚（二）
服務區6：美人俱樂部
服務區7：金山上的小宇宙
服務區8：美好的裸體

The Reception Counter · Membership Application
Zone 1 : We Detoxify Inner Self
Zone 1.1 : Future Weapon
Zone 2 : The Healing Room
Zone 3 : We Stop Time
Zone 4 : I am Goddess
Zone 5.1 : Vague Vogue I
Zone 5.2 : Vague Vogue II
Zone 6 : A Beauty Dining Club
Zone 7 : The Cosmos Energy Picnic Program
Zone 8 : Look Good Naked

服務區 1
內在深層去毒
美麗靈魂的頂級洗滌經驗

Zone 1 : We Detoxify Inne
A Holistic Experience for a Bea

無樹之日(五)：
犒一犒自己，我們犒保最高檔的洗
享受，讓所有的物欲盡情流淌。

A Day without a Tree (5) :
Treat yourself to a top-of-
cleansing experience. Indulge
your desires!

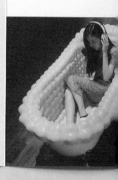

服務區 4
我是女神
相信自己，是最美麗的事

Zone 4 : I am Goddess
Confidence is the Most Beautiful Thing

我們致力於創造一個低「視覺污染」的美麗世
界。透過全球頻道讓「我是女神」，麗美中心展
現每一位滿意度百分百的客戶。

We are committed to building a beautiful
world that's low in "visual pollution".
Showing on our global broadcast channel
"I am Goddess", A Beauty Centre shows
off every of our satisfied customers.

服務區 5.1
模糊時尚（一）
相信時尚，我們創造一個大同世界

Zone 5.1 : Vague Vogue I
Believe in Fashion, We Create a World
without Borders

未來大時尚／影子系列：
我們編織個人或群體的專屬剪影，細緻地貼附著
每一吋誘人的曲線，宣告著時尚趨勢的未來。

The Great Future Fashion/Shadow Series :
We herald the arrival of future fashion trends
with our unique knitted shadows, tailor-made
for individuals or groups. The shadows are
carefully weaved to hug every inch of your
beautiful curves.

服務區 5.2
模糊時尚（二）
完美的服飾，完美您的人生

Zone 5.2 : Vague Vogue II
A Perfect Outfit Perfects Your Life

再循環時尚／飛行裝系列：
我們重新組構過季的時裝，讓個性的您穿上後，
更顯獨特的專屬風采。

Recycled Fashion/Flying Suit Series :
We reconstruct last season's must-have
items into one-of-a-kind outfits that reflect
your unique character.

服務區 6
美人俱樂部
獻給我們備受矚目的顧客

Zone 6 : A Beauty Dining
Dedicated to Our Celebrity Cus

年度網上「美人俱樂部」聚會，讓來自
明星級顧客們，通過網路影片與大家
的典範。
※現場提供「美人俱樂部」會員申請服

The Annual Online Beauty Dinner
where our celebrity customers fro
the world share their success storie
*Membership application servi
available in "A Beauty Dining Club

服務區 1.1

來武器
鐵金鋼

Zone 1.1：Future Weapon
Little Mazinger

相佔在未來的萬能鐵金鋼機器人時代，擁有完美個人的飛彈，是必要的震攝之一。

...the future, we believe robots will be ...potent; a pair of perfect missiles is ...ssary to shock and awe.

ture Weapon

服務區 2

大自然的神奇修復力量
無聲靜寂的雨

Zone 2：The Healing Room
The Restorative Magic of Nature - Silent Rain

神奇的「大音希聲」場域，修復腦細胞，啟動腦按鍵，讓您沐浴在人造的大自然情景中。
*縮城金山版的「大音希聲」神奇場域。

The greatest music has the faintest notes. Immerse and rejuvenate your brain cells in this man-made nature zone.
*The Jinshan version of this magical arena.

服務區 3

我們改造時間的進行方式
拒絕不了的青春

Zone 3：We Stop Time
Irresistible Youth

回復青春的秘密，已不再是純粹地透過美顏霜或高科技雷射治療療程。我們提供非一般延緩時間的方程式。

The secret to rejuvenation is no longer kept in a jar of cream or a laser. We can offer you an extraordinary way to slow time.

您成就我們的完美！

陳燕平

*為尊貴的您，獻上完美的「美人俱樂部」會員資格，請前往櫃檯招待處提交申請。完全免付費唷！

感謝單位 In Gratitude to.

服務區 7

山上的小宇宙
清新的野餐配套

Zone 7：The Cosmos Energy Picnic Program
...anteed to Rejuvenate You

...中心激請了「國際名廚一光之男物理博士」...透過量子力學的理論實踐，設計出各色清... 「宇宙射線野餐配套」，讓您的身體充滿...宇宙的美麗能量。

...Beauty Centre is collaborating with ...nationally-renowned celebrity chef "Dr ...of Light". He uses quantum physics to ...n "Cosmos Energy Picnic Programs", ...will fill your body with beautiful cosmic ...ly.

服務區 8

美好的裸體
優弧步健身操

Zone 8：Look Good Naked
Yoohoo Aerobics

麗美中心邀請了「世界級得奇健身大師一夜之魅影博士」，為麗美中心的會員們編策出世界首創「三合一，即時見效，優弧步健身操」。

A Beauty Centre has commissioned legendary aerobics master "Dr Shadow in Night" to choreograph the world's first "three-in-one instant-results Yoohoo Aerobics".

楊子強

楊子強(1970)，專業建築家，現為新加坡雕塑學會會長(2005-09, 2015-19)，並擔任新加坡南洋藝術學院和拉薩爾藝術學院兼任講師，精研人體造形藝術與當代概念裝置創作，以實踐的態度，深化「雕塑遺物」的原始創作意向，受實驗的角度剖析當代藝術思潮的表現內涵和數位網絡時代的虛擬環境。

透過建立一個獨立運行的個人創作載體，虛擬場域之「美容中心」一體多面地交互觀測著雕塑物件，與多重空間和多方話語權之間的可虛實父替性和可交織性。這個虛擬場域，以顛覆人們的慣性思考方式，從新審視一個超現實實體制，所能塑造的世代視知覺方式，以「不確定性」和「矛盾點」作為創作精神之主軸，探究當代雕塑與概念藝術之間進行相符的多重形式。

楊子強曾擔任新加坡雕塑學會代會長(2014-15)，新加坡「古樓畫室」管委會主席(2014-16)，挪威「境外」藝術家組織(倫敦)顧問團成員(2011-15)，新加坡國家文物局公共藝術評鑒委員會委員(2010-13)，新加坡南洋藝術學院院美術系課程發展顧問團成員(2011-14)，新加坡國家藝術理事會「青年文化獎」專業評鑒團成員(2012,2013,2016)。作品《無樹之島》獲選「亞太傑出藝術大獎」(2008)，《修甜甲》獲選晨出於丹麥大型戶外國際雕塑展Sculpture by The Sea (2013)，《虹點之後》，獲選為新加坡五十周年金禧紀念雕塑(2015)。

Yeo Chee-Kiong

Yeo Chee-Kiong (b.1970) is a contemporary sculptor and installation artist who is fascinated with the language and spatial relationship between object, space and authorship. His work destabilizes the familiar notions of spatial proportions and perspectives, whilst examining the human conditions in the construction of an extended surreal world.

In the course of his career, Yeo has held several appointments including Acting President of the Sculpture Society Singapore (2014-15), Chairman of Telok Kurau Studios Management Committee (2014-16), Advisor, Norwegian Collaborative Organization for Contemporary Art Abroad, London (2011-15), Committee Member of Public Art Appraisal Committee, National Heritage Board, (2010-13), Member of Curriculum Development Advisory Committee of NAFA, Fine Art Department (2011-14), and Panel Member of Young Artist Award's Specialist Panel for Visual Art, National Arts Council (2012, 2013, 2016). He is currently the President of the Sculpture Society Singapore (2005-09, 2015-19). Yeo is currently an adjunct lecturer at Nanyang Academy of Fine Arts and LASALLE College of the Arts.

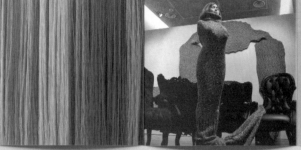

Public Art

Singapore
DTL Expo Station 2017

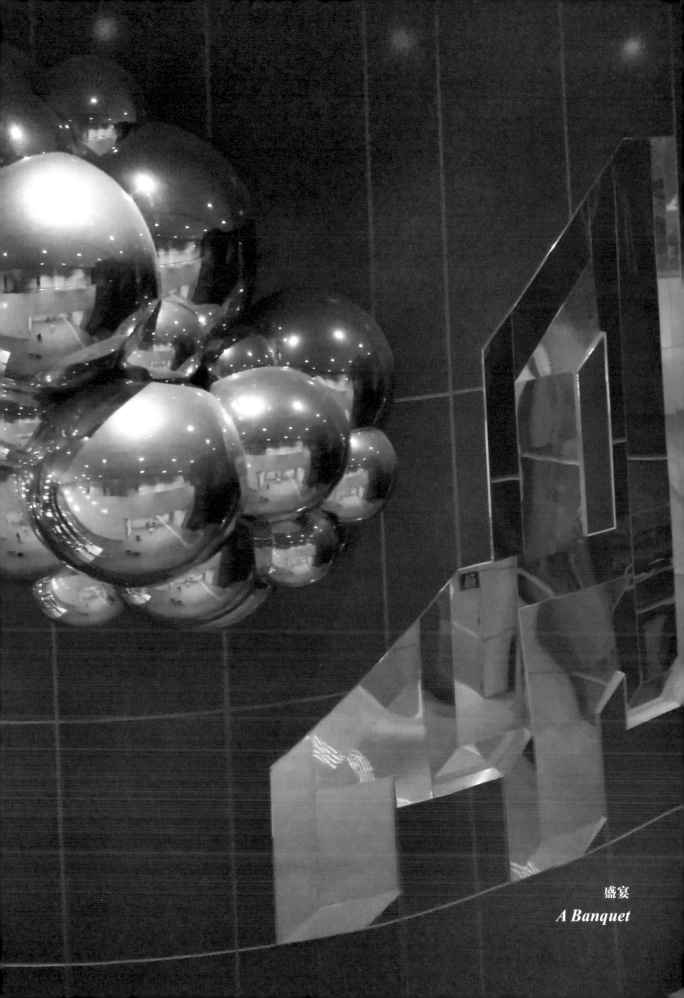

盛宴
A Banquet

未來漫畫日刊

未來武器
Bimbomb

Future Weapon – Missile Mazinger : In the future, we believe robots will b
omnipotent; a pair of perfect missiles is necessary to shock and awe.

未來武器－飛彈鐵金鋼：我們相信在未來的萬能金剛機器人時代裡，
擁有一對完美懾人的飛彈，是必要的震撼性裝備之一。

CONTEMPORARY
WAVE

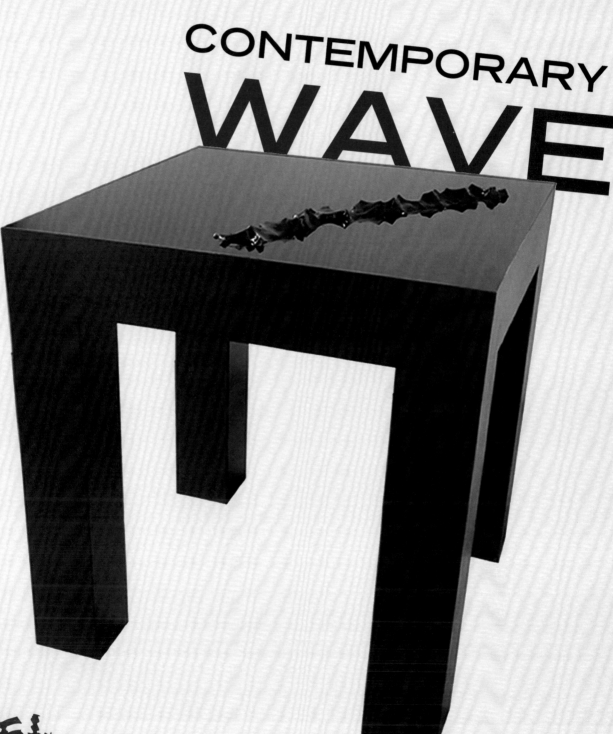

since 2003

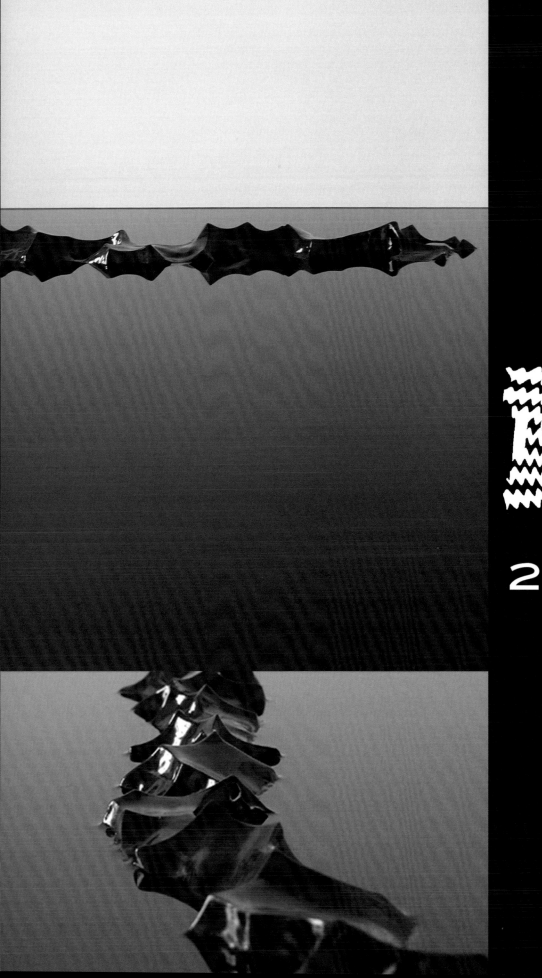

2003

2008

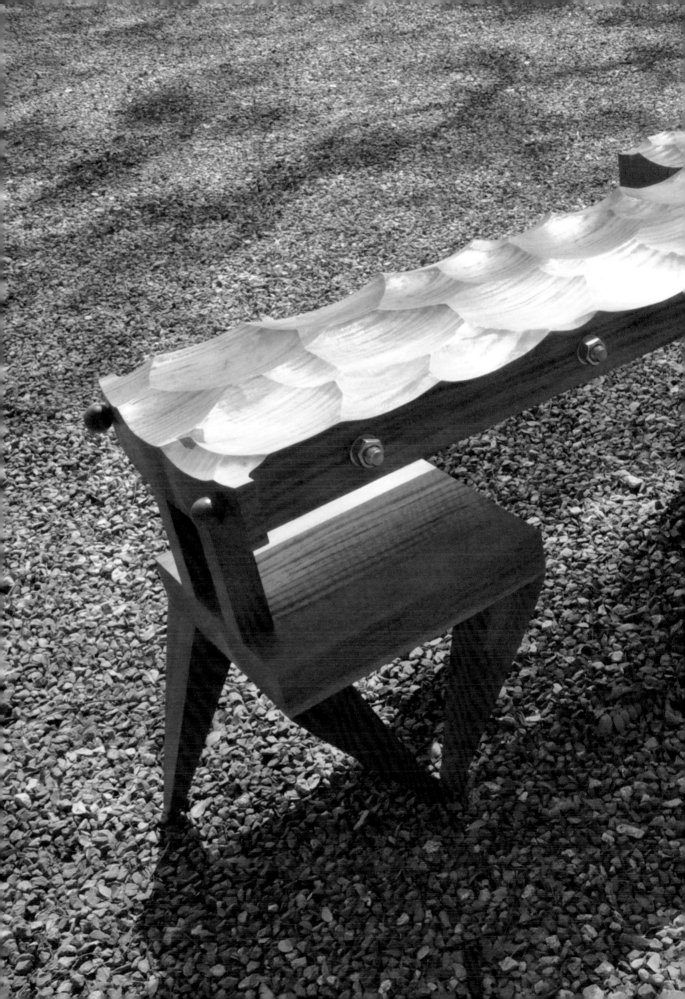

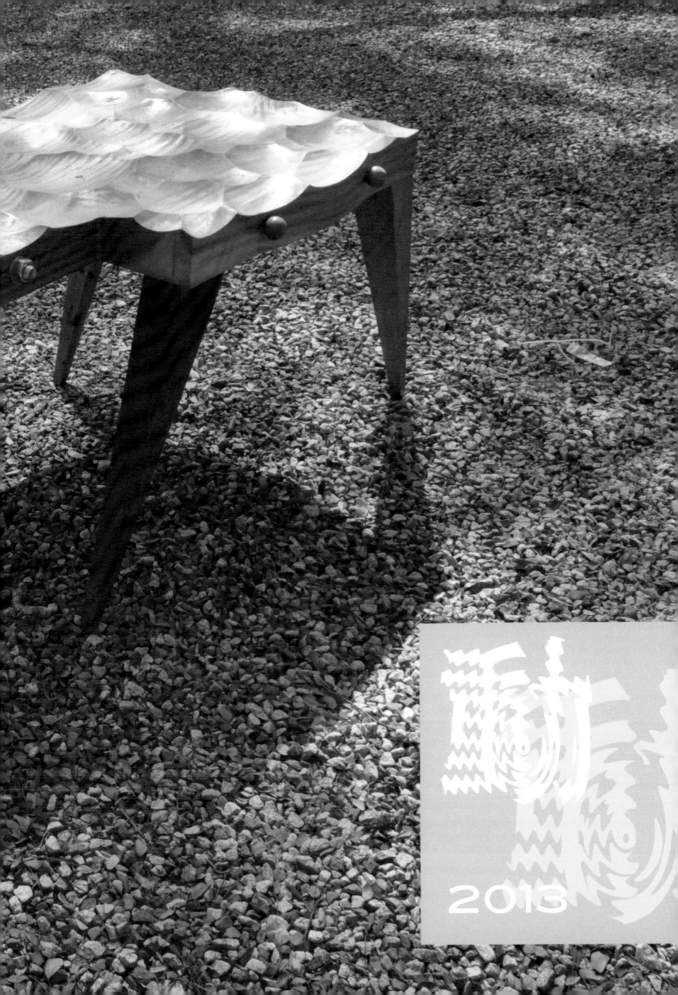

2013

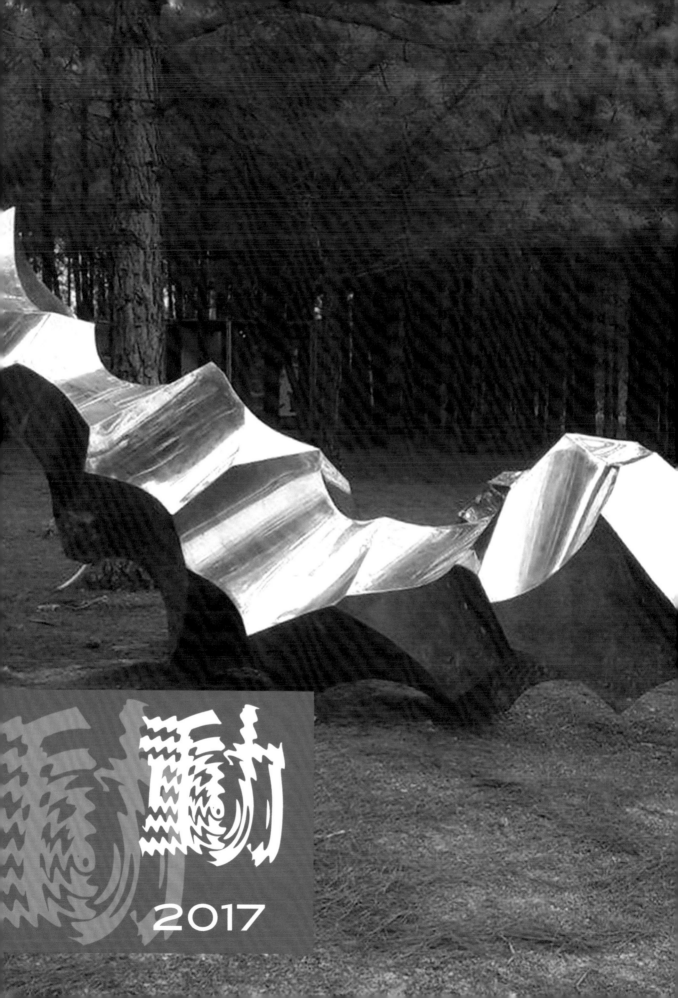

2017

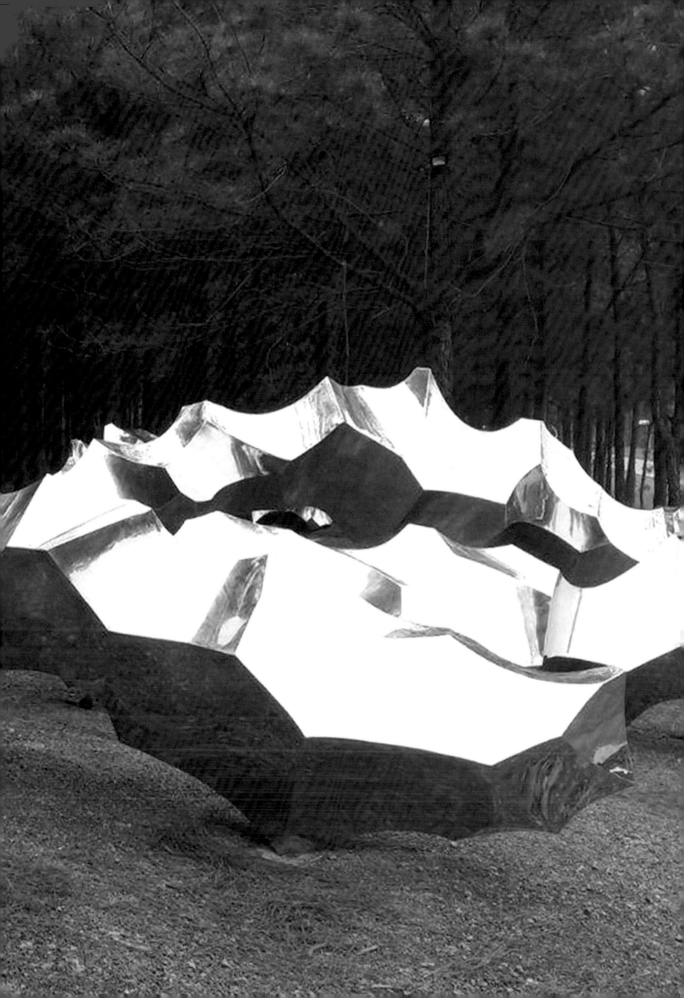

2018

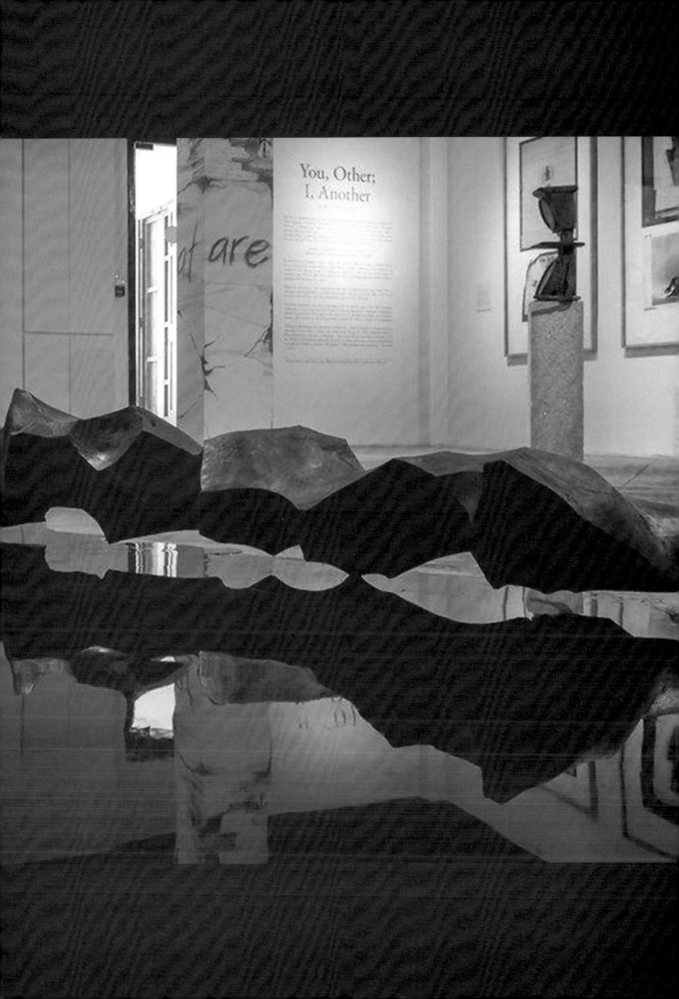

心動／風動／浪動／樹也動

■ 楊子強

風不歇，它隨湧浪漂流而來，形只影單，拍打著
彼岸。
心之所動，如浪隨形，刀起刀落。
或再次回歸浮沉，隨湧浪而去，不復孤獨。

「心動」系列動念於 2003 年。後續的十五年間，那「一道浪」不間斷的出現在不同創作節點上，因應著多方展出空間狀態，以及所涉略的不同材質，而發展出多重形態。有感於著名的禪宗典故，六祖慧能的「心動」說，雕塑家嘗試通過一系列的作品實踐，進一步的再詮釋這禪宗典故。

故事起始於兩位僧人對一面在風中飛揚的旗子所處在的當下狀態堅持不下，一說是旗子在動，一說是風在動，所以旗子動。而六祖慧能回答說是僧人們的心在動，不是風在動，也不是旗子在動。

在 2003 年的現實物質世界裡，「浪」沒有具體的物理形態。浪的形成，是動能在某個時間點上持續不斷的掠過水面，或是在某個時段內當風吹拂過水面的那一刻所創造的。雕塑家試圖通過雕塑的形式，具體「物質」化一個「浪」的抽象概念，通過「浪」這個想法的形態介面，再次把那段對話的焦點帶回到這個物質世界中——一個雕塑的世界。

一個物理形態上的浪的創造，是雕塑家針對同一個提問所嘗試回應的一個答案。

在「心動」系列中，我們可以看到一種對於現代主義中，「物質的真相」和「純粹的形態」的持續堅守。另一方面，當代藝術中所強調的限地創作性對於雕塑家本身同樣是重要的，通過他的雕塑，把觀眾帶入一個經驗與現象的場域。2017年，越南河內的「心動」，是弧面鍛造，高度拋光的不銹鋼塊件所焊接而成的一組五件，修長，曲折流轉，鏡面的「浪」。雕塑被安置在一片松樹種植林間，再逐漸延伸至開闊的地域。垂直的樹木成為了雕塑的對應線條。

每一個限地裝置呼應現場的／在地性的現象氛圍。相對於漂浮著的鈸膠翻製版本（2003），和在園林內／河裡的木雕版本（2008/2013），這鏡面不銹鋼版本突顯周遭環境的映影（2017），就像流動著的水，傾瀉而下，於行進運動中，宛若無法被停止的態勢；那是一種純粹的感性氛圍，超越了靜態的組合構成。

一種未曾到來的存在——心動

since 2003

Tempted Mind, Blowing Wind, Rising Wave, Shaken Tree.

■ Yeo Chee Kiong

On the running river,
a driftwood is floating,
like waves.
A sculptor decided to shape it,
into a 'wave'.
So that,
it could drift away,
as one of the waves,
in the river.

The Tempted Mind series was launched in 2003. In the 15 years that followed, the "wave" frequently appeared in the project in various creative nodes and developed multiple forms in response to the various display locations and different materials involved. Inspired by the famous Zen allusion, the Sixth Patriarch, Huineng's quote from Tempted Mind, the sculptor has attempted to further reinterpret this allusion through a series of works.

The story began with two monks debating over a flag that was flapping in the wind. One said it was the flag that was moving, while the other argued that it was the wind's movement that caused the flag to move. However, the Six Patriarch, Huineng's response was that it was the mind that was moving, not the wind or the flag.

In the material world of 2003, "waves" had no physical forms. They were formed when energy passed through water over a succession of moments or when the wind blew across its surface for a course of time. Through the form of the idea of waves, the artist's intention was to concretize an abstract concept through sculpture, then direct the attention of that discourse back to the material world, a world of sculpture.

The creation of the physical form of the wave was the artist's attempted answer to the same question.

In the Tempted Mind series, we see a constant commitment to the Modernist notion of "truth to material" and "purity of form." On the other hand, the contemporary emphasis on site-specificity is also important for the artist, as his sculptures are often built to engage viewers on an experiential or phenomenological level. In 2017, Hanoi, Vietnam, Tempted Mind was a set of five long, undulating, and highly polished mirror-surfaced stainless steel "waves" forged and welded together. The sculptures were then installed between the planted pine trees, gradually extending to the open field. The vertical trees form the corresponding lines of the sculptures.

Each site-specific installation adapts phenomenally to a certain on-site/in-situ aura. In contrast to the floating silicone rubber cast version (2003) and the wooden carved version in the park/river (2008/2013), the mirror-finished stainless-steel signifies the cast images of the surrounding environment (2017), like running water flowing down the slope. It seems unstoppable and appears to be moving, a pure sensation beyond the stillness of the presented formation.

The presence of absence; Tempted Mind.

We Are Queen
We Are Green

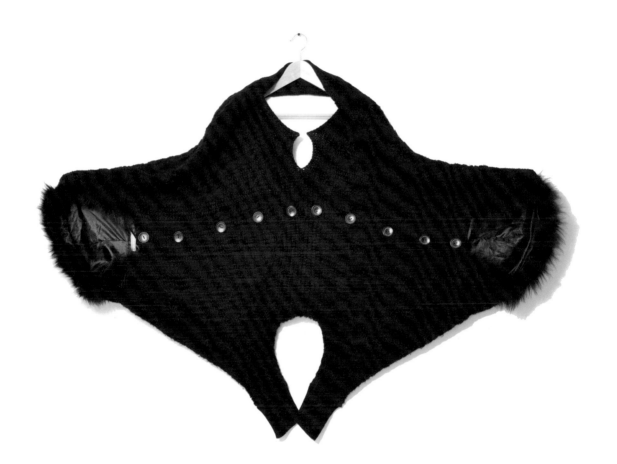

MANTIS
Recycled Fashion

Since 2013

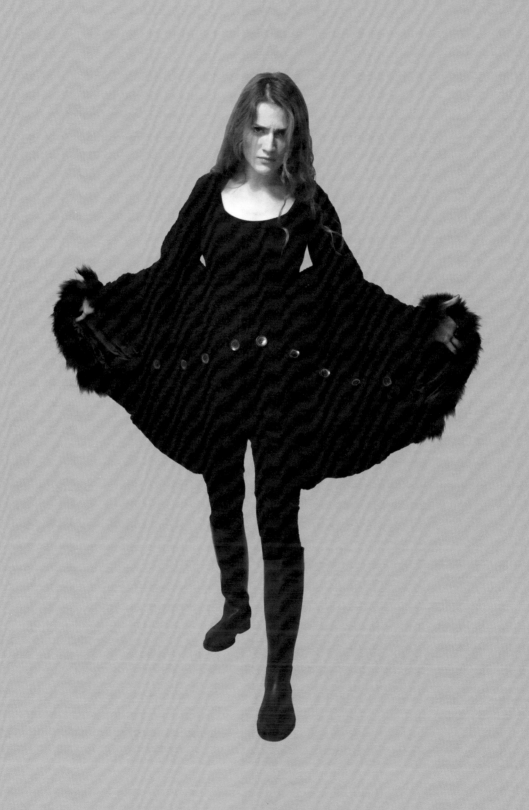

TREE
Some
Art

Since 2003

軀殼之外 In-Corporeal

2019

羅丹藝境　品級美生活館 台北市中山區堤頂大道二段 468 號

策展人｜楊子强

參展藝術家｜王耀萱　洪聖雄　洪瑞翔
曾紀熒　游雯青　鄧聖薰
賴科維　謝易晟　謝莹莹

繆思女神
The Goddess Muse

仲夏午後，金黃色的陽光緩緩地在佛羅倫斯領主廣場（Piazza della Signoria）的古老石磚上蠕動著，時間平靜的跨步在石縫間的刻度上，離晚餐的人潮還有一些距離。隨意選擇任何一間羅列於廣場一端的餐館，都可以品嚐到美味道地的海鮮義大利麵。面向著米開蘭基羅那已佇立了幾個世紀，雋永的大衛像，唇齒間徘徊著的是蛤蜊內流溢而出的海水鮮味。殷紅的酒色在高腳酒杯內輕旋，漸趨濃郁的斜光暗影緊貼著挪移的橙黃光暈，如薄紗般輕覆在那原本灰白的大理石身軀上。

有一位蘇格蘭學者說過，文藝復興的藝術精品，有百分之七十在義大利，而這百分之七十的精品中，又有百份之七十保存在佛羅倫斯這座古老的城市內，以及與其相毗鄰的鄉鎮地區。徒步的走在巷弄間，宛如走進了一個參照了西洋美術史裡，文藝復興時期的佛羅倫斯，所架構出的虛擬實境當中，真實如手機遊戲裡，一次次定點尋獲寶可夢（Pokémon）時的滿足感。適時的停住腳步，踏進小巷咖啡館來杯義式咖啡，更是必要的節奏，這才是慢活的快意。此時此地，如何懂得利用現有的時間去交換這過去就已存在的美好，才是數位生活裡無法比擬的真實存在感。身為旅人的我們常以浮誇的行旅態度介入了佛羅倫斯人的日常中，而對於當地人而言，旅人的駐足也早已成為他們日常生活的一部份了。如果繆思女神未曾留駐於此，時間終將永遠無情的往前推移而帶走所有美麗的痕跡表象，而我們也終將只能在傳唱詩人的美麗詩歌裡移情臆測和遐想。

麗美中心作為美麗日常的當代生活場域之一，以一種開放式的日常氣息，美的瑣事，來鮮活美的經驗。因此，《模糊時尚》邀得藝術評論家高千惠教授為您深度解析美容院中繆思女神們的美麗日常，以及如何與繆思女神們共同進駐的超日常體驗，作為當下真實生活的可預見參照。

楊子強

On a midsummer afternoon, the golden sun creeps slowly over the ancient stone tiles of Piazza Della Signoria. Time strides serenely across the scales between the crevices. It is still too early for the dinnertime crowd. One can choose any restaurant along the square in which to enjoy authentic, delicious seafood pasta. Facing Michelangelo's David that has stood there for centuries, the taste of clams lingers between the lips and teeth. The red wine swirls gently in the long-stemmed glass, the slanting shadows gradually thickening and clinging to a shifting orange-yellow halo-like gauze over the original gray marble.

A Scottish scholar has said that seventy percent of the great works of Renaissance art are in Italy, and seventy percent of those are preserved in the ancient city of Florence and its adjacent towns. Walking in the alley on foot is like walking into a virtual reality program that utilizes the history of Western art as its reference and was constructed during the Renaissance in Florence. The actual place duplicates the satisfaction of finding one Pokémon after another in a game on a mobile phone. The pleasure of slow living is in making a necessary but timely stop, stepping into the alley cafe to have a cup of Italian coffee. At this time and place, how to use the time given right now in exchange for the beauty that has existed here in the past is the sense of real existence with which digital life cannot compare. As travelers, it is easy to get caught up in Florence's daily life with an ostentatious traveling attitude. For local people, the travelers' stop has already become a part of their daily life. If the Muses had not resided here, time would move forward mercilessly forever, taking away all traces of beauty, and we would eventually only be able to transfer our conjecture and fancy through the beautiful verse that has been passed down by poets.

A Beauty Centre, as one of the day-to-day beauty affairs in the domain of contemporary life, adopts an open approach toward daily matters pertaining to beauty to enhance the beauty experience. Therefore, Vague Vogue has invited Professor Kao Chien-Hui, an art critic, to give an in-depth analysis of the beautiful daily life of the Muses in beauty parlours and offer insight into how to enter a superb daily experience with them, as a reference for daily life in the present.

Yeo Chee Kiong

當繆思女神進駐美容院

│楔子│

高千惠 教授

在我書寫的《不沉默的字：藝評書寫與其生產語境》、《發燒的雙年展：政治／美學／機制的代言》、《藝術，以XX之名》、《叛逆的捉影：當代藝術家的新迷思》幾本書，以及目前正在進行的《當代藝術生產線：創作實踐與社會介入的對辯》，均涉及了藝術生產的機制與空間問題。如此回首，發現我對於藝術生產的發生空間與其系統，具有個人意識上的興趣。而此探究方向的背後，在於我認為藝術作品被成立的原因，與藝術社會的結構有關。美學與政治亦無法脫離，即使我們試圖以美學或藝術史的立場評論藝術作品，也無法擺脫意識型態與文化品味的介入。

承載著展覽作為美學與社會訊息的所在，藝術生產機制當中最具權威的認證空間，即是美術館。啟蒙年代的政治哲學家霍布斯（Thomas Hobbes）曾指出，柏拉圖（Plato）的思想誕生是源於雅典民主的錯誤；奧古斯汀（Augustine）的哲學在於解釋為何羅馬被野蠻人入侵；而他自己所面對的年代困境，則是要如何說明英國內戰。基於每一個時空環境對於人類困境的不同看法，當代藝術生產模式與機制空間倫理的形成，又意味著什麼？

面對作品的展現與認證之任務，美術館的異化狀態並沒有因為是繆思的殿堂而具優雅美麗的身段，反而在展覽機制與市場機制下，被賦予一種權能角色的面具。它介入資本者、勞動者、行政服務者與資源支配者等層科結構，展示出藝術社會的微型劇場，提供文化品味的風向。法國當代文化論者布迪厄（Pierre Bourdieu）曾以文化構成的場域與品味的產生，來看社會品味建構的問題。美國當代文化論者丹托（Arthur Danto）的藝術機制論，則指出「藝術圈」就是文化構成的生產場域。他把藝術作為一種社交行為的範圍，從人類學關心的個體與社會互動中的面向，縮小到藝術機

構的形成與建制。無論是人類學或社會學的認知，美術館的存在均表徵一個地方的文化層級，而其展覽、典藏、研究與推廣，亦顯示一個地方藝術生產的水平，以及藝術社會的勢力部署。

2018年春，新加坡藝術家楊子強至國立臺灣藝術大學客座，因而有機會進一步理解其藝術創作背後的一些思維。批判性的藝術作品，其藝術性在於它們不能直白，甚至要在隱晦的狀態中開放出許多閱讀的可能性。楊子強從2007年在新加坡國家博物館展出的《無樹之日》開始，至2008以及2014年兩次在新加坡美術館重新展出，其核心思想從當初對博物館權威的調侃，轉移至藝術生產機制的課題，到後來成為《麗美中心》對「美」與「機制」之間的關係的提問。在美的定義判斷、評審機制、典藏機制等藝術生產線上，最大的加工廠是具有權力的美術館空間，而最大的增值所則是具有對價系統的藝術市場。但還有一個看不見的巨大作用力，即是那個趨動藝術社會轉進的文化資本力。

楊子強的《無樹之日》，是新加坡國家博物館「現場藝術創作計畫」中的參與之作。主辦單位讓藝術家以博物館現場的建物結構作現場的創作對話，期待藝術家能改變觀眾對博物館的觀看印象。在據點對話上，楊子強將博物館圓形大廳內的砌磚和石灰柱化成了一個融化、流瀉狀態中的生命體。(註1) 後來2014年在新加坡美術館的版本，楊子強又將館內特別展廳「密室」（The Secret Room）入口處的古典希臘圓柱溶解為一灘白色液體。那麼，藝術家旨在改變觀眾對美術館的什麼印象呢？作為詩意的、曖昧的藝術表述，《無樹之日》成為一個開放的、非宣言式的謎題。所有後續的想像與爭議，均折射出美術館這個文化機制被觀看的尺度。

THE GODDESS MUSE IN A BEAUTY CENTRE

Prof Kao Chien-Hui

Original in Chinese,
Translated by Tan Yen Peng

| FOREWORD |

I have written a few books that involve issues in the mechanism of art production and art spaces. These books include *Unsilent Words: Text and its Productive Context of Art Criticism; Biennale Fever – The Alternative Voice of Politics, Aesthetics and Institutes; ART – in the Name of XX; Rebellion in Silhouette: The New Myth of the Contemporary Artist,* and *Contemporary Art Production Line - Debates Between Creative Practice and Social Intervention* which I am currently still writing. Looking back, I find that I have a personal awareness of and interest in the system and space where art is produced. At the core of this line of inquiry is my belief that the establishment of an artwork is related to the structure of the art society. Aesthetics is inseparable from politics; even if we try to critique artworks from an aesthetics or art historical standpoint, we will not be able to eliminate the interference of ideology and cultural taste.

Housing exhibitions that carry aesthetics and social information, the art museum is the most authoritative space for authentication, among the art production mechanisms. Thomas Hobbes, a political philosopher from the Age of Enlightenment, once pointed out that Plato's ideas were born from the mistakes of Athenian democracy, and that Augustine's philosophy explained why Rome was invaded by barbarians, while Hobbes, in an era of dilemma, had to find a way to explain the British civil war. Our interpretations of human predicament differ when the space-time environment is different. In this sense, what sort of implication would we see in the way the mode of contemporary art production and the ethics of institutional sphere are formed?

In showcasing and authenticating artworks, the museum's state of alienation remains, and it does not become more sophisticated simply because it is the Muses' Temple. Instead, it is given a mask of power by its exhibition and marketing mechanisms. In its intervention in the bureaucratic structure of the capitalists, laborers, administrative service providers, and resource dominators, it reveals the art society as a mini-theater and provides the trending directions of cultural taste. Pierre Bourdieu, a French contemporary cultural theorist, looked at the issue of the social construction of taste by examining the field of cultural construction and the production of taste. On the other hand, the institutional theory of the American cultural theorist Arthur Danto stated that the "artworld" is exactly the location where cultural construction happens. He considered the production of Art within the range of social behavior and narrowed it down from the anthropological concern of an individual's social interaction to the formation and building of the art institution. Whether from the perception of anthropology or sociology, the existence of the art museum represents the cultural hierarchy of a place. Its exhibitions, collections, research, and promotional works also show the standard of its art production, and the way forces and power are deployed within its art community.

In the spring of 2018, I met Singaporean artist Yeo Chee Kiong who was at the National Taiwan University of the Arts as a visiting assistant professor. I had the opportunity to know his works and further understand some of the thoughts behind his

在這繆思的殿堂，能夠流動的語言，本來就是要很繆思。《無樹之日》之後，楊子強以大眾化、具普普色彩的《麗美中心》，取代了權威表徵的美術館。他以「愛美」、「美化」、「改造」、「美的行銷」等美容院的相關活動，比擬了美術館的相關活動。其在臺灣朱銘美術館舉辦的《金山上的麗美中心》，相關討論重心，竟被轉移到一個物化女性的性別議題上。在藝術生產線上，將藝術品味與物化女性串在一起的聯想，於彼得‧瓦生（Peter Watson）的《從馬內到曼哈頓：現代藝術市場的崛起》一書中曾出現。彼得‧瓦生舉西元前500年巴比倫的「美妻拍賣」為例，認為是人類最早的「美麗品味」之拍賣概念。早期婚姻是買賣行為，富人到市集標買嬌妻美姿，視女人為一種財產。在拍賣市集，漂亮女人的拍賣價，要包括她姊妹淘裡的「賣不掉的成本」，作為一些瑕疵或較醜的女孩之「未來嫁妝」，所以「美麗品味」的價值是包括許多看不見或與其無關的增值成本。（註2）

當繆思女神進駐美容院，會開啟藝術界什麼討論？《金山上的麗美中心》一展的相關討論，事實上迴避了「美的品味生產系統」探討，藝術家似乎也學習接受其創作方案的開放闡釋。至2018年五月，楊子強問我，時隔12年，我對於結集於《叛逆的捉影》一書的〈是誰殺了美術館？〉一文，觀點是否改變過？能不能參加他另一項以媒體作為載體，有關「美的體現」之方案？我因而得以回顧，從1990年代至2010年代，當代藝術生產模式與機制空間倫理的形成，是更加粗糙，還是更加文明。同樣的，我也把答案留給讀者。

〈是誰殺了美術館？〉一文，最早書寫於1990年代後期，文分為四個段落：有關美術館的公共性、美術館的軟體與硬體之爭、「爆堂秀」（Blockbuster Show）與「主題園」（Theme Park）的盛行，民粹與菁英定位之惑。1990年代中期，曾是藝壇「爆堂秀」與「主題園」全盛的年代，就像電影《侏羅紀公園》（Jurassic Park）的暴龍特質，它們是寄居在巨大、誇張、暴力視覺經驗下的娛樂美學，總是有迅暴龍的速度與乖張，以及歷史化石與科學怪物滿場出現，讓人措手不及，又要驚呼又不願錯過現場，讚嘆驚嚇之餘，還要在電影院外搶購一堆塑料紀念品回去當時髦的交待。

《無樹之日》（2007），新加坡國家博物館（局部）
A Day Without A Tree (Detail) (2007), panorama view, National Museum of Singapore.

artistic creations. The brilliance of critical artworks requires that they are not overtly straightforward; even better, they should be ambiguous and have an openness that allows for the possibility of various readings. Yeo Chee Kiong first exhibited his *A Day Without A Tree* at the National Museum of Singapore in 2007. Different versions of the same work were shown again, twice, in the Singapore Art Museum in 2008 and 2014. Between the exhibitions, the core idea of the work shifted from the original inquiry of the authority of the museum to the issue of the institution of artistic production, which later developed into a quest for the relationship between "beauty" and "institution". In art production, which includes the scheme for judging and defining beauty, the system of evaluation, and the mechanisms of collection, the museum is the largest and the most powerful processing factory, while the entity that has appreciated most in value is the art market with the price system. However, there is also a huge, invisible force at play; that is, the cultural capital that drives the art society to move forward.

Yeo Chee Kiong's *A Day Without A Tree* is a work created for the "Art-On-Site Programme" of the National Museum of Singapore. The organizer allowed the participating artists to establish dialogue with the museum's architectural structure and expected that the artists would be able to bring changes to the viewers' impressions of the museum. In this site-specific exchange, Yeo transformed the bricks and the columns under the rotunda of the museum, turning them into a live body in a melting and flowing state. (note 1) Later in 2014, at the Singapore Art Museum, Yeo "dissolved" the classical Greek columns at the entrance of the building's special exhibition hall "The Secret Room", turning them into a pool of white liquid. So, what changes does the artist expect in the audience's impressions of the museum? As a poetic and ambiguous artistic expression, *A Day Without A Tree* is an open-ended, non-declarative riddle. Any imaginings and controversies that develop with the work thereafter will reflect the scale to which the museum as a cultural mechanism is viewed.

In this Temple of the Muses, we ought to find flowing language that is supposed to be amusing. After the A Day Without a Tree, Yeo replaced the authoritative art museum with the secular, Pop-Art-flavored *A Beauty Center*. He compared and linked events in the museum to activities in beauty salons such as "love for beauty," "beautification," "reformation," and "beauty marketing." However, in the forum for his exhibition "*A Beauty Centre at Jinshan*", held at the Juming Museum in Taiwan, the focus of the discussion was diverted to gender issues and the objectification of women. In art production, we have seen the associations between artistic taste and the objectification of women in Peter Watson's book *From Manet to Manhattan: The Rise of the Modern Art Market*. Watson cited the example of the Babylonian marriage market in 500 BC, which he considered to be the earliest example of the auctioning of "beauty" according to the taste of a class of people. In ancient times, marriage was a business transaction; rich men went to the market to bid on and purchase a pretty wife, and women were treated as a kind of property. In the auction, the bidding price of a pretty woman would have to include her sisters' "cost of the unsellable" as the uglier or flawed girls' "future dowry". Therefore, the increase in the value of "beauty" had to include many other unseen or unrelated costs. (note 2)

So what kind of discussions would be opened up in the art world when the Goddess Muses enter and settle in the beauty center? In fact, the discussions related to the exhibition "A Beauty Centre at Jinshan" evaded the issues surrounding the "production system of the taste for beauty", while the artist seems to have learned to accept the open-ended interpretation of his creative scheme. In May 2018, Yeo asked me whether my opinion expressed in the article "Who Killed the Art Museum", collected in the book *Rebellion in Silhouette*, had changed after a lapse of 12 years and whether I could participate in another of his projects that use media as a carrier and related to the "reflection of beauty". I am therefore able to review, in retrospect, whether the mode of production and the ethics of the institutional sphere for contemporary art have become cruder or more civilized from the 1990s to the 2010s. Again, I will leave the answer to the readers.

"Who Killed the Art Museum?" was first written in the late 1990s. It is divided into four sections: the museum as a public sphere; the competition for software and hardware competencies between museums; the prevalence of "Theme Parks" and "Blockbuster Shows"; and lastly, the dilemma of the populist's versus the elitist's stands. The mid-1990s was once the golden era of "Theme Parks" and "Blockbuster Shows" in the art world. Just like the unique character of the Tyrannosaurus from the movie Jurassic Park, the era provided a kind of entertainment aesthetic that was based on a huge, exaggerated, and violent visual experience. Always agile and wilful, these creatures appear in scenes filled with archaeological fossils and *sci-fi* creatures, catching people off-guard, making them yell with fear and yet unwilling to leave the scene. The audience praised the movie while still in shock and would not go home without snatching a bunch of plastic souvenirs outside the cinema to keep up with the trends.

"Who killed the Art Museum?" was once the theme of a forum. It asked questions such as, what does the contemporary art museum want? Who makes decisions about the bearings and directions of the contemporary art museum? What kind of artists and audiences does it appeal to? What kind of new links does it make between academic research and entertainment? What new relationship does it have with popular culture? Furthermore, do changes in a museum's administrative structure lead to changes in its operation? And, how does the Exhibition unit become more important than the Collection and the Research departments? Should regional art museums have individual cultural missions, or should they be allowed autonomy and free competition? These problems have placed the "Art Museum" beyond the boundaries of the "Temple of Muses", making it a public forum where opinions on politics, culture, society, economy, and education could occur together.

When the National Museum of Singapore, who organized the "Art-On-Site Programme", called for artists to dialogue with the museum's architectural structure in 2007, they were hoping for the artists to transform the viewers' impressions of the museum,

《無樹之日》（2007），新加坡國家博物館（局部）
A Day Without A Tree (Detail) (2007), panorama view, National Museum of Singapore.

〈是誰殺了美術館？〉也曾是一個座談會主題。到底當代美術館要的是什麼？是誰在決定當代美術館的方位？它所訴求的藝術家與觀眾群是哪些？它如何在學術與娛樂之間建立一座新橋樑？它與大眾生活文化又有什麼新關係？甚至，美術館內的行政機制之結構變化，是否會影響美術館的經營面向？還有展覽單位的重要性強過典藏部門與研究部門的現象是如何發生？一個區域裡的美術館應該有個別的文化任務，還是任其自治或自由競爭？這些問題均使「美術館」溢於「繆思的殿堂」之限，成為今日政治、文化、社會、經濟、教育都交集得到的公議廣場。

當 2007 年，新加坡國家博物館「現場藝術創作計畫」中，主辦單位讓藝術家以博物館現場的建物結構作現場的創作對話，期待藝術家能改變觀眾對博物館的觀看印象時，究竟期待中有沒有一個答案的方向？至 2018 年，許多美術館紛紛以雙年展主題，而變成政治、文化、社會、經濟都交集得到的公議廣場時，傳統的美術館意象似乎真的溶化了。但溶化後，形塑的藝術載體空間會是什麼？楊子強的大眾化、普普化、媒體化、文娛化的「繆思殿堂」之延伸，似乎是一則未來藝術社會的生產寓言，而我以下這篇過往的〈是誰殺了美術館？〉之論述，則姑且成為一種雙向的互文參照。

———— 註 ————

1. 參見藝術家的「A Day Without A Tree」2007 年展覽目錄。
2. 參見 Peter Watson, *From Manet to Manhattan the Rise of the Modern Art Market* (London: Hutchinson, 1992), 46.

《無樹之日》（2014），新加坡美術館（局部）
A Day Without A Tree (Detail) (2014), panorama view, Singapore Art Museum.

but were they expecting a certain kind of answer? By 2018, many art museums scurried to hold biennales with themes that brought discussions across the fields of politics, culture, society, and economics; this turned the art museum into a public forum and dissolved our image of the traditional art museum. But, after the traditional art museum is transformed, what would the space that houses formal art be like? Yeo has made an extension from the Muses Temple to the secularized and popularized world of media and entertainment, seemingly making an allegory of the production of the art society in the future. As for the discourse raised in "Who Killed the Art Museum" which I wrote some time ago, it shall, for the time being, serve as a two-way, intertextual reference to the issues.

------ Note ------

1. See exhibition brochure *A Day Without a Tree* (Singapore: National Museum of Singapore, 2007)
2. Peter Watson, *From Manet to Manhattan: The Rise of the Modern Art Market* (Random: NY, 1992), p.46

是誰殺了美術館？

高千惠 教授

▎有關美術館的公共性 ▎

從人本的角度看，認識經典裡的樂園想像與烏托邦概念，可以在面對今日的美術館時，看到人類在不同社會結構下的慾求。而如果，當代美術館的展覽與典藏項目無法匯集出年代裡的美學經驗或社會經驗，它在研究與推廣上也很可能因雜化與快速更替，而逐漸失去它的教育機能，並被解放成一個舒適的、無需費神的休閒娛樂場所。

如果，我們至今還認為「美術館」一如神聖教堂，是精神與信仰的膜拜場所，是洗滌心靈的修養道院，那顯然我們還沒有面對近代美術館已典藏的精神：典藏現世文化的誇耀。而這個趨勢，迫使我們也要逐漸接受，日常物件出現在美術館的新典藏價值。它的有形典藏，包括固定留下來的作品、文獻檔案、文教計劃等可見的物質。它的無形典藏，則包括活動的藝術家、流動的作品、進出的人物、願意贊助、支持的單位團體等不定的變數與因素。這些集聚的內容，遂使當代美術館成為當代社會裡，處於通俗性與邊緣性的交割位置上，一個極具爭議性的文化權力空間。

自過去五十年間，美術館的社會功能已明顯在轉型中，且世代有新意。1950 年代，詮釋運動（Hermeneutic Approach）下的美術館功能是刺激群眾與挑戰既有定義，美術館不再是填鴨教室，觀眾要依自己的經驗重新觀讀歷史上的新義。1970 年代，美術館進入生態介入期，法國博物館學家喬治‧亨利‧李維拉（Georges Henri Riviere）的新理念提出美術館生態三大要素：建物、典藏與群眾之結合。他的生態美術館運動（ecomuseum movement）之主張，乃是利用地方天然或既有資產打造地方人文的庫藏，以觀眾認知地方文史為要。生態館適合郊區，後來許多閒置歷史空間之再使用，並與地方產業結合的理念，大致出自這種地方人文展現與建史的概念。它擴張到落後城鎮，至 1980 年代中期，成為社區文化

《無樹之日》（2007），新加坡國家博物館（局部）
A Day Without A Tree (Detail) (2007), panorama view, National Museum of Singapore.

戰鬥營（militant action）。芝加哥後來的文化行動（Cultural Action），以及一些藝術家參與社區據點的建設夢想，則將此運動延伸到替代空間的領域。另外一些屬第三世界地區，還在貧民區作反毒、反暴力與性疾的主題展示。這支運動為具有社會意識的藝術家所認同，甚至在新世紀的一些前衛性國際大展裡，都特別展現了這些自然與社會生態的研究貢獻。

WHO KILLED THE ART MUSEUM?

Prof Kao Chien-Hui

Original in Chinese,
Translated by Tan Yen Peng

| THE MUSEUM AS A PUBLIC SPACE |

From a humanist point of view, knowing the garden of delights and the concept of Utopia from the classics would allow us to see, when facing today's art museums, human beings' needs and desires under different social structures. However, if the Exhibition and Collection of the contemporary art museum do not compile the aesthetic experience or social experience of an era well, it may possibly face difficulties in its research and in promoting ideas if changes and complications happen too rapidly. It may then lose its educational function gradually, and even become a free, comfortable entertainment venue that does not require mental work.

If, today, we continue to think of the "art museum" as a holy temple, seeing it as a place for spiritual and religious worship, or a sanatorium for cleansing the soul, then we apparently have failed to identify the museum's new spirit of collecting - it is one of boastfulness. This trend forces us to gradually accept the value of new collections of daily objects that appear in art museums. The tangible collections include permanent artworks, documentation and archives, cultural and educational program files, and other tangible materials, while the intangible collections include the active artists, portable and mobile artworks, existing people, units or groups willing to give support and sponsorship, and other changing or mutable elements. This agglomeration places the contemporary art museum at a transactional position between popularity and marginality within contemporary society. It is an extremely controversial cultural sphere of power.

In the last 50 years, the social function of the museum has been clearly transformed and new ideas emerge every generation. In the 1950s, under the influence of the Hermeneutic Approach, the function of the museum was to provide stimulation for the masses and to challenge existing definitions. The museum was no longer a "cram school"; audiences have to reread and rediscover new historical meanings according to their own experiences. In the 1970s, art museums entered a period of eco-intervention. The French museologist Georges Henri Riviere proposed a new concept of the ecology of the art museum, where there is an integration of the three elements of the building, the collection, and the public. His eco-museum movement advocated the use of natural or existing resources to create a treasury of the cultural history of places and emphasized the public's learning of local histories. The eco-museum is suitable for the suburbs; the recent idea to reuse unutilized historical spaces and collaborate with local industries mainly derived from such a concept. This concept has further expanded to towns that had fallen behind in development, and many became camps for cultural militant action in the communities during the mid-1980s. Later, Chicago's Cultural Action, together with artists who were involved in realizing the dream of community construction, would extend and usher this movement into the field of alternative spaces. Other than that, some parts of developing countries are still involved in the showcase of subjects such as anti-drug, anti-violence, and campaigns for sexually transmitted diseases. This movement is recognized by artists with a social consciousness. Some major avant-garde

Two Melted Plaques 2007

《無樹之日》（2007），新加坡國家博物館（局部）

A Day Without A Tree (Detail) (2007), panorama view, National Museum of Singapore.

1965年至1995年之間，是美國國家文藝基金會最支持當代藝術的三十年，許多重要當代美國藝術家都曾受惠於此官方支援，作出非營利性的創作。1989年之後，文化不再是冷戰時期的重要思想利器，美國更因幾件挑釁宗教、道德的作品而引起文化論戰。1990年代之後，官方便逐漸消減對藝術的支持與信任，至1995年則全然取消對視覺藝術家的支助。而在此時，藝廊與美術館的年代也已醞釀成形，藝壇的資本與資訊年代同時到來。

在經營生存上，藝壇爭取風行中的高科技企業支持，也改變了藝術作品的適存方向。1990年代中期，跟進新科時潮，一些博物館、美術館、文化中心逐漸重視新科技訊息，打出「藝術與科技」招牌，重視電子資訊與視覺聲光，使美術館成為科技展區，並賦予一些人文詮釋的文本內容，提出美術館的新科教育推廣功能。科技展在太平洋兩岸特別風行，甚至在新世紀中國、日本、韓國、台灣繼起的一些雙年展主題或內容裡，也比歐陸強調科技媒材，以此作為前進的指標。

相對於亞洲新美術館之重視未來，歐陸新美術館則較重視歷史記憶。歐洲地區的美術館，在過去十餘年間多傾於憑弔與記憶上的歷史保存。北歐美術館長期注重此文化機能，瑞典還有一開放空間的美術館，是傳統農作的保留現場。挪威也不斷在增設勞工博物館，紀念他們的工業生產史，陳列其農工業轉型的現代化過程。另外，北美、歐洲、以色列地區，對歷史戰役、屠殺等人類經驗與族群記憶特別強調，多成立悼念館，一些展覽也經常以此為主題。法國與英國更常使用一些老建物改成的藝術展區，做二次世界大戰期間的追悼活動。一些歐陸美術館相信文化機制應包括撫平歷史創傷的社會功能，所以不避新傷舊疤，一再將經驗化

international exhibitions of the new century have even had special exhibitions of their contributions to the research of nature and social ecology.

Between 1965 to 1995 are the 30 years during which the National Endowment for the Arts in the United States had shown most support for contemporary art. Many important contemporary American artists benefited from this official aid and created artworks on a non-profit basis. After 1989, culture was no longer an important ideological weapon in the Cold War, and there were even cultural debates in the United States because of several pieces of artwork with provocative religious and moral themes. After the 1990s, there was a gradual reduction of trust in and official support for the arts. In 1995, grant support for individual visual artists was canceled totally. By this point, a new era of art galleries and art museums had gradually taken shape. At the same time, the ages of capitalism and information have arrived together in the art world.

In terms of business survival, the art world's reach for the support of high-tech enterprises has also changed the way artworks make adaptations. In the mid-1990s, following the trend of new technology, some history museums, art museums, and cultural centers began to pay attention to information on new technology. Promoting "art and technology", the emphasis was placed on electronic information, sounds, lights, and visual effects. Art museums were turned into places for the showcase of science and technology, while humanist interpretations were added to the written texts. In this way, the art museum was put forward as a site for educational purposes. Exhibitions of science and technology were particularly popular on the shores of the Pacific Ocean. In fact, there was more emphasis on the use of technological media in the themes or contents of some biennales in China, Japan, South Korea, and Taiwan than in Europe. Technological media was taken as an indicator for measuring progress.

Compared with the new Asian art museums' emphasis on the future, continental art museums paid more attention to historical memory. For more than over a decade, art galleries in Europe have tended to focus on paying homage to and preserving history. The Nordic art museums have long been paying attention to this cultural function of their institutions. Sweden even has an open-space art museum that was originally a site of traditional farming, while Norway has also been increasing the number of labour museums to commemorate their history in industrial production and to showcase the modernization process of its agro-industrial transformation. In addition, regions such as North America, Europe, and Israel have placed special emphasis on human experiences and ethnic memories such as historical battles and massacres. Many memorial halls have been established and some exhibitions often use this as a theme. France and the United Kingdom frequently make use of art exhibition spaces converted from old buildings for the purpose of memorial services for the Second World War. Some European art museums believe that cultural institutions should assume the social function of healing historical trauma, and frequently turn historical wounds and injuries into aesthetic experiences. Although the emerging contemporary art museums have put forth statements to "go local and think global", the emerging art museums in the East Asia region are actually more focused on achieving internationality, believing that cross-regional, cross-disciplinary, or international activities and the intervention of international art personalities could enhance international reputation. And whether it is increasing the functions of social transformation, the promotion of new technology, or the retrospection of historical memory, art museum operators are always capable of finding the right cultural rhetoric and advance with the times, as they position themselves between a "regional" spirit and an ambition to go "international".

These factors such as the time period, geography and cultural policy have little by little changed the function and content of the museum as a public cultural sphere. The commercialization of the contemporary art museum is especially an important turning point in the art scene of the new century. Besides the surface changes in management methods, the traditional structure of the contemporary art museum has also been transformed, while history, knowledge, art, aesthetics, leisure, and entertainment all come together to give rise to new values. At the

OPPS ... Kids ... 2007

為美學。雖然當代新興美術館都打「立足本土,放眼天下」的理念説法,但比較之下,東亞一區的新興美術館,其實都較注重國際性效益,也相信舉辦跨區、跨領域或找國際藝壇活動者介入,可以提昇國際知名度。而不管是加入社會改造機能、新科成就推廣、歷史記憶回顧,處於「地域性」精神與「國際化」的野心之間,美術館經營者都可以找到很好的文化修辭,隨時代前進。

這些年代、地理、文化政策因素,使美術館這個公共文化空間的機能與內容逐步變化。當代美術館的產業化是新世紀藝壇的一個重要轉折現象,但除了表面經營方式的改變之外,當代美術館的傳統結構也正從歷史、知識、藝術、美學、休閒娛樂等交集中流竄出新的年代價值。在 21 世紀之初,美術館的定義在非學術刊物的大眾報章雜誌頻頻出現,充分顯示出美術館的公共性已成為大眾文化的新議題。

Be Careful ... 2007

《無樹之日》（2007），新加坡國家博物館（局部）
A Day Without A Tree (Detail) (2007), panorama view,
National Museum of Singapore.

beginning of the 21st century, attempts to define the art museum appeared frequently in non-academic journals such as newspapers and magazines for the masses, demonstrating fully that the publicness of art museums has become a new topic of popular culture.

BATTLE BETWEEN MUSEUMS: HARDWARE VS SOFTWARE

Entering the 21st century, the most hyped news about art museums was their hardware battles. In recent years, many art museums have been busy catching up with fashion and modernization and went on with plans to renovate and improve the appearance of their buildings. A large number of new or emerging art museums strove to capture the media's and the public's attention with new architectural features. And when the "art museum's stylish structure" became the most attractive "permanent collection" of the "art museum", the architects then went on to replace the

artists in the museum and were treated as the most popular "visual artists" of the era.

In New York in the fall of 2000, the newspaper *The New York Times* pointed out: "The lineup of fall shows suggests that museum professionals, driven by the desire to be financially secure, wildly popular or socially relevant, opt for one of two alternatives: exhibitions that look like upscale stores, or exhibitions that look like historical society displays." (note 1) Following that, when the British Tate re-opened, and many art museums were expanded or were rebuilt one after another in the millennium year, some commentators also observed that the newly renovated art museum attracts the public with its architectural features; they care about the hardware – the building - more than the collection. Fundamentally, the modernization of the museum's own appearance seems to have gradually forced academic scholarship to take a backseat. *The New York Observer* also made a comment on the renovation plan proposed by the Guggenheim Museum in Lower Manhattan, pointing out that the Guggenheim is no longer a stringent art institution as it "has no aesthetic standards and no aesthetic agenda. It has completely sold out to a mass-market mentality that regards the museum's own art collection as an asset to be exploited for commercial purposes." (note 2)

The Guggenheim Museum's rise in the artworld was marked by its collection of The Era of Non-Objective Painting. According to John L. Davis's biography of Guggenheim, in 1944, the renowned architect Frank Lloyd Wright proposed the museum's building plan to Solomon Guggenheim, and Guggenheim thought that the plan was rather visionary. However, it was not until 16 years later, when both of them had passed away and many things had changed, that the rather controversial round, spiral architecture was finally built on the 87th Street of New York. Although it also houses many masterpieces of the twentieth century, its greatest function is providing "cultural activities" that celebrities love. As for its most attractive artwork, it is

美術館的軟體與硬體之爭

進入 21 世紀，最熱鬧的美術館新聞是它的硬體戰。近年來，許多美術館都趕著搭上現代化的化妝車，紛紛在外觀上提出翻新改建的行動，許多新起或跟進的美術館，更是以新造形建築爭取媒體與群眾注目。而當「美術館造形結構」成為「美術館」最吸引人的「常設典藏」，名建築師遂取代館內的眾藝術家，被視為年代最熱門的「視覺藝術」創作者。

根據 2000 年紐約秋冬的美術館展項訊息，屬於大眾媒體的《紐約時報》便點出：「美術館的專家們已經被經費權限、大眾喜好、社會議題所迷惑。美術館展覽出現二個面向，不是像超大型商品舖，就是像社會視覺歷史的展示廳。」（註1）隨後，當英國泰德美術館（Tate）重新開幕，以及許多美術館在千禧之年相繼擴建或重修，一些論者亦觀察到新翻修的美術館以建築特色吸引群眾，而那些群眾多在乎建築硬體勝過典藏作品。回到一個基本層面，美術館己身的外觀現代化似乎已逐漸迫使學術研究退位。《紐約觀察報》則針對紐約下城的古根漢美術館（Guggenheim Museum）所擬之整修方案提出看法，指出古根漢已不再是一個嚴謹的美術機構，「它旨在建立一個巨大的、具遊樂性質的通俗文化帝國，罔視美學標準，也無美學目標。它完全出賣精神給大眾消費市場，把美術館的藝術收藏充當商機來經營。」（註2）

古根漢以見証「非具象繪畫收藏」（The Era of Non-Objective Painting）興起藝壇，根據戴維思（John L. Davis）的《古根漢傳記》，1944 年名建築師法蘭克 · 洛伊 · 萊特（Frank Lloyd Wright）曾跟索羅門 · 古根漢（Solomon Guggenheim）提出建館計劃，古根漢認為其方案頗具遠見。但一直到十六年後雙方都過世了，物換星移，位於紐約八十七街，頗受當時爭議的圓弧螺旋狀建物才輾轉落成。儘管它也典藏許多二十世紀現代名家之作，但它最大的功能是合於名流們喜愛的「舉辦文藝活動」，而最吸引人的作品，則是美術館自身的造形。自 1960 年代開始，古根漢便如此開啟了美術館外觀即是作品，以及美術館功能邁向文化娛樂活動中心的新趨向。

古根漢分館當中，最引起各地矚目與欣羨的應是西班牙畢爾包（Bilbao）的古根漢美術館。但是，跟畢爾包古根漢美術館聲名相當的也不是館內任何一件作品，或是任何檔期

的大展，而是設計該美術館的建築師法蘭克 · 蓋瑞（Frank O. Gehry）。蓋瑞使畢爾包的古根漢美術館成為地方觀光景點。美國密里蘇達州立大學，其大學美術館（The Frederick R. Weisman Art Museum），1993 年也延請蓋瑞加蓋新館，這座美術館的典藏以 1960 年代以來的美國普普藝術與消費性產物為主，因為蓋瑞與畢爾包的雙重聲名，該館毫無在地文化負擔地選擇了一個異國情調的小名，自稱是「小畢爾包」（Baby Bilbao）。蓋瑞的建築體本身便是一件超大型據點空間藝術，他連續替一些藝文活動中心建構，例如洛杉磯的迪士尼表演藝術中心與其 2004 年完工的芝加哥「千禧公園」之露天音樂廳與步行道，均成為區域重要觀光景點。

「蓋瑞現象」使建築藝術跨進視覺藝術的前衛領域。新世紀美術館的外觀建築不僅成為藝壇焦點，也的確捧出了許多美術館的建築師，他們使美術館因空間造形結構而遠近馳名，促使美術館成為地方觀光地標，在外庭與美術館合照的人比在館內仔細看作品的人還興緻盎然。然而匹茲堡的「安迪 · 沃荷美術館」（The Andy Warhol Museum, Pittsburg）則提出另類作法。該館八層樓高，外在硬體造形並不特別新立異，反倒是間古典花崗岩石的平凡建物，除了中門入口的玄關處，有一張沃荷金白頭髮如電擊直矗的大肖像之外，美術館外表倒像座銀行或高級旅館。沃荷美術館的建築師李察 · 葛拉克曼（Richard Gluckman）很明確指出，他就是要呈現一座「屬於你的平凡美術館」。在內部機能上，他以沃荷的作品呈現為主，空間處理上，讓人覺得像是進入沃荷的藝術展示工廠。安迪 · 沃荷的聲名自然比李察 · 葛拉克曼具普遍人氣，但作為詮釋一座名人美術館的建築師，葛拉克曼沒有喧賓奪主，而是恰守分際。

晚近新改建美術館之追求「愈大愈好」、「愈空愈美」的現象，自然也引起識者批評，認為今日之新館大多大而無當，與作品典藏不匹配。經常是財團或富豪董事們找個建築師，滿足建築師與財團的品味與手筆，使美術館硬體空間成為最大的藝術品，內部作品反倒成為牆飾壁花。以極有名的華裔建築師貝聿銘為例，貝氏一生作品無數，替法國羅浮宮加建的玻璃金字塔尤其名揚藝壇，雖在增建時遭受異議看法，但由於羅浮宮本身就有許多作品可以配合其空間，所以加建的新翼很快納入母體，成為羅浮宮有名的新入口。然而，他為美國康乃爾大學設計的強生美術館（Herbert F. Johnson Museum of Art, Cornell University），則實踐了一個「貝氏建物」的空間觀。因為是國際名建築師設計的學校美術館，

the art museum's own architectural form. In this way, from the 1960s onward, the Guggenheim initiated the trend of treating the museum's outward appearance as the artwork and the museum's function as a cultural and entertainment event center.

Among the Guggenheim branches, the most eye-catching and enviable is the Guggenheim Museum in Bilbao, Spain. However, what matches the reputation of the museum is not any masterpiece from its collection nor something from their featured major shows, but Frank O. Gehry – the very architect who designed and made the Guggenheim Museum in Bilbao a local tourist attraction. The Frederick R. Weisman Art Museum in the University of Minnesota also invited Gehry to design its new building in 1993. The collection of this museum has been based on American Pop Art and consumer products since the 1960s. Because of the prestigious reputation of both Frank Gehry and the Guggenheim Bilbao, the museum carries no cultural burdens and has chosen an exotic nickname for itself, claiming that it is the "Baby Bilbao". In fact, Gehry's architecture itself is a super-large site-specific artwork. He went on to build a number of arts and cultural event centers which have all become important tourist attractions. These include the Walt Disney Concert Hall in Los Angeles and the Pritzker Music Pavilion and the BP Pedestrian Bridge at the Millennium Park in Chicago (completed in 2004).

The "Gehry phenomenon" has allowed the art of architecture to cross over to the avant-garde field of visual arts. The exteriors of the art museums in the new century have not only become the focus of the art world but have indeed made famous many art museum architects. They are responsible for making the art museums world-famous for their spatial structures, and propelling art museums to become tourist landmarks. The visitors who take pictures with the building in the courtyard are more excited than the viewers who scrutinize the artworks in the museum. However, the Andy Warhol Museum in Pittsburg has put forward an alternative approach. The museum is eight stories high, and there is nothing unconventional about its exterior design. Instead, it is an ordinary building of classical granite stone. Except for a large portrait of Andy Warhol with his shocking, electrified white

hair at the entrance to the middle gate, the exterior of the museum is much like a bank or a high-class hotel. The architect of the Warhol Museum, Richard Gluckman, is very clear in his intention to present "an ordinary museum that belongs to you." In terms of the internal functions, he focused on presenting Warhol's works, and in terms of the spatial treatment, he made people feel as if they have entered The Factory – Warhol's grand art showroom. Andy Warhol's reputation is without doubt greater than Richard Gluckman's; as an architect designing a museum for a superstar, Gluckman has accomplished his task just so appropriately without stealing the limelight.

The recent phenomenon of museums to rebuild or renovate their buildings based on the idea of "the bigger the better" and "the emptier the nicer" has inevitably drawn criticism from experts. The opinion is that most of these buildings are too huge for no good reason since their sizes do not match their collections. Often, it is the financial groups or rich directors who pick the architects as a way to satisfy their own taste or as a gesture of wealth. In so doing, the museum's hardware – the spatial structure itself – becomes the largest piece of artwork, while the masterpieces inside the museum become wall decorations. Take the famous Chinese architect I. M. Pei for example; he has designed countless buildings in his life, and the glass pyramid built for the Louvre in France is especially famous in the art world. Although there was dissidence during the period of its construction, but due to the large number of artworks in the Louvre available to match different spaces, the new wing added was well incorporated into the main building quickly, and soon made its name as the famous new entrance to the Louvre. However, in the Herbert F. Johnson Museum of Art designed for Cornell University, he had instead put his unique "Building of Pei" spatial concept into practice. Because it was a university art museum designed by a celebrity international architect, a lot of prestige was added to the university collection. However, external exhibitors who are showing works that do not belong to the university's collection will probably need to learn the art of cutting one's feet to fit smaller shoes – they will need to find ways to match their exhibits with the now huge reputation of the museum.

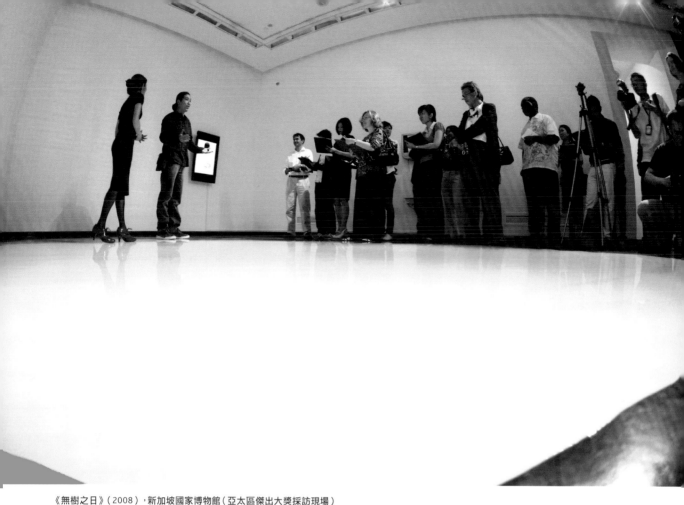

《無樹之日》（2008），新加坡國家博物館（亞太區傑出大獎採訪現場）
A Day Without A Tree (Detail) (2008), APB Signature Art Prize interview, Singapore Art Museum.

為學府館藏增加不少名門姿色，唯非館藏的外來藝術佈展者，大概要懂得削足適履的藝術。

除了康乃爾大學的強生美術館，愛荷華州的迪·莫伊藝術中心（Des Moines Art Center, Iowa）也前後延請三位當代建築師：沙瑞尼（Eliel Saarinen）、貝聿銘、麥爾（Richard Meier），將這 1916 年原來只是藝術俱樂部的藝術單位，提昇到一個區域地標式的「美術館」位置。該館原來建於 1948 年，第一位建築師是沙瑞尼，18 年後便因空間不足，1966 年又請貝聿銘來擴建。1980 年中期，空間又不夠用了，又找曾參與亞特蘭大高等美術館（High Museum）與洛杉磯蓋提中心（Getty Center）的麥爾來助陣。該館以雕塑為主，這三大建物都是名家手筆，自然是座標最明顯的超大空間裝置藝術品了。

美術館硬體與軟體之輕重相爭，在西雅圖藝術館獲得另類的平衡解決。自從藝術家巴洛夫斯基（Jonathan Borofsky）在西雅圖藝術館前作了一個 48 呎高的巨大打鐵人（Hammering Man），這個收藏歐、亞、非三洲藝術文物的綜合館便有

了一個地標上的介紹法：「那個有一個大鐵人敲鎚的美術館！」館名、藝術家、建築師是誰，倒沒有那麼搶先出現了。另外，威斯康辛州的米爾瓦基美術館（Milwaukee Art Museum, Wisconsin）也有硬體幻變的招數。米爾瓦基早年多北歐與德國移民，美術館以典藏德國藝術起家，現在已收有歐美古典、近代、裝飾工藝、與當代藝術，為綜合性地方大館。此館也一再擴建，經過半世紀擴建，至新世紀，二萬件經典又需要更新的建築體了。此次加倍擴建，由西班牙的卡拉撒瓦（Santiago Calatrava）設計。為了向另一位生長於威斯康辛州的建築大師法蘭克·洛伊·萊特（Frank Lloyd Wright）致敬，此館考慮了萊特的空間觀，並用甲板式的通路，將如船型的新館導向湖景。到了 2002 年，米爾瓦基美術館又加建了一個吸引群眾的新建物。此次，在新館右翼面湖的入口處，設計了一個巨大的銀色太陽能鳥翼，會應時張合，一時又締造了新地方觀光景點，吸引很多為了到米爾瓦基看銀鳥的遠地群眾進入館內。這些現象讓人覺得，人要衣裝，佛要金裝。倘若美術館似美人，沒有外表硬體當吸引力，那似美德的軟體也只能曖曖含光。

Besides the Herbert F. Johnson Museum of Art at Cornell University, the Des Moines Art Center in Iowa had also appointed three contemporary architects one after another: Eliel Saarinen, I. M. Pei, and Richard Meier. The unit that was originally only an art club in 1916 was elevated to the status of a regional landmark of an "Art Museum". The building was originally built in 1948 by its first architect Saarinen. After 18 years, in 1966, I. M. Pei was invited to extend the building due to the lack of space. In the mid-1980s, they ran out of space again, and Meier, who was involved in building the High Museum in Atlanta and the Getty Center in Los Angeles was engaged. As a museum dedicated to mainly sculptures, the three buildings by the three famous master architects naturally become the super-large installation art that established the place as a landmark. At the Seattle Art Museum, an alternative strategy was employed to resolve this battle of the hardware and the software between museums. Ever since the artist Jonathan Borofsky erected the 48-foot high *Hammering Man* in front of the building, this comprehensive museum, with collections from all three continents of Europe, Asia, and Africa, has gained itself a one-liner introduction: "That art museum with a giant hammering man!" Here, the museum's title, the artist, and the architect have all stepped aside. In addition, the Milwaukee Art Museum in Wisconsin has also played its trick of hardware transformation. As there were many Nordic and German immigrants in Milwaukee in the early years, the museum thus built its foundation based on a collection of German art. Now, it has become a comprehensive local museum with a collection that includes Euro-American classical art, modern art, decorative crafts, and contemporary art. The museum is also being expanded constantly. After the expansion over 50 years in the new century, 20,000 pieces of works considered classic needed to be housed in an upgraded building again. This time, the extension was designed by the Spanish architect Cala Calatrava. In order to pay tribute to the architect who grew up in Wisconsin – Frank Lloyd Wright - the museum considered Wright's spatial concept and made use of a deck-like path to lead the ship-shaped museum to the lake. By 2002, the Milwaukee Art Museum had added yet another crowd-attracting building. This time, at the entrance of the right wing of the new pavilion facing the lake, the design of a set of huge silver solar

flapping bird wings has become yet another local sightseeing attraction, drawing many visitors who would come from afar to appreciate the Milwaukee silver birds entrance. These phenomena remind us that it is indeed the clothes that make the man. If we liken the museum to a pretty women, her virtue (the software) would be dimmed without her beautiful appearance (the hardware) to attract attention.

THE POPULARITY OF "BLOCKBUSTER SHOWS" AND "THEME PARKS"

The hardware structure of the art museum has become the most attractive marketing subject of the contemporary art scene, making the art museum a large public cultural space. It is no different from trade exhibition centers with special architectural features. Its educational and research function is gradually declining and it is instead increasingly oriented toward mass tourism mentality. Even its achievement and performance are measured by the headcounts of visitors to the museum. Nevertheless, this new type of large-scale art museum with wide open spaces also has its troubles. After the mass fervor for the charm of the hardware (the building) is over, it still has to have exhibitions at the end of the day. The museums with no notable collection or without permanent exhibits will have to settle for being the "space for the display of culture" and bring in some bustling exhibition projects. The most popular exhibition direction has been the "Blockbuster Show" and "Theme Park", which will be discussed next.

In terms of attracting people, many art museums often play the trump card of "Blockbuster Show". By using themes that the public is familiar with, the audience is allowed to return to historical scenes and enjoy the sensational experience of time travel. Rather than highlighting the architect's contribution to the hardware, the magic weapon of the "Blockbuster Show" is the appearance of celebrities and famous paintings. On 2 January 2001, London's *The Guardian* discussed "blockbuster shows" in art museums, saying that "the art exhibition has become one of our favourite treats. Orgies of hype and merchandising,

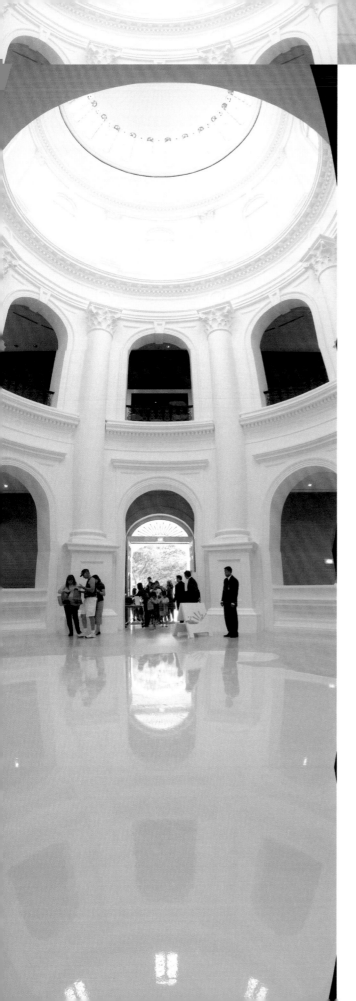

「爆堂秀」與「主題園」的盛行

美術館硬體結構成為當代藝壇最吸引人的行銷主體，使美術館成為一個大型文化廣場，它跟建築特別的商展中心無異，教育與研究機能逐漸退位，而是以大眾觀光心理為導向，並以進出人頭為美術館的成就業績。然而空間廣敞的新型大美術館也有其煩惱，硬體魅力熱潮過後，它還是要有展覽，而典藏不出色或無常設展之館，只好走「文化展示空間」路線，引介一些熱鬧的展項，其間最流行的展覽方向，便是下述的「爆堂秀」（Blockbuster Show）與「主題園」（Theme Park）。

在吸引人數方面，許多美術館在策劃上往往打「爆堂秀」的經典牌，以群眾耳熟能詳的主題為曲目，讓觀眾重臨歷史現場，享受一種神遊時光隧道的官能之旅。相對於建築師在硬體的貢獻，以「爆堂秀」為號召的利器是名人、名畫的出現。2001年一月二日倫敦《衛報》（The Guardian）在千禧開元之日，論美術館的「爆堂秀」時便提出：「藝術展已變成一種偏嗜上的迎合，喜追求狂歡興奮的人潮，彷彿是世界盃或世紀婚禮式的文化界大事。人們覺得那是一種時尚，以莫內大展為例，一群觀眾就好像時髦地要重回1870年代的莫內時光。這些現代與古代大師輪番上陣，一檔接一檔，如同走馬燈。」（註3）

1992年，文化藝術評論者亞瑟・丹托（Arthur C. Danto）寫〈美術館裡的美術館〉（The Museum of Museums）時，便微言了這個美術館潮勢。（註4）他提到後現代的美術館打造，是拿破崙時代所營造的「藝術史禮拜堂」之變體定義。從羅浮宮之新入口加建，龐畢度藝術中心之營造，均將美術館「廟堂化」。不同的是，進香團般的觀眾不再有虔敬瞻仰的心態，反倒像是逛室內廟會，要熟悉那裡有餐飲、咖啡座、禮品、書籍販賣部，還要有許多玻璃景窗與休憩角落可以眺望或穿梭。那裡可作心靈禮拜，但物質需求也明顯講究。

《無樹之日》（2007），新加坡國家博物館（局部）
A Day Without A Tree (Detail) (2007), panorama view,
National Museum of Singapore.

blockbuster shows are the cultural equivalent of a royal wedding or the World Cup - spectacles that make us feel part of a community of chat, deciding that yes, we really do all feel that late Monet is as fascinating if not more so than the Monet of the 1870s. Last year hardly a week went by without the opening of some absolutely unmissable show, and this year the procession rolls on, genuflecting before one modern or ancient master after another." (note 3)

The cultural and art critic Arthur C. Danto made a mild critique of this trend of art museums when he wrote *The Museum of Museums* in 1992. (note 4) He mentioned that the post-modern creation of art museums was a variant of the "Cathedral of Art History" from the Napoleonic era. The new entrance of the Louvre and the construction of the Pompidou Art Center are what make the art museum a "temple". The difference is that the audience no longer has the sincere and respectful attitude of a devotee. Instead, it is like an indoor temple fair where visitors will go around to find out where the restaurant, cafe, gift shop, and bookstore are. Glass windows for views and lounge corners for resting are also necessary; while visitors are here for a journey of spiritual worship, the material needs must be properly attended to with refinement.

In the ten years after the publication of *The Museum of Museums*, the museum as a cultural space was rigorously discussed. As the population of art museum-goers grew steadily, cultural scholars were increasingly becoming intolerant of the crowds in these "temple fairs". They found that there was not much growth in the population of genuine art-lovers; the art museum was only a public leisure venue with a certain cultural atmosphere. In fact, very few people would actually go to the museum for the artworks; more appeared there for the purpose of cultural socialization or were there because of media promotion. Nevertheless, the rivalry for visitors has become warfare among art museums. At the beginning of the 21st century, the two types of museum hype were achievements in hardware with a memorable feat of architecture, or in software, with gimmicks in the curatorial strategy.

"Blockbuster Shows" were popular from the 1980s to the 1990s. Because of cuts in cultural funding at that time, art museums had to find ways to help themselves, spending large sums of money on huge exhibitions in order for bigger returns. The earliest example of the international blockbuster show was the Tutankhamun Exhibition in the early 1970s, which broke a record by pouring all of its resources into funding one single exhibition. Its success attracted the attention of museum managers, and the idea that "the organization of exhibitions makes income" became an important business and management concept. In the 1980s, when the "Blockbuster Show" became a buzzword for art museums, galleries, cultural centers and technological centers, formats included:

· Large-scale loan exhibitions, which would draw unusually huge crowds to queue for the show.
· Exhibitions that were successful in their planning and marketing strategies.
· Popular yet high-end displays of cultural artifacts that belonged to certain historical periods, attracting the masses with different tastes to queue and pay for the show.
· Marketing strategies that involved urgency and immediacy, using short runs to encourage visits within a short period of time.
· Secularization of academic contents to meet the needs of the majority for leisure, entertainment, and common cultural knowledge.
· Institutional units breaking even or even making profit through organizing exhibitions.

Whether it is an exhibition for the visual arts or a showcase of cultural relics, these "Blockbuster Shows" have one thing in common; that is, they are not productions by local artists nor from local industries. It shows that marketers are well aware that "local art" does not carry the sort of "exoticism" that would charm the public. In addition, "Blockbuster Shows" are the so-called "edutainment" which confuses education with entertainment. As the "Blockbuster Shows" distance themselves from academia, museum directors claim that they are "using the crowd to promote the collection of the museum". As for those without collections, they would have to depend on increasing popularity as a way to achieve fame.

After the "Blockbuster Shows", political terms became more prevalent in the artworld than aesthetic ones. When museums looked for their new management

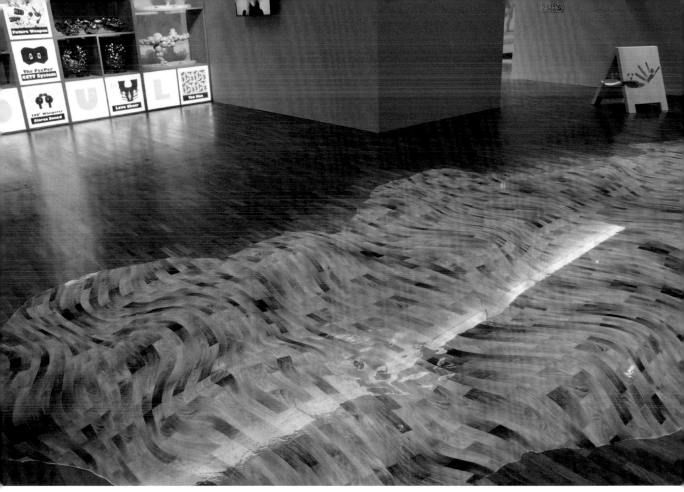

《無樹之日》（2016），新加坡麗美中心（局部）
A Day Without A Tree (Detail) (2016), A Beauty Centre, Singapore.

在該書發表之後的十年間，美術館空間更被廣泛討論，逛美術館的人口日益增多，文化學者卻愈來愈受不了這股逛廟會的人潮，他們發現真正喜愛藝術的人口沒有增多，美術館只是某種文化氛圍製造下的休閒公共場所。很少人真正到美術館看作品，更多人在那裡出現是基於文化社交與媒宣效應。然而，爭取群眾已經成為美術館間的競爭。在21世紀初，美術館最熱門的二大新聞：硬體上的建築名堂，軟體上的策展花招。

「爆堂秀」於 1980 年代與 1990 年代之間盛行，由於當時許多文化經費遭受刪砍，美術館只好自力救濟，花大錢辦大展賺大錢。最早的國際「爆堂秀」之例是 1970 年代早期的「土塔克曼埃及法老展」（Tutankhamun Exhibition），創出美術館所有公關經費資源全都傾於支援一展。它的成功引起美術館經營者注意，逐漸發現「辦展也能有收入」的營利制衡念頭。1980 年代，當「爆堂秀」成為美術館、藝廊、文化中心、科技中心的流行語時，它的形式包括：

· 大型借展，能讓多數觀眾反常地甘願排長龍看展。

· 屬於策劃與行銷技法成功的展覽。

· 通俗而又高檔的展示某一時空文化，誘引雅俗大眾都願排長龍掏腰包前往。

· 具有緊急與即時性，提出有限時期參與的行銷法，促使觀眾短期內趕往應景。

· 學術通俗化，以滿足多數群眾的休閒娛樂和文化常識之需要為主。

· 透過展覽，能為展出單位平衡開支，甚至賺錢。

無論是屬藝術展或文物展，這些「爆堂秀」有一個共同點，就是它們都不是屬於在地藝術家或地方產業，也說明在行銷市場上，行銷者善知「地方藝術」沒有「異國風物」的群眾魅力。此外，「爆堂秀」混淆教育與娛樂，也就是所謂的「寓教於樂」。針對「爆堂秀」遠離學術研究，館長們則自稱「藉人潮推介館藏」，沒有館藏的，只好把人氣視為名氣的培養。

executives, the priority consideration was their ability in fund-raising, marketing, and public relations. In the so-called "culture industry" where culture and business are interdependent on one another, the "Blockbuster Show" makes a superb case study of a phenomenon; it is controversial but widely imitated. The "Blockbuster Show" could be seen as the result of a capitalist promotion of culture; it gradually changes the way in which cultural producers and the general public view the art museum. By the beginning of the 21st century, when the cultural producers looked back, they would be surprised to find that the power of fame and celebrity had taken over that of professionalism.

The museums best at planning "Blockbuster Shows"are mostly those with the "big brother" status. These museums often have exteriors that have lost their potential to grab attention, but yet have collections that are historically famous, which allow them to organize "historical themed shows", create touring exhibitions, or spark media trends. In the case of the art museums in the United States, the National Gallery of Art in Washington, the Metropolitan Museum of Art in New York, and the Art Institute of Chicago are all comprehensive museums that house not only collections of Europe, Asia and Africa but also traditional and modern art. In recent years, almost all of the modern art "Blockbuster Shows" of 1850 to the present have come from these three institutions. (note 5) During these shows, related merchandise and publications are released together. This has quickly become a cultural trend for exhibitions in art museums. The three museums have also combined the forces of their resources and reputations, and have held non-Western art themed exhibitions such as "Treasures from The Forbidden City", "Artifacts of West Africa" and "Taoism and the Arts of China". There was grand media publicity for each of these exhibitions, making them key events of the region. These exhibitions often took three to five years of planning; that they were viewed as investments is apparent.

In order to meet the needs of the masses, many art museums willingly sacrifice the clarity of their position. While the bigger, comprehensive museums are able to organize blockbuster shows for "famous people and famous objects", they have also held some contemporary themed exhibitions. Take the special exhibition section on the second level of the Art Institute of Chicago for example: a major Bill Viola retrospective there stole the limelight of other contemporary art museums. Another example of a blockbuster show of the century that made international headlines was *Sensation: Young British Artists from the Saatchi Collection* at Brooklyn Museum of New York in 2000. This exhibition stirred up controversy amongst American conservatives and liberals, and even the then Mayor of New York, Giuliani, intervened. This caused a dramatic increase in the number of visitors to the exhibition, the traffic was affected, and newspapers from all over the world reported on the event. Arnold Lehman, who was the Brooklyn Museum director at that time, was criticized for his populist direction. (note 6) However, Lehman did not mind the attack and declared that he would give up the so-called in-depth academic research for the majority public if he was given another chance. (note 6) However, after all the commotion, this "foreign exhibition" did not create much impact on the local American masses or the art world. Instead, after the *Sensation* show, the young British artist group became famous, this new art movement and liberal style shone and gained popularity overseas, and London almost becomes the site of the new art trend of the century.

In fact, the launch of themed exhibitions to the masses is in the mold of the hot theme park exhibitions of the previous period. Major exhibitions such as biennials and triennials are the best examples of contemporary theme park shows that are huge and bustling. Many major projects of modern art museums in the new century are often "Biennales" too. Internationally speaking, the few biennials or triennials that have a historical background are usually municipal cultural events, which often require fixed or alternative exhibition venues. There are a lot of available spaces for use since the art museums of the new century are faster at producing their hardware resources than their software; it is, therefore, a very natural thing that Biennales are often hosted at art museums. Museums without a strong body of collection that has international potential tend to plan for "biennial-style theme parks" to enhance international visibility. The "Themed Exhibition" and the "Blockbuster Show" have a number of things in common: they are good at absorbing "big shot" figures and artworks from all

「爆堂秀」之後，藝壇的政治性語言也多於美學語言。美術館尋找新行政人員時亦多考慮具有募款、行銷、公關之能力者。在文化與商業相生相息的所謂「文化產業」裡，「爆堂秀」該是首推的現象案例，既充滿爭議，又被爭相效法。「爆堂秀」算是資本化文化促銷的結果，它逐漸改變文化人與普羅大眾看待美術館的角度。至 21 世紀初，它的影響力發酵，文化人在驀然回首時，不免驚覺另一股名流勢力已取代專業勢力。

最會策劃「爆堂秀」的常是硬體外型已經無可發揮，但典藏則具歷史名氣，可以製造「歷史性主體展」，還可以造成巡迴展，激發出媒體風潮的大老之館。以美國美術館而言，華盛頓的國家美術館、紐約的大都會美術館與芝加哥的美術館，這三館均屬綜合性大美術館，擁有歐、亞、非三大洲典藏，又有傳統與現代的收藏品，近年來有關 1850 年來至今的現代藝術「爆堂秀」幾乎都出自三家手筆。（註5）展出時，相關禮品、書籍一起出爐，一時間成為展期的文化時尚。這三館也結合本身的資源與名氣，舉辦過「故宮五千年文物」、「西非文物」、「道教展」等非西方藝術主題展，每一展均在媒體大作文宣，成為區域藝文要事。這些展往往是三至五年計劃，投資心情自不在話下。

為了迎合群眾需要，很多美術館自願定位混淆。綜合性大美術館除了可以有「名人名物爆堂秀」之外，也作了一些當代性的主題展。以芝加哥藝術館二樓的策劃展區來說，曾經製作「比爾・維爾拉」（Bill Viola）的大型影錄回顧展，搶盡當代館風頭。因具國際新聞而造成「爆堂秀」的新世紀之例，可再以 2000 年紐約布魯克林美術館的「英國聳動展」（Sensation: Young British Artists from the Saatchi Collection）為例。它炒動出美國的保守派與自由派之爭，連當時紐約市長朱利安都出面干預，但卻造成參觀人數暴增，交通幾近阻滯，而各國報章也均轉載了此事件。當時任職於布魯克林美術館的館長阿諾・拉曼（Arnold Lehman），曾被批評走藝術民粹路線，他一點也不為意，甚至公開表示，再讓他選擇一次選展風格，他還是寧可要廣大的一般群眾，而捨棄什麼深度的學術研究。然而看過熱鬧，這個「外來展」對美國本地群眾或藝術界也沒多大影響，反倒自「聳動展」之後，英國年輕藝術團體聲名大噪，倫敦幾乎成為新世紀初的新潮流據點，英國的新藝術動向與開放風格在隔海一役中被發揚光大。

有關主題展大眾化的推出，便是年代上熱門的主題園展覽模式。當代最熱鬧的大型主題園製作，可以雙年展、三年展之類的大型企劃案為例。新世紀許多現代美術館的企劃案，最大的一筆也常常是「雙年展」。國際少數具歷史的雙年展或三年展，是屬於市政文化活動，但在展覽據點上往往需要一些固定或替代空間。新世紀美術館硬體比軟體打造得快，可用空間多，由美術館主辦雙年展，便成為渠到水成之計。典藏不夠國際性，但具有現代化展示空間的美術館，經常傾於以策劃「雙年展式的主題園」來提昇國際知名度。「主題展」與「爆堂秀」共有之處，便是吸收各地名品、名人，借展又沾光。快則三至四月，慢則三至五年，便可以公開展演。

美術館的雙年展製作，最重要的三大「爆堂」條件，一是主題要有魅力能獨領風騷，二是要有國際名家參與以增份量，三是要有公關媒體強打以製造風頭。美術館舉辦國際大展，因為機制是現成的，需要代換的只是策展主題、藝術家、藝術作品，因此當代諸「雙年展」也形同是當代藝壇的「爆堂秀」，只不過此「爆堂」往往是指藝術家人數與藝壇圈內人士，未必是觀眾數目。

在空間營造上，裝置作品適可區隔出園區分站（Station），觀眾可以在每一區裡尋找到站長提供的驚奇。參與性或互動性的作品提出非視覺性的美學，他們更像科技展或商展裡的樣品，希望觀眾玩玩看。而藝術家則像市場分析員，經常要在程式裡設計出統計結果。雖然都具遊園性質，但每一個公園都要打出主題名號，這些名號大玩文宣遊戲，但卻能使藝術家們趨之若鶩，努力迎合，以至於新世紀的藝術家們也出現復古風，藝術家像文藝復興期的承包方案者，他們信譽良好且具票房，可以應題應景地佈展，頗受策展單位歡迎。一些自覺性高的方案創作者，懂得在各主題園裡經營自我，或切割一些邊緣議題，使他／她的場域有了知性或反省性，甚至視觀眾為其作品的一部份，顯示出他們有別於純官能性遊樂園之處。

雙年展的主題，還可以帶動藝壇思潮。每一次重要的國際雙年展一提出新主題，就可以帶出一串類似的主題跟風，還有一群學者專家提出研究座談，使這主題可以生生相自息，流行個一年半載，翻出許多子題或分題。例如，如果有個教父型的雙年展打出「藝術人生」的主題牌，通常這第一張主題牌一定要像美術館的空間，愈大愈好，才有引伸餘地。於是，就會出現「藝術不是人生」、「藝術是人生嗎」、「藝

over the world and tend to bask in the glory of loaned exhibitions. A public exhibition such as these could span as short as three to four months, or as long as three to five years.

In the making of the art museum biennial, the three most important factors for it to become a "Blockbuster" include, firstly, a charismatic theme enchanting enough to make it the only leading show; secondly, the participation of internationally acclaimed personalities so as to add weight to the show; and thirdly, intensive public relations and media publicity. With a pre-existing operating mechanism, art museums only need to worry about changing curatorial themes, artists and artworks. As such, the various "Biennales" are therefore similar to "Blockbuster Shows" in the contemporary art scene, except that the "Blockbuster" here often refers to the explosive number of artists, and art circle personalities, rather than the number of viewers.

In terms of the usage of space in biennials, installation artworks often form the "stations" that appropriately divide the park, allowing viewers to discover surprises as they visit each one. On the other hand, artworks that are participatory or interactive offer a non-visual sort of aesthetics; like samples from trade exhibition centers, they demand that visitors get their hands on and play with them. As for the artists, they are comparable to market analysts who often have to analyze data. Although all these exhibitions are characteristic of a sightseeing park, they, however, have to employ big titles and grand themes that would allow them to play the publicity game, which would in turn attract artists like flies to honey, doing their best to fit in. As a result, even artists of this new century is going retro – they assume the role of a project contractor in the time of the Renaissance, and are much welcomed by the curatorial units, as they are not only well-reputed but also guarantee box-office success, and are versatile. Some project creators who are more self-aware know very well how to manage and promote themselves via theme parks. For example, they may manage to derive some issue peripheral to the theme, such that their subject gains intellectual weight or reflexivity. They may even consider the viewers part of their work, so as to distinguish themselves from the usual amusement parks that depend purely on sensual stimulation.

The theme of the biennial is also capable of stimulating new waves in the art world. Every time an important international biennial presents a new theme, followers would join the bandwagon by coming up with similar topics. Along with groups of scholars and experts, they put forward research seminars so that the theme could develop sub-topics, and be prolonged and stay popular. For example, if a preeminent biennial was to play the theme card of "Life is Art", then this first card must be made as huge as the space of the art museum, so that it has room for further extension, and we would start to see themes such as "art is not life", "is art life?", "art is alive", "art with life", "art without life", "is art alive?", "oh, what is art?" "Art of living", "Art of life", etc. All these are populist themes with a trusted effect. The discussions could go on to include topics such as: "civilian art under the phenomenon of global capitalism", "artistic life beyond the realm of time and space", "the relationship between virtual art and real life", "the artificial and biochemical characteristics of art", and so on. As for the artists' works, those that are relevant would fit nicely within the framework, while those that are not could still find their places.

On the other hand, some non-biennial exhibition themes could achieve regional flavour by celebrating the unique quality of specific sites. To meet popular demand, the Guggenheim Foundation carried out an operation that was utterly market-oriented – the Guggenheim in Las Vegas is an example of a museum that caters to the market's taste at a specific location. In the beginning, when the museum had just opened, Dali's exhibition was featured. Subsequently, "The Art of the Motorcycle ", probably echoing the "Giorgio Armani" show at the New York Guggenheim, would satisfy the material dreams of those at the slot machines, and gratify the taste of those indulging in wine and money. The Guggenheim is considered a modern art museum with a big international collection, yet effort was made in the curatorial planning to compete for attention, and brand names were sought after to guarantee viewership; no wonder modern art museums from other regions have to work hard on their curatorial and marketing strategy.

術是生人」、「藝術生不出的人」、「人生不出的藝術」、「藝術莫生」、「藝術是陌生人？」、「陌生人的藝術」、「啊，什麼是藝術？」「生人藝術」、「生的藝術」等等具托拉斯效應的流行主題。討論的文章可以包括：「全球化消費現象下的平民藝術走向」、「超越時空疆域的藝術生命典型」、「虛擬藝術與真實人生的關係」、「藝術的人工與生化特質」等等等。藝術家的作品，那可就是該入座的全入座，不該入座的也找得到位置。

至於有些非雙年展的主題，以空間據點的特質為主，也可以做得很有地域味。順應民風之下，古根漢集團有一個很市場化的經營行徑，他們在美國拉斯維加賭場蓋的古根漢分館，便迎合了據點的市場品味。原先開館時還展過「達利展」，後來大概與其紐約本館的「阿瑪尼流風秀」前後呼應，也推出了「機車展」，把那種財大氣粗物慾橫流的品味嚮往放在紙醉金迷的豪華賭城裡，給一般玩吃角子老虎的觀光客一個物慾大夢。古根漢算是擁有國際性館藏的現代美術館，在展覽策劃上都要如此爭奇鬥豔，看人頭給品牌，其他的區域現代美術館就更不得不在策展與行銷上賣力了。

民粹與菁英定位之惑

為了增加名氣以吸引觀眾，館與館之間也出現競爭。2000年十二月，波士頓美術館館長曾和哈佛大學美術館館長有過辯論，其針對的議題便是當代美術館的民粹心態。當時波士頓哈洛報便為此論壇而下了一個重標題：「名氣殺了美術館？」為了館方名氣，以及傳統上的「鎮館之寶」已不易添購，當代美術館在硬體與軟體建設上已進入戰國爭雄狀態。另一方面，新世紀初，英國新美術館開幕的人潮訊息，也激發歐美各現代美術館的行銷危機。文化輿論一方面指責「數人頭」非美術館真正的業績，另一方面又十分在意這個數據。「爆堂秀」與「主題園」的吸引，的確使很多美術館定位混淆，人頭最多，廣告有力，展出單位能賺錢，就是好展。

《無樹之日》（2007），新加坡國家博物館（局部）
A Day Without A Tree (Detail) (2007), panorama view,
National Museum of Singapore.

THE DILEMMA:
POPULIST VS ELITIST

In order to achieve greater fame to attract audiences, there is also competition between the museums. In December 2000, the curator of the Boston Museum of Art had a debate with the curator of the Harvard University Art Museum. The topic was the populist attitude of contemporary art museums. At that time, the *Boston Herald* had published a hard-hitting headline for this forum: "Popularity Killed the Museum?" (note 7) As it is no longer easy to acquire crown jewel artworks for the museum to enhance their reputations, contemporary art museums are divided between developing their hardware and software. On the other hand, at the beginning of the new century, the news of the crowds at the opening of new museums in the U.K. also triggered a marketing crisis among modern art museums in Europe and in the U.S.. Whilst cultural opinion is reproachful of museums' obsession with viewership as it does not reflect their real performance, this data is also an important concern for them. All in all, the appeal of the "Blockbuster Show" and the "Theme Park" has indeed confused the position of many museums; an exhibition with high viewership, strong advertising, and big profits is now considered a good one.

Media publicity is another area where art museums have put in tremendous efforts. For example, the American "art museum" is often treated as a cultural trademark and marketed by a public relations company. In 2001, the Los Angeles Museum of Contemporary Art engaged TWBA\Chiat\Day, a major advertising company, as an agent to promote their image. This company had been the agent for projects such as "Absolute Vodka Artists Collaboration", "Energizer Batteries Bunny", and "Apple Computer's Think Different Campaign", etc. The slogan for this advertisement for the Los Angeles Museum of Contemporary Art was "Awareness Campaign", and large-scale advertisements were put up at 60 locations throughout the city. The Art Institute of Chicago also launched a TV commercial to promote its collection and cultural atmosphere. In it, the security guard is featured as the protagonist,

美術館上媒體廣告也是卯足力氣。例如，美國「美術館」的行銷，往往將「美術館」本身當作一個文化商標來處理，並請公關公司來促銷「美術館」。洛杉磯當代美術館在2001年曾找大廣告公司（TWBA\Chiat\Day）代理形象推銷，此廣告公司曾代理過「絕對伏特加藝友會」、「精力電池的兔子」、「蘋果電腦公司的不同思維方式」等企畫案。此廣告替洛城當代館打出的標語是「心智競爭」（Awareness Campaign），在全城六十個據點張貼了大招牌式的連鎖廣告。芝加哥藝術館也打電視促銷廣告，但打的是館內收藏與文化氣氛，主角人物是館內的警衛，在空靜的展場探頭探腦。一般認知，美術館是非營利文化機構，但當美術館

願意投資昂貴的媒宣廣告費，或請公關公司來包裝，它的經營已經是一門文化企業學了。

美術館究竟是誰的文化空間？文化行銷者既要順民意，也要推銷上流名品，結果撞擊出一個新的公共文化空間。從硬體戰、爆堂秀、主題園的操作上看，美術館的生存保衛戰已將凌駕文化保衛戰。今日美術館變成文化學界的大話題，不能全歸於民意或時潮所趨，它有幾個要素惡性循環，迫使一些美術館要走「菜市場路線」。其間，最主要的因素是資金來源者看待藝術的態度。

《無樹之日》（2007），新加坡國家博物館（局部）
A Day Without A Tree (Detail) (2007), panorama view,
National Museum of Singapore.

born. From the operation of the hardware war, the Blockbuster Show, and the Theme Park, the survival and defensive war of the art museum has overridden its cultural one. Today, the art museum has become a big topic in the field of cultural studies, and this should not be attributed solely to public opinion or trends. There are several elements which have caused a vicious circle, forcing some art museums to take "the path of the marketplace". In the meantime, the most important factor is the investors' attitudes toward art.

In 2001, American art critic Michael Brenson published the Visionaries and Outcasts, in which he wrote about the funding of National Endowment for the Arts for contemporary art in the United States, describing the process from support, broken trust, to the final abandonment of sponsorship of 30 years from 1965-1995. Brenson unveiled the influence of cultural policies on artists, art organizations, and cultural mechanisms. The key issue is the source of funding. The ideal scenario for any art circle would be: "Give me money, and it is none of your business thereafter," while the greatest nightmare for the museum is: "I give you money to build the museum, and it is none of my business thereafter." Instead of adding or extending the building because there is not enough room for the collections, many museums actually "build the temple before there is a deity". These are the worst examples of art museums.

Whether it is for survival or to compete for fame, the positioning of the cultural and educational mechanism of the museum has gradually become obscured. The paradox of "good or bad management" has also forced this cultural mechanism to face inspection, disintegration or the crisis of closure. The art museum is no longer capable of firmly standing its ground since historical museums are exhibiting high-tech gadgets, regional art museums are aiming to be international, and eastern museums tend to showcase western artefacts. After all, it is more important to have a "Blockbuster Show". However,

poking around the quiet and empty museum. In our general understanding, the art museum is a non-profit cultural institution, but when the museum is willing to invest in expensive media advertising fees or hire public relations companies for its packaging, its operation has already crossed over to that of a cultural enterprise.

So, who does the museum's cultural space belong to? Apparently, cultural marketers want not only to follow the will of the public, but also to promote high-end and famous artefacts at the same time. As a result, a new type of public cultural space is

2001 年，美國藝評家巴森（Michael Brenson）出版了《夢想與離棄》（Visionaries and Outcasts），寫的是美國國家藝術基金會三十年（1965-1995）對當代藝術從支持、到信賴破產與離棄贊助的過程。他揭出文化政策對藝術家、藝術團體、文化機制的影響，其中經費來源是很大的關鍵。所有藝壇的美好狀態是：「給我錢，以後就沒有你的事。」而美術館最大的惡夢是：「給你錢建館，以後就沒有我的事。」這種蓋了廟才找神，而不是因為典藏過多，必須為增建才增建之館，是所有美術館類最慘的例子。

不管是為爭生存，還是為搶名氣，美術館這個文教機制的定位已經逐漸混淆不清，也有了「經營善與不善」的矛盾，致使這個文化機制也得面臨檢驗、瓦解或關門的危機。美術館不再能堅守定位，歷史文物館展高科技，區域美術館志在國際化，東方館展西洋品，能找到「爆堂秀」最重要。但對藝術家來說，美術館還是藝術作品最理想的家，只是，現在的美術館倒寧可他們把美術館當旅館，而不是當老家

了。沒有計劃當代的典藏與研究，硬體戰、爆堂秀、主題園能許新興美術館什麼樣的未來？菁英理想被名流與民粹品味拖著跑，也無怪乎美國國家藝術基金會在終結對視覺藝術家補助之後，藝術家更要向商機靠攏，更要考慮全球化市場，這些作品如何成為美術館的未來賣點，似乎也只有再用「辦活動」的方式促銷了。

註

1. 參見 "What Museums Want," *New York Times*, December 3, 2000.
2. 參見 "Three-Ring Museum", *New York Observer*, December 6, 2000.
3. "Cynical Blockbusters," *The Guardian (London)*, January 1, 2001.
4. Arthur C. Danto, *Beyond the Brillo Box: the Visual Arts in Post-Historical Perspective* (Harper Canada Ltd., 1992), p.199-214.
5. 他們提出莫內的《花園》、竇加的《舞女》、馬內的《海景》、高更與梵谷的《南方畫室》、秀拉的《大嘉特島》等歐陸印象派的作品，滿足了當代人對於百年前巴黎小資生活情調與波希米亞浪漫的幻想，也整理出研究性的專書。
6. "A Little Show Biz in Brooklyn." *New York Times*, January 1, 2001.
7. "Popularity Killed the Museum?" *Boston Herald*, December 15, 2000.

高千惠教授 ————————————————

獨立藝評家，策展人，藝術教育者，主要研究領域為藝術評論，策展實踐，和亞洲藝術實踐的方法論。2001 年度威尼斯雙年展臺灣館策展人。著有《當代藝術生產線：創作實踐與社會介入的案例》、《不沉默的字：藝評書寫與其生產語境》、《詮釋之外：藝評社會與近當代前衛運動》、《第三翅膀：藝術觀念及其不滿》、《風火林泉：當代亞洲藝術專題研究》、《發燒的雙年展：政治／美學／機制的代言》、《藝種不原始：當代華人藝術跨領域閱讀》等十餘本書。現任教於國立臺南藝術大學藝術創作理論研究所博士班。

for the artists, art museums are still the most ideal home for their works; it is just that current art museums prefer that artists use their galleries as hotels rather than as homes. What kind of future could a new art museum expect if there was no plan for contemporary collections and research, no war for hardware, no Blockbuster Show, and no Theme Park? When elitist ideals are being dragged down by celebrities and populist tastes, it is no wonder that after the National Endowment for the Arts terminated its grants for individual visual artists, artists had to move closer to business opportunities and consider the global market. It seems that the only way to make these artworks the future selling point of museums is through promotional "organization of events".

——— Note ———

1. See "What Museums Want," New York Times, March 12, 2000. (Retrieved from: December 2000, Visual Arts Archives, ArtsJournal Visual Arts: Daily Arts News, accessed April 25, 2019, www.artsjournal.com/visualarts/visualarts1200.shtml)

2. See "Three-Ring Museum", New York Observer, December 6, 2000. (Retrieved from: December 2000, Visual Arts Archives, ArtsJournal Visual Arts: Daily Arts News, accessed April 25, 2019, www.artsjournal.com/visualarts/visualarts1200.shtml)

3. "Cynical Blockbusters," The Guardian (London), January 1, 2001. (Retrieved from: Visual Arts Archives, January 2001, ArtsJournal Visual Arts: Daily Arts News, accessed April 2019, www.artsjournal.com/visualarts/visualarts0101.shtml)

4. Arthur C. Danto, Beyond the Brillo Box: The Visual Arts in Post-Historical Perspective (Harper Canada Ltd: 1992) p. 199-214

5. They presented European artists' works such as Monet's Garden, Degas's Dancer, Manet's Seascape, Gauguin's and van Gogh's "Arles Studio", Seurat's Island of La Grande Jatte, etc., to satisfy modern people's imagination of the romantic and bohemia Paris bourgeois life.

6. "A Little Show Biz in Brooklyn," New York Times, January 1, 2001. (Retrieved from: Visual Arts Archives, January 2001, ArtsJournal Visual Arts: Daily Arts News, accessed April 2019, www.artsjournal.com/visualarts/visualarts0101.shtml)

7. "Popularity Killed the Museum?" Boston Herald, December 15, 2000. (Retrieved from: December 2000, Visual Arts Archives, ArtsJournal Visual Arts: Daily Arts News, accessed April 25, 2019, www.artsjournal.com/visualarts/visualarts1200.shtml)

Prof Kao Chien-Hui ————

An independent art critic, curator and art educator. She focuses on the study of art criticism, curatorial practices, and the methods of art practices in Asia. She was the curator of Taiwan Pavilion in Venice Biennale, 2001. Her major books (in Chinese) includes The Production Line of Contemporary Art - Cases of Creative Practice and Social Engagement, Unsilent Words - Text and Its Productive Context of Art Criticism, Beyond Interpretation - Society of Art Criticism and the Modern Avant-garde Movement, Third Wing - Art concept and Its Discontents, Topics on Contemporary Asia Art in 2010s, Biennale Fever- The Alternative Voice of Politics, Aesthetics and Institute, Discourses on Contemporary Asia Art-2010s, After Origin - On the Topics of Contemporary Chinese Art, Art and Culture in the Early 90's. Currently, she is a Visiting Professor of the Doctoral Program in Art Creation and Theory, Tainan National University of the Arts.

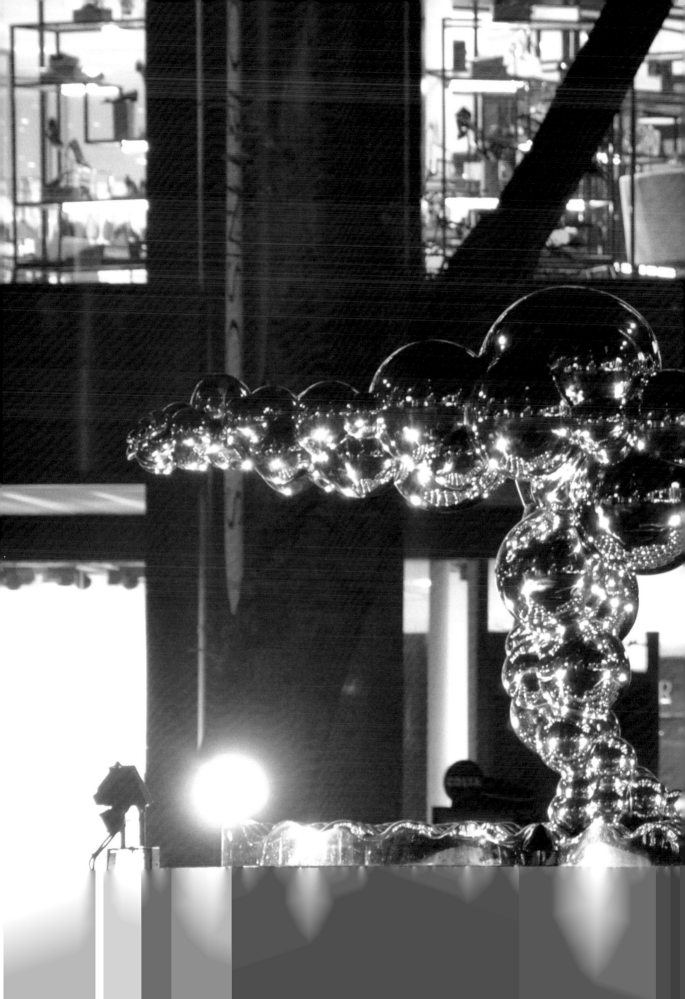

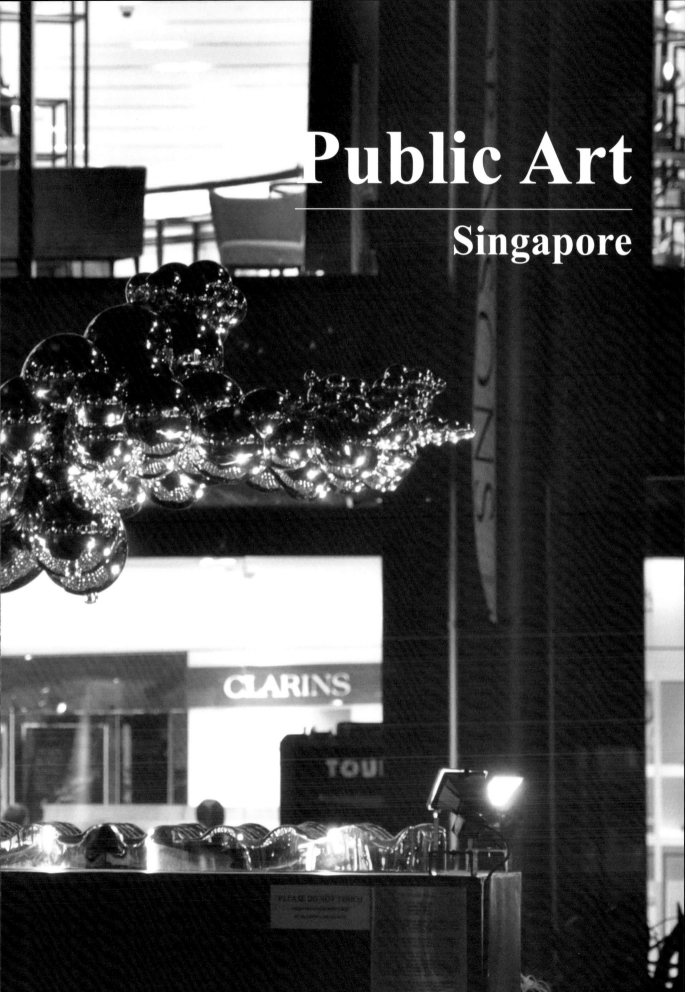

Public Art

Singapore

BOTTOM LAKE

CINEMAX

Glasgow | Scotland

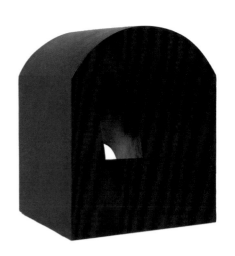

The House
2007

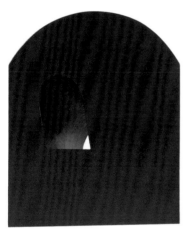

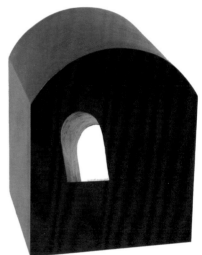

Esplanade

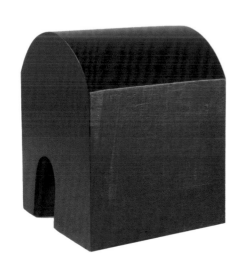

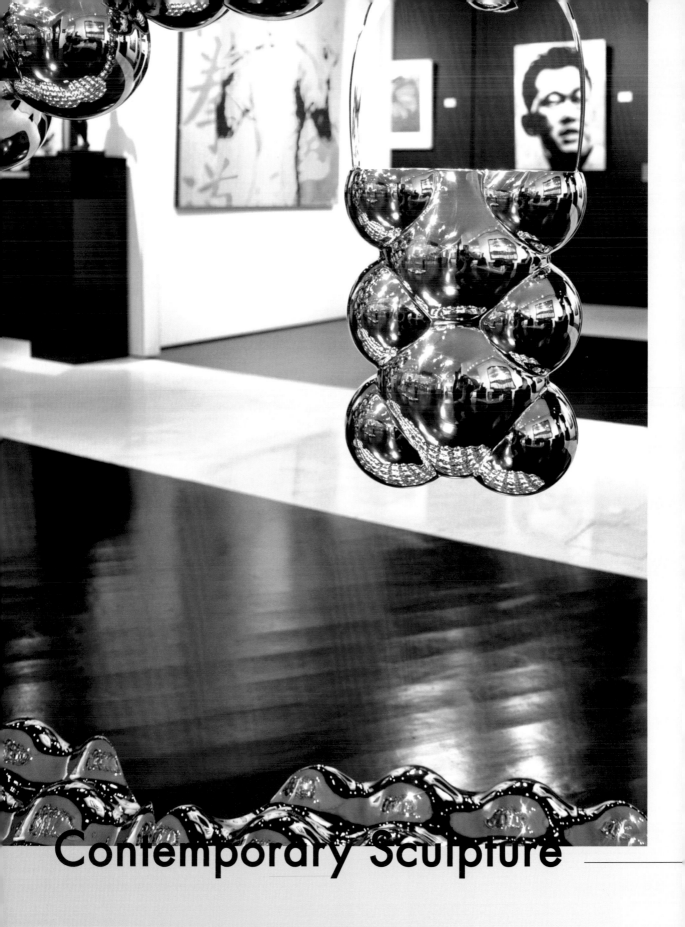

Contemporary Sculpture

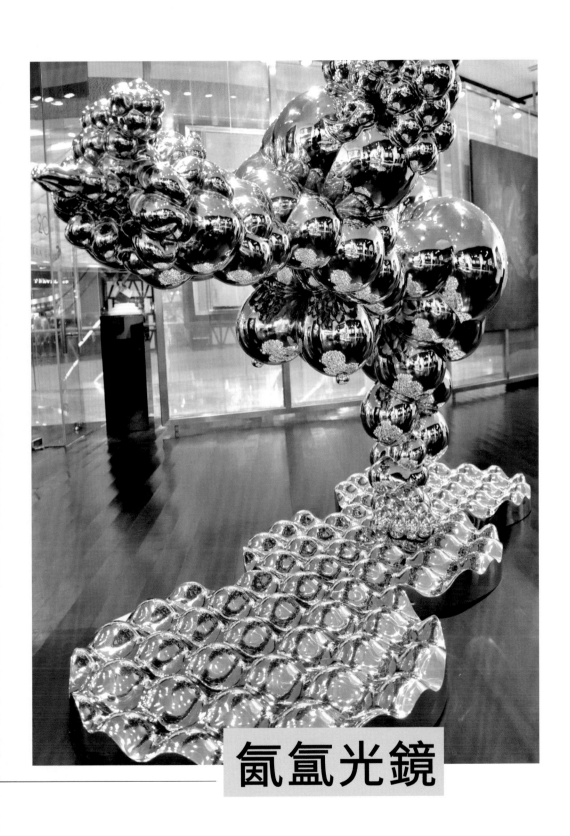

氤氳光鏡

Bubbelloon

Sculpture House

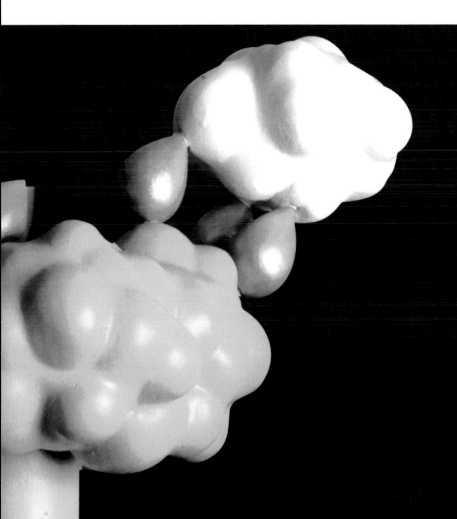

The 2nd CDL
SINGAPORE SCULPTURE
AWARD EXHIBITION

sam
singapore**art**museum
muzium**seni**singapura 新加坡美术馆 சிங்கப்பூர்கலைதரும்பொருளகம்

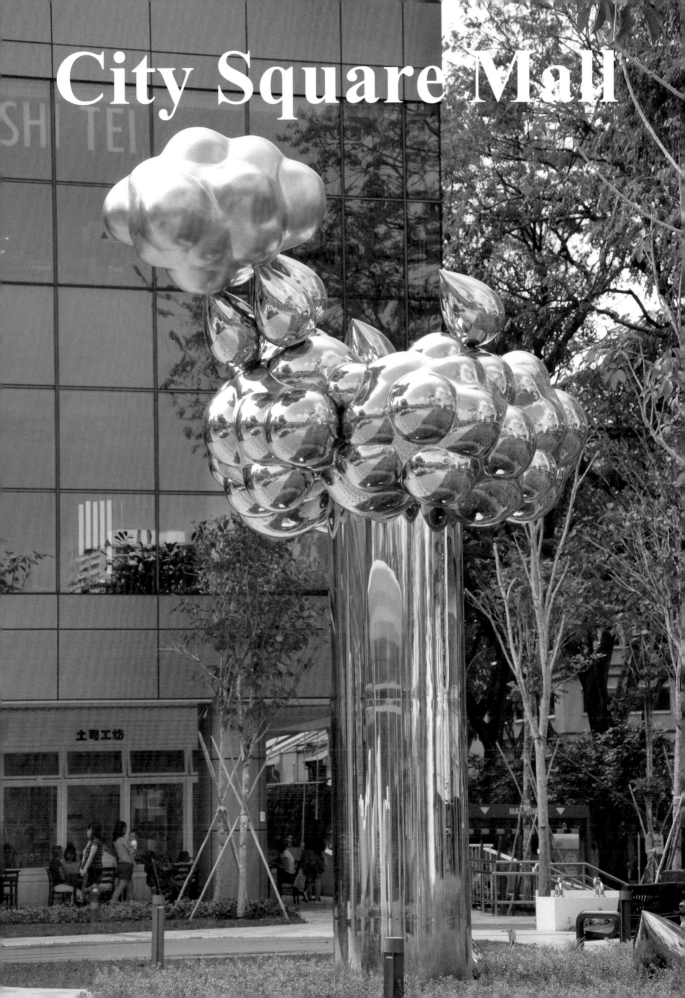

sculpture In Singapore 1991

Set Me Free

Once Upon A Time

Nokia Singapore Art 2001

A Line A Door

美麗的擬態

■ 楊子強

昨晚卸妝後呼吸了一夜的臉上肌膚，還是有些蒼白。輕揉著眼眶四周的穴位，試著活化些血脈神經。沒戴著彩色瞳孔放大片的眼睛，透過手指縫隙間，窺見到鏡子裡一對澄清的眼眸，原始而動人。粼粼眼波，正是昨夜月色殘凝逗留之處。灰褐色的圓月光暈隱約浮動，一眨一眨之間望著鏡子裡那稍稍顯露血色的臉龐，似乎又陌生了些。

黑色的眉筆輕輕劃過眉梢，在轉角處稍稍停留。沿著眉峰斜斜掠下，遙點在那流轉的眼神之外。別過頭瞄了瞄鏡中臉側的輪廓線，除了額頭，瀏海和鬢髮之間所構成的，可調控的黃金頭型比例區塊外，其他能夠加以修飾的輪廓剪影，就只剩眼睫毛的長度和不受控的雙下巴了。輕輕用手指彈著第二下巴的脂肪團，試著調配出昨天午後在時尚雜誌上所看到的當季眼影彩妝，探尋著那堆砌漸進、暈開的層次感，心裡不自禁的讚嘆著那些彩妝大師們如何細膩敏銳的調度著光影和色彩。眉目間每一季的風情，永遠夾帶著走在當季時尚前端的無限滿足。每日形像的新鮮微調模擬，是積極的時尚生活態度，不曾鬆懈如眼睫毛末梢上極限放肆的，不斷伸張的睫毛膏。

鏡子！鏡子！如此精雕細鑿的美麗在鏡面的另一端存在著。我是這世上最美麗的人嗎？無懈可擊！無懈可擊！感謝時尚的力量，讓每個人都能夠像月光仙子般華麗的變身。這是現代時尚的魔法，只要化身進入這彩妝盔甲的美麗擬態中，還有什麼想法是無法實現的呢？

《模糊時尚》了解到時尚不只是美好生活的調味劑，更是社會層面上，職場空間內，必須被認真看待的生活擬態方式之一。因此，我們特別摘錄自金山上的美容院──《擬態：藝術現形記》座談會，第一場講座「掩目：以美之名」的部份座談內容與讀者們分享。通過兩位學術達人：楊子強教授和白適銘教授的知性角度，從各自的生活哲學中，深入剖析和闡述了有關於美麗的擬態所存在的形式和聯想，讓您能更深入的理解和掌控生活中美好純粹的存在感。以下為《擬態：藝術現形記》的講題概述和兩位學術達人的座談內容摘要。

▶ 《慾望都市的影子們》（2011），戈萬希爾百年公共澡堂，格拉斯哥，蘇格蘭。
Sex Shadows & The City (2011), Govanhill Baths, Glasgow, Scotland. 2011

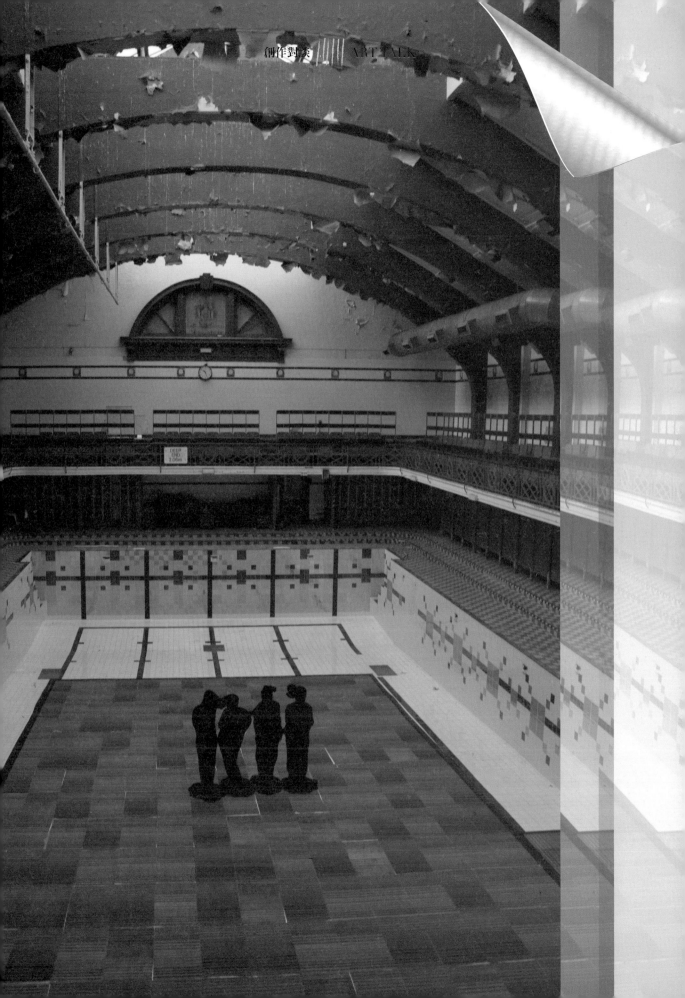

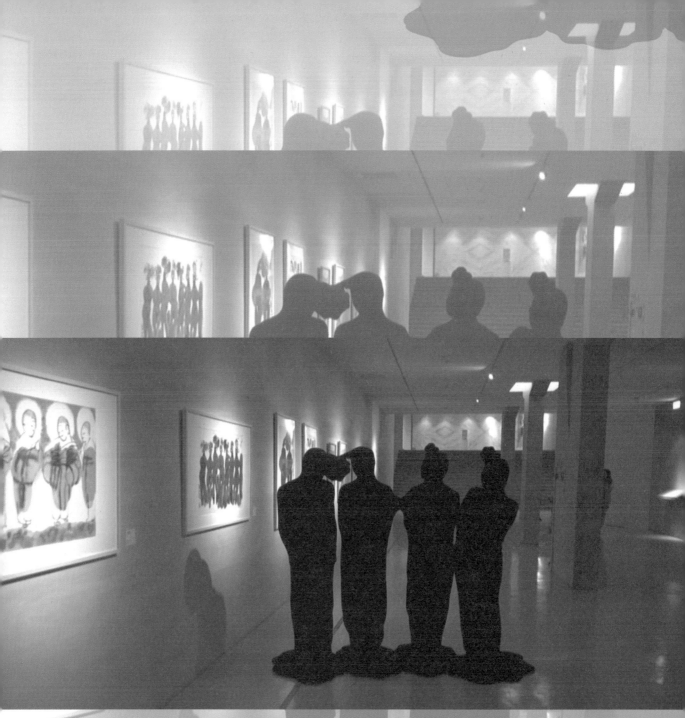

《四個影子》（2017），「金山上的美容院」，朱銘美術館，臺灣。
Four Shadows (2017), 'A Beauty Centre @ Ju Ming Museum', Ju Ming Museum, Taiwan.

Perfect Mimicry

Yeo Chee Kiong

The face is still a little pale, although it was cleared of make-up and allowed to breathe through the night. Rubbing the acupoints around the eyes activates the blood vessels and nerves. Without the effect of coloured lenses, a peek through the gap between the fingers reveals a pair of clear eyes in the mirror, primitive and moving. Sparkling eyes, where the moon left its traces from the night before. The hazel eyes, like the vaguely undulating moonlight, blink, looking in the mirror at a face that is slightly blushed, as if becoming unfamiliar again.

With light strokes, the black eyebrow pencil brushes from the beginning point of the eyebrow, pausing just at the arch, then down from the brow peak and falling away from the eye. Turning and peering at the side profile of the contour of your face in the mirror, aside from the forehead, fringe, and sideburns that constitute the adjustable proportion of the most desirable shape of the head, the only contours of silhouettes that can be reshaped are the length of eyelashes and the stubborn double chin. The fingers gently flick the layer of fat around the double chin, attempting to concoct this season's eye shadow make-up seen in fashion magazines yesterday afternoon, exploring the gradual, fading layers. She can only marvel at the makeup artists' skillful, the delicate blend of colour, light, and shade. Each season, the feel of elegance from the eye and brow always carries the endless satisfaction of being at the current season's forefront of fashion. A slight modification of the daily image is a display of a positive attitude toward the fashionable life, without a moment of negligence, like the mascara constantly lengthening the unbridled tip of the eyelashes.

Mirror, mirror on the wall! Such chiseled beauty lies at the other end of the mirror. Who is the most beautiful woman in the world? Impeccable! Made impeccable by the power of fashion. Everyone is able to undergo a gorgeous transformation like the Sailor Moon. This is the magic of modern fashion. As long as you are transformed and enters the beautiful simulation of your make-up armour, is there anything you can't achieve?

Vague Vogue understands that fashion is not just an add-on for a better life, but also one of the pretenses of life that must be taken seriously at the social level and in the workplace. That is why we specially excerpted contents from the "Session I: Eye Covered: In the Name of Beauty", "Juming Art Forum — Mimicry: Art Unmasked" to share with readers. The intellectual perspectives of two leading scholars, Professor Yeo Chee Kiong and Professor Andrew Pai, thoroughly analyse and expound the forms and associations of beautiful mimicry from their respective philosophies of life, enabling readers to better understand and control the pure sense of existence in life. Attached below are the concept brief of "Juming Art Forum — Mimicry: Art Unmasked" and the selected seminar contents of the two scholars.

|||| 掩目 | 以美之名

■ 白適銘教授、楊子強教授

和生物界相同，人也會為了生存而「擬態」。只是「以美之名」從外而內，從生理到心理地改造自己；或「以美之名」區分出你我之間的不同，進而排斥他人，框限自己。借「掩」蓋自己的視線，或透過縫隙窺視，人形構出「美」的典範。而藝術，作為一不安分角色，則不斷試圖衝破那被制約的典範。從此來討論藝術中美（或美學）的價值判斷，其判定標準如何隨時代改變而受牽引？藝術家又是透過什麼樣的媒介揭發「美」的真相？

楊子強 我不知道大家有沒有仔細看過講座手冊裡的這段引言，我覺得裡頭有兩個部分，我可能可以稍微延伸一下再跟大家說說看。第一個部分：「和生物界相同，人也會為了生存而『擬態』」，第二就是：「而藝術，作為一不安分角色，則不斷試圖衝破那被制約的典範。」我在這部分會提一下，什麼是所謂的生物界的專屬美和全方位的生物界的「擬態」功能。

我印象很深刻的《國家地理雜誌》動物頻道的紀錄片，是關於一些特定鳥類物理上的獨特吸引異性的方式。比如有著藍色腳蹼的海鳥「藍腳鰹鳥」，或者是有很大的氣囊，然後有著非常美麗，而且獨特形象的天堂鳥等等。我覺得整個紀錄片最吸引我的部分，是這些生物具有獨特吸引力的性徵，除了吸引異性、繁殖以外，他似乎並

沒有提高在野外的生存機率。如果套用在人類身上的話，一個非常美的女孩子，（所謂的）「俊男美女」，如果她有一天在非洲大草原迷路的話，別的物種會因為她的美色而放過她嗎？獅子不會因為俊男帥而不吃他，因為這樣的「美」並不適用於獅子。那這些原始的美色是如何架構而來的？如果通過進化論的話，就是某個特殊的性徵，經過多個世代、重複的結合，愈來愈明顯，對專屬族群的異性也愈來愈有專屬的吸引力，最終形成一個新的物種旁支。這個所謂「美」的概念是專屬性的，只適用於某個專屬群體。

第二個部分是相對於非常全方位的、實際應用性的「擬態」功能，是透過模擬周遭的環境隱藏自己，在面對實際挑戰時，卻是存活的關鍵。這兩者之間，第一個「美」是炫耀性的、吸引力的、原始的專屬對象，第二個部分則是非專屬的、隱藏性實際操作方式。如果從人的角度來看，討論「美」和「擬態」之間的那種從屬關係的話，我覺得可能是非常有趣的方向。在這裡我想稍微提一提，藝術是否有著像「美」一樣存在的必要性？是否人類演化過程中是非常重要的一個部分呢？有一種演化美學的論點認為，人腦中相關的藝術與創造的能力，對人類的作用有點像公孔雀的尾巴，有吸引異性的功用。如果依照這樣的推斷的話，

藝術家是不是會相較的比普通人更性感一些，不知道大家認不認同這樣的說法？

其實，什麼是藝術的本質？或應該更確切地說，做為一個藝術家如何對待藝術這件事情的本質？因為藝術常常被界定為一個抒發的管道或平台，一個文化空間或區域，允許藝術家有動機或無動機的創作。我們已經很難將當今的藝術創作目的抽象地畫成一個

《新加坡的雨是淘氣的，當太陽和黑雲相遇在那季候風的季節裡》（2010），「城市內的藝術」，富樂頓酒店，新加坡。
The rain of Singapore is mischievous, a Sun meets a Black Cloud in a Monsoon Season (2010), 'Art in the City', Fullerton Hotel, Singapore.

Eye Covered:
In the Name of Beauty

■ Prof Pai Shih-Ming, Prof Yeo Chee Kiong
Original in Chinese, translated by Rye Lin & Tan Yen Peng

Just as in the world of biology, humans perform "mimicry" for survival. "In the name of beauty", we change ourselves from the outside to the inside, from the biological to the psychological; or "in the name of beauty" we differentiate between you and me, rejecting the others and restricting ourselves. By "covering up" our sight, or by peeping through fingers, we constructed the classic model of beauty, while art, embodying a restless and discontented spirit, seeks eagerly to break through the established norms. This session will gather artists, curators and art historians to discuss the factors that have influenced the shaping of contemporary aesthetics and artists' response towards today's beauty standards shaped by mainstream culture.

Yeo I am not sure if you have read the introduction in the Seminar leaflet carefully – there are two parts that I may be able to expand further here. The first part is, "Just as in the world of biology, human perform "mimicry" for survival." The second part is, "art, as the discontented one, [will] continuously [try] to break through the standard restrictions." I will talk about what is the so-called "beauty" that is exclusive to all living organisms, and the function of "mimicry" in the overall biological world.

National Geographic impressed me with its documentaries on animals, especially those about how some particular kinds of birds attract the opposite sex with unique methods. For example, the marine birds with blue webbed feet called the blue-footed booby, or the birds of paradise with unique huge air sacs and a beautiful appearance. The most attractive part for me was their unique sexual character, which attracts the opposite sex for reproduction, yet it makes no contribution to its chance of survival in the wild. What if we apply this to human beings? If there is a pretty woman or a handsome man who lost their way on the African Savannah, will they be exempted due to their beautiful appearance? The lion will not let go of a man simply because he is handsome, since this kind of "beauty" does not apply to lions. So how did the primitive idea of beauty form? If we take evolution into consideration, it is the special sexual characteristic that has been passed down and reinforced through the combination of genes over many generations, which seemed more and more attractive in the eyes of the opposite sex and finally form a new subspecies. This kind of so-called "beauty" is exclusive, applicable only to a certain group of living creatures.

The second part is the all-around and practical form of "mimicry", which is applied to imitate the features of the surroundings in order to hide oneself; it is the key surviving skill when one is in the face of challenges. The difference between the two is that the first kind of "beauty" involves flaunting, attracting, and is exclusive to a certain species on a primitive level, while the second one is non-exclusive, hidden, and more pragmatic. As for human beings, I think that analysing the subordinate relation between "beauty" and "mimicry" can be quite an interesting topic. At this point I also want to bring up briefly: Beauty seems to be a necessity, is Art the same? Is Art important to human evolution? Some theories on evolutionary aesthetics point out that the human's capability in creating art and making aesthetic judgements is similar to the function of the peacock's tail, which is to attract the opposite sex. If we go by this logic, then the artists will be comparatively sexier than the rest of us? Do you agree?

But what is the nature of Art? Or to be more precise, what is the nature of Art to an artist? These things matter because Art is often assumed to be a channel, a platform, or a cultural venue for one to express themselves, or something that allows spontaneous creation with or without a purpose. We can no longer give one single definition to the motivation behind an artwork, and this is also why art allows the rebellious artists to create works without having to follow a singular example, mode, or standard. It is through the rebellious artists, that art can break through restrictions and established standards to advance forward. I was trying to differentiate between "Art" and "Artist", and a question came to my mind: Does "art" need to survive as well? I think that the correlation between the act of "covering the eyes" and "mimicry" is

單一的概念，也因此，藝術允許不安分的藝術家，不用遵照單一的樣本、模式、典範去思考和觀察從而進行創作。而正是如此，藝術才能經由這些不安分的藝術家，不斷試圖衝破被制約的典範而往前推進，最終成就藝術這個不安分的角色。我想稍微在「藝術」和「藝術家」之間做一個區隔，所以，就會直接想到說，「藝術」也需要生存嗎？其實我覺得「掩目」跟「擬態」的對應是很有趣的。「掩目」不論是蓋住自己的眼睛或是蓋住別人的眼睛，它本身都嘗試通過確立一個框架來達到目的，它可以是比較主動跟主導性的；而「擬態」卻是通過觀察周遭，順應潮流、依附主流，是比較隱藏性和隱晦性的。

我 2013 年在巴黎待了兩個月，那時心裡想著，我既然來到巴黎就學著當一個服裝設計師，然後創作作品。剛好我有一個學生在巴黎住了三十多年，她本身有自己的時尚與時裝品牌，我就趁著這個機會問她：「什麼是時尚？你既然在巴黎，在這個圈子裡，什麼是時尚？」她說其實所謂的時尚，每一季的潮流都是那些大設計師和大腕在兩年前就已經商量好的，兩年後要推出這樣的一個款式、顏色、方向。因為他們比較巨大，所以他們可以引領潮流。那麼小公司能夠做的，就是依附在這樣的潮流下，那他們就可以搭便車，節省成本。如果你另外要推

出一個新的潮流，可能就需要更大的成本，這本身存在著高風險的選擇和商業考量。

我的第一個問題：是否這些「美」的標準和框架是可以間接地被操控和灌輸的？我們是否已經進入「美」的不斷主動更替的時代？也因此，我們為了能夠處在擁有「美」的當下的美好經驗，就主動更新我們對「美」的認知形式，並被動成為被刻意架構出來的「美」的一個部分嗎？但是否處在當下的「美」的經驗，就是真正的「美」呢？因為畢竟很快的，兩年後它又會被替代。所以，我們這一代人會比之前的幾代更有趣，因為我們可以很快速地經歷不同的「美」的形式和階段的時代更替。我覺得這本身是很有趣的一件事情。其實，更深刻的一個問題就是：「藝術」也需要生存嗎？我想這個問題其實是蠻重要的，因為在當下的世代裡，一個美的訊息的形成，很可能是由多個訊息的串連和構成一個短暫的形象。就像藝術家本身這麼努力在工作室去創作他所認為對的藝術創作，但他還是得面對工作室以外的不斷進行式的「美」的框架、「美」的氛圍，也可能會被排除在這不斷地變化的框架外，因為不跳入現有的框架裡，藝術家本身的創作和當下的藝術狀態很可能變成毫無關連的兩件事。

所以，最終回到老問題：是順應還是不安分呢？我不問藝術家需不需要生存這件事情，因為他是可以很客觀或很主觀的。但「藝術」是否需要生存，這個問題一定是主觀的──藝術家用它來決定自己的生存方式。所以，這些問題都是我一直在思考的，也是一種直覺，一種從朦朧到清晰的過程，或者是從已經明白再回到困惑的過程當中。我不是一個哲學家，我通過我的作品來嘗試提出這些問題和尋找答案。接下來我會很簡短地跟大家提一提「麗美中心」、「心中美麗」背後的基本概念。（這個作品）從構思到完成，2016 在新加坡第一次展出，而且幸運地 2017 年能在朱銘美術館進行臺北的版本。這個作品本身就是一個我一直在提問中的一個問題，其實一開始我很想跳出現有的所有的框架，所以我為我自己設立一個不屬於現有框架的框架。這是有點矛盾的，但這是我當初心裡的一個很直接的想法。我想在創作出一個不屬於現有框架的框架的同時，又不會背棄我相信的「美」這件事。另一方面，我又特別喜歡做雕塑這件事情，所以，我就通過設立這樣一個把藝術館跟美容院之間相互重建的可能性，通過相互的「掩目」跟「擬態」，來引伸出一些關於「美」的想法，和所謂「美」的層次的不同的界定方式。

quite interesting. "Covering the eyes" and seeing through the fingers is a more active and domineering act as it suggests the covering of the eyes of oneself or the others in order to set a framework for achieving something, while "mimicry" is more concealed and obscure as it is mainly about observing the environment, following the trend, and catering to the mainstream.

In 2013, I stayed in Paris for two months. At that time, I was thinking to myself that since I am now in Paris, why not learn something about fashion design and create some works? By chance, I have a student who has been staying in Paris for 30 years and owns a fashion label, so I asked her, "Since you are in Paris and in this industry, can you explain what fashion is?" And she said that the trend of each season was actually defined by the big designers and stakeholders two years prior to the season. And within those two years, they will work on the design, the colours, and the direction. Because these people rank top in the industry, they get to set the trend. For smaller companies, what they could do is to attach to the trend to get a ride and save some costs. If they were to push for a new trend, it may require much more costs and that would be a much riskier business decision.

My first question: Is it possible to manipulate others' aesthetic judgements and impose those standards and frameworks on them? Are we entering an era when "beauty" keeps updating itself automatically? And as we seek the wonderful experience of "beauty", do we take the initiative to update our perception of it accordingly, and become part of this deliberately constructed system of "beauty" passively? But, is our current experience of "beauty" real "beauty" as it will be updated and replaced quickly in two years' time? I think this is an interesting issue as we could experience "beauty" in different forms and from various stages as time changes. A more critical question is: does "Art" require a survival plan? This is an important question in the current era because the sign of "beauty" can be the result of a series of messages that form an ephemeral imagery. For example, an artist may work very hard on the artworks he considers good and right in the studio, but he will still need to face the forever changing framework of "beauty" and it is possible that he may be rejected by this framework If he fails to adapt to the current system, he may find no connection between his works and the current states of art.

So, back to the old question: should artists be obedient or rebellious? I will not ask artists the surviving question since the answer could be quite subjective or objective. But is it necessary for "Art" to survive? This is definitely a subjective issue, and it is from here that the artist will decide his or her own method of survival. These are questions that are on my mind all the time. It is a kind of intuition, a process where my thoughts go from vague to concrete, or even from clarity back to the state of confusion. I am not a philosopher. I try to raise these questions and seek answers through my own artworks. Next, I will talk about the ideas behind A Beauty Centre (麗美中心) and "the beauty in the centre of the heart" (心中美麗) ,including the process from conceptualization to completion of the first show in 2016 in Singapore, to the later version in 2017 at Juming Museum in Taipei which I am fortunate to have. This work is one of the questions rooted in my heart. Initially, I wanted to abandon and go beyond all existing frameworks, so I set up a "framework" that does not belong to any "framework". It is actually a contradictory concept, but it is a very straightforward thought in my heart. I wanted to create a framework that does not belong to any existing structure but meanwhile stays true to my belief in "beauty". I have a special love for making sculptures, so I constructed an art museum and a beauty centre based on the possibility for them to overlap, making use of the way they "cover" and "mimic" each other to introduce my thoughts on "beauty" and the various ways to define it.

The concept of this exhibition was that I wanted to create a non-negligible, material beauty through my sculptures. I tried to link the objects that I created with an unrelated thought, a fictional story. This is because I feel that in the contemporary world of art, the intention and ideas of the artists or authors is one thing, but the interpretation of

I. 《模糊時尚之時尚再循環，飛行裝系列（一）–鷹》（2013），「美人」，國際藝術村，巴黎，法國。
Vague Vogue Recycled Fashion, Flying Suit Series 01 – Eagle (2013), 'A Beauty', Cite International Des Arts, Paris, France.

II. 《模糊時尚之時尚再循環，飛行裝系列（三）–猩》（2013），「美人」，國際藝術村，巴黎，法國。
Vague Vogue Recycled Fashion, Flying Suit Series 03 - Chimpanzee (2013), 'A Beauty', Cite International Des Arts, Paris, France.

III. 《模糊時尚之時尚再循環，飛行裝系列（二）–蛙》（2013），「美人」，國際藝術村，巴黎，法國。
Vague Vogue Recycled Fashion, Flying Suit Series 02 – Frog (2013), 'A Beauty', Cite International Des Arts, Paris, France.

IV. 《模糊時尚之時尚再循環，飛行裝系列（四）–六足科》（2013），「美人」，國際藝術村，巴黎，法國。
Vague Vogue Recycled Fashion, Flying Suit Series 04 – Something Six Legged (2013), 'A Beauty', Cite International Des Arts, Paris, France.

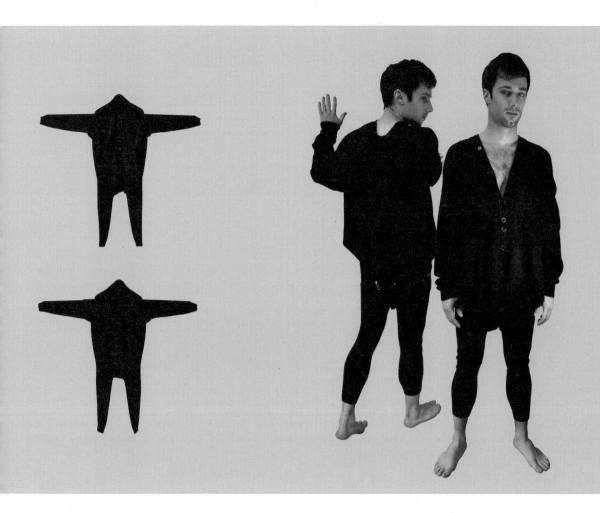

III.

IV.

其實這整個展出的概念，是我想創造一個無法被忽略的物質的美，通過我的雕塑，我又嘗試賦予這個所謂我所創作的物質一個毫無關連的聯想，它就是一個虛構的故事。因為我覺得在當今的藝術世代裡，作家、作者原來所創作的想法是一回事，可是，解讀的方式卻很多。因為不同的人有不同經驗、對事物不同的看法，所以也就有不同的解讀。而且，你無法去掌控每個人解讀的結果，所以，與其被別人解讀，我嘗試提供一個虛構的版本，從中直接把虛構解讀的方式應照我心裡實際可行的想法去描述，想重新攪亂那種所謂的閱讀的方式。然後，當一切東西都無法合理的去解釋的時候，在你面前的雕塑作品是否是需要解釋的？它其實是一件雕塑作品，很實際的立在你的面前。這是我整個《麗美中心》的基本的概念。

在展出的入口處我就放了兩個折頁，一個是《麗美中心》作品的原始概念，另外一個是虛構的故事，我希望當觀眾進入這個《麗美中心》的時候，他無法很確定的知道他所看到的是什麼，當他無法確定的時候，他可能會更加去仔細思考他所看到的是什麼，用他非常個人的角度來嘗試去解讀這樣的一個關係。所以在展場是沒有任何標籤、題目，而是純粹回歸到雕塑本身的一個價值。這裡先讓大家看一下，這是虛構的內容，這邊是真實的作品

內容（另一份），因為實際的內容可能會沈悶一點，我就用比較簡單沈悶的方式來呈現，但這其實卻是我最真實的一些想法。所以，我覺得矛盾的「美」，可以回歸到最初的想法。因為在我心中，「美」是非常重要。而當這個「美」是可以被闡述、被框架起來的時候，它好像就不再那麼的超然。所以，我一直在尋找一種超越，直接去理解、直接去闡述、直接去表達的一種「美」。而這種「美」應該是存在你心中的。只能通過感受、或者通過一種實際去體驗、去呈現一種無法言語的「美」。謝謝大家！

白適銘　這個座談會有一個很特殊的題目，也就是「擬態」。像大家進入這樣的展演空間、從館外草皮看到朱銘先生的作品，還有展場上的所有展示，其實正經歷到一種全然不同的「擬態」狀態。亦即，當我們進入到不同空間之中，經由時間的移轉，其實，我們的身心狀態會產生一種與環境場域連結的反應、經驗，進而進入一種模擬情境的氛圍。所以，今天我想針對「擬態」這個主題，從觀眾、展示、或是藝術品三者之間自我模擬、自我產生及變化機制等幾個問題，來跟大家分享。

因為是座談會，我想就用比較輕鬆的方式來開啟對談。首先，我想喚起大家對於藝術品或藝術家如何透過「擬態」的方式跟手段，來達到「美」的

問題進行思考。剛剛提到空間和時間的一種移轉，比如說我們從臺北到金山來，空間的移轉或地貌的變遷，的確會讓我們產生全新的身心經驗。時間的經過，同樣會讓我們感受到早上、中午、晚上或日夜晨昏等不同變化，在我們的精神情緒上產生相對應的影響。經由美的事物，例如朱銘先生或是楊子強老師的雕塑作品，都不禁能夠感受在創作者的經驗中經過時間、空間調養而成的特質。故而，我覺得「擬態」這個問題，可以從時間跟空間的脈絡來分別討論。

剛剛楊老師提到的「擬態」行為的發生，一開始是跟動物的生存，也就是生物化的機能具有重要關聯。生物為了求生存，有很多偽裝或是「擬態」的行為，大家都知道，特別是人類透過進化變成比較高等的動物，脫離原始的生活進入文明的狀態，其中的生存模態一直都在改變。模態，是經過對於環境或未來的想像、模擬產生的適應形式，同時包含時間跟空間兩個軸向，亦即時間模態與空間模態。我們知道，人類的演化，不只侷限在生物、生理或外形層面，其實歷經了包括言語、思想等，都在不斷地產生「擬態」上的轉變。比如說我們現在自然都穿西服，為何如此？清代臺灣男子都要留辮子、穿長衫，代表什麼意思？其實與時間及空間轉換的因素有關。比如說在時間上，從農業社會到工業

the readers is diverse due to their different experiences and different viewpoints. It is not possible to control how people read the artwork. So, instead of leaving the work for open interpretation, I attempt to provide a fictional version, where the description of this imaginary interpretation is based on the idea that I think is workable, so as to disrupt our usual habit or pattern of reading things. And when things could not be explained with reason, is it still necessary for you to render an explanation for the sculpture that is physically right in front of you? It is a sculptural object that is actually standing right in front of you. These are the basic ideas behind *A Beauty Centre*.

So, I put two versions of the leaflets at the entrance, with one of them covering the original concepts of the artwork in *A Beauty Centre*, and another containing a fictional story. I had hoped that audiences would be uncertain about what they were looking at when they entered the venue of *A Beauty Centre*. When they could not be certain of what they had seen, they would ponder more deeply and interpret the scene from a more personal perspective. Therefore, I did not add any tag and title to the works in the venue, instead, I wanted to return to the purer essence of these sculptures. Now let us look at the fictional part. Here is the proper content of the artworks (the other leaflet), which might be a bit boring, therefore I presented this portion in a simpler format even though this was in fact my truest thoughts. I think that paradoxical "beauty" would allow me to return to my original approach. For me, "beauty" is very important. And when "beauty" becomes interpretable and could be put in a framework, it seems to be less transcendental. This is why I have been looking for a kind of "beauty" that will surpass and allow straightforward comprehension and interpretation. This "beauty" lives in your heart. It is beyond words and could only be expressed through feelings or experiences. Thank you.

Pai The topic for this talk is quite special - "mimicry". When you enter an exhibition and performance venue like this, and look at Mr Ju Ming's works on the grass outside the Museum as well as those in the indoor exhibitions,

you are actually experiencing an entirely different kind of "mimicry". When we enter a different space, along with time transference, our mind and body will respond to situations and interact with the environment while we enter the atmosphere of simulation. So, focusing on the topic of "mimicry", I would like to share my thoughts on self-imitation, self-generation, and the mechanisms of transformation between the audience, the exhibition, and the artworks.

This is a forum, so I would like to open our conversation in a more relaxing way. Firstly, I would like to remind everyone of the question: What are the ways and approaches that artworks or artists apply to achieve the state of "beauty" through "mimicry"? The transference of time and space was mentioned earlier – just like our visit to Jinshan from Taipei – the change of space or landscape refreshes our feelings and sensations. With the continuation of time, we perceive the changing atmospheres between morning, noon, evening, and night, and we respond to the changes accordingly. Through beautiful objects like Mr Ju Ming's or Mr Yeo's sculptures, we can sense the unique quality of the works formed by the passage of time and the change of space. Therefore, I think the issue of "mimicry" could be discussed separately within the context of time and space.

Mr Yeo have mentioned the event of "mimicry" in nature. Initially, it related to the biological features essential to animals' survival. Living creatures develop behaviours of disguise or "mimicry" in order to survive. And, we all know that humans, as higher animals living in a civilised environment where the mode of survival changes continuously, the imitation modality is generated by our imagination and simulation of the surroundings or the future and contains both the aspects of time and space – the simulation of time and the simulation of space. We know that human evolution involves more than biological, physical, and other external factors, and it includes the transformation of the mimicry of languages and thoughts as well. For example, why is dressing in Western style so natural for us today? What does it mean when Taiwanese

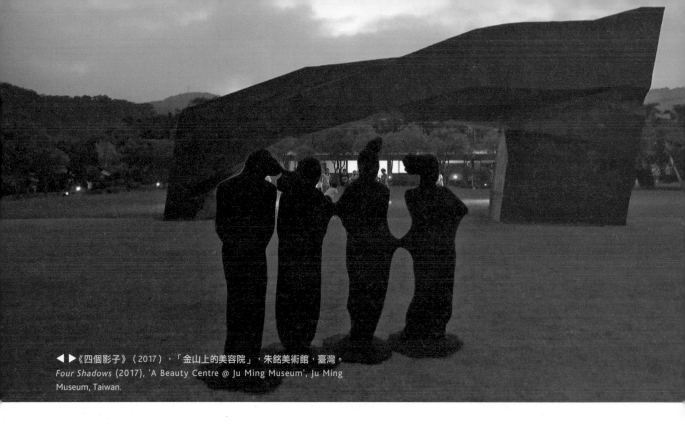

◀ ▶《四個影子》（2017），「金山上的美容院」，朱銘美術館，臺灣。
Four Shadows (2017), 'A Beauty Centre @ Ju Ming Museum', Ju Ming Museum, Taiwan.

社會，在空間上從漢人聚落到西風城市，都代表一種在時空變遷中所產生的模態觀念、擬態結果。

然而，對於觀眾和藝術家來講，「擬態」的問題可能有全然不同的意義可以被探討。剛才提到除了時間空間的軸向需要梳理之外，另一個問題就是角色上的互動關係。比如說，我們覺得一般觀看看到藝術品的時候，勢必會思考「藝術家是在表達什麼？」的問題。看不懂，並不是單純的具象、抽象問題。大家覺得朱銘先生的雕塑作品是具象還是抽象？好像都有，我看得懂，但事實上在表達什麼好像又似懂非懂，其實這就是「擬態」所產生的現象。如果觀眾以較高的藝術標準或所謂符合藝術專業的標準來衡量自己到底看得懂、看不懂的時候，就會產生上述疑問。因此，看作品的時候，事實上已經進入一種自我模擬的狀態之中。好像在畫一顆蘋果、一顆水梨，或者朱銘先生某一件《太極》作品是在表達哪一種橋段？反映何種身心經驗？「擬態」可能隨時出現。我們觀看或理解藝術作品的過程中，通過「擬態」的經驗及過程，達到與

藝術家及作品之間的調和，亦即身心感受的相契。但是，契合的過程未必帶來一定的結果。隨著社會的多元化或民主化，「美」越來越沒有一定的標準。「美」可能變成一種各自闡述、多點並立的狀態。因此，「擬態」的情況也就千奇百怪。「擬態」是一種來自動物適應外部環境的行為，亦是一種身心自然反應的結果。換句話說，我們看到這是藝術品，就會把自己擬裝成自己沉浸在藝術氣息的情境中，去思考或設定自身及作品、藝術家的相互關係。（就如）吳館長特別提到，社會需要藝術氣氛的薰染，讓我們的生活變得更加美化，來自生物生理、心理雙方的需求。

再者，擬態經常存在於我們的社會及歷史之中，它除了是一種生物性行為的反應之外，另一個重要部分，就是隨著人類歷史文明的持續發展，更是社會化不可或缺的工具。亦即，人類在從出生、成長、進入社會或成為社會一分子的一種經歷工具。問題是，在社會化的過程中，我們究竟改變了什麼？產生了何種擬態行為及結果？也就是說，我們今天在這樣一個專業

的美術場域，可能必須扮演得比較有文化氣息、美術氣質之類的，可能跟我們的日常習慣很不一樣，至少心理上會如此。我想我們在日與夜、公與私之間，都需要安然的擬態，讓自己更容易融入外部環境，尤其是在急速變動的環境之中。也就是今天在這樣的一個場域裡面、在美術館的空間裡面，不管是主動或被動，我們必須轉換成一個可以表現出「接近美」、「喜愛美」甚或是「了解美」的身分。但是，離開這個場域之後，可能就完全不同或無此需要。這是社會化所產生的一個必然結果，我們在美術館、公共場合或學校等空間，都可能進行著全然不同的「擬態」。因此，為何說「擬態」是社會化的產物，就是這個道理。亦即，在各種不同的時間、空間狀態底下，人們勢必自主產生的。

回應楊老師的作品問題，大家可能會思考，不知道那究竟是一件雕塑、一個澡堂，或是一個不經意被放置的傢俱，在一個特殊的空間場域裡面？其實，它代表的不是只有純粹的物件或空間概念，有時候可能也會有時間觀念，包含對於童年、成長等不同階段

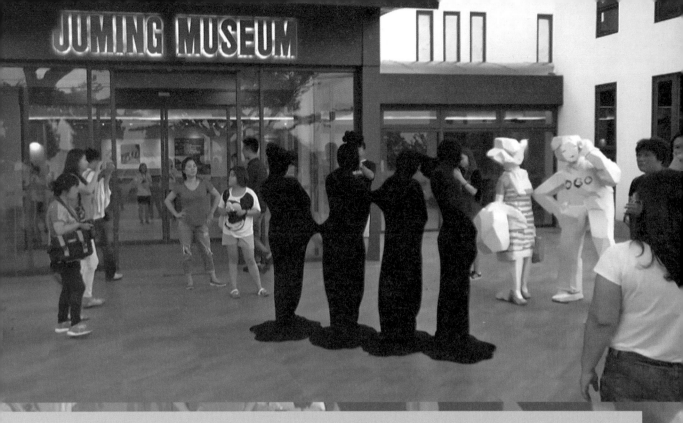

males in the Qing dynasty have to keep long hair and put on long robes? These all resulted from the change of time and space. In terms of time, industrial society replaced the agricultural one. In terms of space, Western cities replaced Han villages – both of which speak of the simulation mode and the mimicry resulted from the change of time and space.

However, audiences and artists may look at the idea of mimicry from different points of view. Aside from the aspects of time and space, the interaction between different roles matters as well. For example, we think that the general public will always ask "what is the artist trying to express?" when they are looking at artworks. And if they do not understand the art, it is not because of the figurative or abstract nature of those works. What do you think of Ju Ming's sculptures? Are they figurative or abstract? They could be both, and it seems like I can understand his works, yet my comprehension of it is partial, and this is what "mimicry" can do. When audiences try to judge the artworks from higher or professional standards, they will question their own understanding of the artworks like I did. Therefore, they would have entered the state of self-simulation when looking at artworks. It is like trying to understand what the artist was trying to express, whether it is a drawing of an apple, a pear, or some of Ju Ming's Taichi series. What kinds of experiences do they reflect? "Mimicry" can happen at any moment. When we are looking at or interpreting artworks, it is mimicry that matches our mental and physical feelings and helps the artist and the work reach a state of harmony. However, the process of matching may not bring forward a particular result. As a society becomes pluralistic and democratic, there are no fixed aesthetic standards and beauty can be interpreted from different points of view. Under these circumstances, "mimicry" has developed a million peculiar ways. "Mimicry" is a way animals adapt to the environment – a result of their natural reactions. That is to say, when we see a work of art, we pretend that we are immersing in an artistic environment and think about the relation between the artworks, the artists, and ourselves accordingly. Society needs art to make our life more beautiful because it satisfies both our sensations and feelings.

Furthermore, "mimicry" is all around in our society and history not only because it is natural biological behaviour but also because it is an indispensable part of the development of human civilisation, a tool people need right from their birth, during their growth, and throughout their journey of socialisation. The problem is, in the process of socialisation, what have we changed? What kinds of mimicry do we apply and what is the outcome? When we are in a professional art venue such as where we are now, it is more likely for us to act like we are really artistic and cultured- it might feel slightly different from the setting of our daily lives, we might not be used to it, at least psychologically if not physically. I think that between day and night, public and private sectors, we need to be able to mimic easily so as to blend in further with the surroundings, especially in a rapidly changing environment. In today's condition, in the art museum, we need to, whether voluntarily or passively, switch to an identity that will "appreciate", "understand", and be keen to approach "beauty". But when we leave this place, the situation may change completely or we no longer have the need to act in this manner. This is the inevitable result of socialisation. We will apply completely different kinds of "mimicry" in different places such as the art museums, public areas, or the schools. It is generated automatically at different times and different spaces.

的生命經驗。比如説，他剛剛提到造訪巴黎種種複雜身心經驗的再現。此種再現，是透過「擬態」的方式而被表達出來，更清楚地説，它不是一般的自然或物理性再現，而是一種精神性、記憶性的「擬態」，混雜著個人不同階段人生經驗的總合。其實，現成物的直接置放及展示，會比自然模仿來得貼近真實，為什麼呢？比如説我們看到澡堂、看到一個書桌，即會直接進入我們的成長記憶中去尋找、模擬，進而產生連結，甚至詮釋，賦予現成物以真實的意義。所以，藝術家是透過現成物這樣的看似「模糊」的狀態，讓它自己跟觀眾產生直接的連結，將意義詮釋轉交予觀眾。所以，當我們論及「作者已死」的觀念，藝術實踐所生產的各種文化價值和意義，其實並非完全由作者所制定、規範，而逐漸轉移至觀眾，致使藝術品不再侷限於展現造形或美感的工具層次，而成為極度開放的一種論壇或場域。藝術家不再提供答案，甚至不需提供問題，而讓作品本身產生可自由論述的機制性。我覺得這是當代藝術當中非常重要的一種相對性的模擬狀態，交錯往返於作者與觀眾之間。

接下來，我要談的是「擬態」的問題。除了剛剛提到生物性的自然反應以及社會化情境所產生的結果之外，其實，「擬態」還包含幾個不同問題。剛剛楊老師也有提到的，就是「擬態」可能

是藝術家用來脱離框架、逃脱體制、建立自我典範的一種可能方式。怎麼説呢？比如説，像我們都是華人，我們都講漢語，但是如果我們把反映漢語文化的作品，放到一個非漢語的體系底下去展示的話，那麼那些外國人真的看得懂、聽得懂嗎？亦即，漢語文化背後既存或被長期制定的障礙，會是一個很大的問題。故而，「擬態」的目的在於超越框架，甚至我們設計的題目，就是超越種族或階級的種種可能性。

我想楊老師的作品裡面，就有涉及這樣的問題。新加坡華人經歷的歷史、身心經驗，跟我們臺灣勢必有很多不同。但是，文化、語言、宗教、信仰上的重疊，或區域生活經驗的累積，可以共同交集出所有亞洲藝術的特徵是什麼？像他的作品，有種亞洲人特有的熟悉感，來自地理、血緣、文化或生活習慣的共同交集，其實是被模擬、被擬態出來的。比如説，我們亞洲人對於人、為人的問題的看法，剛剛吳館長説臺灣人好像很害羞，新加坡人也許比較開放，當然這是反映兩地之間在不同歷史文化薰染下，經過時間、空間的移轉所產生的。它一定會有差異，但不代表不能相互跨越，甚至差異之間一定有大同小異，才有辦法產生各自的連結。藝術品就可以直接跳脱此種框架，進入到即便在巨大文化差異的狀態底下，仍能產生可

能連結的狀態。因此，華人的文化共性，帶動我們對於整個亞洲藝術的跨區域理解，其實，它是在既存框架中跨越差異的相互理解，也可能是在相互理解的過程中發現了各自的差異。所以，我覺得「擬態」是當代藝術當中，既相互連結又得以發現差異的一種創作手法。

那麼，剛剛提到藝術家透過「擬態」或「掩目」的手法進行創作，兩者之間是相關的。比如説，「掩目」是一個手段，「擬態」是一個過程。為什麼這麼説？要讓對方，不管是不是具備同樣文化語言體系的人了解這件作品，為何必須「掩目」？於此，「掩人耳目」並非不好的意思，而是透過一種間接媒介的傳遞，來完成目的。那麼，我們可以看到，在這樣一個手段發揮作用的過程中，可能的現成物或是我們熟悉的一種造形，即可能變成其中一種連結的媒介，包括我們剛才提到的《太極》。太極（拳）在我們亞洲或是華人文化中，其實可以説是國粹，或我們從小就熟悉、即便沒有實際操作也不會不了解的傳統武術。因此，這就是一個媒介、一個手段，也就是一個「掩目」。換句話説，或許我們自身並沒有真正打過太極拳的經驗，但透過所謂「文化符碼庫」的串連，我們知道它在做什麼、有何關聯及意義。故而，觀眾很快得以進入到與藝術家產生對話的狀態。亦即，「掩目」事實上是

238

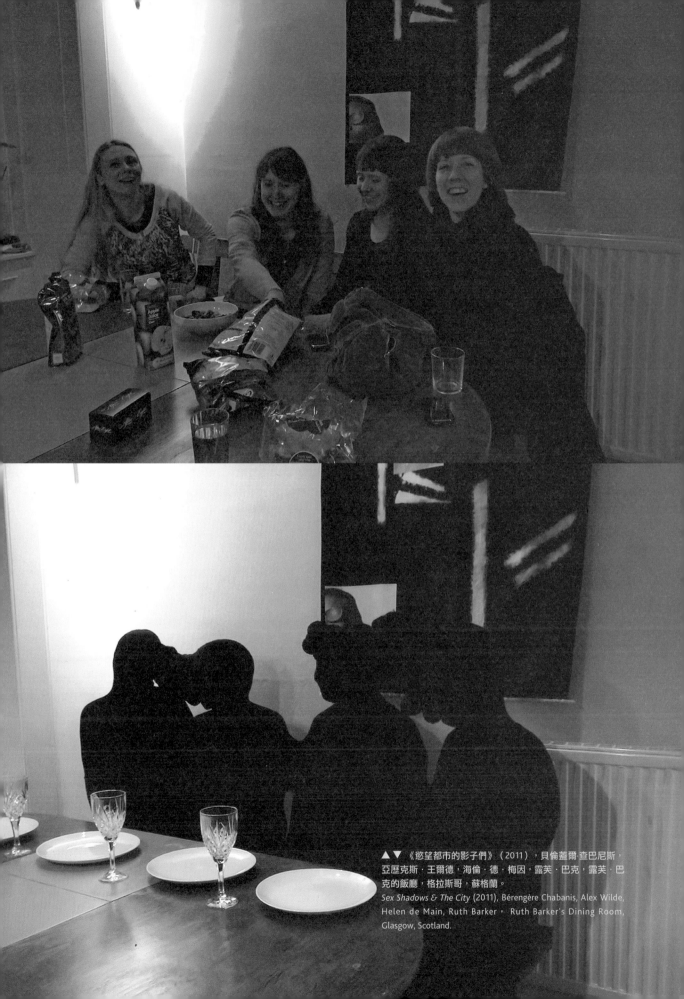

▲▼《慾望都市的影子們》（2011），貝倫蓋爾·查巴尼斯，
亞歷克斯·王爾德，海倫·德·梅因，露芙·巴克，露芙·巴
克的飯廳，格拉斯哥，蘇格蘭。
Sex Shadows & The City (2011), Bérengère Chabanis, Alex Wilde,
Helen de Main, Ruth Barker，Ruth Barker's Dining Room,
Glasgow, Scotland.

透過一個間接或直接機制，然後與觀眾、外部產生連結的一種手段。另外，我們談到「擬態」，它所反映的是個人（藝術家）從自我內部到社會外部產生關係、發生意義的一種必要過程，如果不這樣的話，它就會回到最原始的狀態，作品如何能夠藉由對外部的自我傳達，來產生、製造、詮釋「美」？所以，我們可以看到藝術家跟一般觀眾最大的不同，就是他必須透過「擬態」的方式來傳遞各種不同的身心經驗或審美情趣，與後者產生可能的連結。故而，「擬態」和「掩目」只是一個關係詞，透過對於「美」的傳遞，達到目的與效果。

第三個我要談的，是有關為何需要「以美之名」的問題。藝術創作不會只是跟照相機拍照一樣，只是記錄當下或眼前所見的事物。藝術性的轉化，不管是用什麼樣的方法，例如「掩目」或「擬態」，藝術家必須如此。所以，「以美之名」這樣的課題才有辦法成立。然而，為什麼是「以美之名」？討論這個問題，必須回到「美」或「藝術是什麼」等根本的課題。首先，「美」的功能是什麼？藝術家一定是想傳遞某種特殊的「美」的功能，才製造出這樣的藝術作品，要不然任何人都可以製造出類似的產品物，不需帶有所謂「美」的機制、「美」的訊息及「美」的價值。比如說，如果我們只是著重在一般的物件功能，那麼美不美其實並不重要，只要能夠使

用、符合使用功能即可。但隨著人類文明的不斷提升，「美」變得重要，「以美之名」成為反思「美」在人類社會扮演何種功能、藝術家如何完成「美」的創造等的重要課題。這些問題有必要再進行探索，亦即，「美」與社會的關係，可能有以下兩個層面可以說明：（一）如果我們認為「美」具有淨化社會、改善風習的功能的話，那麼它就接近宗教；（二）如果「美」能夠闡發藝術家對於他自我或社會關注的各種思維理念、精神想像等的話，它就接近哲學。「美」事實上具有上述宗教和哲學等兩個層面的特質，如果我們要談「美」有什麼功能的話，我認為它最主要的是宗教的功能，其次則是哲學的功能。藝術家透過類似宗教或類似哲學這樣的經驗傳遞，可能因此得以淨化人心、美化社會，或發展出純然的美學經驗。因此，當我們在談「以美之名」這個命定的議題時，它的不可疑議性、必然性，必須要考慮「美」與美之外的連結關係，亦即「美」的功能問題。

與此相關的，是藝術家所具備的社會身分。因為我們提到「擬態」這種動物性、生物性行為，基於生存需要，人類除了「自我化」之外，還有「社會化」的機制在運作。藝術家其實是經過「擬態」的方式創造藝術，他也有可能具有生物自我保護、自我養成的必然性。比如說，很多藝術家從小都會畫畫，吳館長是文學家，可能從

小就很會寫作文，藝術或文學才華可能是與天俱來的。這就是我在談的生物性。例如，公孔雀張開色彩絢爛的大尾巴，目的是為了求偶、為了繁殖，很多動物都是如此。因此，色彩多變、造形誇張等視覺外徵，亦即我們認為可能是美的事物，其實來自生物本性、生理本能，與宣示、恐懼、誘惑或適應等有關，「以美之名」只不過是人與社會諸種關係中的一種反映而已。

但奇怪的是，人類的身體似乎缺乏此種與生俱來的變身、變形能力，例如，男性或許能以高大的身軀、健壯的肌肉等外在特徵吸引異性或退斥外敵，卻不具備雄性動物般豐富的環境適應性。在原始社會可能有替代作法，比如說利用面具、刺青或各種擬態裝扮，溝通人神、斥退外敵、象徵權力或進行求偶等等，但總之不像動物那樣地與天俱來。人類男性透過什麼樣的方式來達到求偶或繁殖的目的呢？在生理上，除了散發吸引異性的荷爾蒙之外，外表特徵的「擬態」，例如營造權力、安全、成功或其他視覺意象（如同上述原始社會男性的裝扮），似乎變得更為重要。

同樣地，藝術家就是在創造這種機制。透過「藝術荷爾蒙」（生物性的）、「藝術裝扮」（人為性的），不斷地散發、傳佈美的訊息與價值。它可以無所不在，進入到每一個觀眾的身心

For the question about Mr. Yeo's artwork, you may wonder if it is a sculpture, a bathroom, or a piece of furniture randomly placed at a specific venue. In fact, it represents not only pure object or space but also the concept of time, such as the experience in his childhood or during his growth. Just like the visit to Paris that he mentioned earlier, his work is the re-presentation of what his body and mind have experienced during the trip, which involves "mimicry"; or more specifically, it combines memory and spirituality with the totality of his life experiences in different stages rather than the natural, physical "mimicry". In fact, placing and displaying the ready-mades at the venue make things more realistic than through imitation - why? When we see a bathroom, a desk, we will enter our memory vault directly to search, simulate, and then create links or even interpretations to give the ready-made objects a real meaning. So, artists link themselves with the audiences through the ready-mades, which are in a seemingly "ambiguous" state, and they hand over the right for interpreting the artworks to the audiences. In the discussion of "the death of the author", the practice of art renders various cultural values and meanings, and they are not determined solely by the authors, as the right has gradually been given to the viewers; artworks are no more confined by pragmatic concerns such as expressing formal or stylistic beauty but is an almost completely open field or forum. Artists no longer offer answers, they do not even ask questions, as their work becomes a mechanism that allows freedom of discussion. This state of cross-imitation is very important in contemporary art as it allows mutual exchange between authors and audiences.

Next, I would like to talk about the issue of "mimicry". Besides being the natural result of socialisation, there are in fact more issues involved in it. Mr. Yeo has mentioned that "mimicry" is the artists' way to get rid of frameworks, to escape from existing restrictions, and to set up their own rules. How so? For example, we are all people of Chinese heritage in broad definition, and we all speak Mandarin. But when we showcase artworks that reflect Chinese culture to people of non-Chinese backgrounds, would the foreigners

understand what they see or hear? That is to say, the existing or long-established rules in Chinese culture may be a big issue and an obstacle, and thus the purpose of "mimicry" is to go beyond these frameworks. Furthermore, the topic today also provides solutions to go beyond races and social status.

I think such issues are reflected in Mr Yeo's works. Singaporean Chinese have experienced history and life differently from what we have in Taiwan. However, as our cultures, languages, religions, and beliefs overlap in many ways, we may ask what are the crossing characteristics that all Asian art share? As Asians we find his works familiar because we share commonalities in geography, genes, culture, and lifestyle, all of which are results of simulation or mimicry. For example, we, as Asians, especially Taiwanese, may be more conservative and shy, while Singaporeans may be more open, this is because we are cultivated by different histories and cultures, and the shift of time and space do the tricks as well. The diverse opinions, however, do not stop things from crossing one another; instead, there must be something mutual among different opinions so that they can be linked together. As for artworks, they could get rid of the framework and develop a linkable state even under huge cultural diversity. The similarities of Chinese cultures accelerate our understanding of Asian art across the regions. In fact, mutual understanding is based on differences built on an existing ground, or these cultures might have detected their differences during the process of understanding each other. Therefore, I consider "mimicry" a contemporary art strategy linking things together as well as detecting differences.

So, the approaches of "covering up the eyes" and "mimicry" that artists apply to create artworks are actually relative. For instance, "covering the eye" is a strategy, while mimicry is a process. How so? Why do we have to "cover the eyes" – or conceal something to allow people of different cultural backgrounds to understand a certain idea? To "conceal" something from others means nothing bad but conveying

ideas through indirect mediums to help artists achieve their purposes. Under the process of such strategy, the ready-mades or forms that we are familiar with become mediums that link us together. The work Taichi that we mentioned earlier is a good example. In Asian or Chinese societies, Taichi is a national treasure that we are all familiar with since we were young even if we have never practiced it personally. Here, it is a medium, an approach, or a way for "covering the eye". In other words, we have never practiced Taichi, but we know what it is and how the meanings connect through linking to the "cultural codes". Therefore, as the audience, we can engage in the conversation with the artist more easily. In this case, "covering up the eyes" is a strategy that artists apply to connect with audiences or the external world through indirect means. Moreover, we are also talking about "mimicry" as a necessary process of an individual (the artist) linking himself or herself with external societies and making that connection meaningful. Without doing so, everything will go back to its original state, making it difficult for artworks to activate themselves to define and interpret what "beauty" is. So, the biggest difference between an artist and the general public is that an artist has to make use of "mimicry" to express his or her emotional or aesthetic feelings, and thus connect with the general public. Therefore, "mimicry" and "covering up the eyes" are just two sets of related words facilitating the delivery of certain concepts or ideas through "beauty".

The third issue I want to bring up is the necessity of the notion of "in the name of beauty". Artmaking is different from taking pictures with a camera, and it is something more than capturing the moment or the scene right in front of you. No matter what method the artists apply to perform artistic transformation, - "covering the eyes" or "mimicry" -, it is something they must do, so that the notion of "in the name of beauty" makes sense. But why "in the name of beauty"? To discuss this issue, we must go back to the fundamental questions of "beauty" and "what is art"? Firstly, what is the function of "beauty"? The artist must be trying to convey a certain function of "beauty" so that such a work is created, otherwise anyone could produce something similar without the need for the

mechanism, messages, or values of "beauty". For example, if we are only concerned about functionality, then "beauty" is not important at all as long as something is usable. As our civilisation advances, "beauty" becomes important, and the notion of "in the name of beauty" develops into a good topic that reflects on the function of "beauty" in human societies and on how artists accomplish and create "beauty". It is necessary that these questions be further explored. "Beauty" is related to society in two ways. Firstly, if we consider that "beauty" purifies or improves society, then it is close to religion. Secondly, if "beauty" inspires the artists' thoughts, concepts, or spiritual imagination about themselves or as a concern for the society, then it is closer to philosophy. In fact, "beauty" possesses the characteristics of both religion and philosophy. If we were to discuss the function of "beauty", I think religious function is the main thing, while philosophical function comes next. The purification of minds, beautification of societies, or development of pure aesthetics are achieved through the artists' conveyance of their experiences that are close to that of religious or philosophical experiences. Therefore, when we talk about "in the name of beauty", we have to take note of its indubitability and necessity, and take into consideration how "beauty" is related to an external world beyond itself.

The artists' social identity is also closely related to this topic. As we mentioned, the animalistic and biological behaviours of "mimicry" is because human beings live in a world based on the need for survival. There is also the mechanism of "self-individuation" and "socialisation" in operation. In fact, it is through the method of "mimicry" that artists create art, and they may possess the necessary skills of self-protection and self-nurturing. For example, many artists are good at drawing since they were young; Director Wu is a writer, so he might have been excellent at writing since young. The talents for art or literature may be inborn, and this is the biological function that I mentioned. For instance, a male peacock will open its prominent tail to attract partners for mating and reproduction, many other animals do the same. Hence, even though

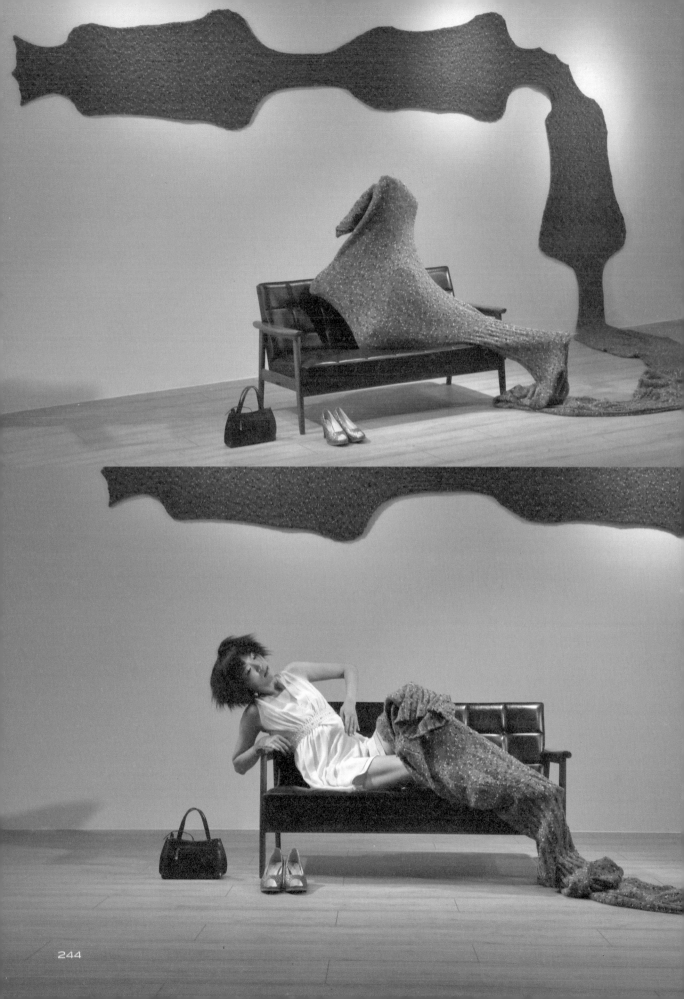

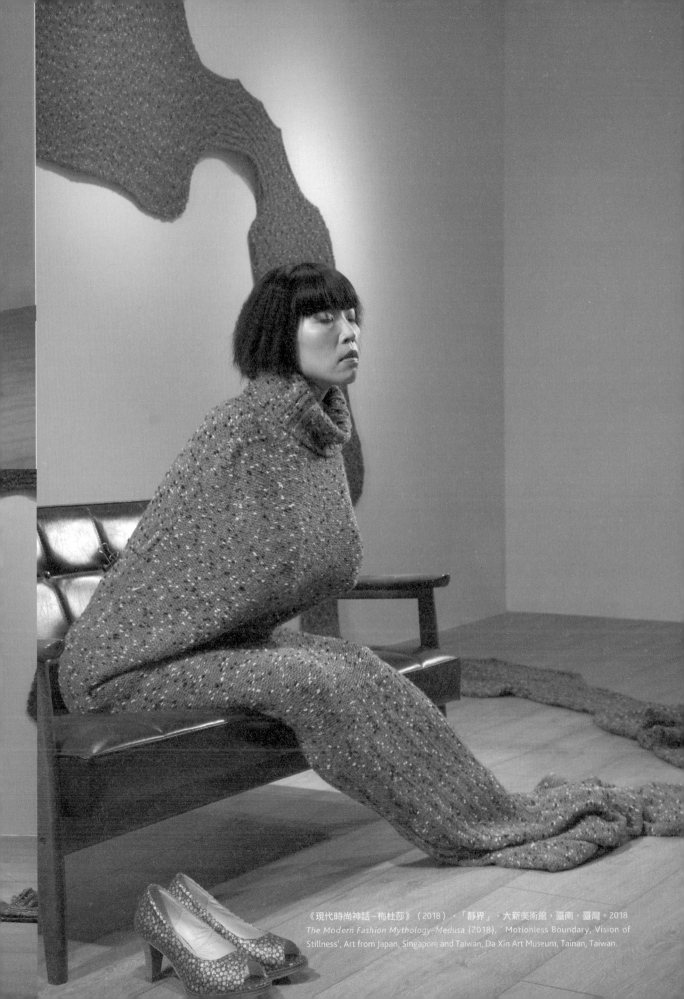

《現代時尚神話−梅杜莎》（2018），「靜界」，大新美術館，臺南，臺灣。2018
The Modern Fashion Mythology–Medusa (2018), ' Motionless Boundary, Vision of Stillness', Art from Japan, Singapore and Taiwan, Da Xin Art Museum, Tainan, Taiwan.

世界。事實上，楊老師的作品有很多可以介入、參與及互動的部分，非常「welcoming」，不斷釋放「藝術荷爾蒙」，歡迎觀眾加入他的作品，甚至成為作品的一部分。我覺得今天談到藝術家的社會身分的問題，必須透過這樣的一種機制來傳遞或是進行連結，讓藝術能夠發揮更大的功能。

最後，我想再回到整個座談會的問題點上面來，亦即，當代藝術為何較少使用傳統工具和媒材，而改用比較直接的擬態方式（如現成物、機具、物件等）來傳遞觀念，甚至透過氣味、聲音、光影及自然現象來表達一種複雜、交錯的當下經驗。可以見到，當代藝術更進入到跨越框架、媒材或形式的層面，得以表達更直接而純粹的身心狀態、思維概念。總歸一句，不管使用何種媒材、觀念或形式，擬態或擬態化現象勢必存在於美的範疇之中，成為藝術家傳遞美的訊息與價值的重要過程。它不只是藝術家動物性行為的反應，同時為了吸引觀眾靠近他的作品，必須發揮社會化的作用，亦即，「擬態」是一種交互性、社會性行為的衍生物。生物性行為來自自發性的生產，透過各種媒材、觀念或形式的裝扮，製造「藝術荷爾蒙」這樣的吸引力，誘導及連結觀眾。反之，他的作品就因此製造、產生了社會化意義，名之為淨化人心或美化社會，最終達到接近宗教或哲學的層次。

觀眾一 因為大家提到所謂的框架和潮流，我想請問在藝術的領域，比如說是透過藝廊或是美術館、藝術館，它也是帶動了一個潮流。如果說今天有個藝術家通過自然的表現，但是因為他可能不符合領先的這個潮流所設定的框架，他就不被接受。而我們一般人也不會認識他，因為他也沒有被做行銷。這是我們想像的，不曉得你們對這個的看法？因為現在資訊的傳遞會造成大家對於（一件事情有）同樣的認識，然後產生共鳴，如果今天他是在一個小島上面的藝術家，他的創作沒有被發現，他是不是就不好？

楊子強 如果從商業角度來說，你如果去到一個商業中心，這麼多品牌，哪一個品牌是最好的？品牌的價位在哪裡？是不是最貴的就是最好的？也許最便宜的也是可以用的。我想說每個國家每一個美術館都有它的定位、思路，美術館背後都有一個團隊在整理這個定位和思路，所以，如果那個藝術家本身去多方的接觸，他可能就找得到適合他的定位的美術館來支撐他這樣的創作，所以，我覺得是看藝術家怎麼去看待生存這件事情，是不是只有這樣的生存方法？

觀眾一 他要忠於他自己的創作和藝術？還是要跟著這個潮流，依他們要的去表現？

楊子強 藝術生存這件事情是非常主觀的。它讓藝術家決定他自己的一種生存方式。我覺得應該是藝術家去思考這樣的情形。如果他覺得他不需要這樣的生存方式，他也可以走他自己的路。可是不是每個人都這樣，Van Gogh 就是這樣，在他過世以後，他的嫂嫂想盡辦法讓每一個人都去知道他。所以，藝術家還是需要有一個活著的、相信他的人，很多藝術家也不會去做（自我推銷的事）。

白適銘 我來回應您的問題。藝術家會以自己的身分來談（這些問題），我則從學者、評論家或觀眾等的不同角度來看這問題。包括兩個方面，首先，就是潮不潮流、合不合潮流，是誰決定的？比如說，藝術家決定去哪個地方展覽？或是不展？或是要展什麼？當然牽涉到面對潮流（或者應說是觀眾）的態度及立場，他是有選擇權的。我不在這裡展，也可以到別的地方展，藝術家的主觀意願可能遠較客觀條件更為重要。在過去威權時代，美術展示空間非常少，創作遭受監控，即便建造美術館，卻只能說是一個威權空間而已。但是，拒絕收編、排斥框架的藝術家，就無法進入這個體制，美術館成為排除異己的威權象徵。但現在展示空間非常多，我們也提到「替代性空間」這個名詞，可能在一個工地廢墟裡面就可以展覽，不一定非到美術館不可。於此，美術館間接成為

colourful appearances or eye-catching body figures are beautiful characteristics for the eyes, that is, "beauty" in our eyes, they actually relate more to an innate capacities of defending, frightening, tempting, or adapting. "In the name of beauty" in this sense is but a response to the relationships between people in a society.

However, strangely, humans seem to lack the capacities to morph and to transform. For instance, men's robust figures and strong muscles may attract the opposite sex or frighten their enemies away, but they do not adapt to the environment like those of other male animals. In primitive societies, there might be some alternatives methods, for example, they might use masks, tattoos, or other forms of disguise for facilitating communication between humans and gods, intimidating enemies, serving as symbols of power, or pursuing partners of the opposite sex. Nevertheless, these are not inborn abilities like those of the animals. How do males attract females to reproduce their offspring? In biological terms, aside from emitting hormones that attract the opposite sex, the mimicry of appearance in terms of creating visual impressions of power, security, or success (like the masculine dress of the primitive society mentioned above) seems to be more important.

Similarly, artists are creating similar mechanisms to disseminate beautiful messages and promote aesthetic values through their "artistic hormones" (inborn) and "artistic dressing" (man-made). This mechanism could be everywhere and penetrate the inner world of the audiences. In fact, Yeo's works allow the audiences to intervene, engage, and interact in many aspects. His works are very "welcoming", they continue to release "artistic hormones" and invite the audiences to be part of them. Therefore, I think that in our discussion about the social identity of artists, we must talk about this kind of mechanism that involves transmission and connection to make art more powerful and functional.

Finally, I would like to go back to the main point of this forum's topic, why does contemporary art use comparatively less traditional means and mediums but applies more straightforward strategies of "mimicry" (e.g. ready-mades, machines, objects) to convey ideas? It may even make use of smells, sounds, light and shadow, and other natural phenomenon to deliver complicated, interweaving experiences at a particular moment. Contemporary art has entered the interdisciplinary realm where its frameworks, media, or forms could work together to present purer and more direct states of mind and ways of thinking. To sum up, no matter what media, concepts, or forms are in use as the strategy, "mimicry" or mimetic phenomena will always be in place within the realm of "beauty" as it is an important process whereby artists convey messages and values of "beauty". It is not only a reaction of the artists' animal behaviour, but in trying to attract viewers to approach their works, it has to perform its role in socialisation. "Mimicry" is thus a product derived from social interaction. The animal behaviour is the result of spontaneous production; through various media, ideas or styles, artists generate a sort of "art hormones" to lure, guide, and connect the viewers. Otherwise, their works would render a value of socialisation in the name of social beautification and catharsis and eventually reach the status closer to philosophy and religion.

Audience 1 There were mentions of "framework" and "trend", I would therefore like to ask this question: in the field of art, the art galleries or the art museums are institutions that lead the trend. However, there might be artists who are just expressing themselves naturally, yet their art might not fit in with the current trend or the established framework and is therefore not accepted. I imagine such artists would be unknown to the public, as they would not be "marketed". I wonder what are your views on this? Today's information dissemination tends to develop in people's mind similar understanding about things and create resonances among them – if an artist works alone on an island and their creations were not discovered, does that mean they are no good?

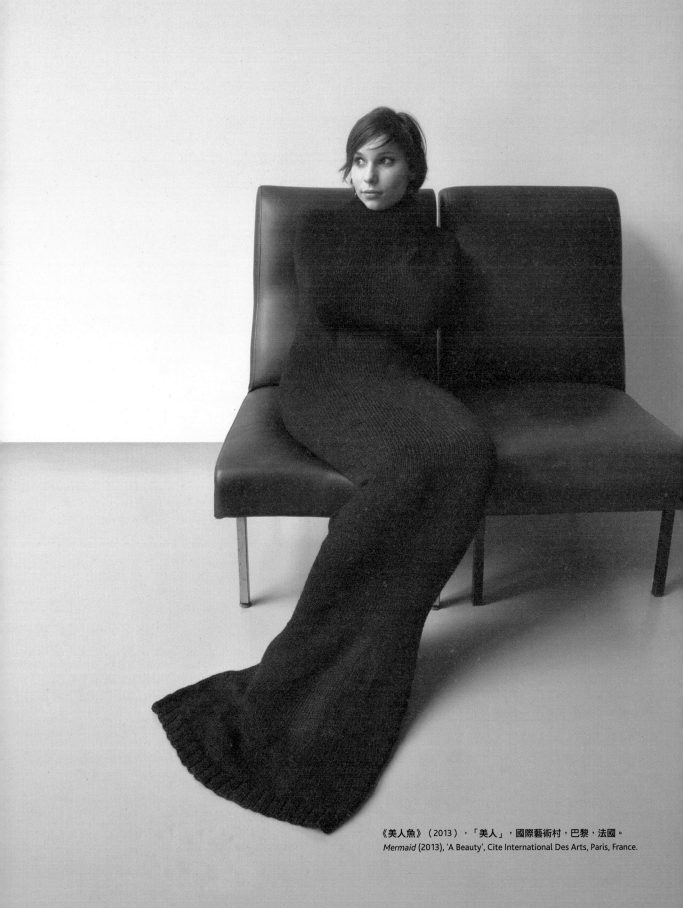

《美人魚》（2013），「美人」，國際藝術村，巴黎，法國。
Mermaid (2013), 'A Beauty', Cite International Des Arts, Paris, France.

Yeo From a commercial point of view, if you go to a shopping mall with so many brands available, you will think: Which one is the best? What is the price range of these brands? Are expensive labels the better ones? Probably the cheapest brand is good enough for daily use. What I want to say is that every art museum has its aims and objectives worked out by a team behind. If the artists make an effort to reach out, they could probably find a museum that recognises their art. This is about how an artist takes survival into account. They need to think about whether this is the only way to survive.

Audience 1 Should they be true to their own art and practice, or should they follow this trend and perform what is required?

Yeo Surviving in the art sector could be a very subjective issue; it is about how an artist defines his way of survival. I think that artists should think about this because if they do not consider this kind of survival necessary, they could lead their life according to their own will; but it is not the case for everyone. Van Gogh is one such example. After he passed away, his sister-in-law tried her best to introduce him to the world. So it is still true that artists need a living person who has faith in them as many artists will not do such things as promoting themselves.

Pai I'll answer your question. Artists will talk about this issue from their perspectives, and I will use the perspective of a scholar, a critic, or an audience. I will put this in two parts. Firstly, who should decide what is the trend? For example, where should an artist exhibit his works? Or should he not exhibit his works at all? What works should he exhibit? This definitely involves the attitude or the stand of the artists when facing the trend (or should we say the audiences), and they have the right to make their own choice. If I do not want to exhibit my works here, I could do it elsewhere. The artists' subjective willingness is probably way more important than the objective condition. In Taiwan, during the martial law era, there were few exhibition venues, and artmaking was closely monitored and controlled. Even the art museums built were spaces of authority and power. The artists who refused to join the system and framework would not be able to enter that system, and thus the museum becomes the symbol of dictatorship that excludes dissidence. Today, there are so many more venues for exhibiting artworks including alternative art spaces such as the abandoned construction sites. So it is not compulsory to turn to art museums for exhibiting artworks. Here, the museum indirectly becomes the passive or the rejected one that is subjected to the supervision of artists and the general public. This results in issues such as the weakening of the museum's social function and their shifting away from the mainstream. In fact, the diversity of exhibition venues frees the artists from struggling with the need to catch the trends, and this allows them to be more autonomous and creative. Therefore, in my opinion, there should be no opposition in the relationship between the artist and the exhibition venue. Instead, they should negotiate with one another. On the other hand, what should we make of the audiences' perspective? Do they expect artists to follow the trend? This is something that the audiences must decide for themselves. If the artist stays too close to the trend, audiences may consider their works too commercial; if they stay closer to the system, audiences may have doubts about their personality or principle. Yet those who stay away from the trend may be taken as weird or eccentric, every small error they make will be scrutinized. Therefore, in terms of the relationship between the artists and the audiences, whether to suit the trend or to break away from the framework, are relative questions of choices.

Recently, I have just finished a thesis on Taiwan's art scenes of the 80s when artists tried to "emancipate from the system". It is known to us that in the wake of Taiwan's democratisation, the art sector developed new perspectives on "framework" as artists no longer had to surrender to the governmental system - thanks to the emergence of alternative art spaces; freedom of choice became the new rule. Artists wandered around different exhibition venues according to their wills, and they could turn down

被動者或受拒者，接受藝術家及社會大眾的監督，產生社會功能的虛級化及非主流化問題。事實上，展示空間的多元化，促使藝術家不須對潮流不潮流的問題產生天人交戰，進而具備更多的主導權及可能性。所以，我想藝術家和展示空間的關係，應該不是對立的，而是協商的。另一方面，是觀眾的角度如何？觀眾期不期待藝術家成為潮流者？這是觀眾必須自己決定的事，如果太符合潮流，觀眾可能會覺得過於商業化；太依附機制，可能又會對藝術家的人格打上問號。而所謂不符合潮流的藝術家，反過來講，觀眾可能會覺得太古怪、太孤僻等等，動輒得咎。因此，我覺得從藝術家及觀眾二者的關係來說，要不要符合潮流、要不要跳脫框架，是一個相對性及選擇性的問題。

最近，我剛好完成一篇討論臺灣1980年代以後「脫體制」藝術現象的論文。我們知道臺灣社會民主化之後，藝術對於「框架」這件事情產生很大的、全新的概念，亦即類似「替代性空間」那樣的展示機制出現之後，藝術家不須完全對官方體制屈服，自由選擇成為一種新的體制。藝術家遊走於不同的展示空間之中，形成自由自主的狀態，反制權與合作權如同天平兩端，亦即在野體制可以反過來不合作、不連結，促使官方體制空轉、失衡或接受妥協。這種新的自由體制，反而是當代藝術最好的一種展示方式。比如說，我們看到剛才那些作品都是影像，

那些影像事實上是從很多不同空間、時間或歷史觀念所產生的。那個東西應該在美術館展出嗎？我不知道。因為我們有美術館所以就要舉辦展覽，但是攝影、影像這種媒介，如果不在美術館展覽的話又會如何？這同樣又回到上述兩方面的問題：（一）美術館希望展什麼作品，以及（二）藝術家希望在什麼樣的空間或場域被展示？如果是我的話，我覺得「自然」或「生活」就是展場，不需要到一個所謂白盒子或黑盒子的美術空間去觀賞，美術展示不須依附帶有權力宰制關係的任何體制。如果藝術家必須依附美術館體制、隨時考量是否符合「政治正確」規範的話，他又如何平衡所見、所思，甚至揭露真相？因此，隨著當代社會主體性需求的不斷強化，藝術家為突顯個人身分、行為或觀念，走向「去美術館化」自由機制難以避免，可能隨機在市場、街角或一個無名的自然原生地展示藝術創作，建構其與外部世界的全新關係。此時的外部世界，可能處於實存與虛構、社會與自然並存的狀態，具有流動性及難以定名的時代特質。我大致回答如此。

楊子強　若照現代現象學來說，所有的資訊、訊息、經驗都在（我們腦子裡），每個人都有，可是每個人選擇的方式、找出資料的方式不一樣。就好像探射燈一樣，若你腦海裡都已經有那些資料，當你嘗試想要找出某些訊息的時候，你的找出方式可能是一個進行過很多次的方式，所以你找出

來的資料都將會是一樣的，因為你找東西的方式是一樣的。而我覺得做為一個藝術家就是要提供一個不一樣的尋找方式，修改其中的一個點，修正某個看的角度，你可能會在已經存在的其中找出你平常不會找到的訊息。我想我們並不是魔術師可以無中生有，我們只能在既有的狀況底下嘗試提供多一個不同的選項。

白適銘　這個問題好像聽起來有點矛盾，亦即，藝術家必須尋求觀眾，與他產生共鳴，所以必須要有一個所謂的共通性存在，要不然就無法達到溝通。但事實上，我們要回到藝術創作的本質論上面來談。藝術是為了要跟社會溝通而存在的嗎？藝術需要溝通，但是它的成立基礎是溝通嗎？如果理解其中的意義，就不會產生矛盾。換句話說，藝術家要有知音、觀眾，可是他的目的不是只服務這些觀眾，讓這些觀眾理解而已，或是滿足他的視覺、聽覺、觸覺等種種物理性、生物性的一種感覺而已，這是第一個，所以其實並不是矛盾的。第二個，我覺得要回到藝術對社會的功能問題上面來講，為什麼需要藝術家存在？藝術家是一個身處邊緣、無政府狀態之下的特殊居民嗎？還是服膺體制、追求利益的生意人？或許都有可能。但問題是，不同社會化的結果或程度的人，會造成全然不同的社會效應。比如說，有的藝術家希望變成一位文化大師，他可能必須透過藝術的媒體、媒介，配合國家政策、宣揚民族價值或突顯

invitations and connections proposed by the government – the rights of going against or following the system were at two opposite ends of a scale. With their refusal, the government or the system might become void, unbalanced, or surrendered. This newly defined, autonomous system, however, became the best way to present contemporary art. For instance, the artworks we were discussing and looking at were video images; they were produced at different times, in different spaces, and from different historical perspectives. The question is: should these be exhibited in an art museum? I do not know. We have an art museum so we have to organise some exhibitions, don't we? However, for mediums like photographs or videos, what will happen to them if they are not exhibited in art museums? These issues lead us back to the two mentioned questions. (1) What kind of works do art museums expect to exhibit? (2) Where do artists expect to showcase their works? If I were an artist, I would take "nature" or "life" itself as the exhibition space. There is no need for the so-called white cube or black box because the exhibition of art does not rely on any authoritarian systems. If an artist relies on art museums and always takes political correctness into account, how would he be able to balance what he sees, thinks, and even reveals the truth? Therefore, as subjectivity is reinforced in modern societies, it is inevitable that artists tend to turn away from museums in order to accentuate their own identities, behaviours, or concepts. They may showcase their works at random marketplaces, street corners, or unknown natural sites so as to establish new relationships with the external world. At this point, the external world could be in a state where reality and fiction, urban spaces and natural landscapes conglomerates and co-exist, and is characterized by mobility and indefinability.

Yeo According to modern phenomenology, we have all information, messages, and experiences stored in our mind, everyone has it, but the methods we choose to find the materials are not the same. Just like the searchlight - if you already have pre-existing data in your mind when trying to search for some information, your method of search may be something that you have done many times, so the information that you find will always be the same because your approach is the same. However, I feel that as artists we need to offer new ways of searching – a bit of

modification here, some adjustment of angle there, and you may find information that you will not discover within the existing system of knowledge. I think we are not magicians who could create something from nothing; all we can do is to offer one more option under the existing circumstances.

Pai This may sound contradictory: Artists must seek audiences and resonate with them, therefore there must be some existing commonality between them, otherwise they cannot establish communication. In fact, we have to return to the nature of art making in our discussion of this issue. Is art meant for the purpose of communication with society? Art needs communication, but is it built fundamentally on communication? If we understand the meaning within, then there will be no contradiction. In other words, artists need audiences but do not aim to serve them. It is also not merely about making them understand something, nor to satisfy their physical and biological sensations with visual, audio, and other stimulation. This is the first point -there is no contradiction. Secondly, we should go back to the social function of art. Why do we need artists? Are artists special residents living at the borders with no governors? Or are they businessmen who conform to the system looking for commercial benefits? Maybe it is possible that they are both, but the thing is, people from different socialisation levels or consequences bring totally different social effects. For example, some artists wish to be a cultural master, so they may have to promote ethical values, highlight social expectation through social media, and align with national policies. There is nothing wrong with this. However, returning to what we mentioned earlier, if the audiences think that art needs a two-way communication between its functions of purification and beautification, have the artists reached this goal? This is the commonality mentioned earlier, as for whether the goal has been reached is open for examination. Now let us go back to the earlier question again: Is serving audiences the only function of art? Of course not. I believe Mr Yeo commented that artists have to satisfy both themselves and the society, so it is natural for them to look for balances and search for answers between the two opposite ends. If we think of art as a platform or a mechanism for communication, who will it serve and how does it offer mutual satisfaction? Who will consider it unsatisfactory? These questions definitely exist. Going

社會期待，這也無可厚非。但是，回到我們剛提到的，如果觀眾認為藝術需具備淨化及美化的雙向溝通，那麼他們達到了嗎？這就是剛才提到的共通性，有沒有達到可以被檢驗。再回到我們剛才的提問，藝術只具備服務觀眾這樣的功能而已嗎？當然不是。我想楊老師有提到，藝術家除了自我滿足之外，他還要滿足社會，要追求一種平衡，在兩極之間如何做出選擇，（這個問題）是自然存在的。如果認為藝術創造是一個溝通平臺、傳達機制的話，它到底對哪些人產生共通性的滿足？哪些人產生不滿足？（這些問題）都是很自然會產生的。回到藝術和社會關係上來說，我覺得藝術家不斷在創造一種新的自由體制，不管它

對體制的態度、立場或看法是什麼，必須去思考最終目的，比如藝術家是否要傳達哲學或宗教理念？他是為了自己還是別人？可能都有，所以他們雖身處矛盾，卻又能透過自由選擇產生平衡。尤其是必須討論藝術作品在當下社會環境中的位置，現在藝術家已經不再追求美這麼傳統而遙遠的價值了，更重要的是要關心現實、介入社會、跨越疆界。比如說現在世界上發生什麼，藝術如何與此現狀產生關係，展演現實及傳遞現有，才能完成當下的意義與作用。比如說，何館長有提到對於生態破壞的紀錄、對於戰爭的控訴，或對於包括人類未來可能會滅絕的提醒種種，當代藝術已經無法透過美這種單純概念加以涵蓋。所

以，你要說他是為了追求社會的共通性，還是為了自己的獨特性，我覺得這都有，都是相互交錯的。謝謝！

《我爬行在一條名叫「夜」的黑蛇身體裡》（2011），露芙‧巴克的客廳，格拉斯哥，蘇格蘭。
I am crawling inside the body of a black serpent named 'Night' (2011), Ruth Barker's Living Room, Glasgow, Scotland.

back to the relation between art and society, I think that artists are continuing to create a new system of freedom. No matter what their attitude, stand, or view is, they have to take their ultimate goal into account. For example, are they going to promote a certain philosophy or religious belief? Do they create art for themselves or for others? Maybe both, that is why they are always able to balance the elements through free choices although they are situated within contradictions. It is especially necessary to discuss the position of artworks in the current social environment, the goals of artists today are not so much about pursuing the traditional and distant value of beauty, but more about looking into reality, making intervention in the society, and crossing over the borders. For example, what is happening in the world? How can art relate to different phenomena? How do they represent reality and convey current condition in order to make all that has

happened meaningful and useful? For example, Director Ho mentioned the documenting of environmental destruction, the condemnation of wars, and the reminder of possible human extinction, etc. with all these, the simple concept of "beauty" has become too limitative for the broad area that contemporary art is covering. So, is contemporary art about achieving social commonality or for the artists to pursue their own uniqueness? I think it is both as they are intertwined. Thank you.

《新加坡的雨是淘氣的，當太陽和黑雲相遇在那季候風的季節裡》（2010），「城市內的藝術」，富樂頓酒店，新加坡。
The rain of Singapore is mischievous, a Sun meets a Black Cloud in a Monsoon Season (2010), 'Art in the City', Fullerton Hotel, Singapore. 2010.

白適銘教授

東亞藝術史學者、策展人、藝評家。台大藝術史研究所碩士、日本京都大學美術史博士，目前為國立台灣師範大學美術系專任教授。研究領域包括：（一）台灣現當代美術、（二）中國傳統書畫、（三）東亞區域文化交流、（四）策展學、（五）當代藝術評論等部分。特別關注東亞區域美術史的方法學運用及當代史觀建構問題，研究議題包含：美術的現代化、現代性、視覺再現、歷史記憶、文化疆界、地方認同、跨殖民論述及文化主體性等。

楊子強教授

麗美中心創辦人，專業雕塑家，精研人體造形藝術與當代概念裝置創作，以實踐的態度深化「雕塑造物」的原始創作意向，從實驗的角度對應當代藝術思潮的表現內涵和數碼網絡時代的虛擬語境。於新加坡南洋藝術學院及拉薩爾藝術學院執教多年，也於 2017-2020 任職國立臺灣藝術大學雕塑系客座助理教授。

Prof Pai Shih-Ming

A curator, art critic, and scholar in East Asian art history. He holds a master's degree from the Graduate Institute of Art History in National Taiwan University and a Ph.D. in Art History from the Kyoto University in Japan. He is currently a full-time professor at the Department of Fine Arts in National Taiwan Normal University. His research area includes modern and contemporary Taiwanese art, traditional Chinese painting and calligraphy, regional cultural exchanges in East Asia, curatorial studies, and contemporary art criticism, etc. He is particularly keen in the methodological application of East Asian regional art history and issues in the construction of contemporary historical views, the research topics include: modernization of art, modernity in art, visual representation, historical memory, cultural boundaries, local identity, cross-colonial discourse, and cultural subjectivity.

Prof Yeo Chee Kiong

The founder of *A Beauty Centre*, a contemporary sculptor and conceptual artist who is fascinated with the language and spatial relationship between object, space and authorship. His work destabilises the familiar notions of spatial proportions and perspectives, whilst examining the human conditions in the construction of an extended surreal world. Yeo teaches at the Nanyang Academy of Fine Arts and Lasalle SIA College of Art in Singapore, and was Visiting Assistant Professor in the Sculpture Department at National Taiwan University of Arts from 2017-2020.

泉湧之境

手放之處

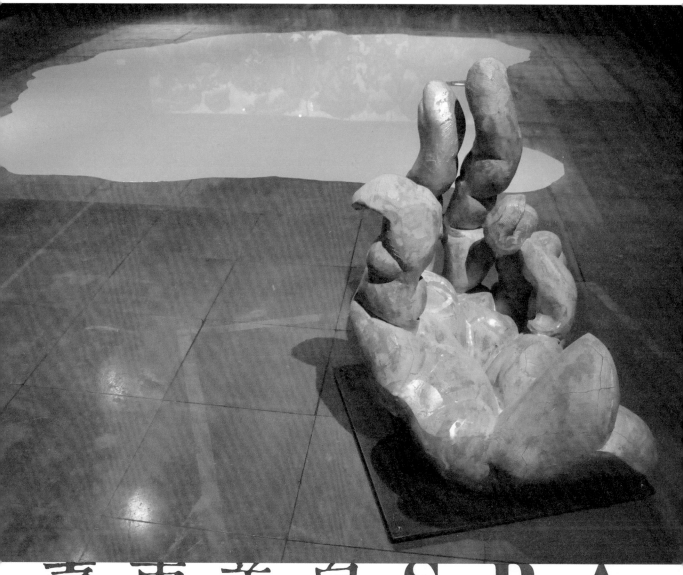

臺東美泉ＳＰＡ

Public Art

Korea

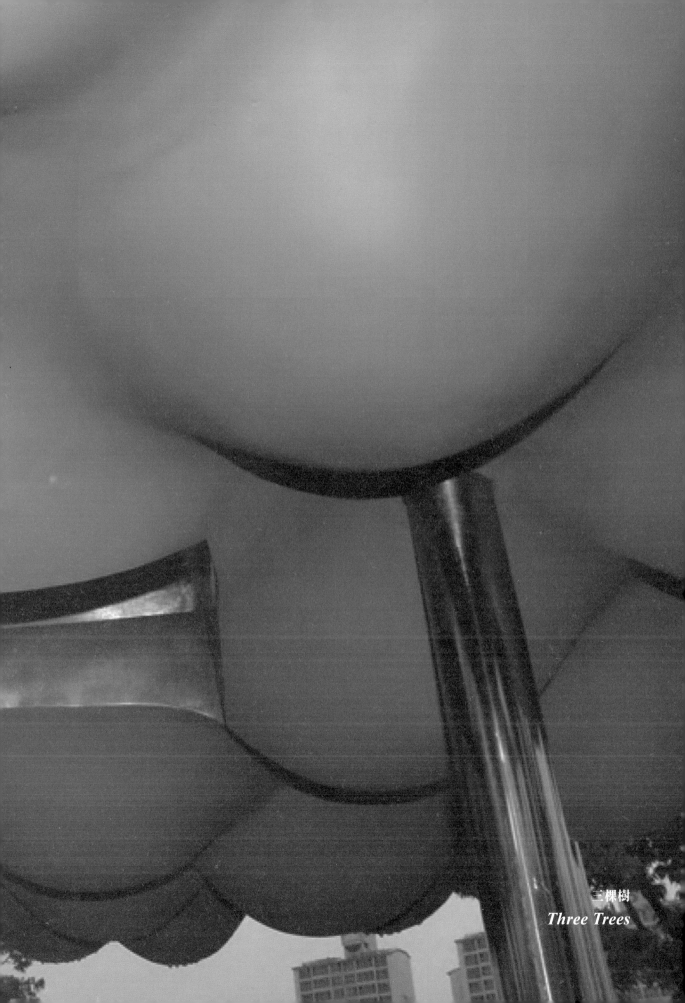

三棵樹
Three Trees

一刀三刻　布丁天堂

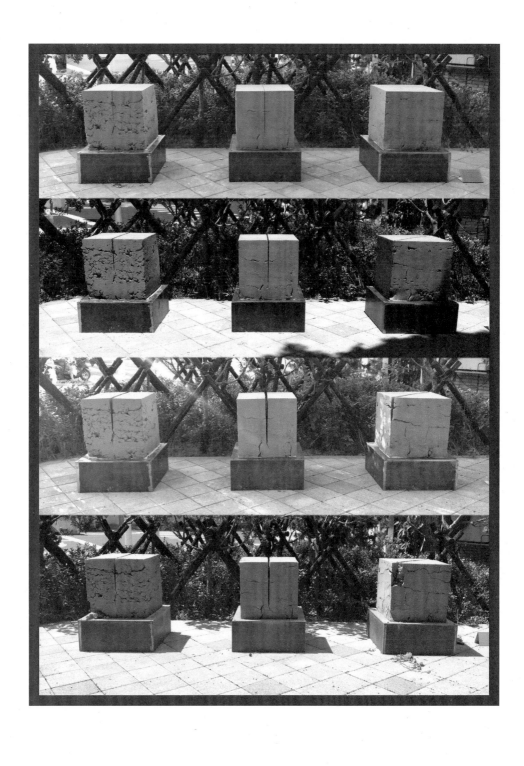

One Cut Three Puddings

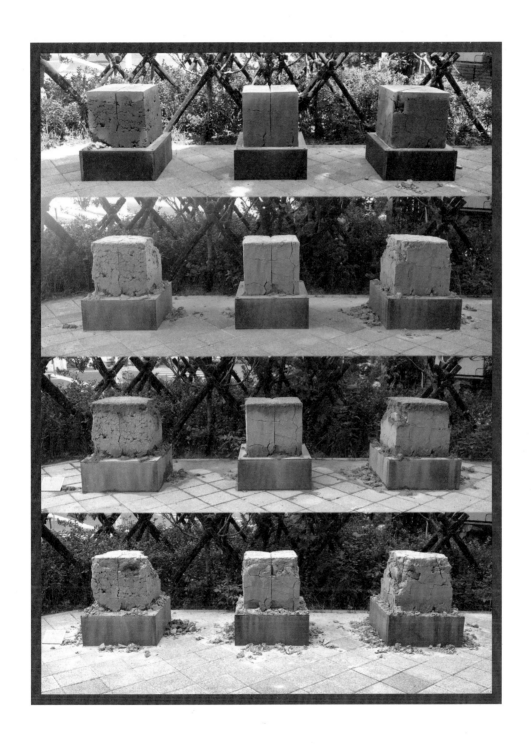

Pudding Paradise

ONE CUBIC

Project 2013

紅點之眼
In The Eye of Red Dot

Public Art

National Museum of Singapore 2015

SG
50

Public Art

Singapore

從另一個角度觀看森林的雨
Another way to percieve the rain of the forest

Bubbelloon

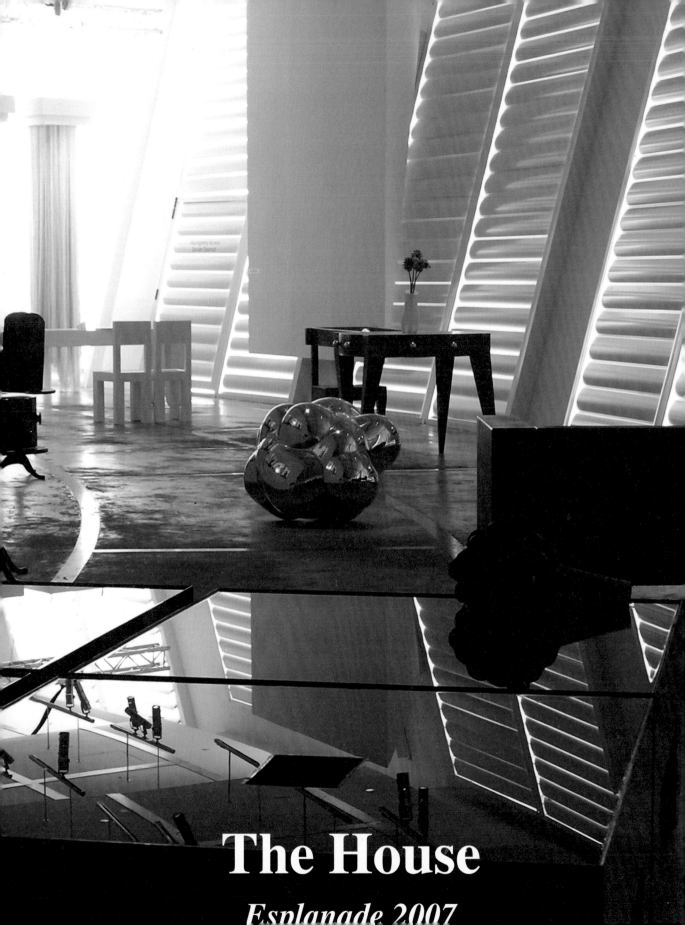

The House

Esplanade 2007

他者性、旁邊以及諧擬

——關於楊子強的《模糊時尚》

■ 簡子傑

雖然説相較於藝術創作，製作一本書的過程有著較高的目的性，其編輯與設計都仰賴多方協調，並經常流於某種瑣碎事務的執行，但在藝評人高千惠引介下，我因緣際會下獲得參與《模糊時尚》一書的過程，卻更接近某種協作式的創作經驗，而不太像一件「工作」。這當然要歸功於參與本計畫的團隊具備嚴謹的當代藝術專業，但最關鍵的，仍必須回到本書真正的作者——楊子強，他在面對書的出版時毫不鬆懈的藝術家態度，讓成書過程更像是一場由他所號召的藝術行動，事實上，這本書也可視為是楊子強的創作，一個以書的製作連同其流通為主體的展演行動。

當然，產生這樣一本橫跨新加坡與臺灣的書，在嚴峻的新冠肺炎疫情籠罩下，有一大部分的工作是透過網路視訊會議的方式而展開，但兩個島國間相隔三千多公里的距離，其實並不會大過於任何一場在臺灣兩座不同城市間的視訊會議的差異，這是當「我們」多數人都已逐漸習慣所謂社交距離後必然產生的結果，但也因此，這裡的「我們」意指的範圍就不侷限在新加坡與臺灣，因為疫情造就的隔離是全球性的，當我們失去了在異地生活與創作的條件，彼此之間卻意外地獲得了某種平等的資格，某種只能仰賴資訊串流、乃至透過這樣一本書在世界的流通因而獲得同等重視的機會。

然而，我們還是知道，所謂的平等通常是一種幻見，距離對於他者而言仍是貨真價實的中介性存在。至少，對於以書承載其創作實踐的藝術家楊子強而言，《模糊時尚》在臺灣出版，當然是一種有意識的選擇——無疑地，這與他過去數年在國立臺灣藝術大學擔任客座教授的異地生活背景有關，但作為臺灣當代藝術脈絡中至少是國籍意義上的外來者，這種他者性不禁讓我們思索，這個相對來說更不方便的臺灣出版計畫，究竟是基於怎樣的選擇與什麼樣的他者視點？另一方面，佔據《模糊時尚》主要篇幅的「麗美中心」計畫雖是先後於 2016 年及 2017 年在新加坡與臺灣的朱銘美術館進行過展出，但這個在授予藝術資格的美術館中諧擬著美容院的計畫，卻更像是在體現著文化範式的核心場域，從其內部引入他者性的藝術批判計畫。

針對這種藝術批判性，在蘇茜‧林厄姆（Susie Lingham）的〈金山上的美容院〉中已經多所闡述，這種批判除了源自楊子強傾向「過度」的造型策略，也透過質詢「美」因而圈圍出系列性的問題意識，而在這本書末尾，高千惠在上個世紀末就已寫下的〈誰殺了美術館？〉更可視為這種機制批判在華語世界中的超前部署。

但關於他者性的問題，楊子強畢竟劃出了一個更為特別的輪廓。在異地出版的楊子強，對臺灣讀者而言雖然具備了明顯的他者性，卻也讓回到新加坡的《模糊時尚》擁有了另一種他者性，但這種他者性卻不同於不同國籍背景所意味的那種外來者而已，與此相對，它傾向具有誘惑力的那種他者性，這種誘惑當然不像坊間常見的那種透過音譯西方品牌以創造出讓人想一探究竟的陌生化作為，我個人認為，這種誘惑恐怕更多的源自臺灣做為華語世界中為數不多的民主政

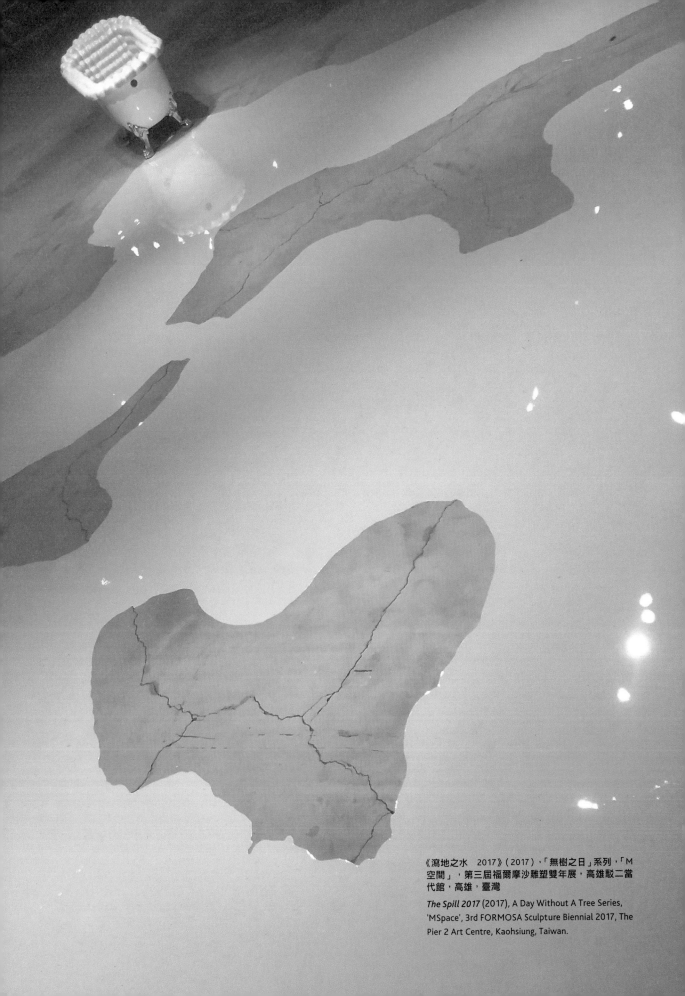

《瀉地之水　2017》（2017），「無樹之日」系列，「M空間」，第三屆福爾摩沙雕塑雙年展，高雄駁二當代館，高雄，臺灣

The Spill 2017 (2017), A Day Without A Tree Series, 'MSpace', 3rd FORMOSA Sculpture Biennial 2017, The Pier 2 Art Centre, Kaohsiung, Taiwan.

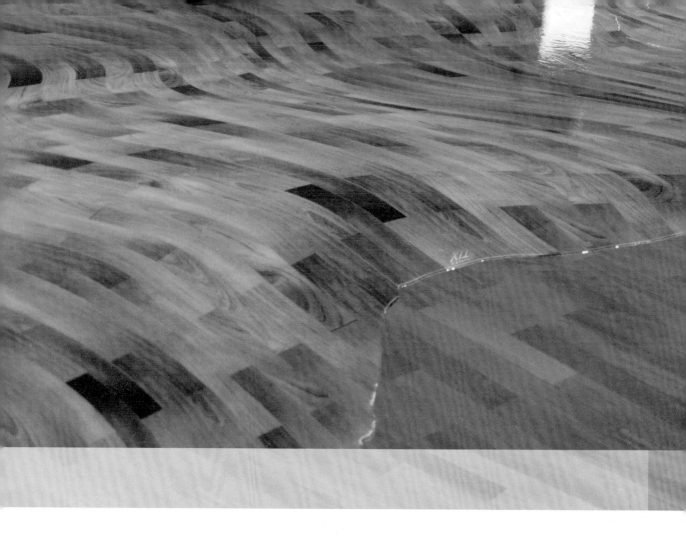

體的某些文化政治特徵——在這樣一個各種政治爭議總是帶來太多媒體聲量的開放社會中，當代藝術的政治批判潛力被習慣性低估，但也是這樣的低估保留了在他方正視其批判性的可能性，或也因此，《模糊時尚》選擇了一條這樣一個從新加坡出發，行經臺灣，再折返故土的迂迴路徑。

* * *

最後，我想談一談這個計畫中的諧擬，其實我們也習慣低估各種型態的諧擬，例如山寨品可能會被視為屈辱性的文化生產，相對於完美的典範，他者性就會演變為某種注定無法到位的東西。但諧擬著美容院的美術館的「麗美中心」卻不是為了提醒典範仍在遠處，而更多的是各式各樣被我們習慣低估的他者，其中，甚至也包括楊子強自己的作品。在「麗美中心」展場中，美容中心般的空間設計仍然難以覆蓋我們正在美術館觀看楊子強作品的事實，雖然這些原來各有創作脈絡的作品也確實在《模糊時尚》作為流行文化景觀的閱讀框架中被削弱，他者性卻獲得了成為其他什麼的可能性。（註1）

義大利哲人阿岡本（Giorgio Agamben）曾提出一系列關於諧擬的觀點：諸如諧擬從不妄想取消被諧擬物，它所需要的更是一種對於被諧擬物的「過度」（而非否定），而這種過度不僅帶來了某種門檻經驗，更是一種在「旁邊」的存在。（註）

我不確定義大利原文的「旁邊」是否接近前述的他者性，但如果要詮釋出現在《模糊時尚》中的各種楊子強作品，「旁邊」這種觀點倒是深具啟發性：出現在本書中的這些作品並未被藝術

《瀉地之水　2016- 溶化的木地板》（2016），「無樹之日」系列，《麗美中心》，南洋藝術學院，新加坡
The Spill 2016 - Melted Wooden Tiles (2016), A Day Without A Tree Series, 'A Beauty Centre', NAFA, Singapore.

家置入某種作品集的分類框架中，而是毗鄰著彼此，它們有時相互滲透，有時也排斥著對方；新加坡與臺灣分別開展的兩個「麗美中心」也是在彼此的旁邊，諧擬著對方並持續地變異，但它們絕非同一個展覽的兩個不同版本；在翻閱《模糊時尚》時，我也發現「疊椅桌去當代家具」系列甚至從這種旁邊的位置擴展到東西方文化相互沾黏的程度，而新加坡與臺灣，在華語世界中也可以視為某種相鄰又不同的存在吧。

註

這裡有關的譯名，我都採用臺灣習慣的譯法，在中國譯本中將「諧擬」譯作「滑稽模仿」，「阿岡本」則翻作「阿甘本」。無論如何，以下引文充分說明了這種「旁邊」何以是一種門檻經驗：「事實上，滑稽模仿不但與虛構契合，更構成與虛構對立的一極。這是因為，和虛構不一樣，滑稽模仿並不質疑其客體／對象的實在；確實，這個客體／對象對滑稽模仿來說是如此不能容忍地真實以致於有必要把它留在遠方。滑稽模仿用它激烈的『這太過了』（或『好像不是』）來和虛構的『好像／仿若』對立。因此，如果說虛構定義了文學的本質的話，滑稽模仿就把自身，可以說，維持在文學的門檻上，固執地懸置於現實與虛構，詞與物之間。」，同理，《模糊時尚》也可視為楊子強在藝術上堅持的某種門檻處境。引文見吉奧喬・阿甘本（Giorgio Agamben），王立秋譯，《瀆神》（Profanazion），北京：北京大學出版社，2017，頁 79-80。

Bubblelloon

THE COLUMNS GALLERY
SEOUL SINGAPORE

作品索引

Artwork Index

國家圖書館出版品預行編目 (CIP) 資料

模糊時尚：楊子強作品 = VAGUEVOGUE: The Yeo Chee Kiong
Collection / 楊子強，陳燕平，約翰·卡爾卡特，蘇茜·林厄姆，
高千惠，白適銘，簡子傑作；楊子強，陳燕平總編輯. -- 臺北市
: 藝術家出版社, 2021.05
280 面；19.5×26.5 公分
中英對照
ISBN | 978-986-282-274-6（平裝）

1. 現代藝術 2. 藝術評論 3. 文集

901.2 110006450

模糊時尚：楊子強作品

作　　者｜楊子強、陳燕平、約翰·卡爾卡特、蘇茜·林厄姆、
　　　　　高千惠、白適銘、簡子傑
總 編 輯｜楊子強、陳燕平
編　　輯｜簡子傑、林怡秀
校　　稿｜林以珞（華文）；張曉韻、傅鳳玲（英文）
翻　　譯｜陳燕平、林庭如、楊子強、朱銘美術館策展部
裝幀設計｜Idealform 理式意象設計
編排設計｜李孟杰、何　真、溫其綸

出版單位｜藝術家出版社
　　　　　臺北市金山南路（藝術家路）二段 165 號 6 樓
電話｜(02) 2388-6715、2388-6716
傳真｜(02) 2396-5708

總 經 銷｜時報文化出版企業股份有限公司
　　　　　桃園市龜山區萬壽路二段 351 號
TEL｜(02) 2306-6842
製版印刷｜欣佑彩色印刷股份有限公司

出版日期｜2021 年 5 月
定　　價｜新台幣 800 元
ISBN｜978-986-282-274-6

法律顧問｜蕭雄淋
版權所有·未經許可禁止翻印或轉載
行政院新聞局出版事業登記證局版台業字第 1749 號

VAGUEVOGUE: The Yeo Chee Kiong Collection

Authors | Yeo Chee Kiong, Tan Yen Peng, John Calcutt, Susie Lingnam,
Kao Chien-Hui, Pai Shih-Ming, Jian Tzu Chieh
Chief Editor | Yeo Chee Kiong, Tan Yen Peng
Editor | Jian Tzu Chieh, Lin Yi Hsiu
Proofreader | Lin Yi Lo (Chinese). Chan Xiao Yun, Lindy Poh (English)
Translators | Tan Yen Peng, Rye Lin, Yeo Chee Kiong,
Juming Museum Exhibition Department
Graphic Design | Idealform Co.
Layout Design | Li Meng Chien, Ho Chen, Wen Chi Lun

Produced by | Artist Publishing Co.
Add | 6F., No. 165, Sec. 2, Jinshan S. Rd., Da'an Dist., Taipei City 106, Taiwan (R.O.C)
Tel | +886 2 2388-6715, +886 2 2388-6716
Fax | +886 2 2396-5708

General Distributor | China Time
Warehouse | No. 351, Sec. 2, Wanshou
Rd., Gueishan Dist., Taoyuan City
333019, Taiwan (R.O.C.)
Tel | +886 2 2306-6842

Printer | Sinew Color Printing &
Reproduction Co., Ltd.
Publishing Date | May, 2021
Price | NTD 800
ISBN | 978-986-282-274-6